KATIE QUINN DAVIES began her career as a graphic
designer, then, in 2009, focused her creative energies on
food photography, and soon her blog, "What Katie Ate",
was born. It became an internet phenomenon, with
a huge following in the U.S., Europe, and Australia, and
won a Best Food Blog award from Saveur.com. Her first
cookbook, *What Katie Ate*, won a James Beard Award for
Photography. When she's not shooting advertising and
editorial features for leading food and lifestyle magazines
and advertising clients from her Sydney studio,
Katie loves to cook and update the blog with a variety
of new and seasonal recipes.

whatkatieate.com

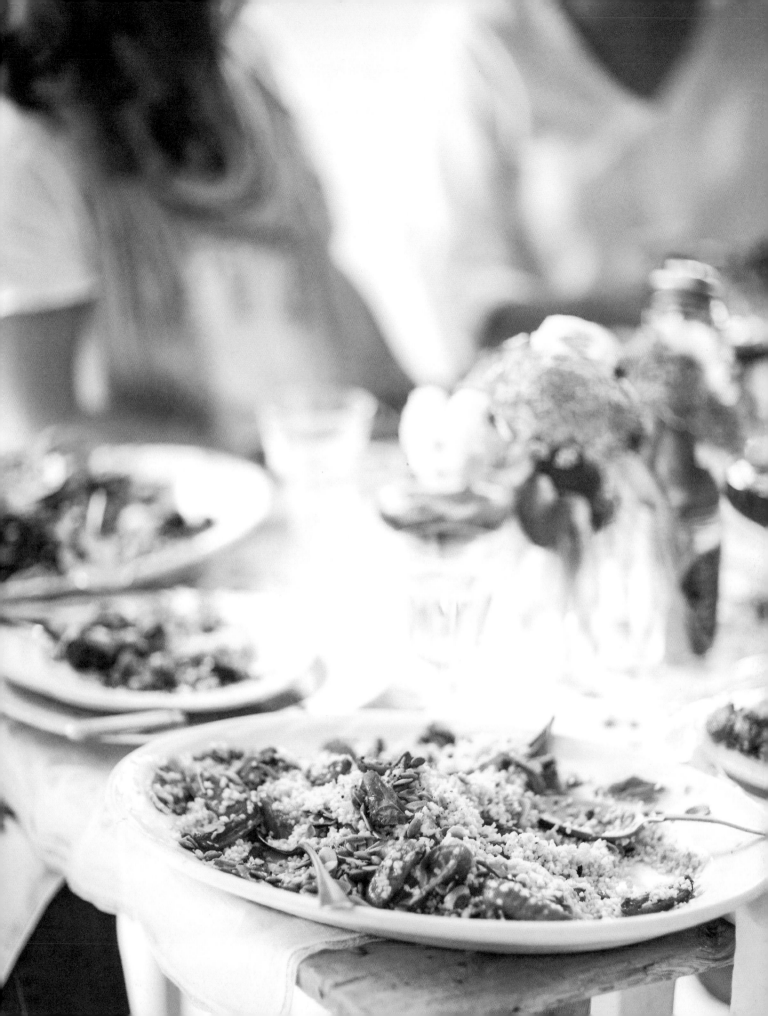

WHAT KATIE ATE

on the weekend...

Photography by
Katie Quinn Davies

VIKING STUDIO

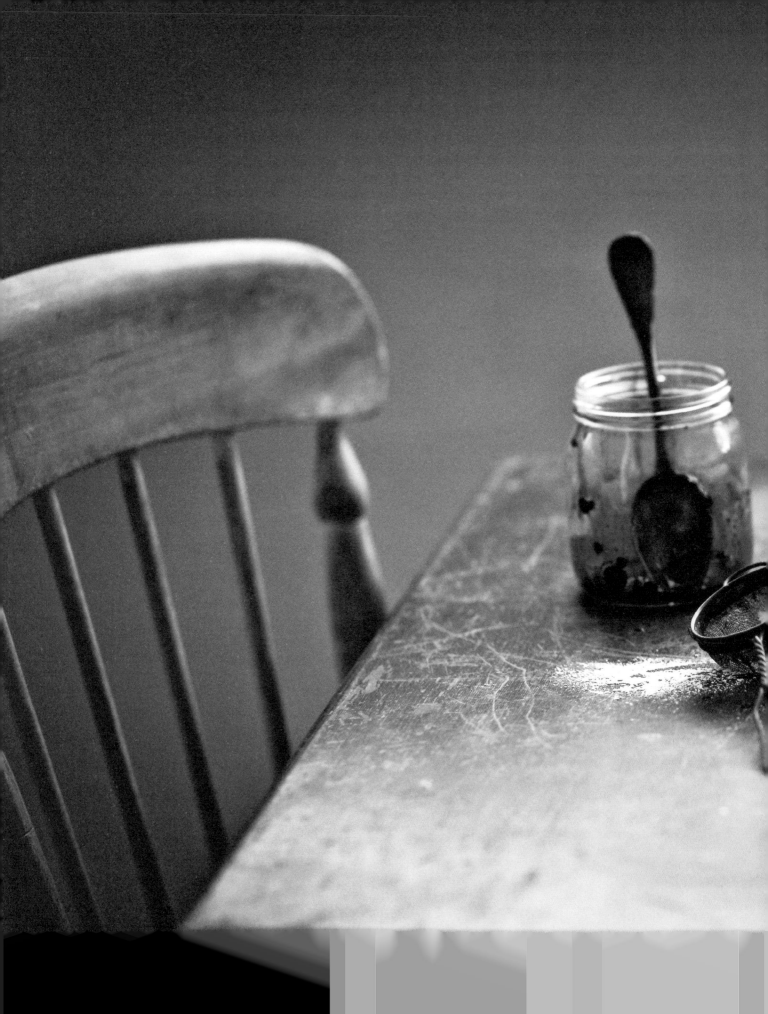

This book is affectionately dedicated to all my
stupendously amazing friends and family and,
in particular, Alice, Lou and Madeleine — there's no way
I could have done this without you, I love you all
loads. You're all supercalifragilisticexpialidocious :) x

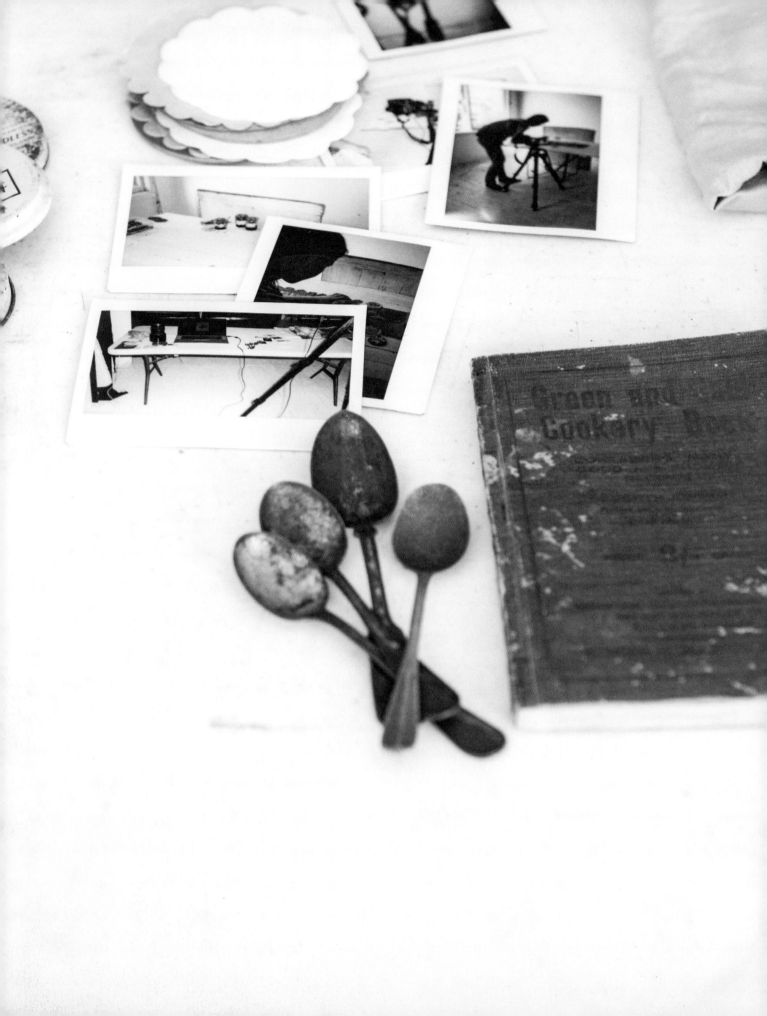

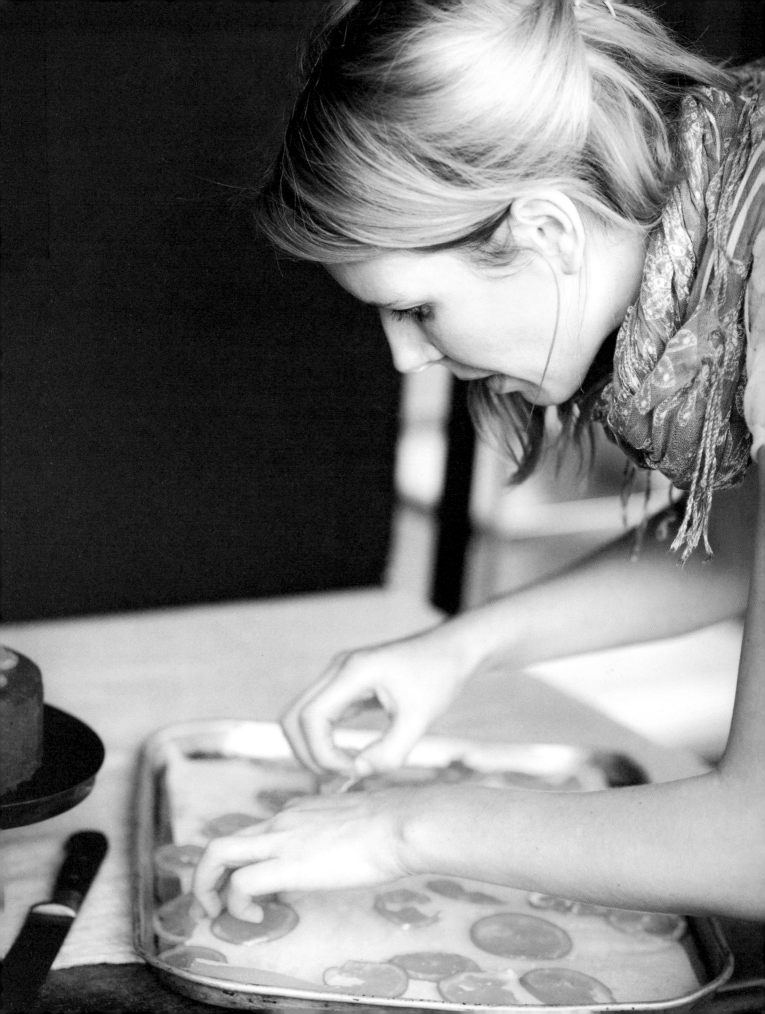

INTRODUCTION

The past two years, since the release of my first book *What Katie Ate*, have been a massive whirlwind for me. I pinch myself sometimes when I realize the book has sold into almost twenty countries worldwide and been translated into ten languages. I love it when yet another foreign edition turns up in the mail and I see my recipes translated into Italian, Portuguese, French, Russian or German. So I was thrilled to be asked to write a follow-up, and to continue on this relatively new journey as a cookbook writer, photographer, stylist, designer (and all the other gazillion hats I wear to make this dream a reality, somewhat single-handedly!).

This book is all about weekend eating and what I love best — cooking food for my family and friends. I've always said one of my favorite things to do is throw a great dinner party or a barbecue during the warmer months here in Sydney, and that hasn't changed. I get enormous enjoyment from cooking for the masses, and I love the whole process, from the planning to the serving, before watching my mates dig in. To me, one of the best things in life is to enjoy good food and good wine with those closest to you. Breaking bread with friends, so to speak.

I'm super-happy with these recipes, which have been inspired by so many wonderful experiences, from my own experimentation in the kitchen, to meals enjoyed on my travels over the past two years and recipes borrowed from friends. The dishes include ideas for lazy brunch get-togethers, lavish dinner parties, cocktail party food and drinks, textural salads and beautiful marinated or slow-cooked meats. They're not just good for weekends, either — many can easily be whipped up for a midweek meal.

I've learnt so much about food and writing recipes over the past couple of years, mainly due to my time spent doing a monthly column for Australia's *delicious.* magazine. Every month I would write, test, cook, style and shoot a collection of recipes for the magazine based on a seasonal theme. It taught me a lot about seasonal produce and putting flavors together, and I had great fun doing it. I've included a few of those dishes here, as well as a handful of favorites from my blog, *whatkatieate.com*.

Since the first book was published, I've done quite a bit of traveling: to Tokyo (amazing!), the US, Italy, London, Ireland and around Australia. Finding inspiration in meals I've eaten with friends and family on my travels is probably my favorite way to come up with recipe ideas — I love trying to work out what might be in each dish and experimenting in the kitchen when I get home, often combining one or two recipes and putting my own spin on them. The sliders on pages 236–239 are a perfect example of this.

For this book, I have included loads of photos of weekends enjoyed in my hometown of Dublin (see pages 76–85), the beautiful Barossa Valley with its wonderfully warm people (see pages 32–41), and *Italia* – my favorite country in the world (see pages 142–151). Plus, there's also some weekends spent back home in Sydney: a girly get-together with some of my Aussie blog readers (see pages 178–185 – thanks again, girls!), and a party at my house with a bit of Mexican flair (see pages 250–257).

The highlight of these past few years was, without a doubt, traveling to New York and winning the coveted James Beard Award for Best Photography and being nominated for Best General Cookbook in May 2013. I don't think I've ever been as shocked in my life as when I woke up one morning to a plethora of tweets congratulating me on my nominations; I was totally stunned, yet utterly thrilled and crazy excited. The awards are the Oscars of the culinary world in the US and I was honoured (and just a bit gobsmacked) to have been chosen as a finalist alongside many high-caliber people from the world of American cookery, media and publishing.

For a while, I tossed up whether or not to go to the ceremony, but I knew in my heart of hearts it was a no-brainer, so plane tickets and hotel were duly booked and – in typical girly fashion – deliberations regarding dress/shoes/bag/accessories/hair and make-up began! The evening arrived and there I was, sitting at the awards table in Gotham Hall with my U.S. publisher Megan. When my name was called out as a nomination for Best Photography I was a bag of nerves, and even more so when I heard my name called out again as the winner: I nearly died with excitement! I have great recollections of walking what felt like about two miles through the grand dining room to the stage, being high-fived by a load of strangers en route. After a nervously mumbled acceptance speech – something about the luck of the Irish – I was whisked away to have my photo taken, complete with a glass of champers which I almost slopped onto the floor because my hands were shaking so badly. It was an incredible experience and I will always be grateful to the judges who voted for my book and to the James Beard Foundation.

My goal with this book was to produce a cookbook that would be familiar to my readers, but with a lighter, brighter feel – a reflection of my life here in Sydney and the food I love to eat and serve. I guess this book is a journal of my recipe writing and travels over the past two years, with a few behind-the-scenes shots included to show the real 'glamor' of a frantic food shoot!

I have really enjoyed writing and shooting this book, although it's been a much bigger undertaking than my first. Sure, it was tough and super-stressful at times, but I am incredibly proud of the end result. I hope that you find lots of recipes to enjoy with your own family and friends, and continue to follow my work.

With love
Katie x

BREAKFAST AND BRUNCH

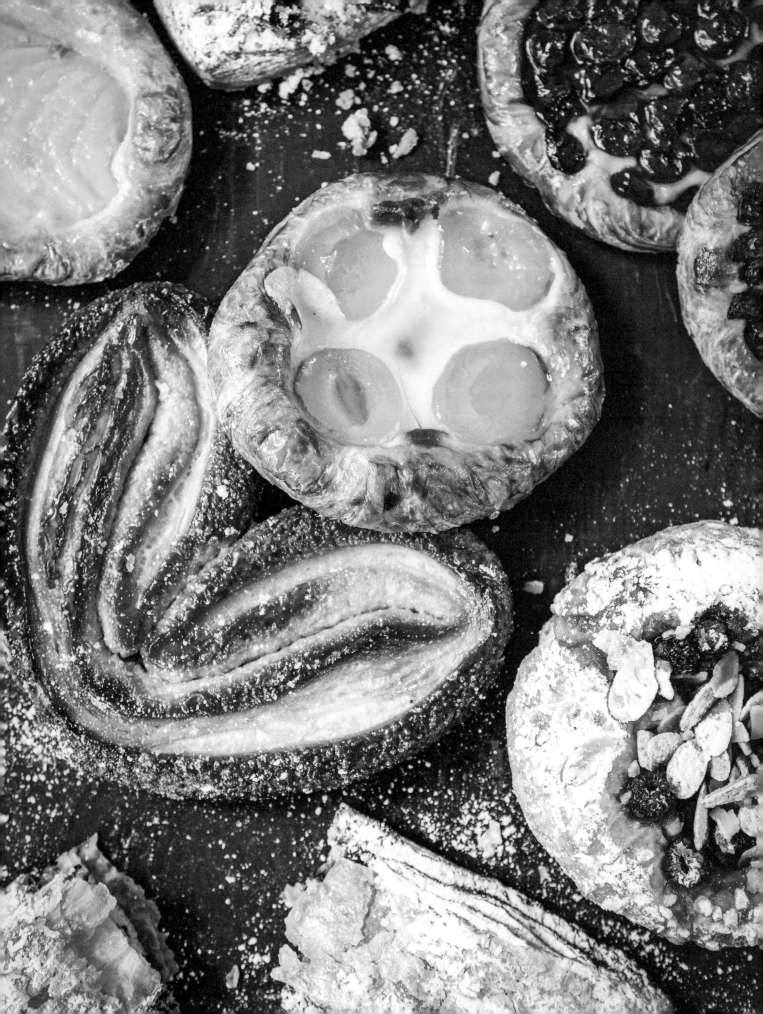

KATIE'S GRANOLA WITH BLUEBERRY COMPOTE AND YOGURT

Serves 4–6

Homemade granola is one of the easiest things to make; I love to whip up a batch on a Sunday evening and use it throughout the week. The nut, seed and berry mix will keep in an airtight container for up to 2 weeks. Puffed quinoa and chia seeds are available from health food stores, and light agave nectar (a plant-derived sweetener) can be found at health food stores and gourmet delis.

1 cup hazelnuts
½ cup almonds
½ cup sunflower seeds
⅓ cup pumpkin seeds
2½ tablespoons light agave nectar
⅓ cup dried cranberries
4 tablespoons dried blueberries
4 tablespoons goji berries
1 cup puffed quinoa
2½ tablespoons chia seeds
2 cups plain yogurt

BLUEBERRY COMPOTE
9 oz blueberries
2½ tablespoons light agave nectar
2 teaspoons lime juice

Preheat the oven to 400°F and line a baking sheet with parchment paper.

Combine the nuts and seeds in a bowl, then pour over the agave nectar and stir to coat. Spread out evenly on the prepared sheet and bake for 8–10 minutes or until golden brown and toasted. Remove and set aside to cool completely, then transfer to a large bowl, breaking up any larger pieces. Add the dried berries, quinoa and chia seeds and stir to combine. (Makes about 5½ cups.)

For the blueberry compote, place all the ingredients and 4 teaspoons water in a small heavy-bottomed saucepan and bring to a boil over high heat. Reduce the heat to low and simmer, stirring often, for 2–3 minutes or until the berries are soft. Drain the fruit, reserving the liquid, and set aside. Simmer the reserved liquid over low heat for 4–5 minutes or until reduced by half. Pour this over the berries and leave to cool.

To serve, divide the compote among bowls or jars, add a layer of yogurt and finish with the nut, seed and berry mixture.

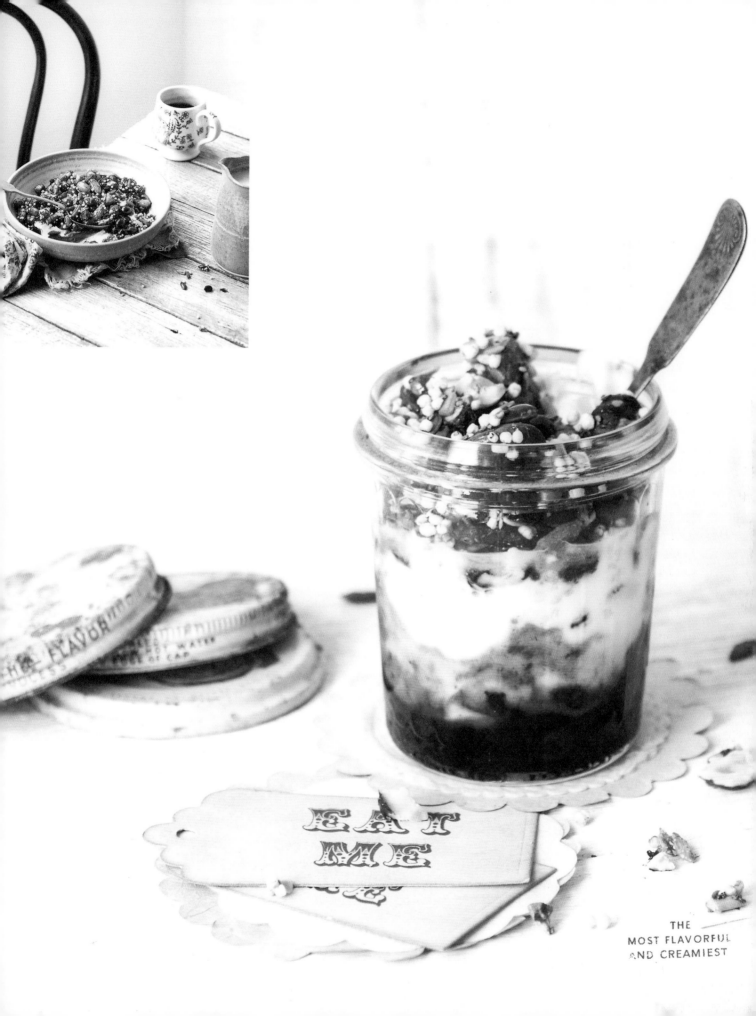

THE
MOST FLAVORFUL
AND CREAMIEST

SUPER SMOOTHIES

Serves 2 {Makes about 2¾ cups}

Honestly, I've never been much of a fan of the
super-healthy 'green shakes' that are so popular
nowadays, but this one tastes fantastic. It contains kale,
which ordinarily would make some people run for
the hills screaming, but it's virtually undetectable
in the finished drink. This is a great one to make
for the kids, to get their leafy greens into them on
the sly . . .

2 kiwi, peeled
1 green apple, cored
¾ oz kale or baby spinach leaves
2 teaspoons lemon juice
1 small handful mint
1 large handful ice, plus extra to serve

Put all the ingredients and 1 cup cold water into
a blender and whiz until smooth.

Pour into chilled glasses, add extra ice and serve.

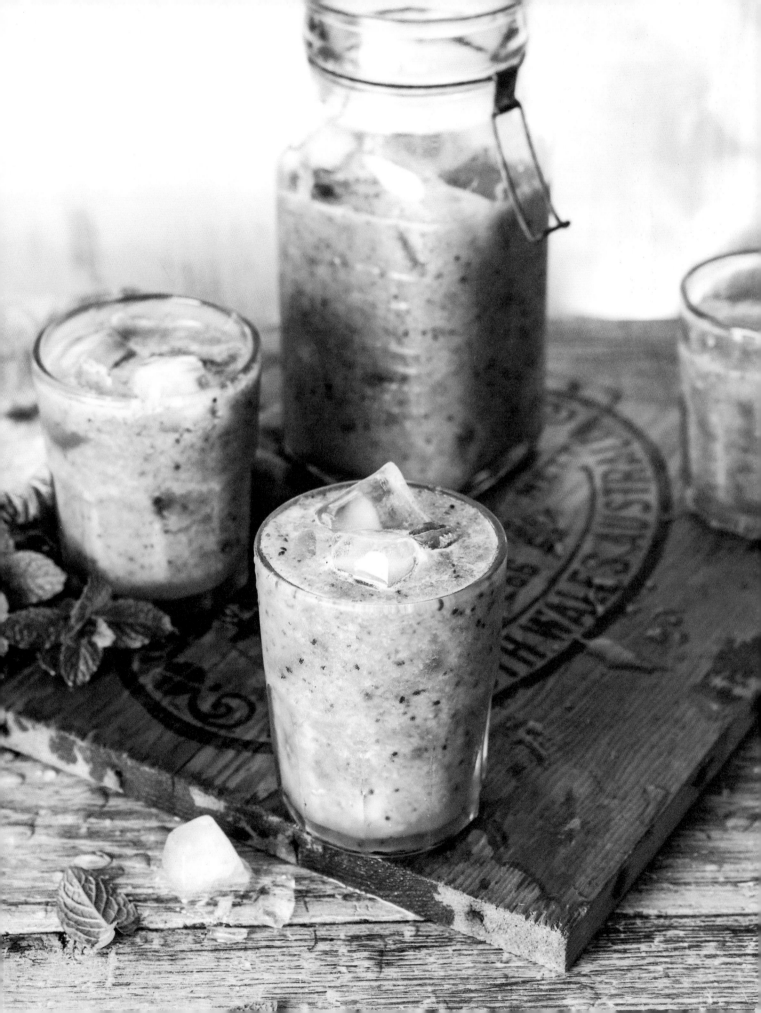

SARDINES ON TOAST WITH TARRAGON AND LEMON MAYO

Serves 4

These are great for a weekend brunch with friends. I like to remove the bones from sardines, but you can leave them in if you like — they are tiny, and full of calcium!

9 oz cherry tomatoes
sea salt and freshly ground black pepper
16 fresh sardines, cleaned and scaled (ask your fishmonger to do this for you)
4 teaspoons all-purpose flour, sifted
4 teaspoons rice flour, sifted
finely grated zest of 2 lemons
olive oil or rice bran oil, for shallow-frying
4 free-range eggs
buttered whole-wheat sourdough toast and dill sprigs, to serve

TARRAGON AND LEMON MAYO
3 free-range egg yolks
2½ tablespoons lemon juice
sea salt
½ cup canola oil
2 teaspoons tarragon vinegar
1 teaspoon Dijon mustard
2 teaspoons capers, well rinsed
1 small handful dill
freshly ground white pepper

Preheat the oven to 400°F and line a baking sheet with parchment paper.

Place the tomatoes on the prepared sheet, season with a little salt and roast for 20 minutes or until the skins start to burst.

Meanwhile, for the mayo, place the egg yolks, lemon juice and a pinch of salt in the bowl of a food processor. Process on high speed for 1 minute then, with the motor running, add the oil in a thin, steady stream until the mixture is thick and glossy. Add the vinegar, mustard, capers, dill and white pepper and process again until just combined, then cover and set aside.

Pat the sardines dry with paper towel.

Place the sifted flours, lemon zest, a pinch of salt and a good seasoning of black pepper in a shallow bowl and stir to combine. Add the sardines and toss to coat well.

Fill a large, deep, heavy-bottomed saucepan with oil to a depth of ¼ in and heat over medium–high heat. Shallow-fry the sardines for a minute or two on each side until cooked through and golden brown. Remove with a slotted spoon and drain on paper towel. Set aside and keep warm.

Fill a saucepan with water and heat to 176°F or until just barely simmering. Working with one egg at a time, crack the eggs onto a slotted spoon (allowing any watery egg white to run off), then slide the egg into the simmering water. Cook for 4 minutes, then remove with the slotted spoon and drain on paper towel. Cover and keep warm while you cook the remaining eggs.

Place a piece of toast on each plate and top with the tomatoes, sardines, egg and some mayo. Finish with a good grinding of pepper and garnish with dill. Serve right away.

CHOCOLATE AND SOUR CHERRY HOTCAKES

These hotcakes are great for a special weekend breakfast or brunch. You could also serve them as a dessert, if you like. I use frozen sour cherries in the batter, but you can opt for the morello ones that come in a jar (just drain them well before use) or, even better, use fresh if they're in season. Toast the slivered almonds in the oven for 6–8 minutes at 350°F, keeping an eye on them to make sure they don't burn. Buckwheat flour is available from health food stores.

2 cups buckwheat flour
2 teaspoons baking powder
2 teaspoons baking soda
½ teaspoon ground cinnamon
4 teaspoons Dutch-process cocoa (optional)
2 cups buttermilk
1 large free-range egg
4 tablespoons butter, melted, plus extra for cooking
2½ tablespoons light agave nectar (see page 10), plus extra to serve (optional)
2 cups frozen sour cherries, thawed and drained on paper towel
¾ cup, plus 1 tablespoon crème fraîche
7 oz fresh cherries, halved and pitted (or use drained canned or jarred sour cherries)
⅓ cup slivered almonds, toasted and chopped

Makes 16

Preheat the oven to 300°F and line a baking sheet with parchment paper.

Sift the dry ingredients into a large bowl and set aside.

Whisk the buttermilk, egg, melted butter and agave nectar together in a pitcher.

Make a well in the center of the dry ingredients and pour in the wet ingredients. Using a wooden spoon, beat everything together until combined, then fold in the thawed cherries.

Melt ½ teaspoon butter in a large nonstick crepe pan or skillet over medium heat. Add three portions of batter to the pan (about 4 tablespoons each), and cook for 2–3 minutes or until browned underneath. Carefully flip the hotcakes and cook for 2–3 minutes on the other side, then transfer to the prepared sheet and keep them warm in the oven while you continue with the remaining batter, adding ½ teaspoon butter to the pan to cook each batch.

Sandwich the hotcakes together with crème fraîche. Top each stack with a final dollop of crème fraîche, the halved cherries, almonds and an extra drizzle of agave nectar, if using.

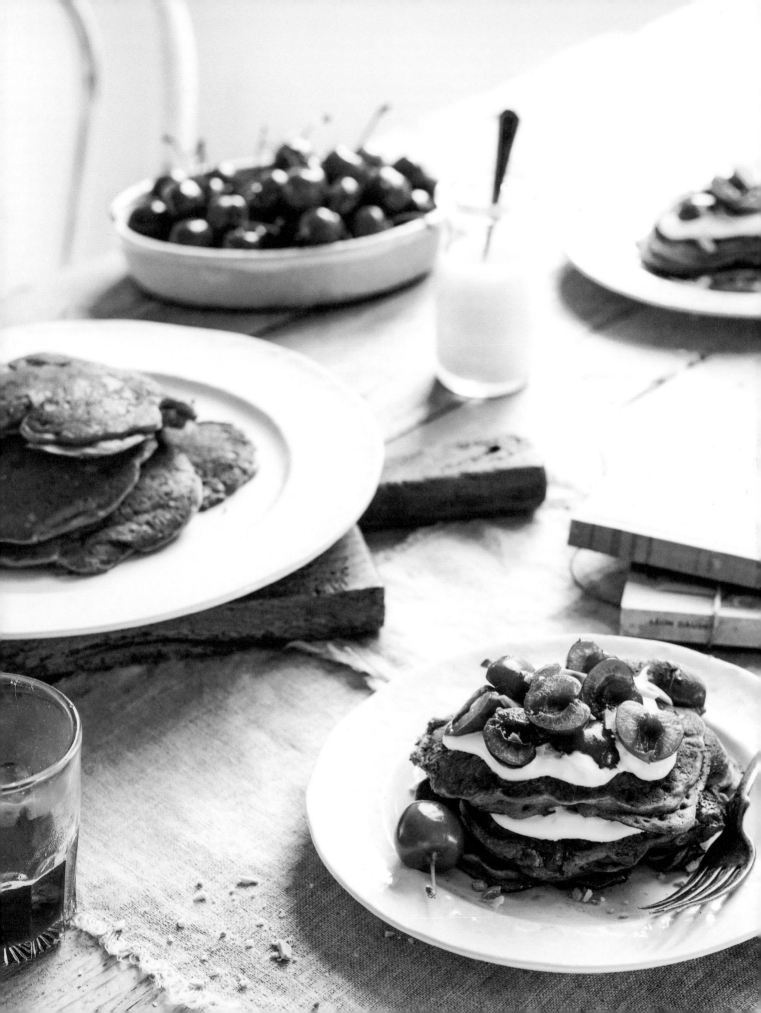

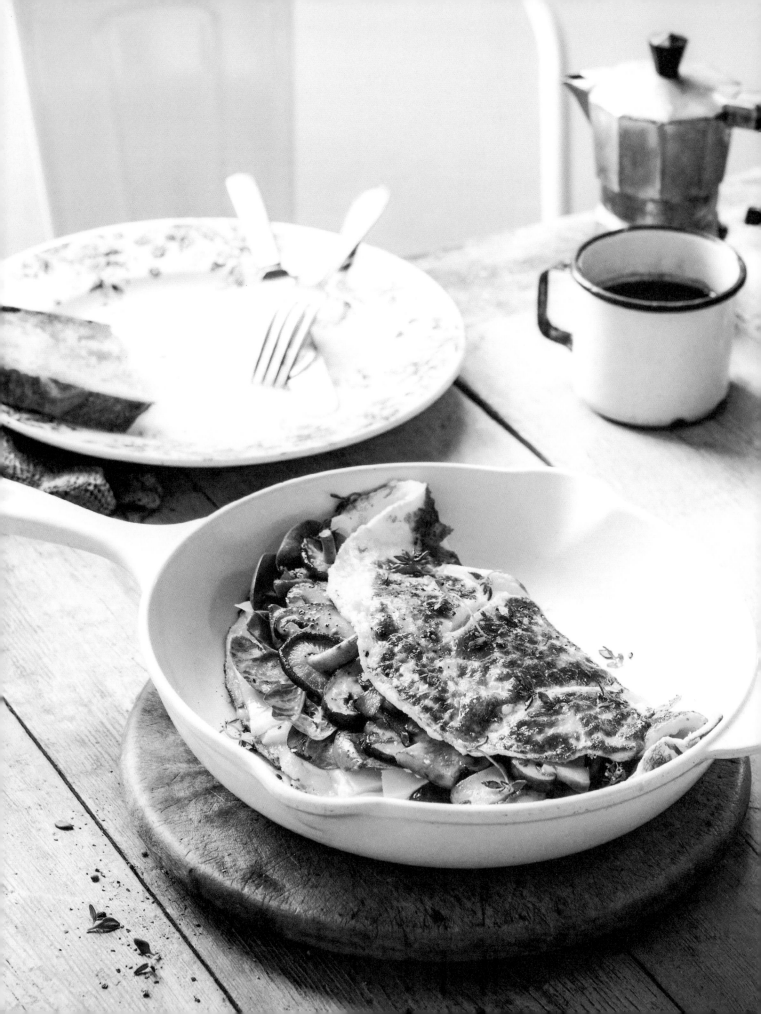

MUSHROOM, SPINACH AND CHEESE OMELETTE

This is my 'fluffy' omelette, made by whizzing the eggs in a blender to give a light and airy texture to the final dish. Serve this with buttered toast, if you like.

3 free-range eggs
4 tablespoons milk
sea salt
2 tablespoons butter, plus extra for cooking
1¾ oz shiitake mushrooms, sliced or left whole if small
1¾ oz cremini mushrooms, sliced
2 sprigs thyme, leaves stripped
freshly ground black pepper
1 large handful baby spinach leaves
1 oz emmental cheese, thinly sliced

Serves 1–2

Place the eggs, milk and a pinch of salt in a blender and whiz for 30–40 seconds or until combined and fluffy, then set aside.

Melt the butter in a nonstick skillet over high heat. Add the mushrooms and most of the thyme, saving a little for the garnish, then season well and cook for 4–5 minutes or until the mushrooms are just tender. Transfer to a plate and keep warm.

Wipe the skillet clean and melt a little extra butter over low heat. Pour in the egg mixture and cook for 4–5 minutes or until it starts to set around the edges. Add the mushrooms, spinach and cheese to one half, then fold the remaining half over the filling and cook for 1–2 minutes. Flip the omelette over and cook for 1 minute or until just cooked. Turn out onto a plate, sprinkle over the remaining thyme and serve immediately.

MANDARIN, PISTACHIO AND POPPY-SEED MUFFINS

These are brilliant for breakfast-on-the-run or a snack at work — make a batch
on a Sunday night and you're sorted for a few days. Just remember to check
your teeth for poppy seeds before you smile at your boss!

> 4 mandarins
> 2 cups all-purpose flour
> 2 teaspoons baking powder
> 2 teaspoons ground cinnamon
> ½ cup firmly packed light brown sugar
> fine salt
> 4 large free-range eggs
> 1 stick unsalted butter, melted and cooled slightly
> 2 teaspoons orange flower water
> 1 cup shelled pistachios, coarsely chopped
> 4 teaspoons poppy seeds

Makes 10 large muffins

Preheat the oven to 400°F. Cut out ten squares of parchment paper and use to
line 10 cups of a 12 cup muffin pan.

Finely grate the zest of one mandarin and set aside. Peel and segment the
mandarins, removing any excess pith and seeds (you'll need 12 oz mandarin
segments). Cut the segments in half and set aside.

Sift the flour, baking powder, cinnamon, sugar and a pinch of salt into a large
bowl and stir to combine.

Lightly whisk the eggs together in another bowl. Stir in the cooled melted butter,
orange flower water and reserved mandarin zest, then pour this mixture into
the dry ingredients and combine with a wooden spoon.

Set aside a handful of mandarin pieces for the garnish and add the rest to the
batter, along with two-thirds of the pistachios and three-quarters of the poppy
seeds. Gently fold everything together.

Spoon the batter into the lined muffin cups and top each with some reserved
mandarin pieces. Scatter the remaining pistachios and poppy seeds over the top.

Bake for 25–30 minutes or until a skewer inserted in the centers comes out
almost dry. Leave the muffins to cool slightly in the pan before lifting out onto
a wire rack and cooling completely.

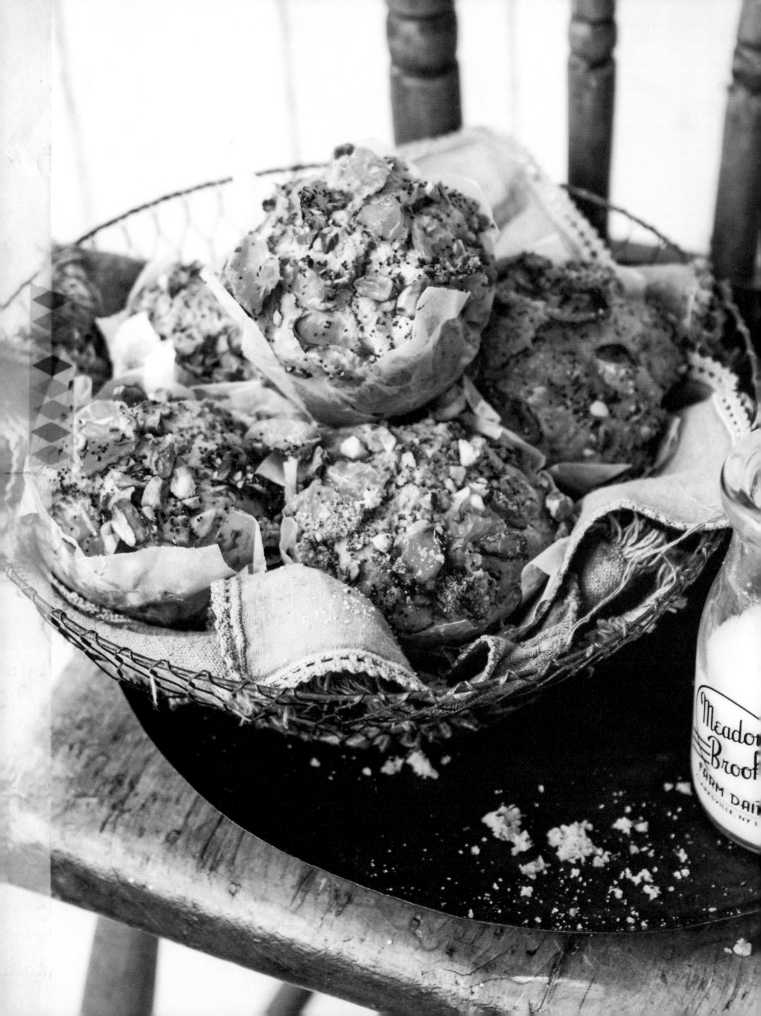

CHORIZO ROSTI WITH DUCK EGGS AND ANCHOVY MAYO

This is inspired by a meal I enjoyed on a recent trip to New York that featured ramps, a popular North American vegetable with an oniony, garlicky flavor. If you can't get duck eggs, use four large free-range eggs instead. Serve this with roasted tomatoes, if you like.

4 potatoes (about 1 pound 12 ounces), scrubbed and coarsely grated
2 tablespoons butter, melted
sea salt and freshly ground black pepper
olive oil or rice bran oil, for cooking
1 onion, finely chopped
4 cloves garlic, 2 finely chopped, 2 cut in half
1½ (7¾ oz) good-quality chorizo sausages, finely diced
2 bunches scallions, white and pale green parts only, halved crosswise
4 free-range duck eggs
snipped dill, to garnish

ANCHOVY MAYO
2 free-range egg yolks
4 teaspoons lemon juice
sea salt
½ cup canola oil
2 teaspoons Dijon mustard
4 teaspoons white wine vinegar
2 large anchovies, chopped
1 teaspoon Worcestershire sauce
freshly ground white pepper

Serves 4

Place the grated potato in a clean kitchen towel, then wrap up and squeeze hard to wring out as much excess water as possible. Place the potato in a large bowl with the melted butter, salt and pepper and toss to coat thoroughly, then set aside.

Heat 4 teaspoons oil in a large nonstick skillet over medium–high heat, then add the onion and chopped garlic and cook for 4–5 minutes until softened. Transfer to the bowl with the potato mixture.

Heat 2 teaspoons oil in the skillet over medium heat, then add the chorizo and cook for 3–4 minutes, stirring, until just browned. Add this to the potato mixture and toss to combine well.

Preheat the oven to 400°F and line a baking sheet with parchment paper.

Wipe the skillet clean with paper towel, then add 4 teaspoons oil and place over medium–high heat. Spoon one-quarter of the potato mixture into the pan and shape roughly into a circle. Flatten with a spatula and cook for 1–2 minutes until browned, then flip over and cook for a further 2 minutes. Transfer to the prepared sheet and repeat with the remaining mixture to make four rostis in total, adding more oil to the skillet as needed.

Place the sheet in the oven and bake the rostis for 20–25 minutes or until golden brown, crisp and cooked through.

Meanwhile, for the mayo, place the egg yolks, lemon juice and a pinch of salt in the bowl of a food processor. Process on high speed for 1 minute then, with the motor running, add the oil in a thin, steady stream until thick and glossy. Add the remaining ingredients and process for 30 seconds to combine, then transfer to a bowl, cover with plastic wrap and set aside until needed.

Heat 4 teaspoons oil in the skillet over medium heat, add the halved garlic cloves and cook for 1 minute, stirring often, then remove the garlic and discard. Add the scallion to the skillet and cook, tossing, for 3–4 minutes or until light golden-brown and slightly softened. Remove from the skillet and cover to keep warm.

Wipe the skillet clean again and heat 4 teaspoons oil over medium–high heat. Working in batches, crack the eggs into the skillet and cook for 2 minutes, then cover with a lid and cook for a further 1½ minutes or until the underside is crisp and the yolk is still runny.

Top each rosti with scallion and an egg, then drizzle with mayonnaise, season and scatter with dill to finish.

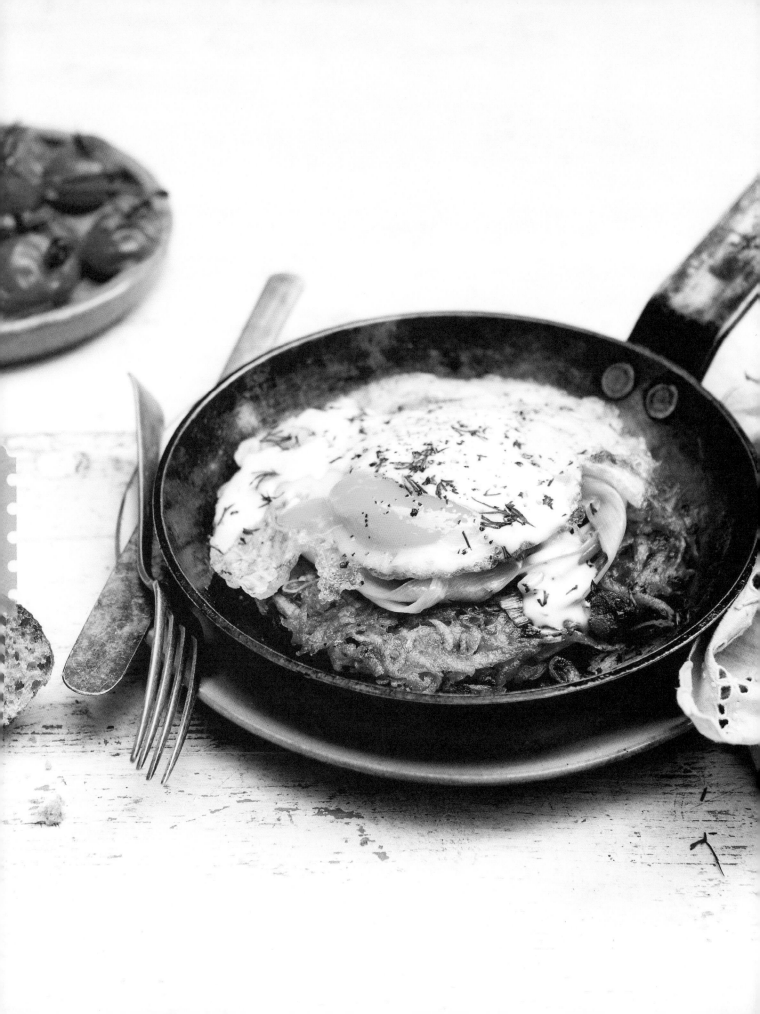

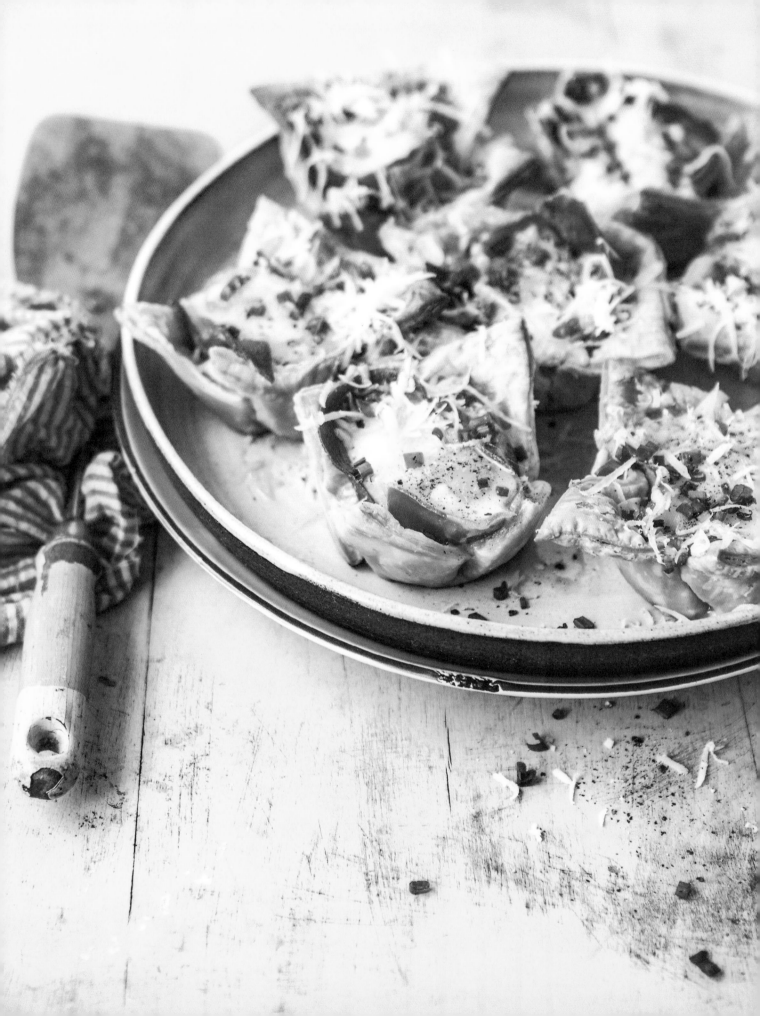

BAKED EGGS IN PASTRY CUPS

These are impressively flavorsome given the few ingredients involved. Try to use the best store-bought pastry you can: I use Carême, which is an Australian-made pastry that gives excellent results, but you could use Pepperidge Farm frozen puff pastry instead. The truffle oil is optional in this dish, but it's a wonderful addition.

2 sheets good-quality puff pastry (10 in × 10 in), thawed if frozen
2½ tablespoons milk
1 free-range egg yolk
8 thin slices prosciutto, halved lengthwise
8 free-range eggs
3¼ oz grated gruyere, plus extra to serve
white truffle oil (optional), snipped chives and freshly
 ground black pepper, to serve

Makes 8

Preheat the oven to 400°F and grease eight ⅔ cup-capacity cups of a muffin pan.

Cut the pastry into eight 5 inch squares and use to line the muffin cups, pleating and folding the pastry as necessary to form a cup. Press any overlapping pastry to an even thickness. Prick all over with a fork.

Cut out eight squares of parchment paper slightly larger than the pastry squares. Scrunch up the paper, then smooth it out and use to line the pastry bases. Fill with pie weights or rice and blind-bake for 10 minutes. Remove the paper and weights or rice and bake for a further 10 minutes or until the bases are cooked.

Whisk together the milk and egg yolk, then brush over the bases. Line each base with two thin strips of prosciutto, then crack an egg into each one and sprinkle with cheese.

Bake for 12–15 minutes or until the pastry is golden and the egg is set. Leave to cool slightly in the pan, then remove and serve topped with a drizzle of truffle oil, if using, some snipped chives and a grinding of pepper. Top with extra grated cheese to finish.

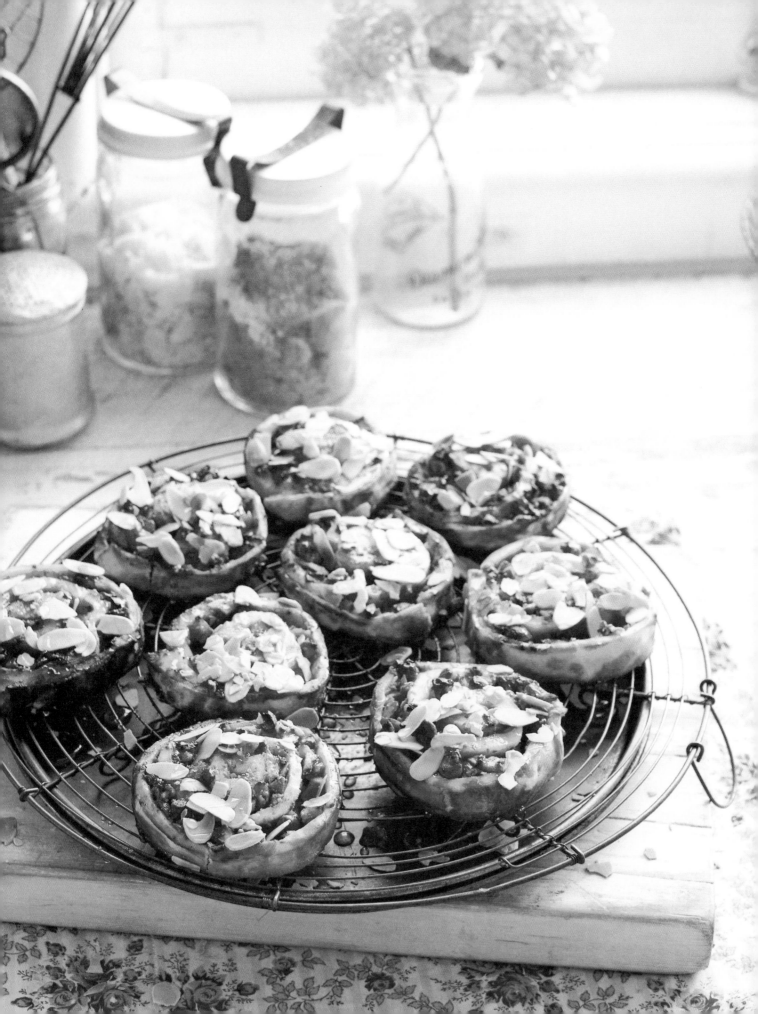

APPLE AND ALMOND PASTRIES

These are my take on homemade rough-and-ready French
pastries – great with coffee for a Sunday brunch. Use store-bought
whole-wheat or gluten-free pastry if you prefer.

5½ oz honey, plus extra for drizzling
2½ tablespoons maple syrup
½ teaspoon ground ginger
1½ teaspoons ground cinnamon
2 teaspoons vanilla-bean paste
1 cup almonds, toasted and coarsely chopped
3 green apples, peeled, cored and cut into ⅝ in dice, then combined with the juice of ½ lemon
1 free-range egg yolk, mixed with a little milk
toasted sliced blanched almonds, to serve

ROUGH PUFF PASTRY
2 sticks, plus 2 tablespoons unsalted butter, chilled and cubed
¾ cup, plus 1 tablespoon whole-wheat all-purpose flour, sifted, plus extra for sprinkling
¾ cup, plus 1 tablespoon all-purpose flour, sifted
fine salt

Makes 18

For the pastry, place 1 stick of the cubed butter in the freezer to keep really chilled. Place the flours and a good pinch of salt in the bowl of a food processor and pulse to combine. Add the remaining butter and pulse until incorporated.

Add the butter from the freezer and pulse once or twice, then add 1¾ fl oz cold water and pulse once. Add another 1¾ fl oz cold water and pulse once or twice to just bring together.

Scrape the dough onto a lightly floured countertop and sprinkle a little flour on top. Using your hands, squeeze and shape the dough into a log, then wrap in plastic wrap and refrigerate for 30 minutes.

Roll out the chilled dough on a lightly floured countertop to a 20 in × 10 in rectangle.

With the short side facing you, fold the top third of the dough two-thirds of the way down, then fold the bottom third up and over that. Give the dough a quarter-turn and roll out again to the original rectangle shape. Repeat this process four or five times, wrapping the dough in plastic wrap and refrigerating for 15 minutes after every second

turn so it remains easy to handle. When the folding and rolling is complete, wrap the dough in plastic wrap and refrigerate for 2 hours.

Preheat the oven to 400°F and line two baking sheets with parchment paper.

Roll out the chilled dough on a lightly floured countertop to a 20 in square.

Combine the honey, maple syrup, ginger, cinnamon and vanilla-bean paste in a small bowl. Using a spatula, spread the mixture over the pastry sheet, leaving a 1¼ in border. Scatter over the chopped nuts and apple. Carefully roll up into a log shape (like a Swiss roll) as tightly as you can without breaking the pastry. Brush all over with the egg wash.

Using a very sharp knife, cut the roll into ¾ in slices. Lay the slices on the prepared sheets at ¾ in intervals, drizzle with a little extra honey and scatter with toasted sliced blanched almonds. Bake for 25–30 minutes or until golden brown.

Serve warm or at room temperature.

MEXICAN BEEF AND EGGS

Chipotle sauce and fresh jalapeños were once only found in the US, but are now fairly widely available in Australia from greengrocers and some supermarkets. I like Goya chipotle sauce: it's not too strong and comes in a decent-sized bottle.

4 teaspoons olive oil
1 onion, finely chopped
sea salt
14 oz lean ground grass-fed beef
4 tablespoons chipotle sauce
1 × 28 oz can chopped tomatoes
1 large handful cilantro, coarsely chopped, plus extra to serve
freshly ground black pepper
4 free-range eggs
1 jalapeño chile, thinly sliced

Serves 4

Heat the oil in a large wide saucepan or deep skillet over medium–high heat. Add the onion and a pinch of salt and cook, stirring often, for 3–4 minutes or until soft. Increase the heat to high, add the beef and cook, stirring occasionally, for 5 minutes or until browned, breaking up any lumps as you go. Stir in the chipotle sauce, tomato and cilantro, season with salt and pepper, then reduce the heat to medium and cook for 5–6 minutes or until slightly thickened.

Using a spoon, make four indents in the beef mixture and crack an egg into each one. Cover and cook for 5–7 minutes or until the eggs and beef are cooked. Garnish with sliced chile and extra cilantro, then grind some black pepper over and serve right away.

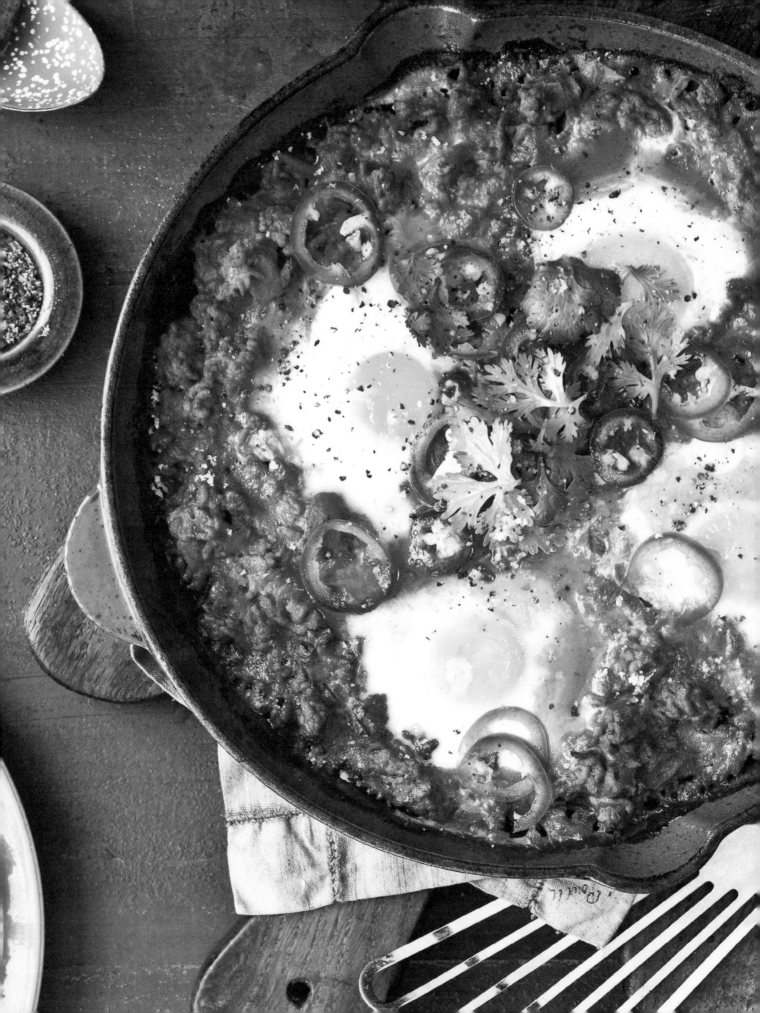

BUCKWHEAT CREPES WITH SPINACH AND RICOTTA

This light meal is healthy and very tasty, with a lovely combination of textures. Hot sauce is available from selected gourmet delis (in Australia I use Crystal hot sauce).

2 cups buckwheat flour
sea salt and freshly ground black pepper
1 large free-range egg
3¾ cups milk
light olive oil or canola oil spray, for greasing
light sour cream, hot sauce and mint leaves, to serve

RICOTTA FILLING
1 cup fresh ricotta
8 oz baby spinach leaves
4 scallions, trimmed, white and green parts finely chopped
1 large handful mint, finely chopped
4 tablespoons pine nuts, toasted

Serves 6–8

Preheat the oven to 300°F and line a baking sheet with parchment paper.

Place the flour and a pinch of salt in a large mixing bowl. Add the egg and 4 tablespoons of the milk and whisk together to combine. Pour in the remaining milk, whisking constantly until smooth. Season with pepper and pour into a pitcher.

Spray a nonstick 8 in crepe pan or skillet with a little oil and heat over high heat. When hot, ladle in just under 4 tablespoons portions of the batter and swirl the skillet so that the batter coats the base evenly. Cook for 40–50 seconds or until browned around the edges, then flip with a spatula and cook for a further 30 seconds. Transfer to the prepared sheet and keep warm in the oven while you cook the remaining batter; you'll get about twenty-four crepes.

Meanwhile, for the filling, place all the ingredients in a bowl and mix together. Season to taste and set aside.

To assemble, spread a thick layer of sour cream on each crepe and top with a heaping tablespoon of filling. Add a splash of hot sauce and garnish with mint leaves, then roll up the crepes and serve.

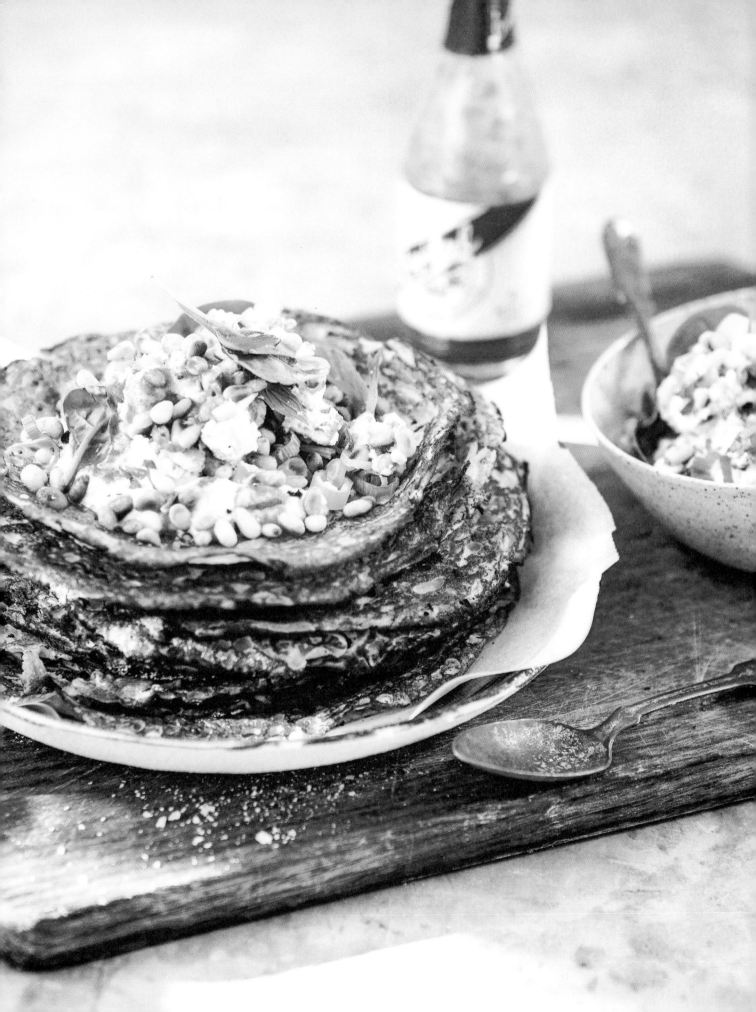

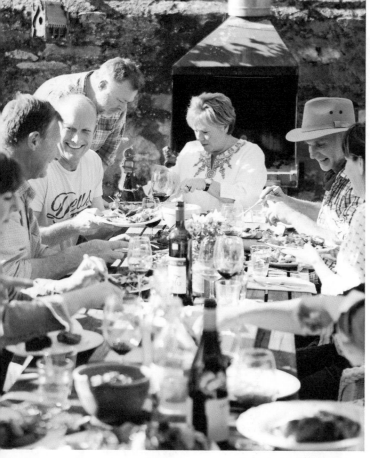

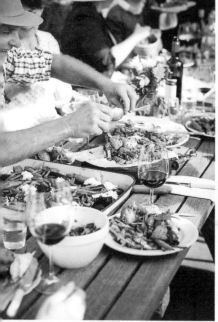

Just before I left to go to Europe in the winter of 2013 (I'm still getting used to the fact that June to August is winter in Australia – those months will always be summer ones to me…), I was booked on a photography job in the Barossa Valley, just north of Adelaide in South Australia. It's predominantly a winemaking region, and it's a place I have totally fallen in love with – not just because of its beauty and stunning natural surroundings, but also the people. They are probably the warmest, friendliest, most hospitable people I have met in this incredible country.

I was there to photograph a selection of local artisan food producers, including cheesemakers, farmers, pickle makers, smoked meats producers, noodle makers, winemakers and restaurateurs. One of these was an amazing woman called Jan Angas. Jan and her husband John farm sheep and run a vineyard

called Hutton Vale, and their cellar door was just mind-blowing. I was left slack-jawed when I drove up to it, and even more so when I explored the many outbuildings and the main house. They were full of everything vintage and there was a powerful sense of history and love about the place. I found it impossible not to snap away for hours, in between photographing Jan and her produce. I just knew I'd have to return here one day to do a photo shoot for my next book.

So, in October 2013, I went back to the Barossa to stay with Michael Wohlstadt. Michael is one of the most welcoming people you'll ever meet. He runs a free-range pig farm and dairy, as well as a stunning guesthouse called Dairyman's Cottage. I took much delight in furiously photographing all his baby piggies and pottering around his farm, building up a great collection of images. Over at the guesthouse I was greeted with a stunning breakfast tray full of the best local produce, as well as meats, cheeses and wine. We enjoyed a few glasses of red that night, accompanied by his incredible toasted spiced almonds (see recipe page 220).

continued overleaf…

PuLLETS FOR SALE

The next day I was up early to go to the Barossa Farmers' market, where I stocked up on the best of the local produce: free-range organic chickens from Saskia Beer (Maggie Beer's daughter), vegetables, cheeses and breads. I then headed to Hutton Vale to whip up a thankyou lunch for all those I had met on my earlier trip. It was outstanding, and I was blown away by everyone being so willing and eager to chip in and help me prepare the feast. I fondly remember standing in the kitchen, watching my guests chopping veggies, making breadcrumbs, preparing the meat and just generally being amazingly supportive and kind. After a few hours of prep and cooking, we all sat down (well, all except me, as I was snapping like crazy for an hour or two!) to enjoy the food and wine. We had a ball and the fun lasted long into the wee hours as bottle after bottle of superb Hutton Vale wine was generously produced by John. I have the most wonderful memories of sitting around the outdoor fire surrounded by so many amazing people who I hope will be friends for life.

Places I stayed and websites of interest:

huttonvale.com
barossaheritagepork.com.au
dairymanscottage.com.au
barossafarmersmarket.com.au
saskiabeer.com

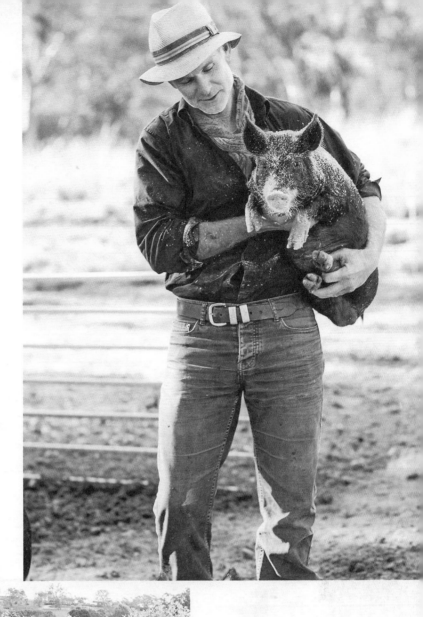

HUTTON VALE

MN LBS

1ST X LBS

LBS FX

CRUTCHINGS

CATARPO

C

RFA

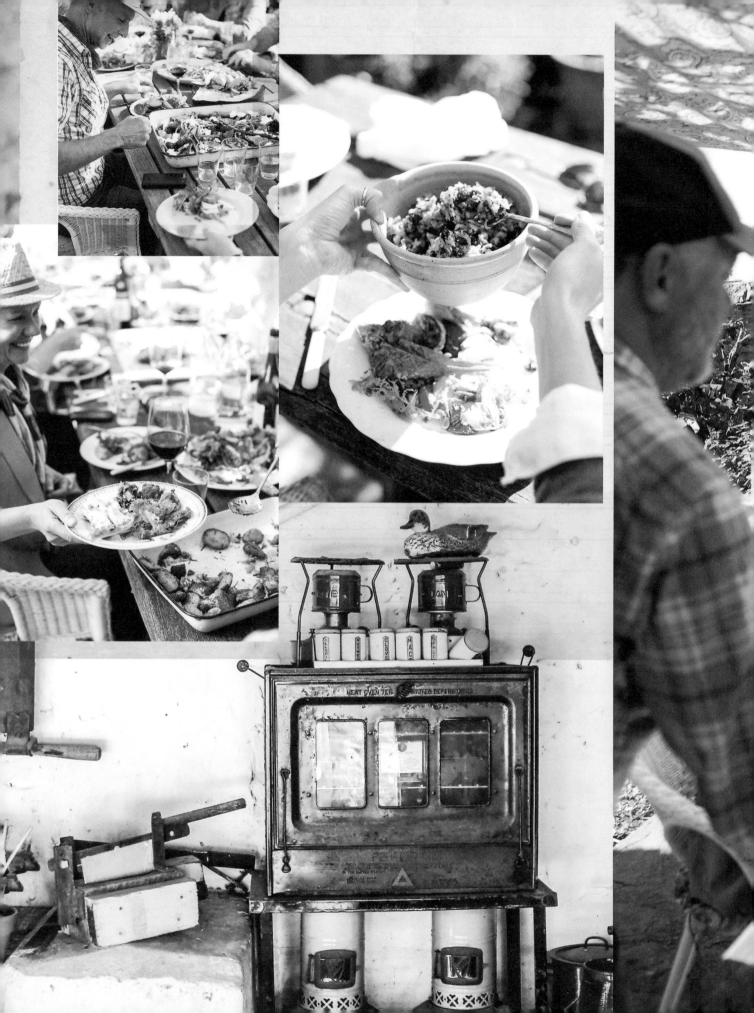

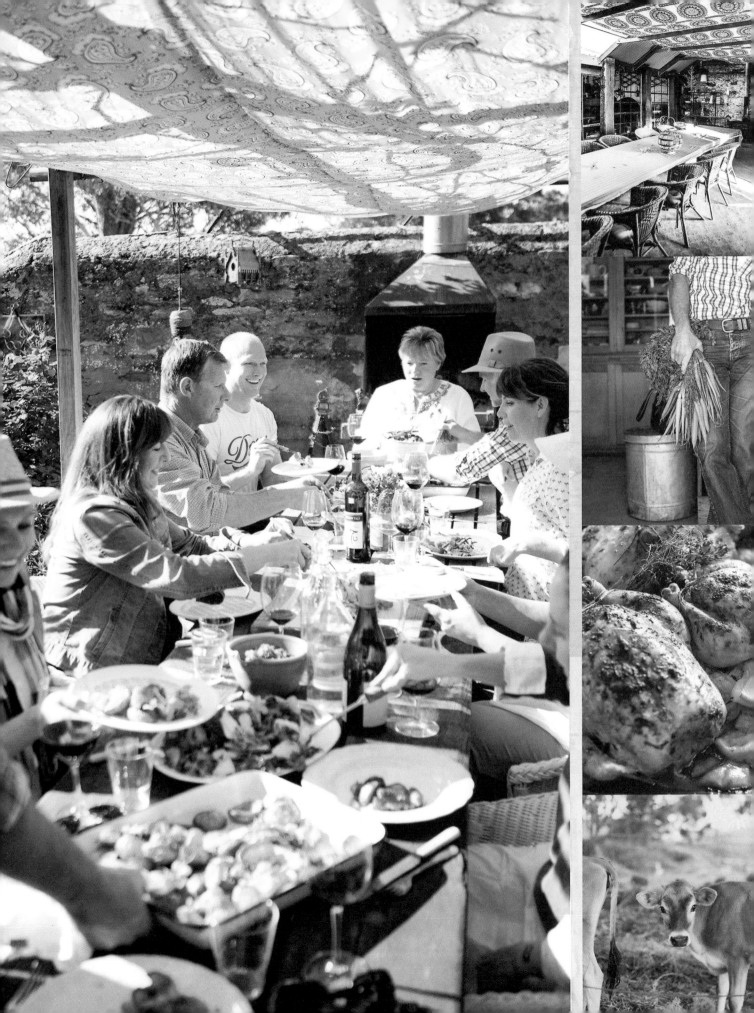

SALADS AND SOUPS

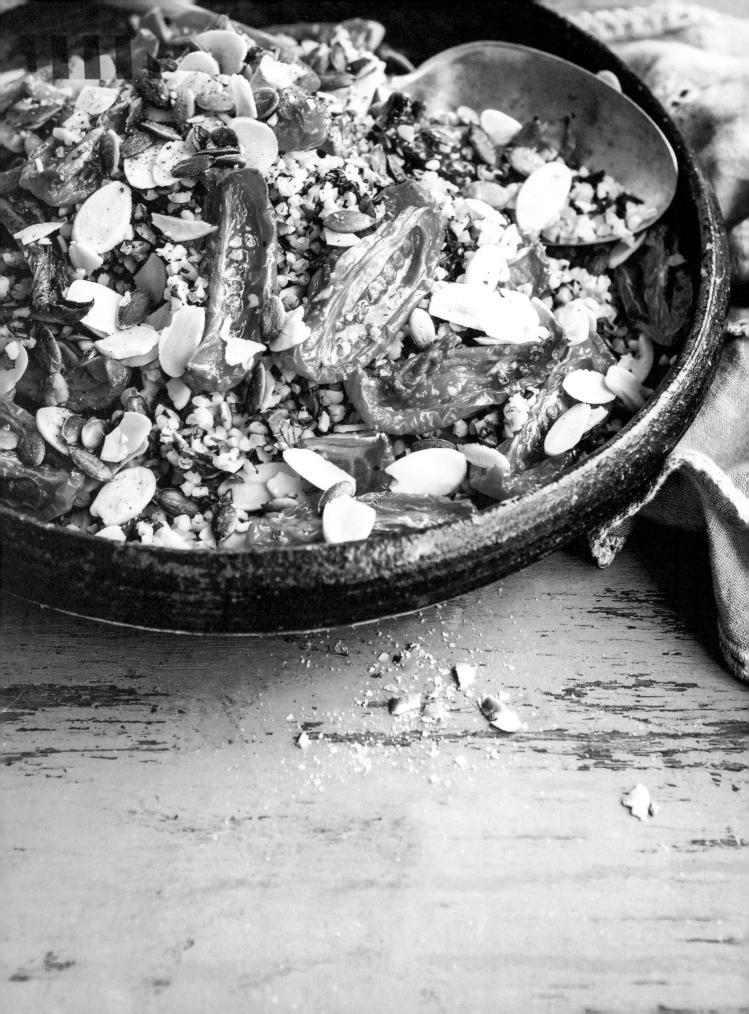

BULGUR AND HERBS WITH SEMI-DRIED TOMATOES

Bulgur (or burghul) is an ingredient I only started using recently after it was the feature of a photoshoot I did for the magazine *Eating Well*. It has a wonderful texture, and is most commonly found in the classic Middle-Eastern salad tabbouleh. For a gluten-free option, use white quinoa instead.

6 plum tomatoes, quartered
sea salt and freshly ground black pepper
olive oil spray, for cooking
1 cup coarse bulgur
½ cup pumpkin seeds
½ cup sliced blanched almonds
1 large handful mint, finely chopped
1 large handful basil, finely chopped

Serves 4 as a side

Preheat the oven to 300°F and line a baking sheet with parchment paper.

Place the tomatoes on the sheet, season and spray with a little oil. Roast for 2 hours or until semi-dried and just starting to brown around the edges.

Meanwhile, place the bulgur in a bowl and pour in 2½ cups cold water. Set aside for 1 hour, then drain, rinse and squeeze out any excess water. Set aside until needed.

Scatter the pumpkin seeds and sliced blanched almonds on another baking sheet, then place in the oven with the tomatoes and bake for 12 minutes or until lightly toasted. Remove and set aside to cool.

Place all the ingredients in a large bowl, season well and mix to combine, then serve.

SMOKED TROUT, EGG AND POTATO SALAD

The ingredients in this salad work incredibly well together.
Any leftover mayo will keep in an airtight container in the fridge for up to 3 days.

3 green apples, halved, cored and thinly sliced
juice of ½ lemon
12 baby potatoes (about 1 pound)
8 radishes, thinly sliced
iced water
4 free-range eggs
2 large handfuls watercress
14 oz hot-smoked ocean trout fillet, skin removed, flesh flaked
sea salt and freshly ground black pepper
extra virgin olive oil, for drizzling
1 handful mint (optional)

CIDER MAYO
2 free-range egg yolks
4 teaspoons lemon juice
sea salt
½ cup canola oil
2 teaspoons Dijon mustard
2 teaspoons apple cider vinegar
4 tablespoons dry cider
freshly ground white pepper

Serves 4 as a main, 6–8 as a side

Place the apple slices in a bowl and cover with the lemon juice to prevent them from browning. Drain before use.

Place the potatoes in a large saucepan of salted water and bring to a boil. Reduce the heat to medium and simmer for 20–25 minutes or until a knife can be inserted easily into the centers. Drain and set aside to cool, then cut into ½ in thick slices.

Meanwhile, place the radish slices in a bowl of iced water and leave to stand for 10 minutes to curl slightly, then drain.

Place the eggs in a saucepan, cover with cold water and bring to a boil over high heat. Reduce the heat to medium and simmer for 3 minutes, then plunge the eggs into cold water to halt the cooking process. When cool enough to handle, peel and halve lengthwise, then set aside.

For the cider mayo, place the egg yolks, lemon juice and a pinch of salt in the bowl of a food processor. Process on high speed for 1 minute then, with the motor running, add the oil in a thin, steady stream until the mixture is thick and glossy. Add the mustard, vinegar and cider, season to taste with salt and white pepper and process again to combine (makes 1 cup).

Toss the apple, potato, radish, egg, watercress and smoked trout together, then stir through the mayo. Season well, drizzle with olive oil and serve garnished with mint, if using.

PROSCIUTTO, FIG AND GRILLED PEACH SALAD

For this salad, I like to use San Daniele prosciutto and my favorite blue cheese, the Irish Cashel Blue, which is super-creamy and not too pungent so it won't overpower the other flavors. If watercress isn't in season, use arugula instead.

8 fresh figs, halved lengthwise
½ cup light agave nectar (see page 10)
1⅔ cups pecans
8 ripe yellow peaches, halved and pitted
light olive oil spray, for cooking
12 slices prosciutto
7 oz good-quality mild, creamy blue cheese, crumbled
1 handful watercress sprigs
1 handful mint leaves
sea salt and freshly ground black pepper

SWEET CREAMY DRESSING
7 tablespoons crème fraîche
2 teaspoons light agave nectar (see page 10)
juice of 1 small lemon
1 teaspoon Dijon mustard

Serves 8 as a side

Preheat the oven to 400°F and line a baking sheet with parchment paper.

Place the figs, cut-side up, on the prepared sheet. Drizzle with 4 teaspoons of the agave nectar and roast for 7 minutes, then remove and set aside.

Meanwhile, place the pecans in a nonstick skillet and dry-fry over medium heat for 4–5 minutes, tossing often, until lightly browned. Add 4 teaspoons of the agave nectar and stir through the hot nuts in the pan. Remove and set aside to cool, then slice lengthwise.

Spray the flesh-sides of the peaches with olive oil. Combine the remaining agave nectar and ⅓ cup cold water in a bowl.

Heat a grill pan over medium–high heat until almost smoking, then add the peaches in batches, flesh-side down, and cook for 2–3 minutes or until grill marks appear. Turn the peaches over and cook for 1 minute, then carefully spoon some of the agave mixture over the flesh (they will sizzle and spit) and grill for another minute or so. Remove from the pan and cut each half into two or three slices.

For the dressing, whisk all the ingredients together in a small bowl.

To serve, assemble the salad ingredients on a large plate or platter and season to taste. Drizzle a little of the dressing over the top and serve the rest alongside.

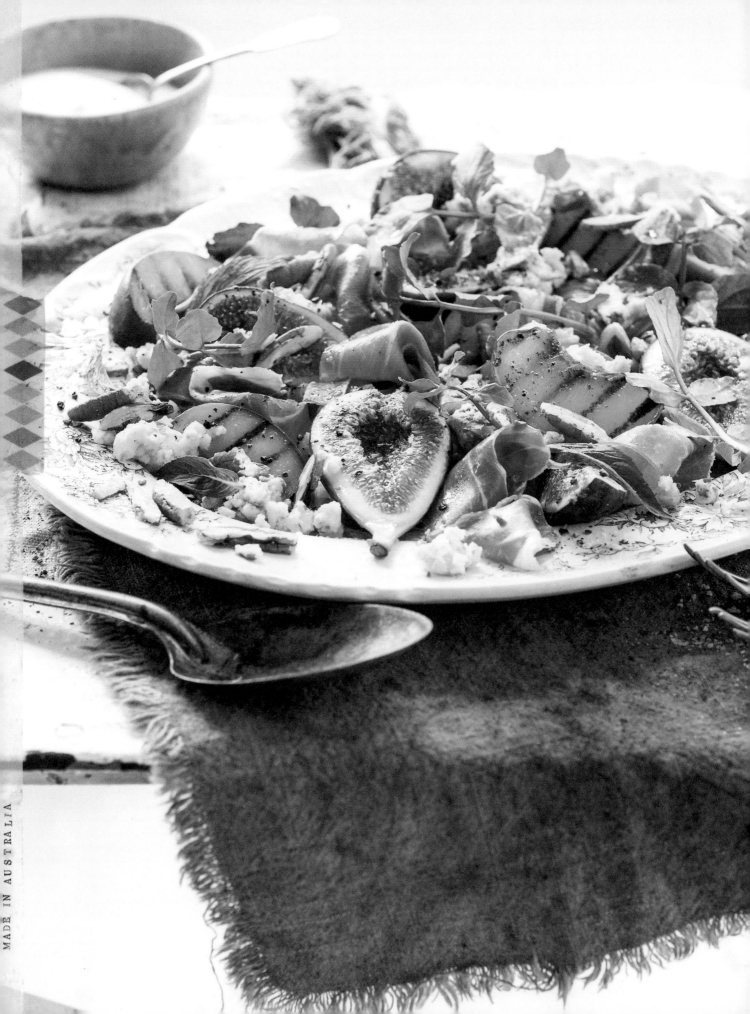

NOODLES WITH SHRIMP AND PICKLED CUCUMBER

There are great sweet-and-sour flavors going on in this dish. Don't be nervous about pickling your own cucumber — it's a cinch and once you try it, you'll be hooked. This is a superb summery lunch recipe that tastes great both hot or cold. Nori flakes are available from selected health food stores and Asian food stores.

1 pound 12 ounces uncooked shrimp, heads removed but tails left intact, deveined
6½ oz soba noodles
2 long red chiles, seeded and sliced
cilantro, to garnish
tamari or light soy sauce, to serve

SOY AND GINGER MARINADE
2½ tablespoons tamari or light soy sauce
2½ tablespoons brown rice vinegar
4 teaspoons mirin
1 teaspoon fish sauce
1 teaspoon superfine sugar
½ teaspoon firmly packed finely grated ginger

PICKLED CUCUMBER
4 teaspoons superfine sugar
4 teaspoons black sesame seeds
1 teaspoon nori seaweed flakes
1 large cucumber, cut into ½ in cubes
good pinch of sea salt

Serves 4 as a light lunch

For the marinade, whisk all the ingredients together in a large shallow glass dish. Add the shrimp and toss to coat, then cover with plastic wrap and marinate in the fridge for 1 hour.

Meanwhile, for the pickle, combine all the ingredients in a bowl, cover with plastic wrap and chill in the fridge for 30 minutes. Taste and add more salt or sugar if desired, then set aside.

Heat a large skillet or wok over medium–high heat. When hot, add the shrimp and the marinade and cook for 2 minutes, turning halfway through, until the shrimp are cooked and the sauce has reduced. Remove from the heat and leave to cool completely.

Cook the noodles in a saucepan of simmering water for 3 minutes, then drain and rinse well under cold running water.

Place the noodles, shrimp, pickled cucumber and chile in a bowl and toss to combine. Turn out onto a platter, then drizzle with tamari or soy sauce to taste and garnish with cilantro.

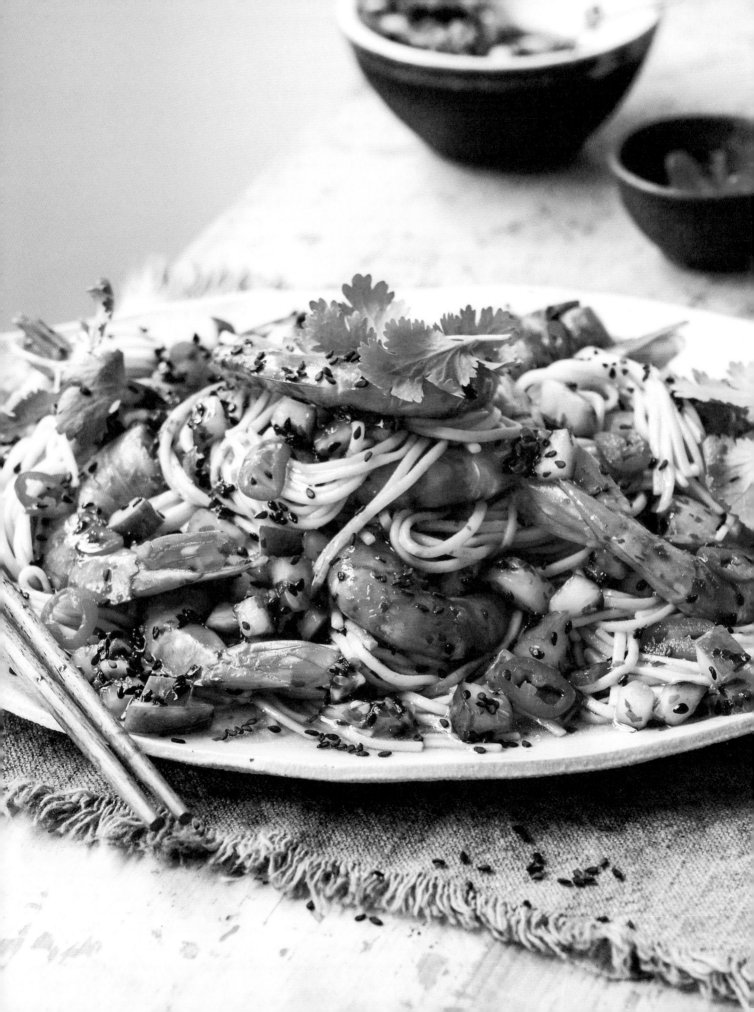

QUINOA AND GRAPE SALAD

Champagne grapes are tiny and packed full of sweetness. If you can't find them, use small seedless black grapes or large red grapes cut in half. This colorful salad is always a major crowd-pleaser at barbecues.

1 cup red quinoa, rinsed
4 teaspoons olive oil
½ teaspoon ground cinnamon
1 × 14 oz can chickpeas, drained and rinsed
sea salt and freshly ground black pepper
½ small red onion, very finely diced
1 long green chile, seeded and very finely diced
1 large handful mint, finely chopped, plus extra leaves
 to garnish
2 cups black champagne grapes or 2 cups black
 or red seedless grapes, halved or left whole
1 cup dried cranberries
1 cup almonds, toasted and coarsely chopped
4 teaspoons extra virgin olive oil
finely grated zest and juice of 1 lemon
1 handful baby spinach leaves

Serves 6 as a side

Place the quinoa in a saucepan with 2 cups water and bring to a boil over high heat. Reduce the heat to low and simmer for 25 minutes or until the quinoa is tender and the water has been absorbed. Set aside to cool.

Meanwhile, heat the oil in a large nonstick skillet over medium heat. Add the cinnamon and stir for 10 seconds. Add the chickpeas, season to taste and stir to coat, then cook for 6–8 minutes, stirring occasionally, until the chickpeas are golden brown and a little crisp — take care as they can spit a little in the oil. Remove from the heat and set aside to cool.

Combine the cooled quinoa and chickpeas in a large bowl, then add the onion, chile, mint, grapes, cranberries and almonds and stir through.

In a small bowl, whisk together the extra virgin olive oil and lemon zest, then add lemon juice to taste. Season with salt, then pour over the salad and toss to coat.

Season and serve with baby spinach and extra mint leaves scattered on top.

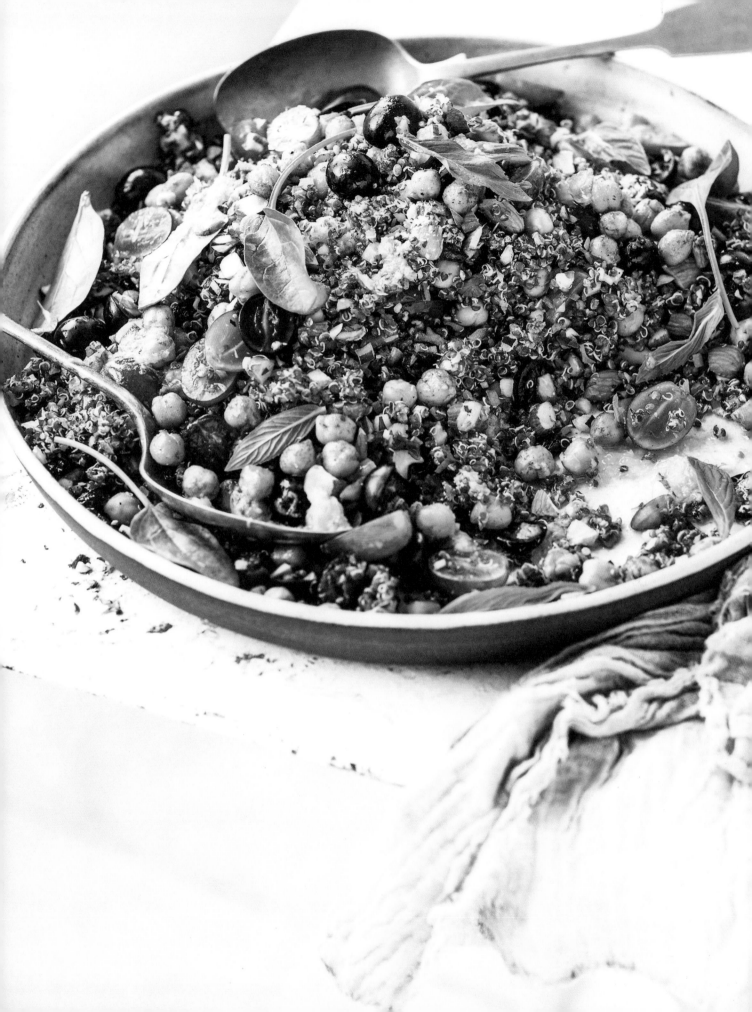

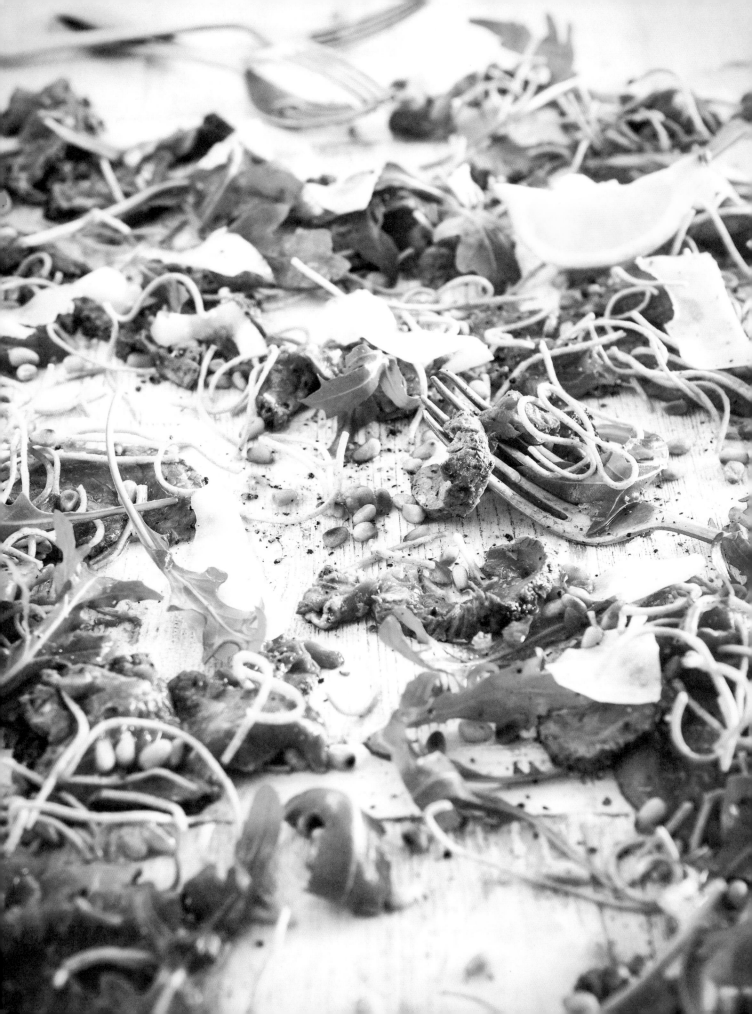

PEPPERED BEEF WITH CRISPY NOODLES

When cooking the beef for this dish, I line the skillet with parchment paper, as the sugar in the balsamic burns easily and can ruin your skillet in seconds. Use pecorino *sardo* (from Sardinia) or pecorino *toscano* (from Tuscany), if you can find them.

5½ oz soba noodles
sea salt and freshly ground black pepper
4 teaspoons balsamic vinegar
2½ tablespoons extra virgin olive oil, plus extra for drizzling
1 × 14 oz grass-fed beef tenderloin, silver skin removed
(ask your butcher to do this for you)
½ cup pine nuts
3 cups rice bran oil
2 large handfuls wild arugula, coarsely chopped
1¼ cups shaved pecorino
lemon wedges, to serve

Serves 4

Cook the noodles in a saucepan of simmering water for 3 minutes, then drain well. Transfer to sheets of paper towel to dry thoroughly, blotting away the excess water.

Crush three or four pinches of salt with your fingers onto a plate. Grind 1 tablespoon of pepper onto the plate and mix together.

Place the balsamic vinegar and 4 teaspoons of the olive oil in a bowl. Add the beef and roll it in the marinade, then leave to marinate for 1 minute. Remove the beef from the marinade, shake off any excess, then coat in the salt and pepper mixture.

Line a heavy-bottomed skillet with parchment paper, trimming it so it doesn't hang over the edges, and heat over medium–high heat. Add the remaining olive oil and the beef and cook for 6–7 minutes on each side (for medium–rare). Remove the beef from the skillet and set aside to rest before slicing thinly.

Toast the pine nuts in a skillet over low–medium heat for 6–7 minutes or until light golden-brown, then set aside.

Heat the rice bran oil in a large, heavy-bottomed saucepan to 350°F. Working in small batches of about a handful at a time, carefully add the noodles (the oil may spit and bubble) and fry for 1 minute. Turn the noodles over with tongs and cook for a further 1–2 minutes or until they are crisp and just golden brown. Remove with a mesh skimmer or a slotted spoon and drain on paper towel. When all the noodles have been fried and cooled completely, break them up into small pieces.

To serve, scatter the beef, crispy noodles, pine nuts, arugula and pecorino on a large board or platter. Season well with pepper, then drizzle over a little more olive oil and serve with lemon wedges.

FARRO WITH FETA, LEMON AND PINE NUTS

Farro is an Italian wholegrain that's low in gluten. I use
it a lot in salads as it has a great, nutty texture and is very
versatile. In Australia I like Chef's Choice brand, which
is whole-grain and unpearled: you'll need to adjust the
cooking time if using the cracked or pearled type. Farro is
available from health food stores and some supermarkets.

1⅓ cups (9 oz) whole-grain farro
9 oz cherry tomatoes, quartered
1 long green chile, very finely chopped
½ cup pine nuts, toasted
½ small red onion, very finely chopped
2 cloves garlic, very finely chopped
1 large handful flat-leaf parsley, finely chopped
1 large handful basil, finely chopped, plus extra to garnish
1 large handful mint, finely chopped
1 large handful arugula, finely chopped
1 cup feta
finely grated zest and juice of 1 lemon
2½ tablespoons extra virgin olive oil
sea salt and freshly ground black pepper

Serves 4 as a side

Place the farro in a saucepan with 2 cups water. Cover and
bring to a boil, then reduce the heat to low and simmer for
30 minutes or until the farro is tender. Drain and rinse
well under cold running water, then drain again to remove
as much water as possible.

Place the farro in a large bowl along with the tomato,
chile, pine nuts, onion, garlic, herbs and arugula. Toss
to combine well, then crumble in half the feta. Add the
lemon zest and juice and the olive oil and season to taste.

To serve, crumble over the remaining feta and garnish
with a few extra basil leaves.

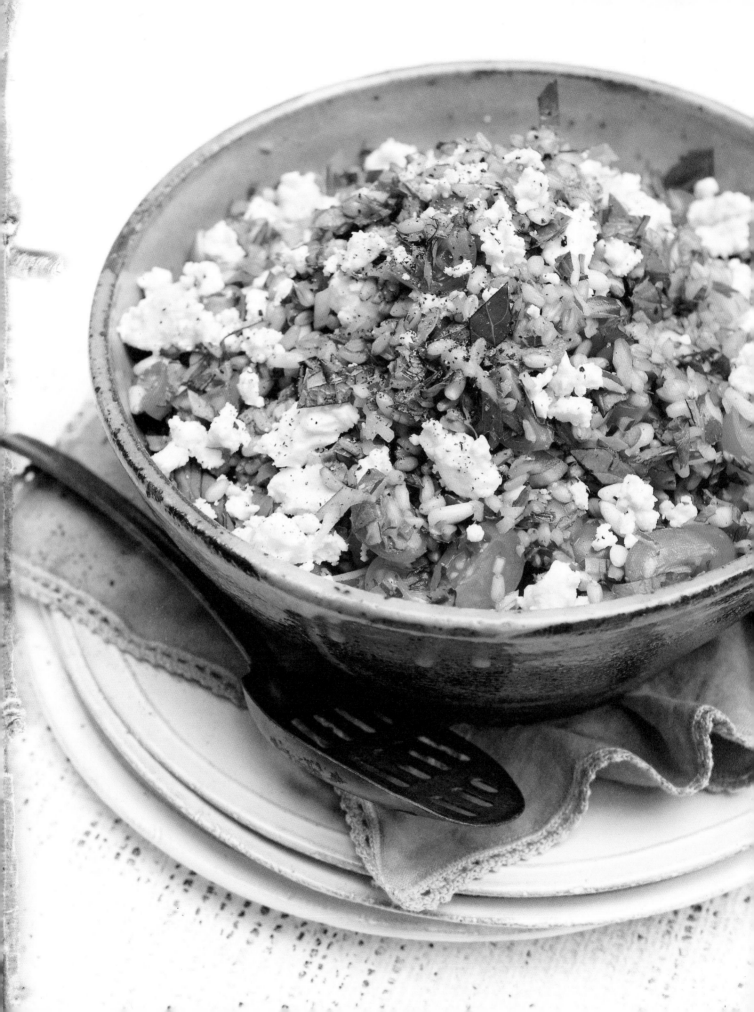

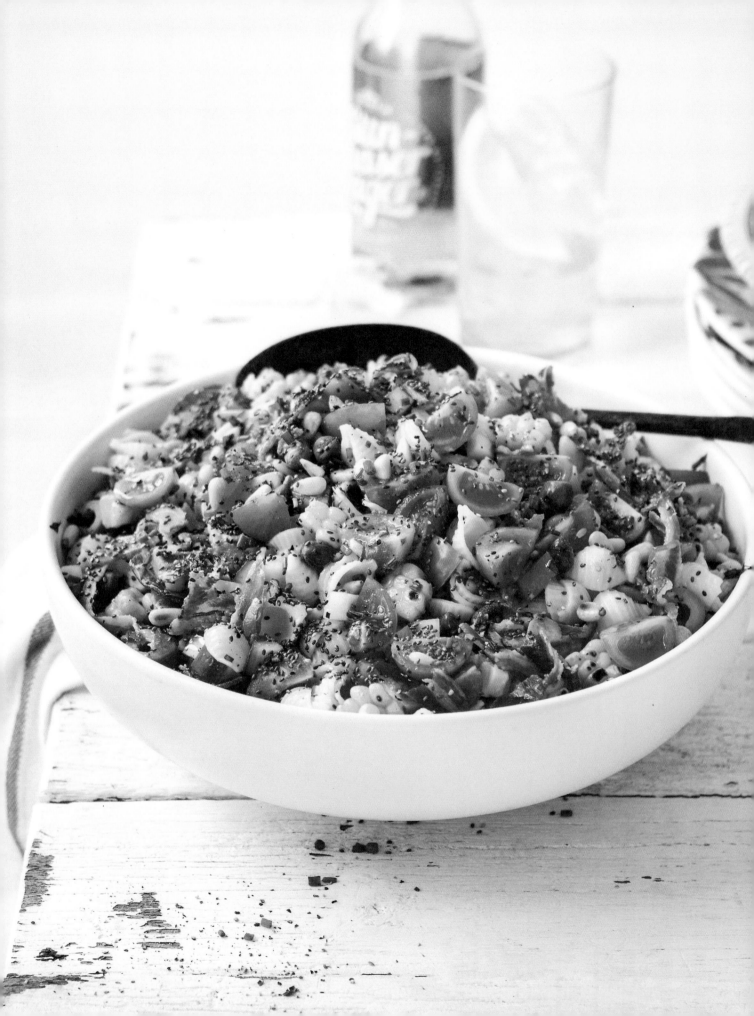

KATIE'S PASTA SALAD

Everybody loves a good pasta salad to serve at a barbecue: this is my version,
jam-packed full of great flavors and colorful textures.

7 oz thinly sliced round pancetta
4 cups small pasta shells
2 ears sweetcorn, husks and silks removed
1 red onion, finely diced
1 red, 1 yellow and 1 orange bell pepper, trimmed, seeded and finely diced
1 large cucumber, cut into ¼ in dice
9 oz cherry tomatoes, quartered
¾ cup pitted green olives, thinly sliced
½ cup capers, well rinsed
½ cup pine nuts, toasted
4 tablespoons black chia seeds
16 large basil leaves, coarsely chopped
finely chopped chives, to garnish

DRESSING
4 tablespoons extra virgin olive oil
2½ tablespoons apple cider vinegar
½ teaspoon Dijon mustard
sea salt and freshly ground black pepper

Serves 6–8 as a side

Preheat the oven to 400°F and line two baking sheets with parchment paper.

Arrange the pancetta on the sheets and bake for 12–15 minutes or until crisp. Remove
from the oven and leave to cool slightly before crumbling into small pieces.

Cook the pasta shells according to the packet instructions, then drain and rinse
well under cold running water.

Meanwhile, cook the corn in a saucepan of boiling water for 2–3 minutes, then lift out
with tongs, shake off the excess water and place each ear directly on a gas burner or
under a broiler on medium heat for 1–2 minutes each, turning often, to lightly blacken
the kernels. Leave to cool slightly, then stand the ears on one end on a board and, using a
sharp knife, carefully slice off all the kernels and place in a large serving bowl.

Place all the salad ingredients (except the chives) in the bowl with the corn
and toss together.

For the dressing, whisk together the oil, vinegar and mustard, then season to taste
and drizzle over the salad. Toss well and serve topped with the chives.

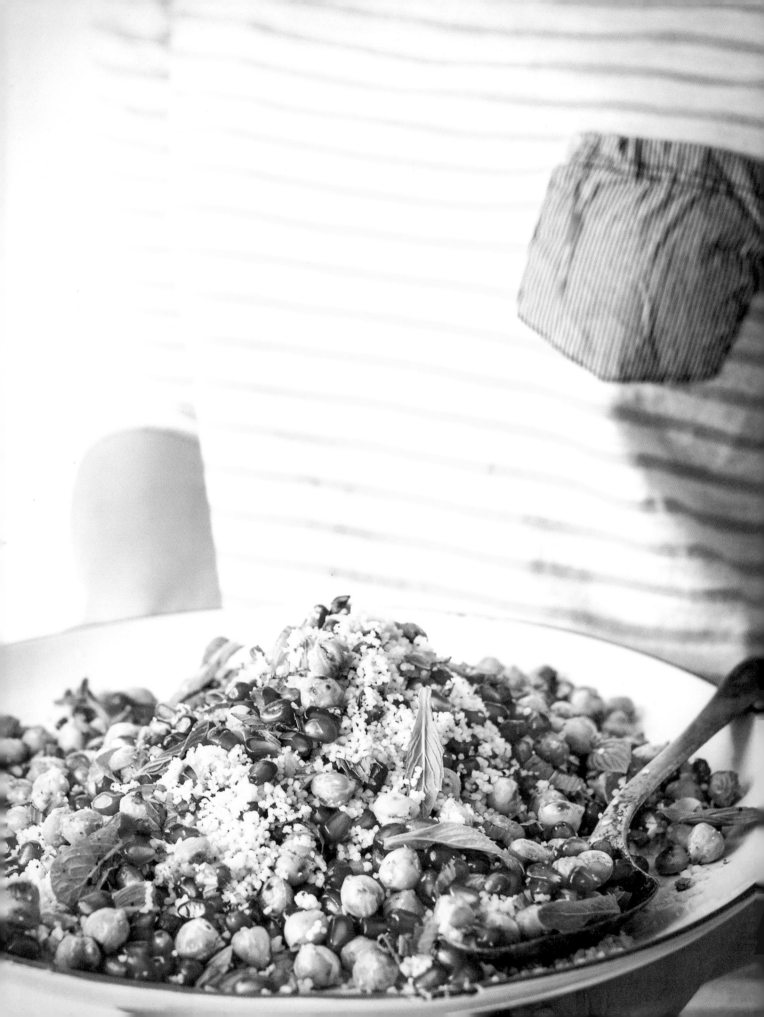

COUSCOUS WITH SPICED CHICKPEAS AND POMEGRANATE

This salad pairs brilliantly with any grilled meat, especially lamb.
The pomegranate seeds offer little bursts of fruity flavor, and look
very pretty and jewel-like.

1 cup couscous
sea salt and freshly ground black pepper
1¼ cups sliced blanched almonds
1 tablespoon olive oil
1 × 14 oz can chickpeas, drained and rinsed
1 teaspoon ground cumin
finely grated zest and juice of 1 lemon
seeds from 2 pomegranates
1 large handful mint, torn
extra virgin olive oil, for drizzling

Serves 4 as a side

Cook the couscous according to the packet instructions. Fluff with a fork
to break up any lumps, then season to taste and set aside in a large bowl.

Toast the sliced blanched almonds in a skillet over medium heat for 5 minutes or
until golden brown, then set aside to cool.

In the same skillet, heat the oil over medium heat and add the chickpeas, cumin
and salt and pepper to taste. Cook for 8–10 minutes, tossing often, until crisp
and golden. Add the lemon juice and cook for another minute or two, then
transfer the contents of the pan to the bowl with the couscous, along with the
cooled toasted almonds.

Add the pomegranate seeds, mint, lemon zest and a good drizzle of extra virgin
olive oil and gently toss to combine. Season with a little extra salt and pepper
before serving.

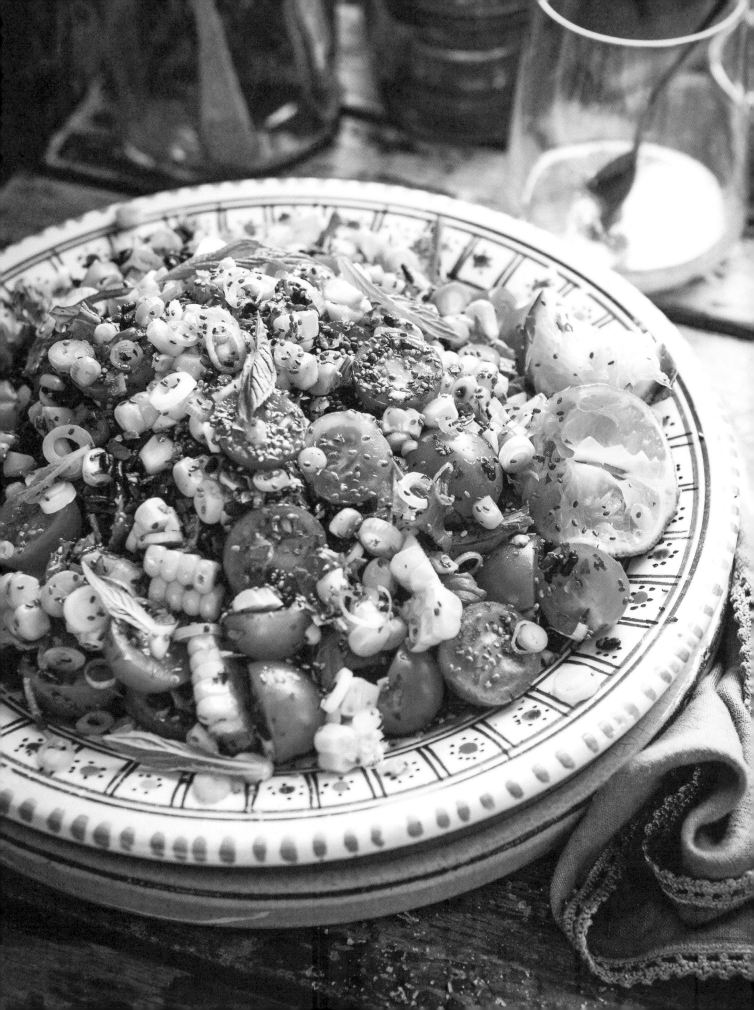

SWEETCORN, BLACK RICE AND CHIA SALAD

Black rice is available from selected health food stores and is a nice alternative to brown rice; if you can't find it, use whichever rice you prefer. This fresh-tasting, punchy salad goes particularly well with Mexican food or barbecued fish or chicken.

1 cup black rice
2 ears sweetcorn, husks and silks removed
9 oz punnet cherry tomatoes, halved
4 scallions, trimmed and thinly sliced
1 large handful flat-leaf parsley
1 large handful mint
2 tablespoons chia seeds, plus extra to garnish
finely grated zest and juice of 1 large lime
4 teaspoons extra virgin olive oil
sea salt and freshly ground black pepper

Serves 4–6 as a side

Cook the rice according to the packet instructions, then rinse under cold water and drain. Set aside to cool completely.

Meanwhile, cook the corn in a saucepan of boiling water for 2–3 minutes, then lift out with tongs, shake off the excess water and place each ear directly on a gas burner or under a broiler on medium heat for 1–2 minutes each, turning often, to lightly blacken the kernels. Leave to cool slightly, then stand the ears on one end on a board and, using a sharp knife, carefully slice off all the kernels and place in a large bowl. Set aside to cool completely, then add the tomato, scallion, herbs and chia seeds.

Whisk together the lime zest, juice and extra virgin olive oil in a small bowl and season to taste. Pour over the salad and gently toss to coat.

Serve garnished with extra chia seeds.

SPICED SQUASH AND APPLE SOUP WITH BACON

№. 68

This is an absolute favorite of mine – it's fantastic as a dinner-party starter, and I always get lots of compliments when I serve it. I had never thought about putting apple into a soup before, but it works really well here with the squash and adds just the right amount of sweetness to contrast with the bacon and spices.

⅓ cup pumpkin seeds
1 teaspoon cumin seeds
1 teaspoon coriander seeds
1 teaspoon dried sage
2 pounds 4 ounces butternut squash, peeled, seeded and cut into 1¼ in pieces
4½ tablespoons olive oil
sea salt and freshly ground black pepper
2 green apples, peeled, cored and cut into 1¼ in pieces
1 pound 2 ounces free-range bacon, fat and rind removed, diced
1 onion, chopped
3 cloves garlic, finely chopped
4 cups chicken broth
⅔ cup goat's cheese

Serves 4

Preheat the oven to 400°F and line two baking sheets with parchment paper. Scatter the pumpkin seeds on one of the sheets and bake for 5 minutes until lightly golden brown.

In a small nonstick skillet, toast the cumin and coriander seeds over low heat for 2–3 minutes or until fragrant. Transfer to a mortar, add the sage and grind to a fine powder with the pestle.

Place the squash, ground spices and 2½ tablespoons of the olive oil in a large bowl, season and toss to coat. Place on the second sheet, arrange in a single layer and roast for 30 minutes. Add the apple and roast for a further 20 minutes or until the squash and apple are tender.

Meanwhile, heat another 2 teaspoons oil in a large skillet over medium heat. Add the bacon and cook, stirring often, for 5 minutes or until golden. Set aside to drain on paper towel.

Heat the remaining oil in the skillet. Add the onion, garlic and a pinch of salt, then cook, stirring, for 3–4 minutes or until softened. Transfer to a blender along with the squash mixture, 2 cups of the broth, half the goat's cheese and half the bacon and blend until smooth.

Pour the pureed squash mixture into a large heavy-bottomed saucepan, add the remaining broth and cook over medium heat for 8–10 minutes or until reduced slightly, then season.

To serve, divide the soup among bowls and sprinkle the remaining bacon and goat's cheese over the top. Finish with a scattering of toasted pumpkin seeds and a grinding of pepper.

NEW YORK
HOUSE NUMBER
AND
TRANSIT GUIDE

MAP No. 3000 SIZE: 33"x31"

COMPILED, PRINTED AND PUBLISHED BY
HAGSTROM COMPANY
MAP MAKERS PUBLISHERS LITHOGRAPHERS
30 VESEY STREET NEW YORK 7, N.Y.

EXPLANATION

Subway Lines (I.R.T. West Side)
Subway Lines (I.R.T. East Side)
Subway Lines (B.M.T.)
Subway, 42nd St. Shuttle

Subway Lines (IND)
Subway Express Stations
Subway Local Stations
Elevated Lines
Elevated Express Stations
Elevated Local Stations
Hudson Tubes
Playgrounds
2,350 ETC House Numbers
Surface Lines
Bus Lines
Main Auto Routes

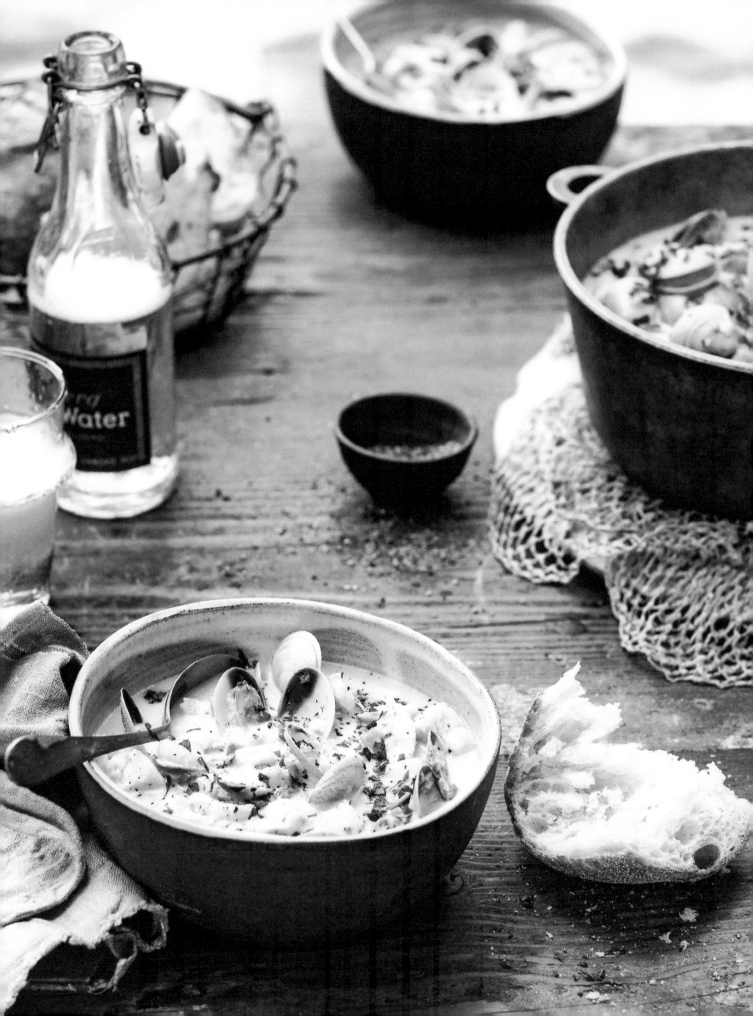

FISH AND CLAM CHOWDER

This recipe was inspired by a chowder I had in Provincetown, Massachusetts, during a trip there a few years ago. I like to use halibut or mahi-mahi, but any meaty white fish would work well.

2 pounds 4 ounces clams
4 teaspoons olive oil
9 oz free-range bacon, fat and rind removed, cut into
 thin strips
1 onion, chopped
2 cloves garlic, finely chopped
2½ tablespoons all-purpose flour
4 cups fish broth
5 sprigs thyme, tied in a bunch with butcher's twine
1 bay leaf
1 pound 2 ounces red or new potatoes, cut into 1 in pieces
sea salt and freshly ground black pepper
1 cup milk
1 cup heavy cream
1 pound 2 ounces firm white fish fillets, skin and
 bones removed, cut into 1¼ in pieces
finely chopped flat-leaf parsley and crusty bread, to serve

Serves 4–6

Soak the clams in cold water for 30 minutes to remove any grit, then drain, rinse and set aside.

Heat the oil in a large heavy-bottomed saucepan over medium–high heat. Add the bacon and cook, stirring often, for 3–4 minutes, then add the onion and garlic and cook for 2–3 minutes until softened. Add the flour and stir to coat.

Stir in the broth, thyme, bay leaf and potato and season. Bring to a boil, then reduce the heat to low–medium and simmer for 20 minutes or until the potato is just tender when pierced with a small, sharp knife.

Stir in the milk and cream. Increase the heat to high, add the clams and fish and cook for 3–4 minutes, stirring, until the clams are cooked and the shells are open, and the fish is just cooked.

Serve immediately with plenty of freshly ground black pepper and flat-leaf parsley, accompanied by crusty bread.

ROAST TOMATO, LENTIL AND CHICKPEA SOUP

This is a great winter warmer that's suitable for vegetarians. Feel free to add more harissa if you like things a little more spicy. Serve with plenty of crusty bread.

3 pounds 5 ounces plum tomatoes, halved lengthwise
2 red bell peppers, trimmed, seeded and each cut
 into eight wedges
sea salt and freshly ground black pepper
4 tablespoons extra virgin olive oil
1 large red onion, finely chopped
4 large cloves garlic, finely chopped
2 stalks celery, thinly sliced
2 long red chiles, seeded and finely chopped
1½ teaspoons harissa
2 × 28 oz cans chopped tomatoes
1 teaspoon smoked paprika
½ teaspoon ground cumin
2 cups vegetable broth
2 × 14 oz cans lentils, drained and rinsed
2 × 14 oz cans chickpeas, drained and rinsed
plain yogurt and thyme, to serve

Serves 6–8

Preheat the oven to 350°F and line a baking sheet with parchment paper.

Place the tomato and pepper on the prepared sheet, cut-side up, season with salt and drizzle with 2½ tablespoons of the oil. Roast for 1 hour or until the tomato is starting to brown at the edges and the pepper is tender. Peel the skin from the cooked pepper.

Meanwhile, heat the remaining oil in a large heavy-bottomed saucepan over medium heat. Add the onion and cook for 3–4 minutes or until soft, then add the garlic and cook, stirring, for 3–4 minutes or until fragrant. Add the celery and chopped chile and cook, stirring often, for 4–5 minutes. Stir in the harissa, then add the canned tomatoes, paprika and cumin and cook for 5–6 minutes.

Remove the pan from the heat, add the roast tomato and pepper and use an immersion blender to puree until smooth. Return the pan to medium heat, then add the broth and stir, season to taste and simmer for 10 minutes.

Add the lentils and chickpeas and warm through for 1 minute, then season again. Serve hot with a grinding of pepper, a swirl of yogurt and some thyme scattered over the top.

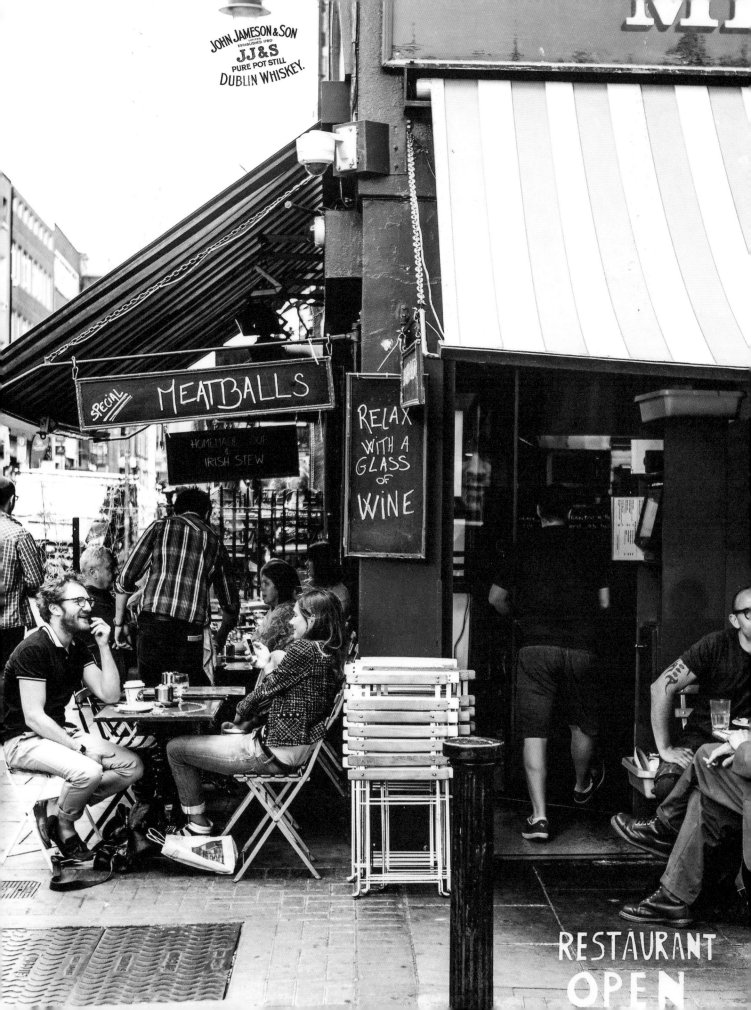

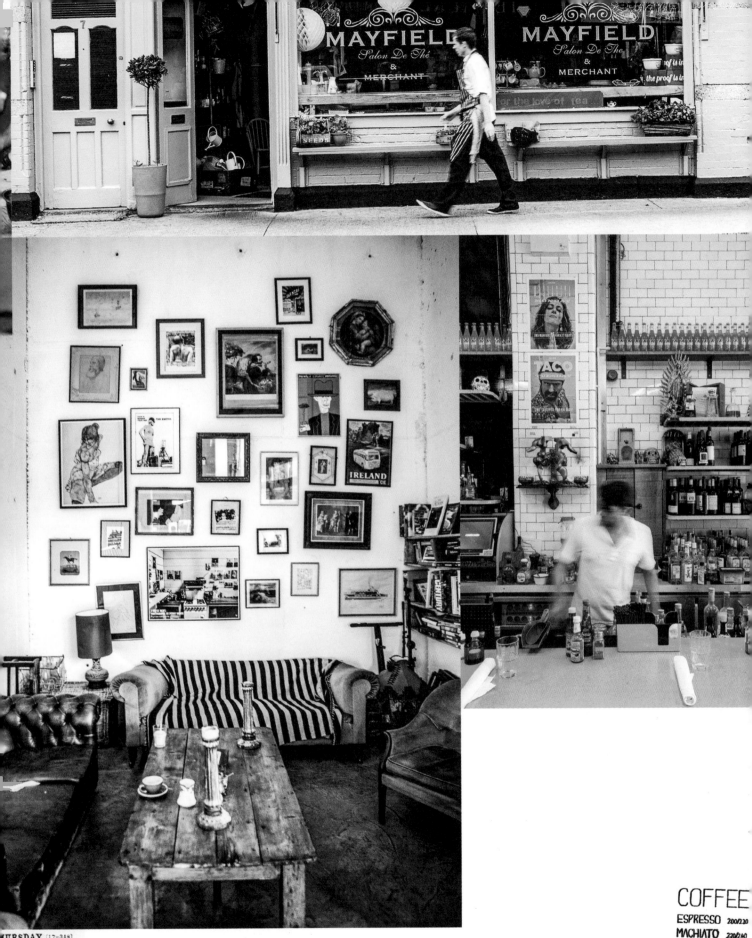

COFFEE

ESPRESSO 200/220

MACHIATO 220/240

LONG BLACK 240

FLAT WHITE 230

CAPPUCCINO 270

HOT CHOCOLATE 300

TEAS 200

I took a trip back to my hometown of Dublin last year. It had been a while since I'd visited my old stomping ground, and I couldn't wait to catch up with all my mates and my sister and her family. I flew in on my birthday and met up with a big group of friends for cocktails at a funky little bar called Vintage Cocktail Club that's hidden away in the Temple Bar area, before heading to one of my all-time favorite Dublin pubs, McDaids, just off Grafton Street. McDaids is an authentic Dublin pub, buzzing with locals and only a few tourists. The weather was amazing — 86°F and beautifully sunny, a rarity in Dublin — and the city was packed with people, all out enjoying pints of Guinness on the streets.

During my stay, I immersed myself in the burgeoning food scene in Dublin; wowzers, it has totally taken off! Funky, cool new restaurants are popping up all over the city, and they're really hopping all week long. I had a blast shooting loads of pics in some fabulous new spots. Given the economic downturn in Ireland in recent years, it was nice to see things are on the up.

There's a great new chain of urban restaurants by Irish restaurateur John Farrell – his diner-style Dillinger's, The Butcher Grill steakhouse and his amazing Mexican eatery, 777, are all worth a visit if you are in Dublin. Another place I adore is The Fumbally, a funky coffee house that serves delicious salads and sandwiches with a Middle-Eastern feel. This place attracts a young crowd and the food is served in a great space that has a very laidback, creative feel. Mayfield Eatery is another relaxed spot for brunch or dinner. Run by a lovely bloke called Kevin Byrne, it's charming (very shabby-chic), and the food is cozy and warming. It's a little way out of the city, but hop on a bus and you'll be there in no time.

It was amazing being back home for a decent amount of time and seeing all my family and friends. Living on the other side of the globe, I miss them a lot, and the time difference between Sydney and Dublin is a bit of a bummer when it comes to calling each other! I wanted to spend as much time with them as possible, so I arranged plenty of get-togethers at my good friend Colm's house (remember his soup from my first book?). I cooked up some of the recipes from the book and had a great time catching up with my sister and my old school friends, including Emily, Julie, Rebecca and Sarah, not to mention all their gorgeous kids.

When I left Ireland back in 2006, my only niece, Erika, was three years old. She's eleven now, so I've missed a lot of her growing-up years and I relish catching up with her whenever I can. The weather was amazing so we threw a good few barbecues at my sister's place. My brother-in-law, Claudio, is a real character. He's Brazilian and therefore a superman on the barbecue – in fact, he's one of the best on the planet at cooking sausages (the one food I really miss from home – Irish pork sausages are, quite simply, the best in the world!).

Places I visited and websites of interest:

vintagecocktailclub.com
mcdaidsirishpub.com
dillingers.ie
thebutchergrill.ie
777.ie
thefumbally.ie
mayfieldeatery.ie

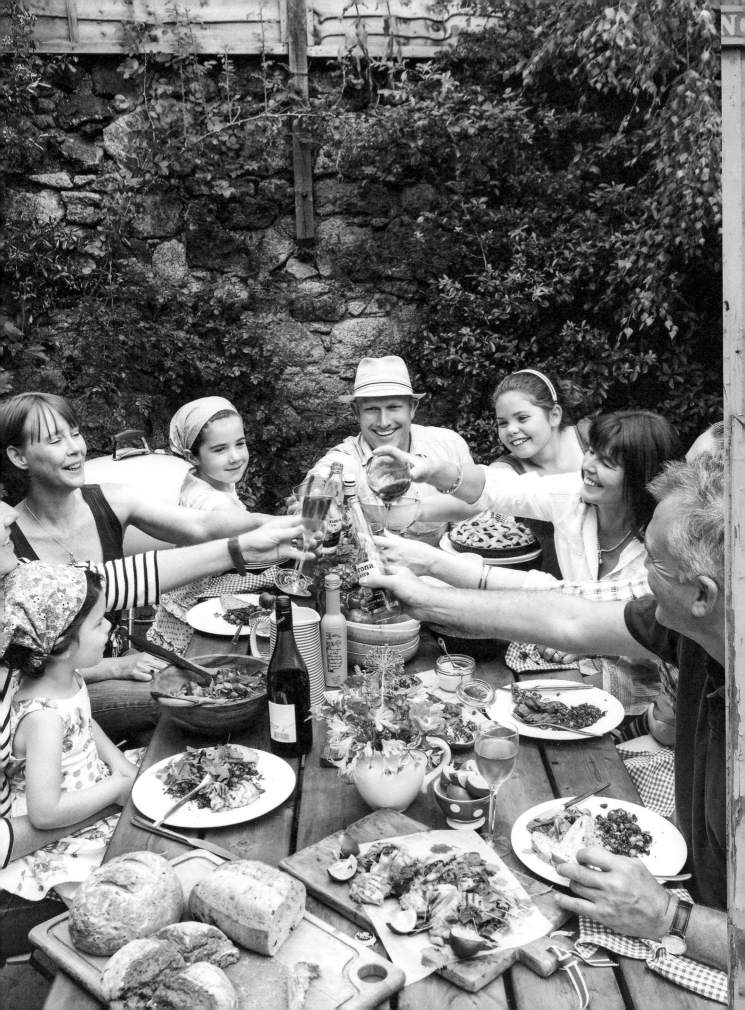

MENU

PLEASE

OFF THE GRASS

PLEASE

NOT WALK ON

THE GRAVES

Ʒaeveal Comluct Taiʒde um
Uppavaiʀ Náipiúnta, Teo.
IRISH NATIONAL ASSURANCE CO., LTD.
Office—30 COLLEGE GREEN, DUBLIN

e Clergy and all Irish-Irelanders, by insuring their Lives
d Property with the Irish National, will be helping to
engthen the Industrial Arm of the Irish Nation. ::

This is the only IRISH LIFE AND GENERAL
ASSURANCE COMPANY, and is DIRECTED
AND STAFFED BY IRISH-IRELANDERS.

5,000,000 are drained out of Ireland yearly in Assurance
emiums by Foreign Companies. We are fighting to keep
s great sum at home for the use of the Irish People.

——— YOU CAN HELP US ———

e have £20,000 invested in Irish Trustee Stocks as Security
our Policyholders. Our total assets after only two year's
rk amount to nearly £50,000. Our Present Income
£1,000 per week, and increasing by leaps and bounds.

We guarantee that all our Funds will be
invested in Irish Enterprises. :: ::

An Irish National Agency is a paying pro-
position, and we have openings for some
good workers :: :: :: :: :: ::

——— BUSINESS TRANSACTED: ———

e, Fire, Live Stock, Endowment, Burglary, Motor
r, Plate Glass, Sickness, Accident, etc. :: ::

DIRECTORS:

RENCE CASEY, JOHN CUMMINS, D.C.
 Managing Director
CULLETON P. St L. O'DEA
RAIC Ó MAILLE, T.D. JAMES A. BURKE, T.D.
MAK'GAN EAMONN O'DUIBHIR

OYAL EXCHANGE
ASSURANCE

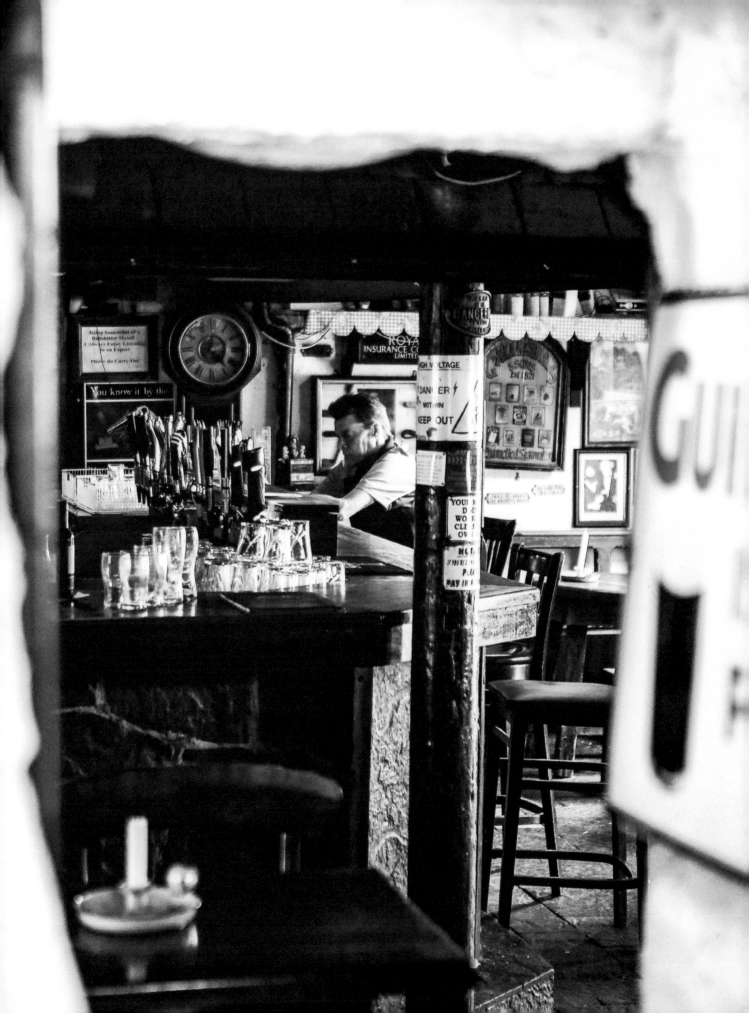

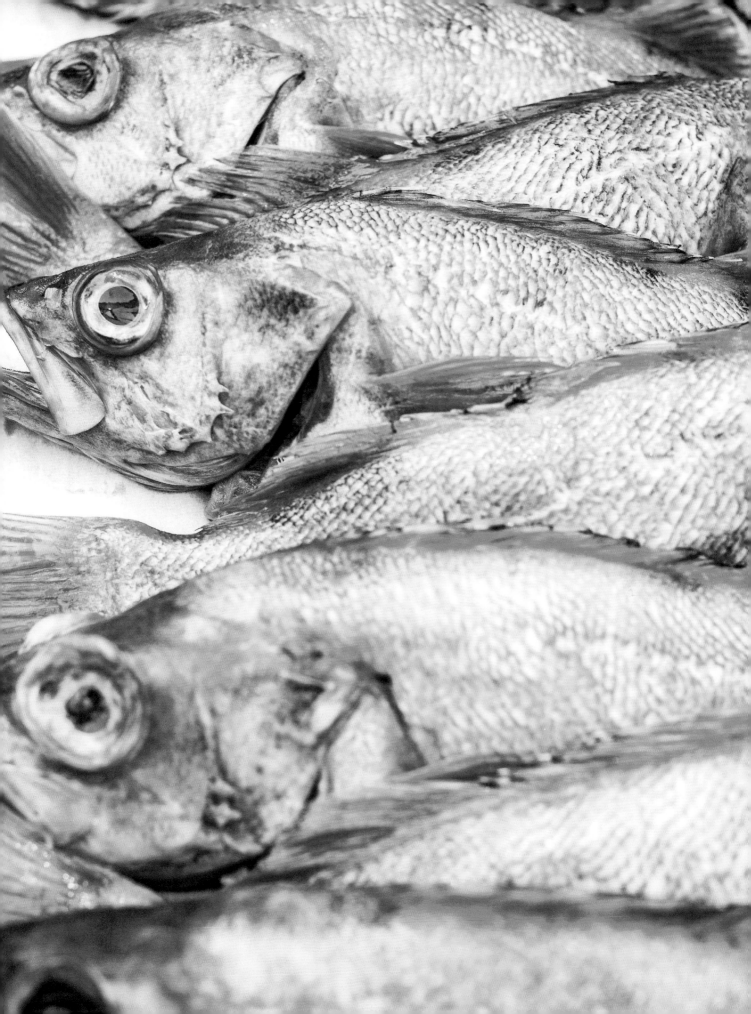

179
west
4th St.
EW YORk
10014

POULTRY, MEAT AND FISH

№ 90

BUFFALO-INSPIRED WINGS WITH BLUE-CHEESE MAYO

On my first visit to New York in 1997, I visited a bar in Greenwich Village called Down the Hatch, which was (and still is) famous for its 'Atomic Wings' — deep-fried chicken wings smothered in a spicy buffalo sauce. I ate buckets of them, and have been hooked ever since — so much so that I've spent years experimenting in the kitchen, trying to perfect my own version of the sauce. Finally, I can present it to you here! A few tips: hot sauce is available from selected gourmet delis (I use Crystal hot sauce). Don't use Tabasco sauce as a substitute as it's too hot for this recipe. Also, don't add the butter to the sauce until right at the end when the pan is off the heat, otherwise the sauce will split.

12 free-range chicken wings
light olive oil spray
1 heaping tablespoon all-purpose flour
1 teaspoon cayenne pepper
1 teaspoon sweet paprika
1 teaspoon onion salt
celery stalks, to serve

BLUE-CHEESE MAYO
3 free-range egg yolks
4 teaspoons white vinegar
2½ tablespoons lemon juice
sea salt
1 cup sunflower or canola oil
1 heaped teaspoon Dijon mustard
2½ tablespoons light sour cream
5½ oz blue cheese

BUFFALO-INSPIRED SAUCE
1 cup white vinegar
2½ tablespoons honey
3½ tablespoons hot sauce, to taste
1 teaspoon sweet paprika
1 teaspoon garlic powder
½ teaspoon cornstarch
4 teaspoons lemon juice
1 teaspoon butter

Serves 4—6

Recipe continues overleaf →

Thank You!

MON TO SAT
5 TO 1145
SUN
5 TO 11
WEEKENDS
11 TO 230

RRY OUT
AILABLE

Preheat the oven to 400°F and line two baking sheets with parchment paper.

Remove the tips from the chicken wings, then cut the wings in half at the joint. Pat them dry with paper towel, then lightly spray all over with olive oil.

Place the flour, cayenne pepper, paprika and onion salt in a large resealable plastic bag, seal and shake to combine. Add the chicken to the bag and shake well to coat evenly in the spice mixture.

Divide the chicken among the prepared sheets and bake for 30 minutes. Remove the sheets from the oven and use tongs to turn the chicken pieces over (wiping away any excess moisture with paper towel), then return the chicken to the oven to bake for a further 30 minutes or until it is crisp, golden brown and cooked through.

Meanwhile, for the mayo, place the egg yolks, vinegar, lemon juice and a pinch of salt in the bowl of a food processor. Mix on high speed, adding the oil in a thin, steady stream — you'll end up with a thick, glossy mayo. Add the mustard, sour cream and blue cheese and mix until smooth. Transfer to a serving bowl, cover with plastic wrap and chill in the fridge until required.

For the buffalo-inspired sauce, place the vinegar, honey, hot sauce, paprika, garlic powder and ½ cup water in a heavy-bottomed saucepan. Bring to a boil, then reduce the heat to medium and simmer for 10–15 minutes. In a small cup, whisk the cornstarch with 4 teaspoons water until smooth. Whisk this into the sauce, then simmer, whisking continuously, for 5 minutes. Stir in the lemon juice, reduce the heat to low and cook for 1–2 minutes. Remove the pan from the heat and stir in the butter until it has melted and the sauce is smooth and glossy (don't return the sauce to the heat or it will split).

Place the chicken in a lined serving basket and drizzle with the sauce (keep some parts uncovered so they remain crisp). Serve immediately with the blue-cheese mayo and celery stalks alongside.

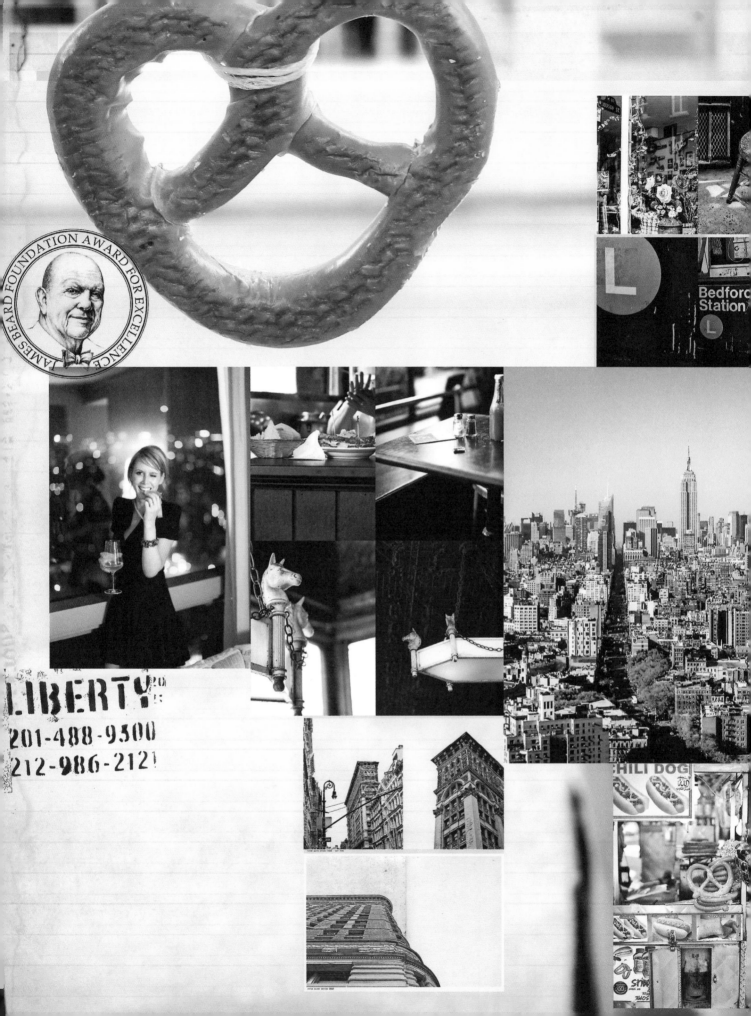

JAMES BEARD FOUNDATION AWARD FOR EXCELLENCE

LIBERTY

201-488-9300

212-986-2121

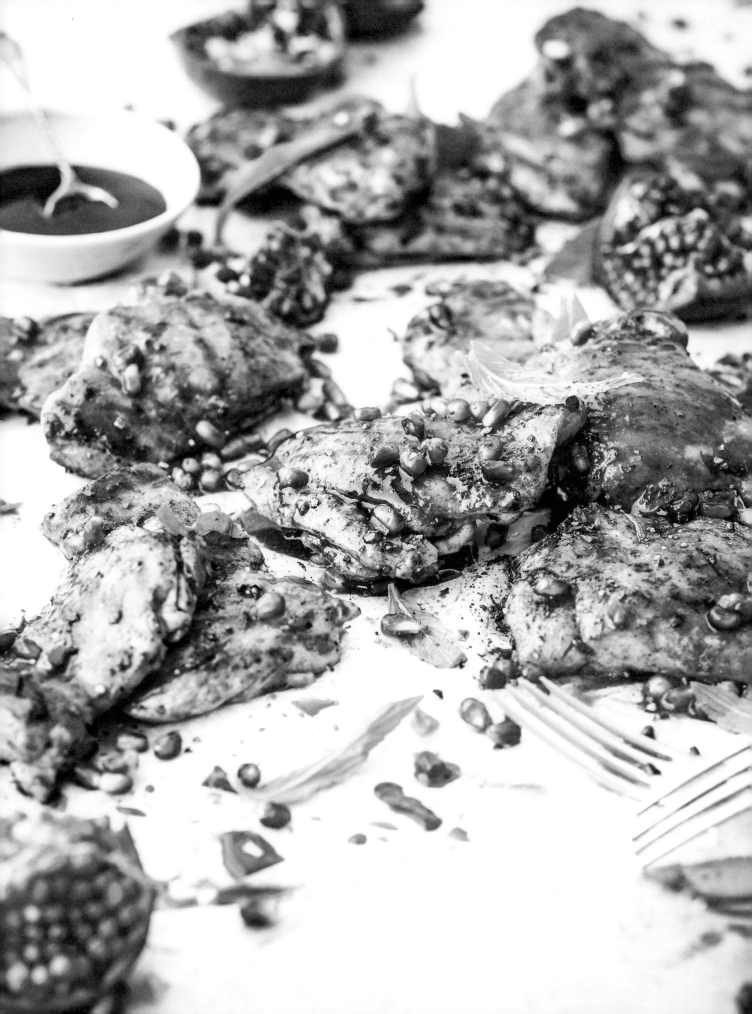

Start this dish the day before, if possible, as the chicken is incredibly flavorsome when left to marinate overnight. You can buy pomegranate molasses at Middle-Eastern grocers or selected gourmet delis. If you haven't used it before, you'll soon be hooked. It's sticky and sweet and sour, and pairs fantastically with chicken. Pour it over a roast chicken towards the end of the cooking time and you'll get a great contrast in flavors. It looks superb, too, caramelized on the skin. This dish goes particularly well with the quinoa salad on page 56.

POMEGRANATE CHICKEN

12 free-range skinless boneless chicken thighs, trimmed of excess fat
pomegranate molasses (optional), mint and pomegranate seeds, to serve

POMEGRANATE MOLASSES MARINADE
2½ tablespoons olive oil
⅓ cup pomegranate molasses
juice of 1 lemon
3 large cloves garlic, finely chopped
2½ tablespoons Dijon mustard
2½ tablespoons sherry vinegar
2 sprigs mint, leaves picked and very finely chopped
sea salt and freshly ground black pepper

Serves 4–6

For the marinade, place all the ingredients in a pitcher or bowl and whisk to combine. Pour into a large resealable plastic bag, add the chicken thighs, then seal and shake to combine. Marinate in the fridge for at least 6 hours (or overnight if possible).

Heat a grill pan or barbecue flat plate over medium–high heat until hot. Working in batches, cook the chicken thighs for 5–6 minutes on each side or until golden brown and cooked through.

Drizzle over some pomegranate molasses, if using, then serve hot, scattered with mint and pomegranate seeds.

CRUNCHY CHICKEN WITH SWEET-SALTY DIPPING SAUCE

This dish is a healthy choice for when friends come over, and kids will love it, too. Tamari (Japanese soy sauce) is available from Asian food stores and gourmet delis.

8 free-range skinless boneless chicken thighs, trimmed of excess fat
4 tablespoons tamari
4 tablespoons light agave nectar (see page 10)
¾ cup puffed quinoa
¾ cup rolled quinoa flakes
¾ cup black or white sesame seeds (or a mixture of both)
freshly ground black pepper

SWEET—SALTY DIPPING SAUCE
⅓ cup tamari
2½ tablespoons light agave nectar (see page 10)
2½ tablespoons mirin
1 long red chile, seeded and thinly sliced
2—3 scallions, trimmed and thinly sliced
2 cloves garlic, very finely chopped
few sprigs cilantro

Serves 4

Halve the chicken thighs lengthwise. Place the tamari and agave nectar in a small shallow dish and whisk together. Add the chicken and toss to coat, then cover with plastic wrap and refrigerate for 1 hour.

Preheat the oven to 400°F and line two baking sheets with parchment paper.

Place the puffed quinoa, quinoa flakes, sesame seeds and a good pinch of black pepper in a large bowl and combine. Remove the marinated chicken from the fridge and, working one by one, take a piece of chicken from the marinade, allowing the excess to drip off, then place in the bowl and toss to coat with the quinoa mixture. Transfer to the prepared sheets.

Bake the chicken for 20—25 minutes or until golden, crispy and cooked through.

Meanwhile, for the dipping sauce, place the tamari, agave nectar, mirin and 4 teaspoons water in a pitcher and whisk to combine. Pour into a small serving bowl and stir in the chile, scallion, garlic and cilantro.

Serve the hot chicken strips with the dipping sauce alongside.

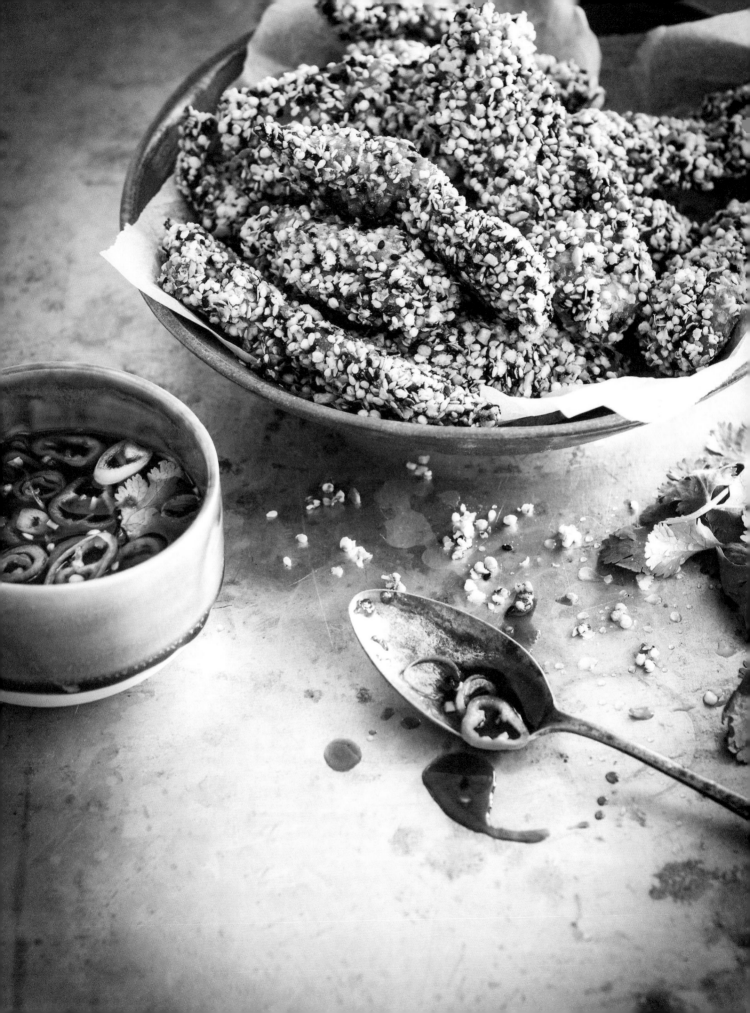

GRILLED CHICKEN WITH LIME AND HERBS

You'll need about ⅔ cup lime juice for this recipe, so if fresh limes are out of season and too expensive, you could use bottled lime juice instead.

6 limes, plus extra wedges to serve
2½ tablespoons olive oil
1 long green chile, seeded and finely chopped
1 handful mint, finely chopped, plus extra leaves to garnish
1 handful cilantro, finely chopped, plus extra sprigs to garnish
sea salt and freshly ground black pepper
12 free-range skinless boneless chicken thighs, trimmed of excess fat
thinly sliced green chile, to garnish

Serves 6

Finely grate the zest of two of the limes into a large shallow glass or ceramic bowl. Add the juice from all six limes, reserving the squeezed lime halves, then stir in the oil, chile and herbs. Season.

Add the chicken and turn to coat in the marinade. Scatter the squeezed lime halves on top, then cover with plastic wrap and marinate in the fridge for at least 3–4 hours.

Before cooking, bring the chicken to room temperature.

Heat a grill pan or barbecue flat plate over medium–high heat. Working in batches if necessary, use a pair of tongs to transfer the chicken pieces to the hot grill, draining off any excess marinade as you go. Cook, turning occasionally, for 10–12 minutes or until lightly charred and cooked through.

Serve right away with extra sliced chile, mint, cilantro and lime wedges.

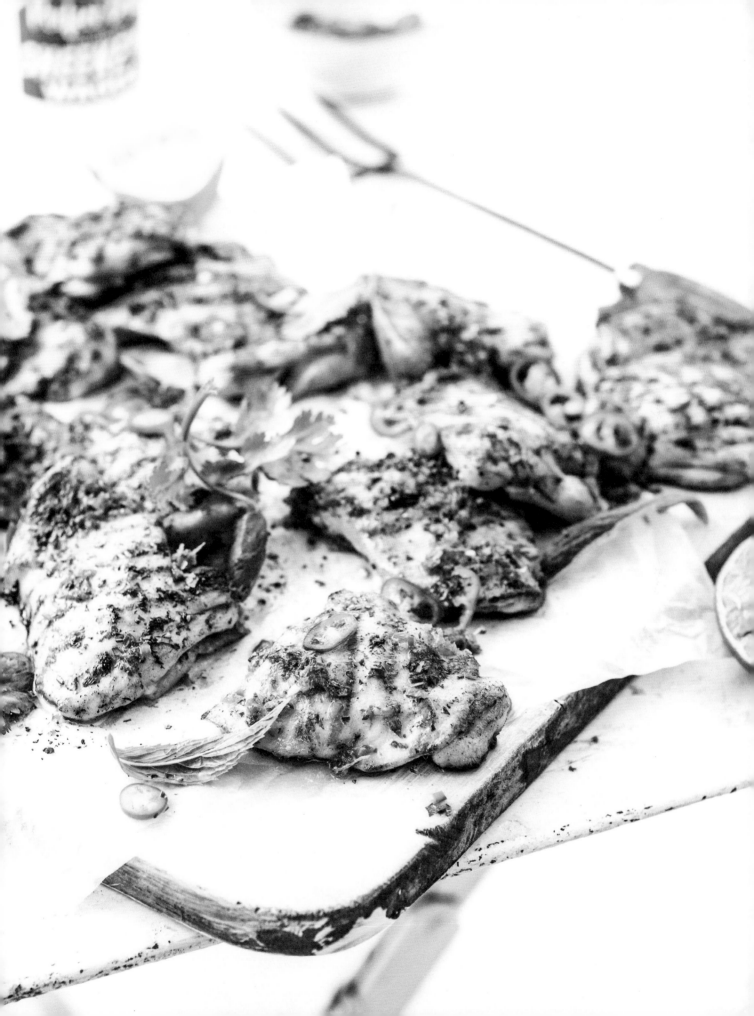

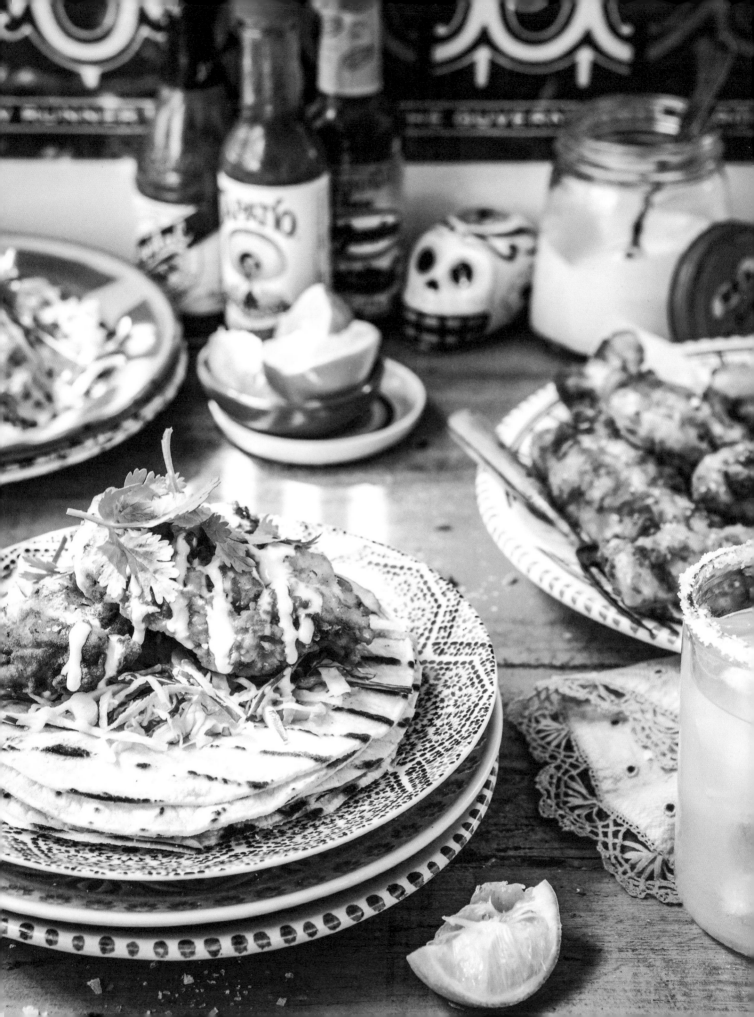

CRISPY CHICKEN TACOS

POULTRY, MEAT AND FISH

This fried chicken is so delicious you may have a hard time getting it into the tortillas: you'll want to snaffle it right away instead. If you're pushed for time, use a store-bought ranch-style dressing for the slaw rather than making your own mayo.

1 pound 5 ounces free-range skinless boneless chicken
 thighs, trimmed of excess fat, halved lengthwise
¾ cup buttermilk
1–2 teaspoons Tabasco sauce
sea salt
2 ears sweetcorn, husks and silks removed
1 long green chile, finely chopped
freshly ground black pepper
½ cup rice flour
½ cup all-purpose flour
rice bran oil, for deep-frying
8 corn tortillas
lime juice, hot sauce or chipotle sauce (see page 28)
 and cilantro, to serve

CREAMY SLAW
1 free-range egg yolk
2½ tablespoons lemon juice
sea salt
7 tablespoons canola oil
2 teaspoons Dijon mustard
1 teaspoon white wine vinegar
2½ tablespoons light sour cream
2¼ cups very finely sliced red cabbage
2¼ cups very finely sliced white cabbage
1 carrot, peeled and finely grated (you'll
 need about ¾ cup grated carrot)

Serves 4

Place the chicken thighs in a glass or ceramic bowl and add the buttermilk, Tabasco and a good pinch of salt. Using clean hands, mix everything together to coat the chicken thoroughly. Cover with plastic wrap and marinate in the fridge for 1–2 hours.

Meanwhile, for the slaw, place the egg yolk, 4 teaspoons lemon juice and a pinch of salt in the bowl of a food processor. Process on high speed, adding the oil in a thin, steady stream until the mixture is thick and glossy. Add the mustard, vinegar and sour cream and process again to incorporate. Transfer to a bowl, cover with plastic wrap and place in the fridge.

Cook the corn ears in a saucepan of boiling water for 2–3 minutes, then lift out with tongs, shake off the excess water and place each ear directly on a gas burner or under a broiler on medium heat for 1–2 minutes each, turning often, to lightly blacken the kernels. Leave to cool slightly, then stand the ears on one end on a board and, using a sharp knife, carefully slice off all the kernels. Place in a bowl, add the chile and stir to combine, then season to taste.

Combine the flours in a bowl. Remove the chicken from the marinade, shake off any excess and dredge in the flour.

Quarter-fill a large, heavy-bottomed saucepan with oil. Heat over high heat until the temperature reaches 350°F, then reduce the heat to medium–high. Working in batches of about eight pieces at a time, fry the chicken for 4 minutes, turning once or twice, until golden brown, crispy and cooked through. Drain on paper towel, patting off the excess oil, then transfer to a plate, season with plenty of sea salt and cover with foil.

Heat a grill pan or skillet over high heat and toast a tortilla on both sides until lightly browned. Transfer to a plate and cover with foil to keep warm, then continue with the remaining tortillas.

To finish making the slaw, toss the cabbage and grated carrot together in a bowl, then add half the dressing and the remaining lemon juice and toss to combine.

To serve, add some slaw and corn to the middle of a warm tortilla and top with crispy chicken. Add a squeeze of lime juice and a splash or two of sauce, then drizzle over a little of the remaining slaw dressing. Finish with a scattering of cilantro.

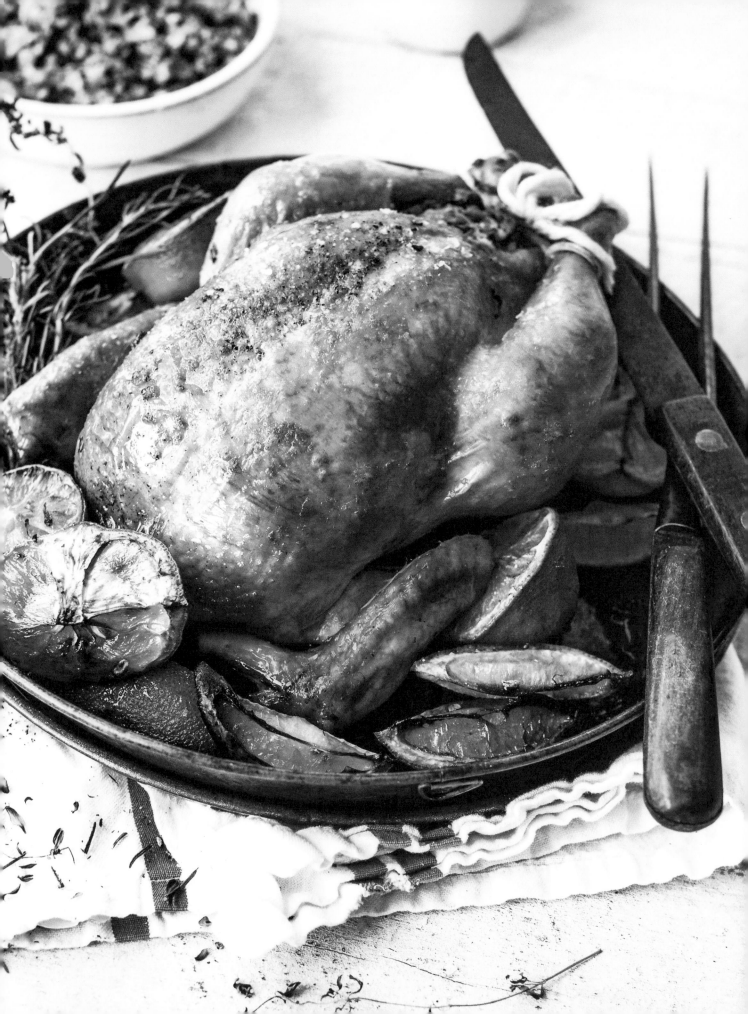

ROAST CHICKEN WITH BACON, KALE AND ALMOND STUFFING

This is one of my staple quick and easy dinner-party recipes: I cooked
it at my Barossa lunch (see pages 32–41) and it went down a treat.
I absolutely adore stuffing, so I always make extra and serve it alongside
the bird. You can have it in sandwiches the following day, too.

1 onion, roughly chopped

3 cloves garlic, peeled

⅔ cup almonds

1 handful flat-leaf parsley

2 sprigs rosemary, leaves stripped and chopped

5½ oz sourdough bread, crusts removed

9 oz free-range bacon, fat and rind removed, finely diced

4½ oz curly kale, stalks removed, leaves finely sliced

1–2 pieces preserved lemon rind, rinsed and diced

1 apple, grated

sea salt and freshly ground black pepper

1 × 3- to 3½-pound free-range chicken

3 large pats unsalted butter, at room temperature

sea salt

4 teaspoons olive oil

2–3 lemons, halved or quartered and a few sprigs rosemary (optional)

Serves 4

Preheat the oven to 400°F.

Place the onion and garlic in the bowl of a food processor
and whiz until finely chopped but not mushy, then
transfer to a large bowl. Whiz the almonds in the food
processor until medium–finely chopped, then add to the
bowl. Add the herbs to the processor and whiz until finely
chopped, then add to the bowl. Finally, whiz the bread in
the processor to fine bread crumbs and place in the bowl.

Add the bacon, kale, preserved lemon and apple to the
bowl of bread mixture, season with pepper and combine
well. Set aside.

Carefully separate the skin from the chicken breasts,
taking care not to tear the skin. Slide half the butter under
the skin of each breast, then carefully spread the butter out
evenly by rubbing your fingers over the top of the skin.

Season the cavity of the chicken. Take two handfuls of
the stuffing mix and form into a loose ball. Push into
the cavity, taking care not to overstuff the bird, then tie
the legs together with butcher's twine to help hold the
stuffing in place. Pop the remaining stuffing on a sheet of
foil, form it into a log shape and roll up to secure.

Place the chicken in a roasting pan, season with salt
and pepper and drizzle with the oil. Tuck the lemons
and rosemary, if using, around the chicken and roast
for 30 minutes, then place the foil-wrapped stuffing
in the oven and roast for a further 40 minutes or until
the chicken is cooked through and the skin is crisp
and golden brown.

Set the chicken aside to rest for 10 minutes before
carving and serving with the extra stuffing and lemon
wedges and rosemary, if using, alongside.

INDIAN-SPICED LAMB CUTLETS

These cutlets are fantastic to serve at a barbecue or casual dinner party;
they are wonderfully flavorsome and always get snapped up quickly.
I usually allow 4 cutlets per person as they are so popular. Serve them
on a platter and let people help themselves. They go really well with the
couscous and chickpea salad on page 65 and the smashed baby potatoes
on page 160. Start this the day before if you have time, as the lamb is
even more delicious if left to marinate overnight.

**16 grass-fed lamb cutlets, French-trimmed (ask your butcher to
do this for you)**
lemon wedges, to serve

INDIAN-SPICED MARINADE
⅓ cup olive oil
1 tablespoon garam masala
1 teaspoon ground cumin
1 teaspoon dried oregano
3 large cloves garlic, finely chopped
1 handful flat-leaf parsley, very finely chopped
1 handful mint, very finely chopped
finely grated zest and juice of 1 large lemon
sea salt and freshly ground black pepper

Serves 4

For the marinade, place all the ingredients in a pitcher or bowl, season with salt and
pepper and whisk to combine. Pour into a large resealable plastic bag with the lamb
cutlets, seal and shake to combine. Marinate in the fridge for at least 6 hours (or
overnight if possible).

Heat a grill pan or barbecue flat plate over medium–high heat until hot. Working
in batches, cook the cutlets for 2 minutes each side for medium–rare, or until cooked
to your liking, then serve hot with lemon wedges alongside.

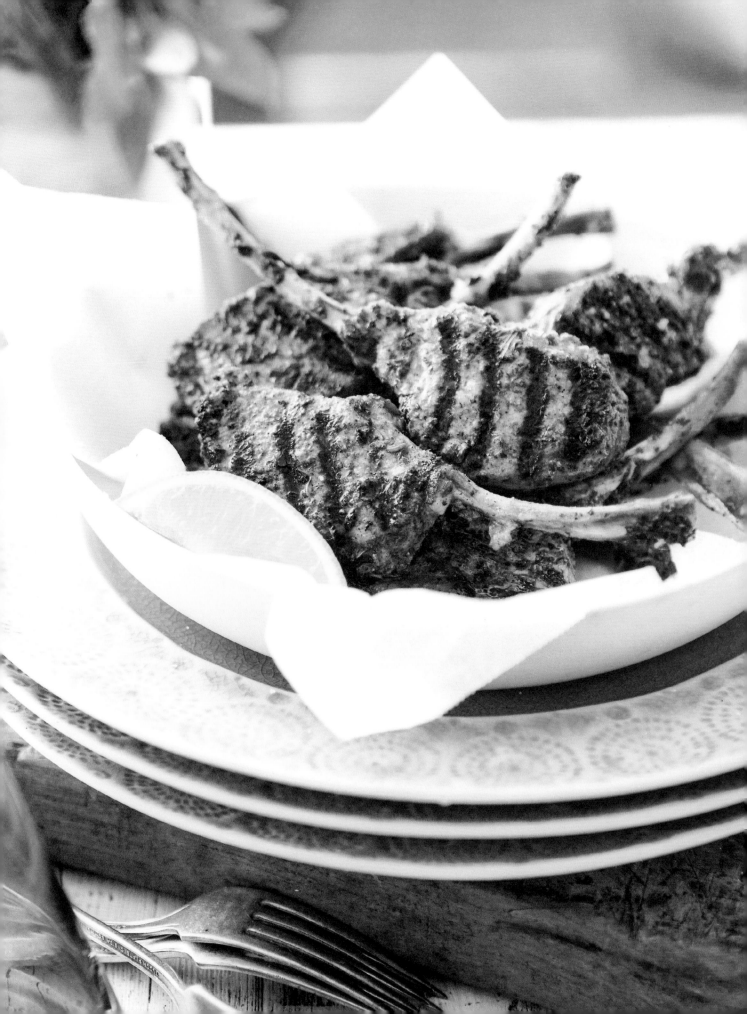

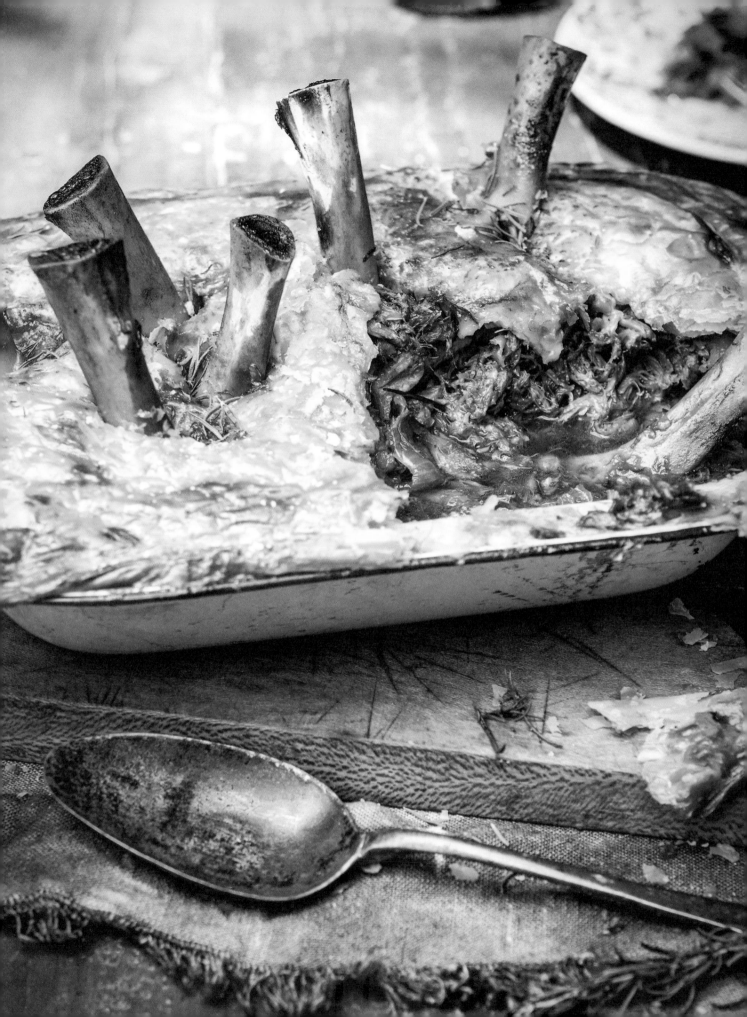

A total winner for a winter dinner party, this is a joy to prepare and is guaranteed to impress! This pie goes perfectly with the mashed potato on page 166. I use a gutsy red wine for this: a cab sav/ shiraz blend is ideal.

Serves 6−8

LAMB SHANK PIE

4 tablespoons all-purpose flour
8 (about 10½ oz each) free-range lamb shanks,
 trimmed of excess fat
2½ tablespoons rice bran oil
2 onions, quartered
2 carrots, cut into ¾ in thick rounds
3 stalks celery, diced
8 large cloves garlic, peeled
2¼ cups good-quality red wine
6 sprigs rosemary, leaves stripped from
 4 of the sprigs
4 sprigs thyme, leaves stripped
3 cups beef broth
4 teaspoons tomato paste
2½ tablespoons Worcestershire sauce
4 teaspoons Dijon mustard
sea salt and freshly ground black pepper
finely grated zest of 1 large lemon
1 sheet good-quality puff pastry, such
 as Pepperidge Farm
1 free-range egg yolk, mixed with a little milk

Preheat the oven to 310°F.

Place the flour on a large plate, add the shanks and toss to coat.

Heat the oil in a large flameproof casserole dish over medium−high heat. Working in batches, brown the shanks evenly on all sides, then remove and drain on paper towel.

Arrange the onion, carrot, celery and garlic in the casserole. Place the lamb shanks on top, pour over the red wine and scatter over the rosemary and thyme leaves.

Place the broth, tomato paste, Worcestershire sauce and mustard in a large bowl or pitcher, whisk together and season with salt and pepper. Pour this mixture over the shanks, then add the lemon zest. Place the lid on the casserole and bake for 4−5 hours or until the lamb is very tender.

Remove the casserole from the oven. Transfer the lamb shanks to a large bowl and set aside until cool enough to

handle. Strip the meat from the bones − it should come away easily − and transfer to a clean bowl. Reserve six or seven of the bones, rinse them well under cold water and set aside on paper towel to dry.

Transfer the lamb to a 3 quart roasting pan, then spoon in the cooked vegetables from the casserole using a slotted spoon. Mix well and check for seasoning.

Spoon off any excess fat from the liquid in the casserole, then place over medium−high heat. Bring to a boil, then reduce the heat to medium and simmer for 25−30 minutes or until the sauce has reduced by almost two-thirds and is thick and glossy.

Preheat the oven to 425°F. Pour the sauce over the ingredients in the roasting pan. Carefully lay the pastry sheet on top and pinch to seal the edges. Using a small sharp knife, pierce six or seven holes in the pastry and insert the cleaned shank bones. Brush the pastry with the eggwash.

Bake for 35−40 minutes or until the pastry is puffed and golden brown. Serve piping hot.

SPICED LAMB WITH LEMON

Saturday afternoon barbecue? Sorted. This dish is perfect for a large gathering, as you can cook two or three lamb legs, slice them up and pop it all on a platter. Serve this with the farro salad on page 60 (you could even put out pita breads as well and fill them with the meat and salad – no plates required!).

8 cardamom pods
4 teaspoons coriander seeds
4 teaspoons fennel seeds
1 teaspoon ground cinnamon
sea salt and freshly ground black pepper
finely grated zest of 1 lemon, plus an extra 2 lemons,
quartered lengthwise, seeds removed
4 large cloves garlic, roughly chopped
¾ cup extra virgin olive oil
1 × 3 pound 5 ounce grass-fed boneless leg of lamb, butterflied

Serves 6

Bruise the cardamom pods with the back of a heavy knife, extract the seeds and place them in a small nonstick skillet along with the coriander and fennel seeds. Toast over low–medium heat for 2 minutes or until fragrant.

Transfer the toasted spices to a mortar along with the cinnamon and 1 teaspoon each of salt and pepper. Grind with a pestle to a fine powder. Add the lemon zest, garlic and olive oil, then mix together to form a paste.

Place the lamb in a large shallow dish and use your hands to thoroughly massage the marinade into the meat. Cover with plastic wrap and marinate in the fridge for 4 hours.

Once the lamb has been marinating for 3 hours, preheat the oven to 350°F.

Place the lemon quarters on a baking sheet lined with parchment paper and roast in the oven for 1 hour. Remove and set aside.

Heat a barbecue or grill pan to high. Remove the lamb from the fridge and place on the grill, cooking for 5–6 minutes on both sides for medium–rare or continue until cooked to your liking.

Set the meat aside to rest for 15 minutes before slicing.

Serve the sliced lamb on a platter lined with parchment paper, surrounded by the roasted lemons and sprinkled with sea salt.

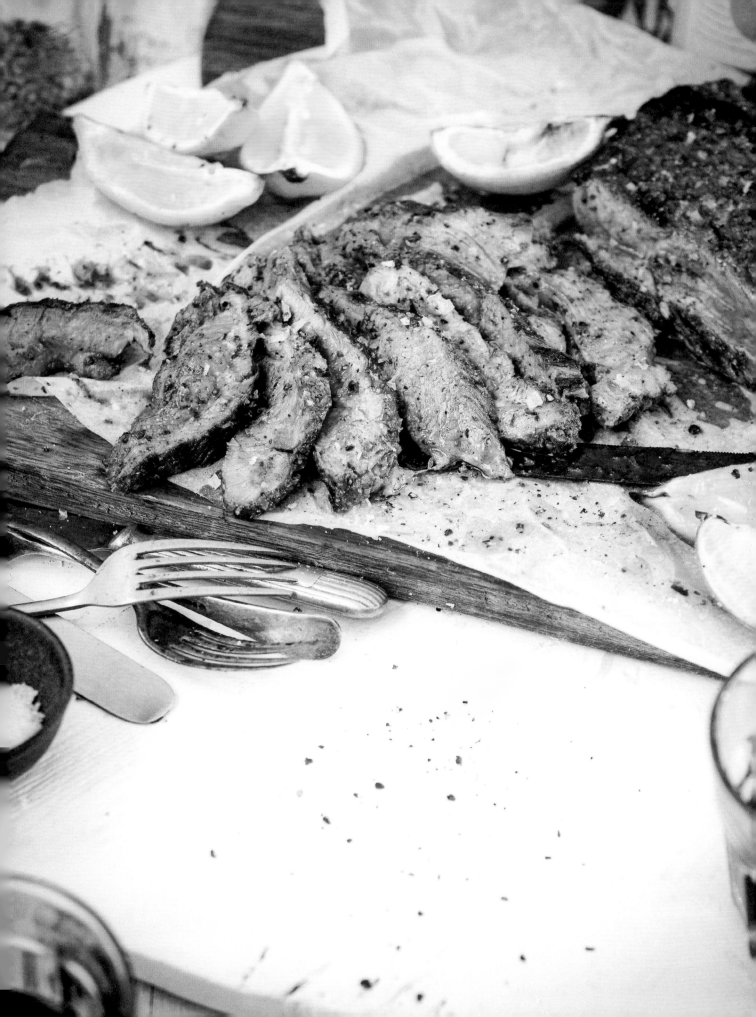

CHORIZO AND TOMATO TART

During my last visit back home to Dublin, I found the most incredibly
pretty and colorful heirloom tomatoes in a gourmet food shop. I took them
home and created this dish with some chorizo I had in the fridge,
a huge bunch of basil, a box of oh-so-pretty micro herbs and a bottle
of aged balsamic. Super-simple and very pretty to serve at a summery
weekend brunch or as a starter. If you can get hold of Pepperidge Farm
frozen puff pastry, you'll get the best results.

1 sheet good-quality store-bought puff pastry, thawed
1 free-range egg yolk, mixed with a little milk
1½ good-quality chorizo sausages (about 7¾ oz), thinly sliced
8–10 tomatoes, sliced
sea salt and freshly ground black pepper
⅓ cup extra virgin olive oil
1 small handful basil, plus extra to garnish (optional)
micro herbs and flowers, to garnish (optional)

Serves 4 for a light brunch

Preheat the oven to 400°F and line a baking sheet with parchment paper.

Lay the pastry sheet on the prepared sheet and brush with the eggwash.
Using a small, sharp knife, score a ⅝ in border around the edge of the
pastry sheet, taking care not to cut right through the pastry. Prick the
center of the pastry sheet a few times with a fork. Place a folded 8 in square
of parchment paper in the center of the pastry and gently weigh down with
a small ovenproof saucepan lid.

Blind-bake for 20 minutes, then remove the sheet from the oven. Remove
the weight and parchment paper, then line the pastry with the chorizo and
the sliced tomato within the scored border, overlapping slightly if you need
to. Season with a little salt and pepper and drizzle over 1 tablespoon of the
oil, then bake for 25–30 minutes or until the pastry is puffed around the
edges and golden brown.

Meanwhile, place the basil and the remaining oil in a blender and blend to
a smooth paste, then season to taste.

To serve, drizzle the basil oil over the tart and garnish with extra basil
or micro herbs and flowers, if using.

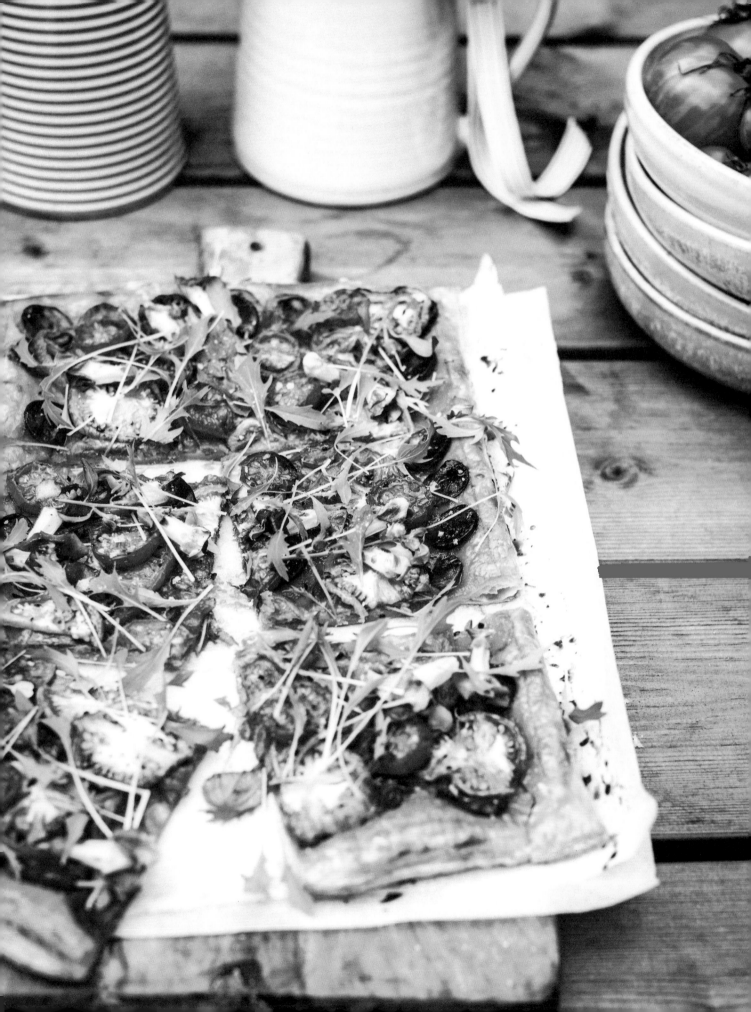

PORK FLAUTAS WITH CREAMY APPLE AND RADISH SLAW

These deep-fried filled and rolled tortillas are not for the faint-hearted, but are wonderful to feed a hungry crowd. Make sure to reserve half the dressing from the slaw, as it's great to dip the flautas into. Serve them immediately after frying so they stay crisp.

2 teaspoons coriander seeds
1 teaspoon caraway seeds
2 teaspoons garlic powder
1 teaspoon sea salt
1 teaspoon sweet paprika
1 teaspoon ground cinnamon
2 teaspoons unsweetened cocoa powder
1 teaspoon crushed red pepper flakes
1 teaspoon onion powder
½ cup chipotle sauce (see page 28)
4 tablespoons olive oil
1 free-range pork shoulder (about 4 pounds 8 ounces), bone-in
2 onions, quartered
6 large cloves garlic, skin-on
1 carrot, cut into ¾ in rounds
2 cups apple cider
10-12 corn tortillas
rice bran oil or olive oil, for shallow frying

CREAMY APPLE AND RADISH SLAW

4 teaspoons apple cider vinegar
½ cup good-quality mayo
4 tablespoons sour cream
finely grated zest and juice of 1 lemon
7 oz red cabbage, very thinly sliced
8 radishes, trimmed and very thinly sliced using a mandoline
1 green apple, cored and cut into thin matchsticks, then covered in a squeeze of lemon juice
1 handful cilantro leaves

Serves 4–8

Preheat the oven to 315°F.

Place the coriander and caraway seeds in a small, nonstick skillet over low–medium heat and toast until fragrant. Add to a mortar along with the garlic powder, salt, paprika, cinnamon, cocoa powder, pepper flakes and onion powder and grind with a pestle to a fine powder. Transfer to a large roasting pan, add the chipotle sauce and oil and combine well. Add the pork, and use clean hands to thoroughly massage the marinade into the meat.

Arrange the onion, garlic cloves and carrot around the pork in the roasting pan. Pour the cider into the pan, along with 1 cup water, transfer to the oven and roast for 4½ hours, checking every now and then to ensure the liquid does not evaporate (add a little more water at any point if the pan looks dry).

Leave the pork to cool for 15 minutes before transferring to a cutting board and shredding the meat from the bone with two forks. Remove the cooked vegetables from the pan with a slotted spoon and discard, then place the shredded pork back in the pan and toss to coat in the sauce.

Preheat the oven to 250°F. Lay the tortillas out on a clean countertop. Divide the shredded pork among the tortillas, arranging it in a line across the center. Roll up into a tube and secure with a toothpick.

Fill a large heavy-bottomed skillet with oil to a depth of ½ in and heat to 315–325°F. Working in batches of two or three, fry the flautas for 1–2 minutes on each side or until golden brown and super-crispy, then remove and drain briefly on paper towel. Keep the fried flautas warm in the oven while you cook the rest.

For the slaw, combine the vinegar, mayo, sour cream, lemon zest and juice in a small bowl. Place the cabbage, radish and apple in a large bowl, add half the dressing and toss well to combine. Scatter over the cilantro.

Remove the toothpicks from the fried flautas and cut them in half crosswise. Serve with plenty of slaw and the remaining slaw dressing to the side.

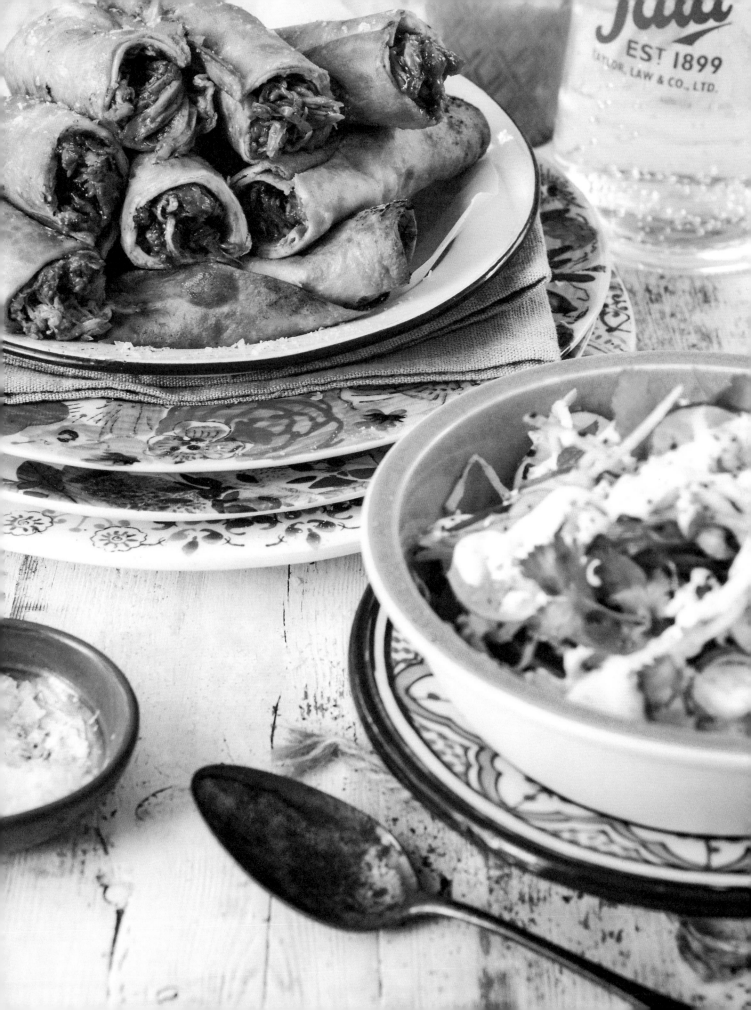

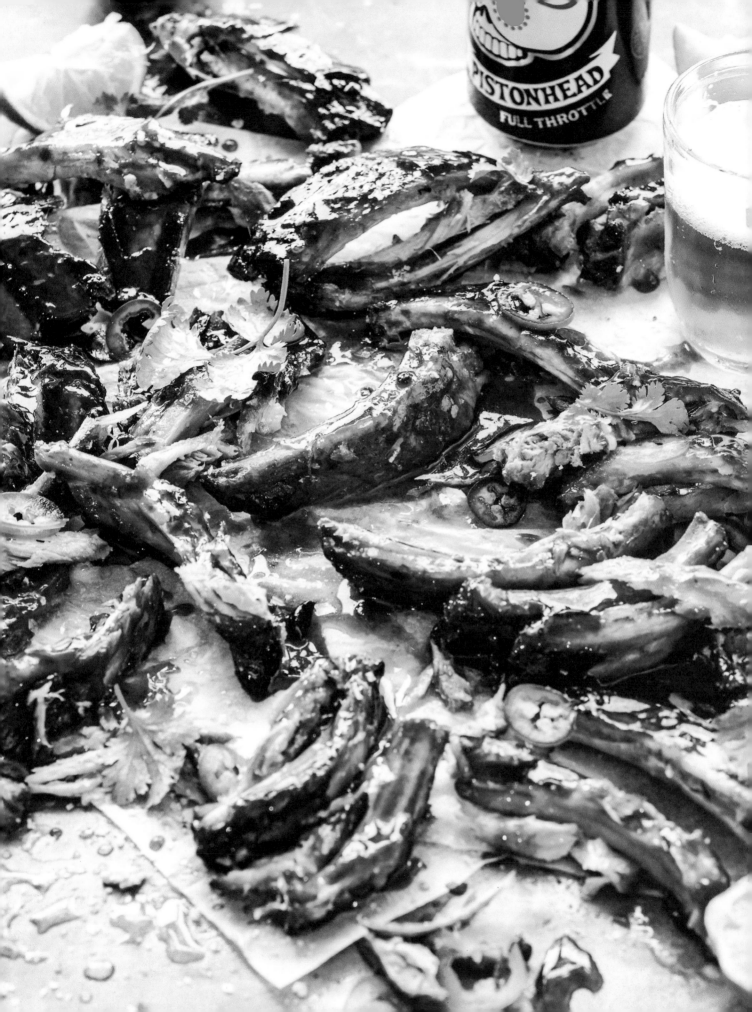

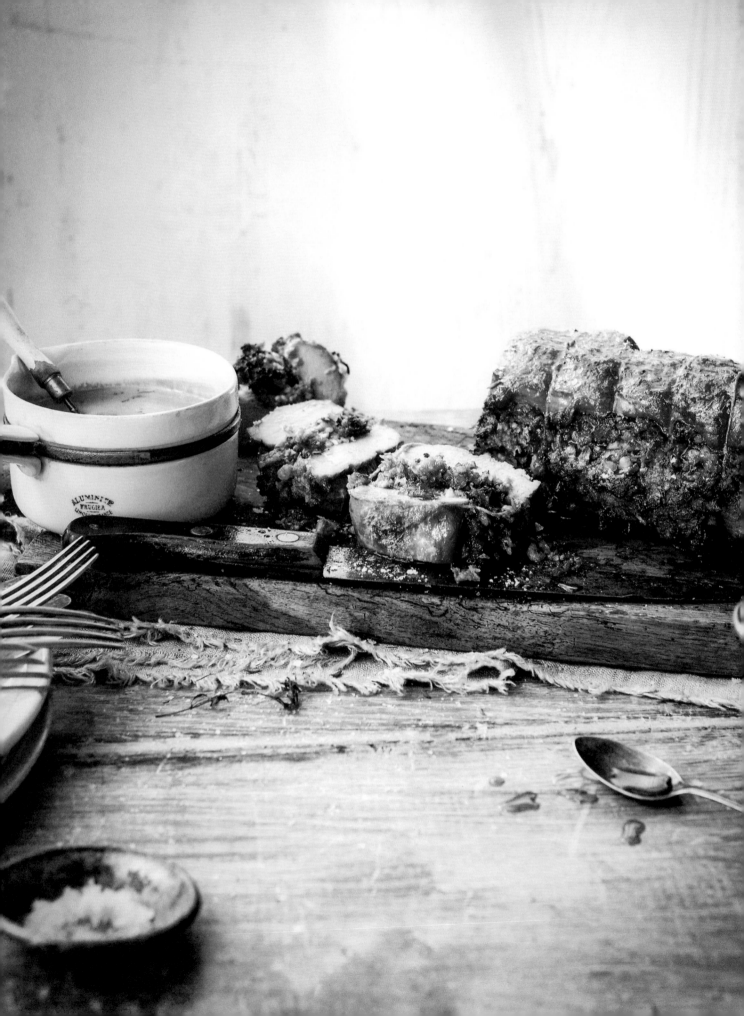

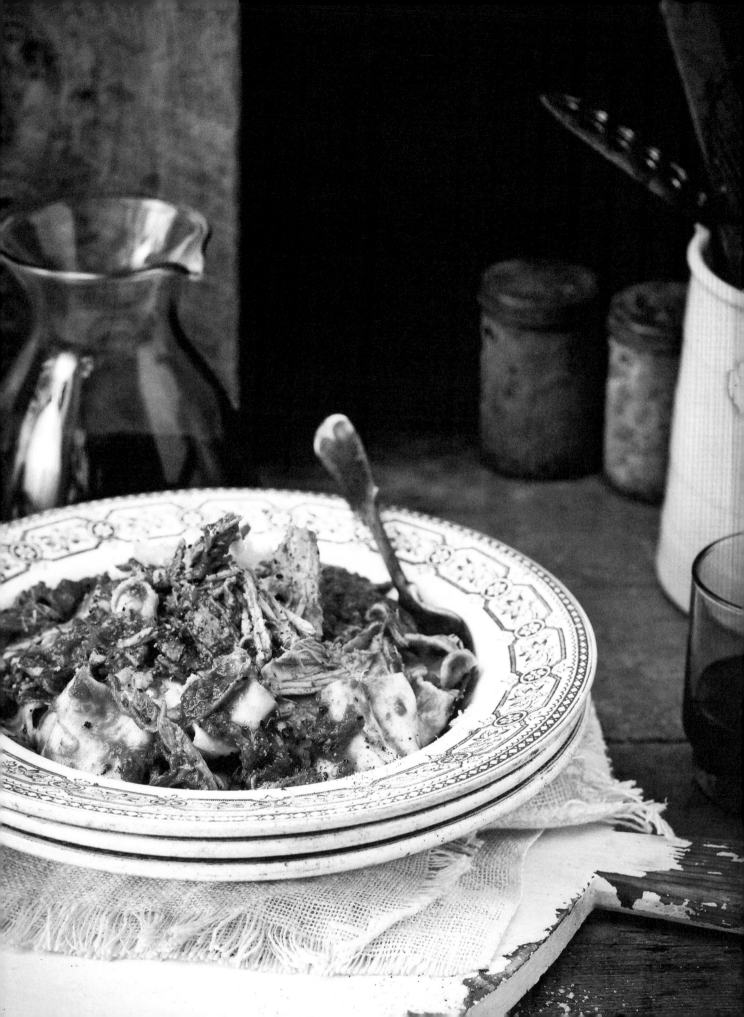

SLOW-ROASTED PORK RAGU

A wonderful, cozy meal to enjoy with a good bottle of red. If you have time to make your own pasta, so much the better, but I find I always resort to buying fresh or dried pasta for this.

2 onions, quartered
1 head garlic, cloves separated and peeled
3 cups good-quality red wine
1 free-range pork shoulder (about 3 pounds 5 ounces), bone-in
olive oil, for drizzling
sea salt and freshly ground black pepper
8 large plum tomatoes, halved
1 large handful basil
2 × 28 oz cans chopped tomatoes
4 teaspoons balsamic vinegar
4 teaspoons finely grated lemon zest
2½ tablespoons chopped oregano
1 pound 5 ounces pappardelle or tagliatelle
grated parmesan, to serve (optional)

Serves 6–8

Preheat the oven to 315°F.

Scatter the onion and garlic in a large roasting pan, then pour over half the wine and 1 cup water. Set a roasting rack over the pan and place the pork on the rack. Drizzle the pork with 1 tablespoon oil, then season well. Roast for 3 hours, checking every now and then and adding a splash of water if the pan looks dry.

At the 3-hour mark, put the tomato halves into a roasting pan, then season and drizzle with 1 tablespoon oil. Place in the oven with the pork and roast for 2 hours or until the tomato is soft and starting to collapse and the pork is tender (remember to keep checking from time to time that the roasting pan is not drying out).

Remove the pork and tomato from the oven. Transfer the pork to a cutting board and set aside, then spoon the onion, garlic and juices from the roasting pan into a blender, along with the tomato halves and their juices. Add the basil and blend to a smooth sauce.

Place the blended sauce in a large heavy-bottomed saucepan and add the canned tomato, vinegar, lemon zest, oregano and remaining wine. Season and simmer over low–medium heat for 45 minutes or until reduced and thickened.

Meanwhile, shred the pork, discarding the skin, fat and bones, and set aside.

Cook the pasta according to the packet instructions, then drain.

Add the meat to the sauce in the pan and cook for 10 minutes or until the meat has warmed through and the sauce thickens a bit more.

Add the pasta to the sauce and stir to combine. Divide among serving bowls and serve with plenty of freshly ground black pepper and grated parmesan, if using.

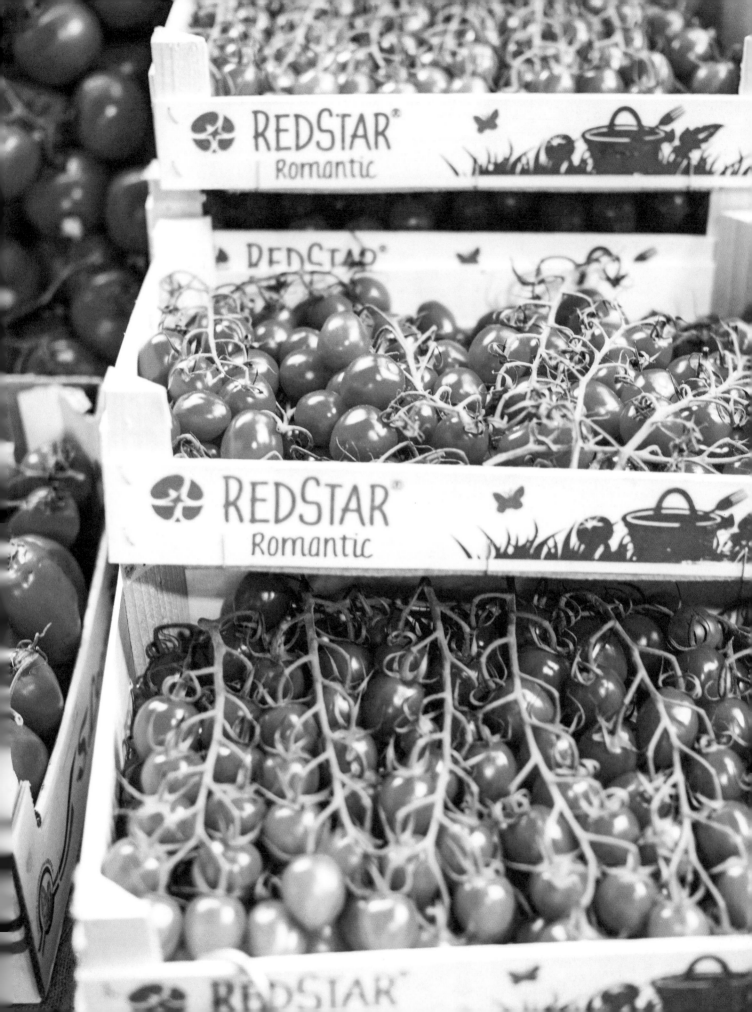

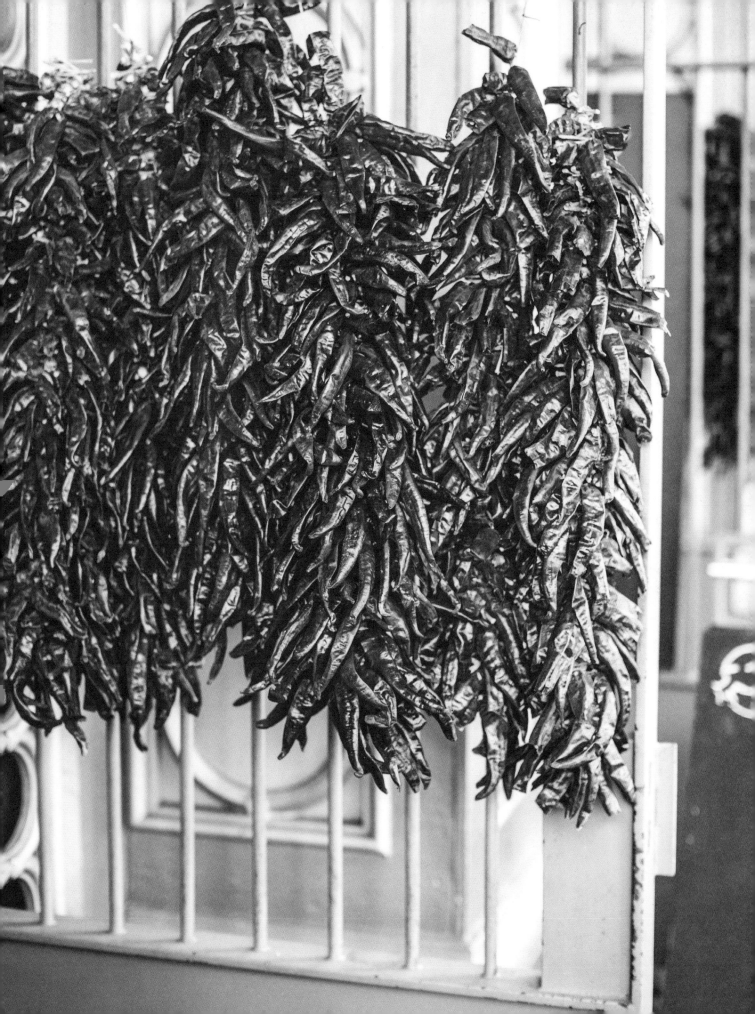

SMOKY BEEF CHILI WITH BLACK BEANS

I am super-proud of this recipe: it took me months of fine-tuning, and it's smoky and sweet and totally yum. It's definitely worth the effort! I use Jack Daniels sour mash bourbon for this, but another brand would work just as well.

2 large dried ancho chiles
2 dried chipotle chiles
boiling water, for soaking
2 pounds 4 ounces grass-fed beef chuck steak, trimmed
 of excess fat, cut into 1¼ in cubes
2½ tablespoons all-purpose flour
sea salt and freshly ground black pepper
4 tablespoons olive oil
1 onion, diced
4 cloves garlic, finely chopped
2 teaspoons ground cumin
2 teaspoons smoked paprika
1 teaspoon ground cinnamon
1 teaspoon dried oregano
4 teaspoons Dutch-process cocoa powder
4 cups beef broth

⅓ cup bourbon
4 teaspoons chipotle sauce (see page 28)
1 bay leaf
2 red bell peppers, trimmed, seeded and
 cut into bite-sized pieces
2 × 28 oz cans chopped tomatoes
2½ tablespoons tomato paste
2½ tablespoons dark brown sugar
1 × 28 oz can black beans, drained and rinsed
1 × 28 oz can kidney beans, drained and rinsed
cilantro, to garnish
steamed brown rice, sour cream and shredded
 cheese, to serve

Serves 6–8

Place the dried chiles in a heatproof pitcher, cover with boiling water and set aside for 30 minutes to reconstitute. Drain, then finely chop, reserving the seeds, and set aside.

Place the beef and flour in a large resealable plastic bag, season with salt and pepper and shake well to coat evenly.

Heat one-third of the oil over medium heat in a large, flameproof casserole dish, add half the beef and brown on all sides for 2–3 minutes. Remove to a plate lined with paper towel, then repeat with another third of the oil and the remaining beef.

Add the remaining oil to the casserole and cook the onion and garlic over medium heat for 3–4 minutes or until the onion is soft. Stir in the spices and oregano and cook for 1 minute, stirring constantly.

In a small cup, whisk together the cocoa and 2½ tablespoons of the beef broth, then add this mixture to the casserole, along with the remaining broth, the bourbon, chipotle sauce, bay leaf, pepper, tomatoes, tomato paste, sugar, the reserved beef and chopped chile and seeds. Stir well to combine, then partially cover with the lid and bring to a boil. Reduce the heat to low and simmer for 1½ hours or until the beef is very tender, checking and stirring every 15 minutes or so to make sure the mixture doesn't catch on the bottom of the casserole.

Add the beans and simmer for a further 15 minutes. Season with salt and pepper and serve garnished with cilantro, with steamed rice, sour cream and shredded cheese to the side.

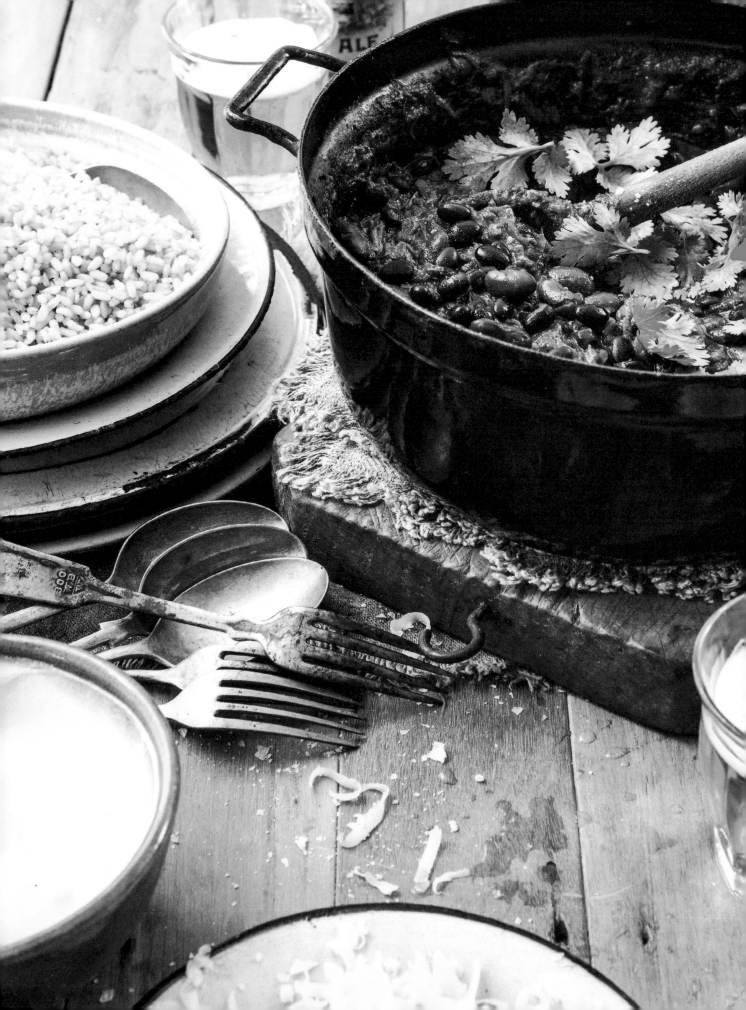

BEEF WELLINGTON

A classic dish that pairs perfectly with my creamy indulgent mash on page 166 and loads of good hearty shiraz. There's enough batter here to make around seven crepes, which is more than you'll need but allows for some mistakes!

⅓ cup all-purpose flour
1 free-range egg
1 cup milk
2 teaspoons finely chopped flat-leaf parsley
1 teaspoon finely chopped thyme, plus extra sprigs to garnish
sea salt and freshly ground black pepper
olive oil, for cooking
1 grass-fed beef tenderloin (about 1 pound 14 ounces), silver skin removed (ask your butcher to do this for you)
4 teaspoons Dijon mustard

4 teaspoons horseradish cream
1 sprig rosemary, leaves stripped and very finely chopped
2 tablespoons butter
11 oz chestnut mushrooms, finely chopped
6 large slices prosciutto
1 large sheet good-quality puff pastry, such as Pepperidge Farm
1 free-range egg yolk, mixed with a little milk

Serves 4–6

Sift the flour into a mixing bowl and make a well in the center. Crack in the egg and whisk into the flour, then gradually pour in the milk, whisking until the batter is smooth. Stir in the herbs and season with salt and pepper.

Heat a nonstick 8 in crepe pan or skillet over medium heat, then add enough oil to just coat the base of the skillet. Add 3 tablespoons batter and swirl the pan so the batter coats the base evenly. Cook for 1–2 minutes until golden, then flip with a spatula and cook on the other side for 30 seconds–1 minute until golden. Transfer to a plate and repeat with the remaining batter until you have four uniformly round crepes.

Heat 2½ tablespoons oil in a skillet and sear the beef on all sides until browned, then set aside. Mix 4 teaspoons each of salt and pepper together on a plate. Combine the mustard, horseradish cream and rosemary in a small bowl. Use a knife to spread this paste all over the seared beef, then roll it in the salt and pepper mixture.

Wipe the skillet clean, then place it over medium heat and melt the butter. Add the mushrooms and a pinch of salt and cook for 12–15 minutes or until most of the moisture has evaporated. Remove the mushrooms from the skillet and set them aside to cool completely.

Lay the prosciutto slices lengthwise on a large piece of parchment paper, overlapping them slightly. Spread the mushrooms evenly over the prosciutto, leaving a 1¼ in

border. Place the beef on top crosswise, and bring the overhanging prosciutto up and over to cover the beef and mushrooms securely.

On another large piece of parchment paper, lay the four crepes in a square pattern, overlapping by ¾ in, then place the prosciutto-wrapped beef on top and use the parchment paper to bring the crepes up and over to cover the beef completely. Peel off the parchment paper.

Finally, lay the puff pastry sheet on another piece of parchment paper and roll out to 12 in square. Place the beef parcel in the center. Moisten the edges of the pastry with water to create a good seal. Fold one side of the pastry over the beef, tuck the ends in, then roll the parcel over so it is fully enclosed in the pastry. Press the edges together well, then place on a plate, seam-side down, and chill in the fridge for 15 minutes.

Preheat the oven to 400°F and place a baking sheet inside to heat.

Brush the pastry with the eggwash, then lift the parchment paper and the pastry parcel onto the heated sheet and bake for about 40 minutes or until the pastry is golden and the meat is cooked to your liking (if using a meat thermometer, the temperature of the beef will register 131°F for medium–rare).

Set aside to rest for 5 minutes, then carve into 1 in-thick slices and serve.

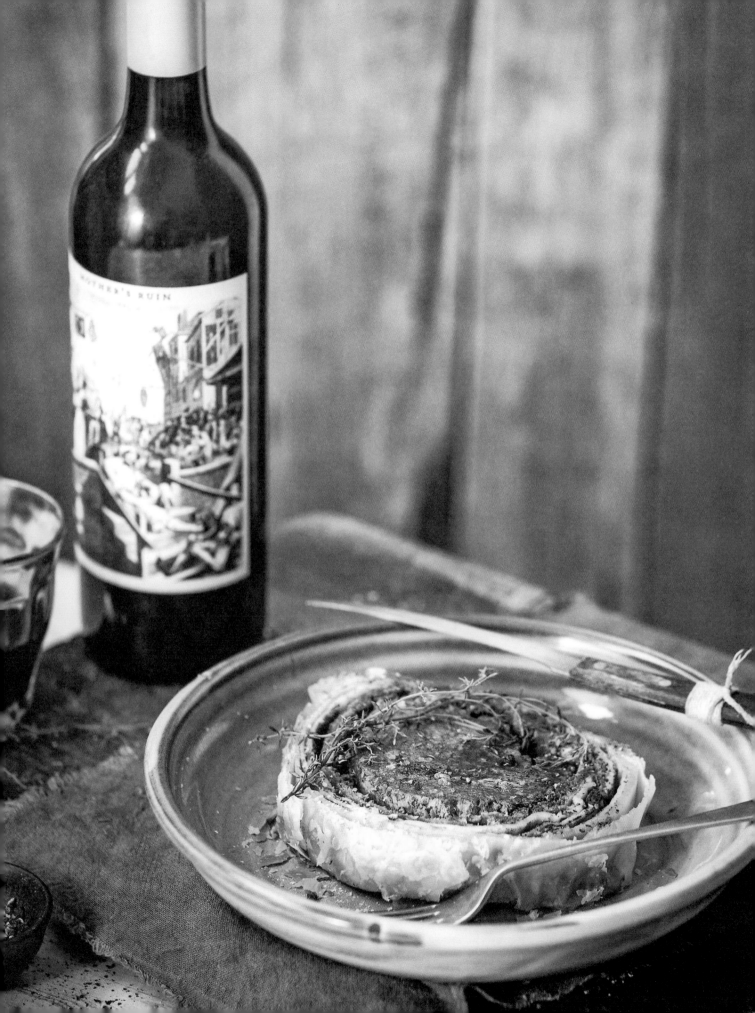

THE 'MANWICH'

A sure-fire way to please your man, or anyone with a healthy appetite, for that matter.
Any leftover beer and onion jam is perfect served as part of a cheese platter alongside
a vintage cheddar. For the pesto, you can use ordinary kale leaves with the central stems
removed if you can't get hold of baby kale.

sea salt and freshly ground black pepper
2 grass-fed sirloin steaks (about 7¾ ounces each)
8 thick slices crusty bread
1 large clove garlic, halved
2 large handfuls baby spinach leaves
2 vine-ripened tomatoes, sliced
½ cup good-quality store-bought mayo,
mixed with 1 tablespoon barbecue sauce (optional)

BEER AND ONION JAM
4 teaspoons olive oil
2 large red onions, halved and thinly sliced
sea salt
2½ tablespoons firmly packed brown sugar
½ cup beer
2½ tablespoons balsamic vinegar

SPINACH AND KALE PESTO
1¾ oz baby spinach leaves
1¾ oz baby kale leaves
1 oz walnuts
2¼ oz goat's cheese

Serves 4

For the jam, heat the oil in a large heavy-bottomed nonstick skillet over medium heat. Add the onion and a good pinch of salt and cook, stirring often, for 10–12 minutes or until the onion starts to caramelize. Stir in the sugar, beer and vinegar and cook, stirring often, over low–medium heat for a further 15 minutes or until the jam is thick and glossy. Remove from the heat and set aside.

For the pesto, place all the ingredients in the bowl of a food processor and blitz to a thick, smooth paste (add a teaspoon or so of water to loosen if needed).

Season the steaks well on both sides. Heat a barbecue grill plate or grill pan to medium–high heat and cook the steaks for 3–4 minutes on each side or until cooked to your liking. Transfer to a plate and set aside to rest for 5–6 minutes, then cut into 1 in thick slices.

Grill the bread until lightly toasted, then rub one side with the cut garlic.

Spread half the bread slices with the pesto, then add a small handful of spinach leaves, some sliced tomato, some sliced steak and a dollop of onion jam. Top with barbecue mayo, if using, then add the bread lids and serve held together with a skewer.

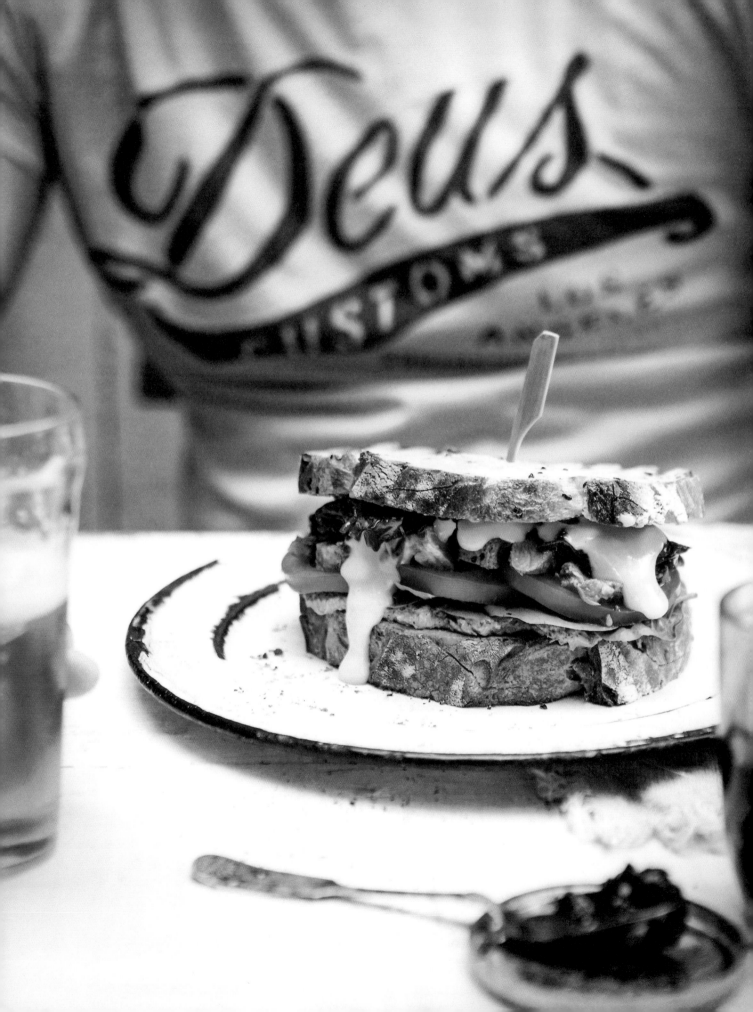

TRUFFLE BEEF BURGERS WITH CREAMY MUSHROOMS AND PANCETTA

Truffle salt is expensive, but you only need a small amount and a little goes a long way. You'll find it at selected gourmet delis.

2½ tablespoons olive oil
11 oz cremini mushrooms, ⅓ chopped, ⅔ thickly sliced
3 sprigs thyme, leaves stripped
1 pound 12 ounces lean ground grass-fed beef
1 small onion, finely chopped
4 large cloves garlic, finely chopped
½ teaspoon truffle salt
1 cup finely shredded parmesan
1 tablespoon tomato paste
1 teaspoon Dijon mustard
sea salt and freshly ground black pepper
8 thin slices pancetta
4 tablespoons crème fraîche
thinly sliced vintage cheddar, lettuce leaves and sliced tomato, to serve
4 white burger bun or brioche buns

Serves 4

Heat 4 teaspoons oil in a large nonstick skillet over medium heat. Add the chopped mushroom and thyme and cook, stirring, for 2–3 minutes or until browned, then transfer to a bowl and set aside to cool.

Place the beef, onion, garlic, truffle salt, parmesan, tomato paste, mustard, salt and pepper in a large bowl. Using clean hands, mix everything together well. Shape into four burgers about 4¼ in in diameter and place on a plate lined with paper towel. Cover with plastic wrap and refrigerate for 30 minutes.

Preheat the oven to 400°F and line two baking sheets with parchment paper.

Spread out the pancetta on one of the prepared sheets and bake for 6–10 minutes or until crisp and browned.

Preheat a barbecue grill plate or grill pan until hot. Cook the burgers for 2–3 minutes on each side, then transfer

to the remaining sheet, place in the oven and bake for 6–8 minutes or until done to your liking. Remove them from the oven and set aside to rest for 10 minutes.

Meanwhile, heat the remaining oil in a large nonstick skillet over high heat. Add the sliced mushroom and cook for 3–4 minutes until softened and browned. Remove the skillet from the heat and stir through the crème fraîche, then season to taste with salt and pepper and transfer to a serving bowl.

Top each burger with some reserved mushroom and thyme mixture and a slice or two of cheese, then pop under the hot oven broiler briefly to broil and melt the cheese.

To assemble, place some lettuce, sliced tomato and pancetta on each bun base. Top with the mushroom and cheese-topped burger, then finish with the bun lid and serve with the creamy mushrooms alongside.

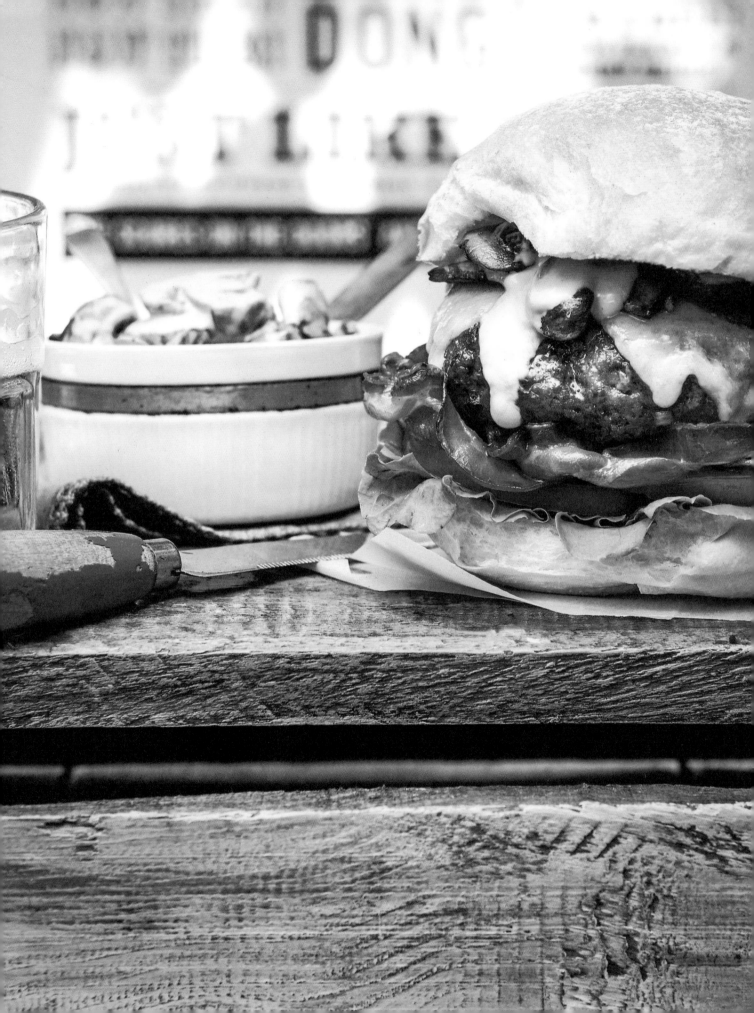

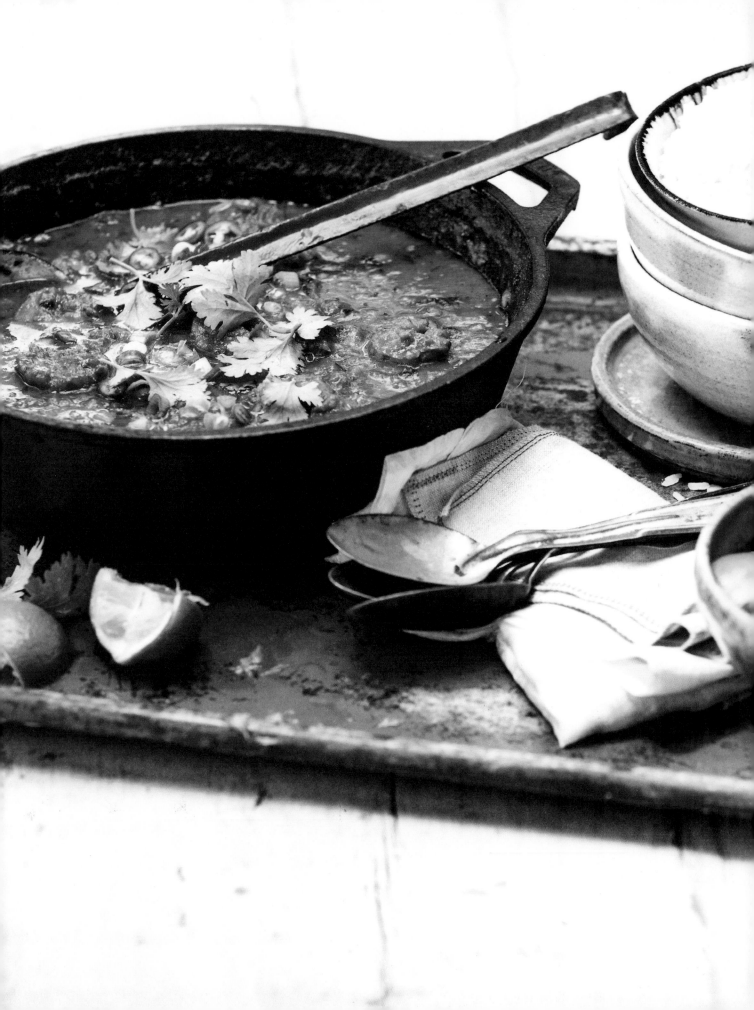

CHILE AND TAMARIND SHRIMP CURRY

Tamarind puree is readily available in jars, but for a fresher tamarind flavor you can prepare your own using tamarind pulp. Place 4 teaspoons pulp in a small saucepan with 4 tablespoons water and bring to a simmer over medium–high heat. Once simmering, cook for 30 seconds–1 minute, breaking up with a potato masher, until the pulp has dissolved and the liquid has thickened slightly. Push through a fine-mesh sieve with the back of a spoon, discarding the seeds and fiber, and use the resulting puree in the recipe. Both the pulp and puree are available from Asian food stores.

2½ tablespoons olive oil
2 small onions, finely chopped
5 large cloves garlic, finely chopped
sea salt and freshly ground black pepper
2 long green chiles, seeded and finely chopped,
 plus extra sliced chile to garnish
2 × 28 oz cans chopped tomatoes
3 cups chicken broth
2½ tablespoons Thai fish sauce (nam pla)
1 stalk lemongrass, white part only, finely chopped
2 kaffir lime leaves, very finely shredded
4 scallions, thinly sliced
4 teaspoons tamarind puree
1 × 14 fl oz can coconut milk
2 pounds uncooked small shrimp, peeled and deveined
1 large handful cilantro, finely chopped,
 plus extra leaves to garnish
finely grated zest and juice of 2 small limes,
 plus extra lime wedges, to serve
steamed rice, to serve

Serves 4

Heat the oil in a large heavy-bottomed saucepan over medium heat. Add the onion, garlic and a pinch of salt and cook, stirring, for 4–5 minutes or until the onion is soft. Add the chile, tomato, broth, fish sauce, lemongrass, kaffir lime leaves, scallion, tamarind and coconut milk and stir to combine. Simmer for 20 minutes.

Stir in the shrimp and cilantro, then season and cook for a further 2–3 minutes or until the shrimp are just cooked. Stir in the lime zest and juice and garnish with extra chile and cilantro. Serve with steamed rice and lime wedges.

OCEAN TROUT WITH LEMON AND CHAMPAGNE SAUCE

This is a simple dish with wonderful, subtle flavors. A good one for a celebration dinner, it goes well with boiled and minted baby potatoes.

3 cups dry white wine
2 stalks celery, thinly sliced
1 small bulb fennel, trimmed and thinly sliced, fronds reserved and roughly chopped
1 teaspoon black peppercorns
2 lemons, thinly sliced, seeds removed
1 bunch tarragon, 12 leaves finely chopped and set aside for the sauce, remaining leaves stripped
1 tablespoon capers, well rinsed
1 side ocean trout or salmon (about 2 pounds 4 ounces), skin-on and pin-boned
(ask your fishmonger to do this for you)
lemon thyme, to serve
freshly ground black pepper

LEMON AND CHAMPAGNE SAUCE
1 free-range egg yolk
1 teaspoon white wine vinegar
4 teaspoons lemon juice
sea salt and freshly ground white pepper
1 cup sunflower or light olive oil
1 teaspoon Dijon mustard
⅓ cup sparkling wine or champagne

Serves 6

Pour the wine and 10 cups water into a large flameproof roasting pan (mine is 14¼ in × 10½ in × 3¼ in), then add the celery, fennel, fennel fronds, peppercorns, lemon slices, tarragon leaves and capers. Place over medium–high heat and bring to a boil, then reduce the heat to medium and simmer for 10–12 minutes.

Add the fish, skin-side down, and simmer for 5 minutes, spooning the liquid over the fish now and then (if the fish protrudes out of the liquid, push it back down so it is immersed in liquid). Turn off the heat and leave the fish to stand in the liquid for a further 10 minutes; it will continue to cook in this time.

Meanwhile, for the sauce, place the egg yolk, vinegar, lemon juice and a pinch of salt in the bowl of a food processor. Mix on high speed, adding the oil in a thin, steady stream – you'll end up with a thick, glossy mayo. Add the mustard, some white pepper and the reserved finely chopped tarragon leaves and mix. Pour in the wine or champagne and mix briefly to combine so the mixture is light and creamy. (Makes 1½ cups.)

To serve, carefully remove the poached fish using two spatulas and place on a serving platter. Scatter the lemon thyme over the fish and grind over some pepper. Serve with the sauce drizzled on top.

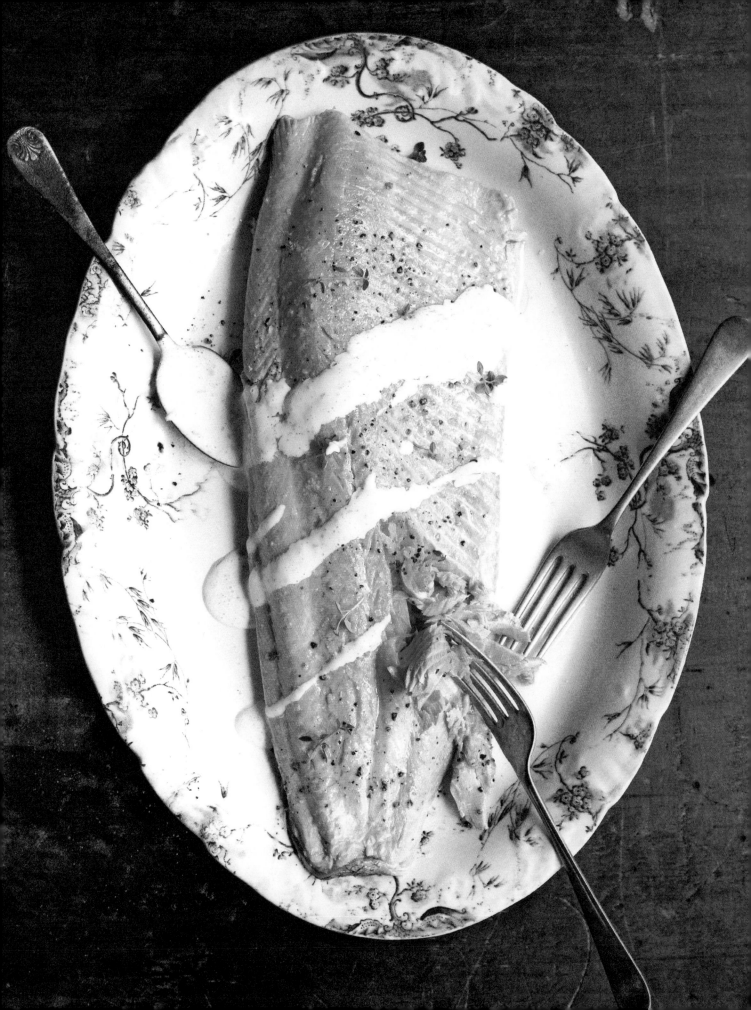

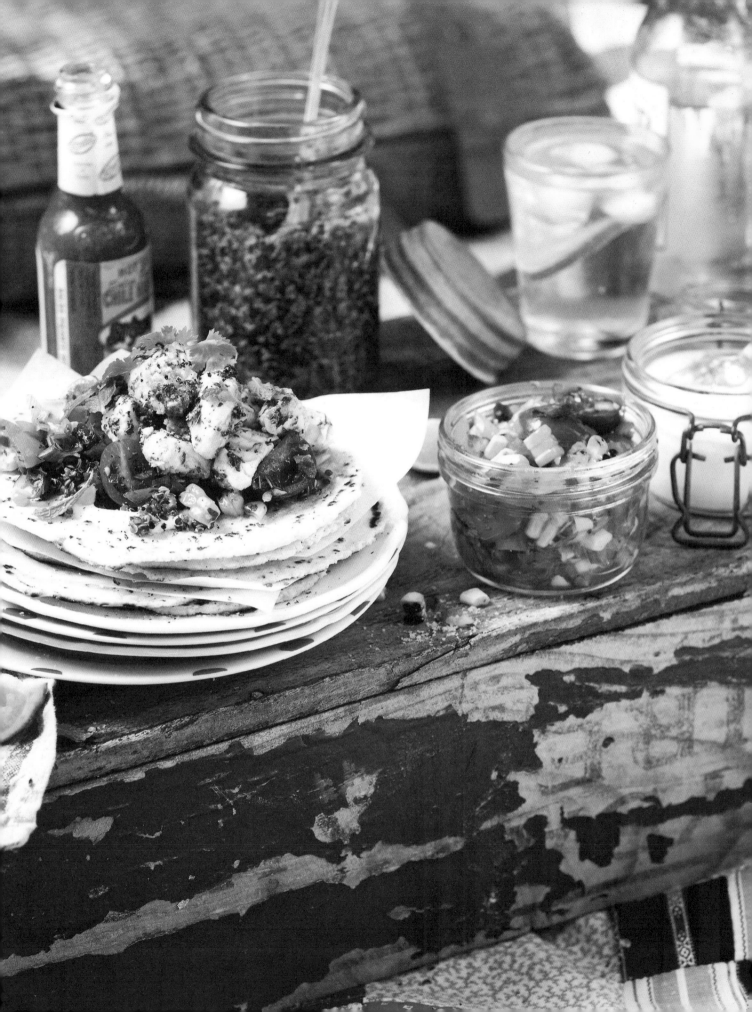

FISH TACOS WITH BLACK QUINOA AND SWEETCORN SALSA

I make these a lot for weeknight meals, but they are also fab to take to a weekend picnic. Just make up all the elements in advance, pop them into plastic containers and assemble in situ. Tip: never salt the water when boiling sweetcorn as it will toughen it.

1 pound 5 ounces barramundi, mahi-mahi or
 halibut fillets, skin and bones removed, cut
 into 1 in cubes
2½ tablespoons extra virgin olive oil
3 limes, plus extra wedges to serve
sea salt and freshly ground black pepper
½ cup black quinoa
2 ears sweetcorn, husks and silks removed
9 oz cherry tomatoes, quartered
4 scallions, thinly sliced
½ small red onion, finely chopped
2 jalapeño or long green chiles, seeded
 and finely chopped
1 large handful mint
1 large handful cilantro
¾ cup, plus 1 tablespoon (7 oz) sour cream
12 corn tortillas (8 in diameter), warmed

Serves 4

Place the fish and 1 tablespoon oil in a glass or ceramic bowl. Add the finely grated zest of one lime and the juice of two limes. Season well, cover with plastic wrap and marinate in the fridge for 1 hour.

Meanwhile, place the quinoa in a heavy-bottomed saucepan with 1 cup cold water. Bring to a boil, then reduce the heat to low–medium, cover and simmer, stirring occasionally, for 30 minutes or until the quinoa is cooked and the water has been absorbed. Set aside to cool.

Cook the sweetcorn in a saucepan of boiling water for 2–3 minutes, then lift out with tongs, shake off the excess water and place each ear directly on a gas burner or under a broiler on medium heat for 1–2 minutes each, turning often, to lightly blacken the kernels. Leave to cool slightly, then stand the ears on one end on a board and, using a sharp knife, carefully slice off all the kernels and place in a bowl. Once cooled completely, add the tomato, scallion, red onion and chile, then squeeze

in the juice of half a lime and leave to stand for 30 minutes to allow the flavors to develop.

Finely chop one-third of the mint and cilantro and add to the salsa. Season well and stir to combine, then set aside.

Combine the sour cream and the juice from the remaining half a lime in a small bowl and set aside.

Roughly chop the remaining herbs (leaving a little for the garnish) and place in a bowl. Drain the fish, then toss through the herbs to coat. Heat the remaining oil in a large nonstick skillet over medium–high heat. Cook the fish, turning, for 1–2 minutes until just cooked and starting to fall apart.

Spread a little lime-flavored sour cream over each tortilla, then top with quinoa, salsa and fish. Garnish with the remaining herbs and serve with lime wedges.

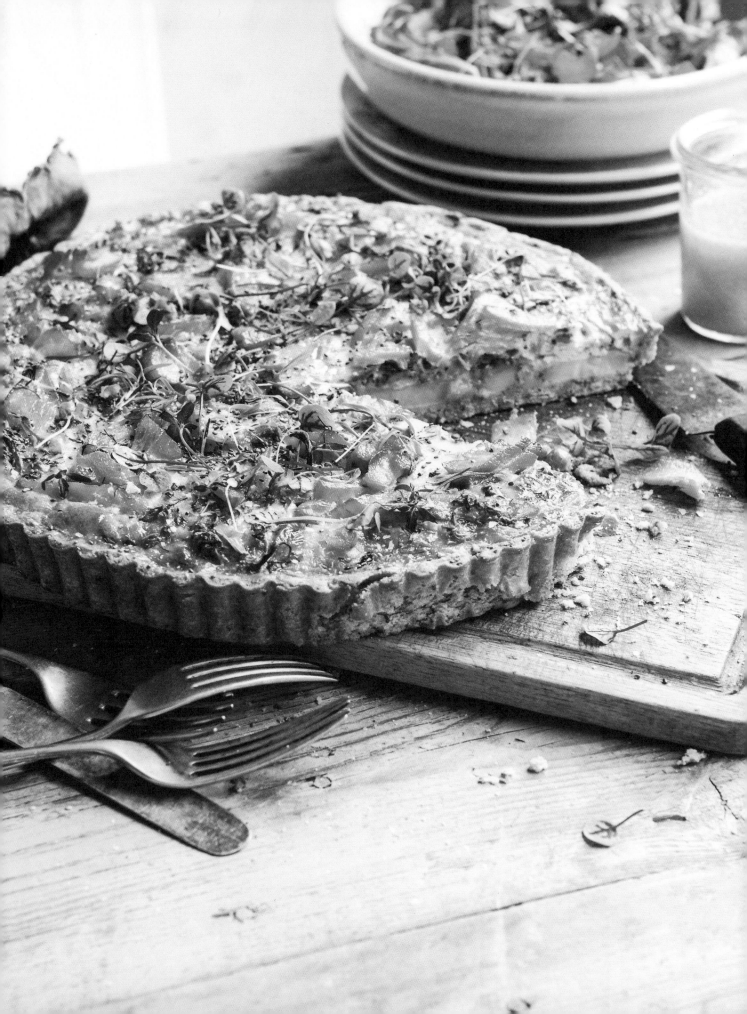

CHIA-SEED QUICHE WITH OCEAN TROUT AND POTATO

This is a great "mother-in-law is coming for lunch on Saturday" dish. You can use store-bought shortcrust pastry if you are short of time. Micro herbs are available from some supermarkets and come in many varieties: baby sorrel would go particularly well with the trout.

14 oz baby potatoes, scrubbed
1 tablespoon olive oil
3⅓ cups very thinly sliced white cabbage
6 free-range eggs
½ cup milk
½ cup crème fraîche, whisked to soften
1 handful dill, snipped into small lengths
2½ tablespoons chia seeds
sea salt and freshly ground black pepper
1 × 7 oz smoked ocean trout or salmon fillet, skin and
 bones removed, flaked
1 handful micro herbs (optional)
green salad, to serve

CHIA SOUR-CREAM PASTRY
1¾ cups all-purpose flour, plus extra for dusting
⅔ cup unsalted butter, chilled and cubed
sea salt
⅓ cup sour cream
2½ tablespoons chia seeds

Serves 6–8

For the pastry, place the flour, butter and ½ teaspoon salt in the bowl of a food processor and whiz until it resembles bread crumbs. Add the sour cream and chia seeds and whiz until the dough just starts to come together; it should be soft and a little sticky to the touch.

Turn the dough out onto a lightly floured countertop and press together, shaping into a disc. Wrap in plastic wrap and refrigerate for 30 minutes.

Meanwhile, place the potatoes in a large saucepan of salted water and bring to a boil. Reduce the heat to medium and simmer for 20–25 minutes or until a knife can be inserted easily into the centers. Drain and set aside to cool, then cut into ½ in thick slices.

Preheat the oven to 400°F and grease a round 11¼ in loose-based fluted tart pan.

Heat the oil in a deep skillet over medium–high heat. Add the cabbage and cook, stirring often, for 3–4 minutes or until it starts to soften and turn golden brown around the edges. Remove from the heat and set aside.

On a floured countertop, roll out the pastry to a thickness of ¼ in and use to line the prepared pan, patching any holes that may appear. Refrigerate the pastry case for 30 minutes.

Take two large pieces of parchment paper and scrunch them up in your hands, then smooth them out and use to line the pastry case, overlapping them to cover the whole base. Fill with pie weights or rice and blind-bake for 20 minutes, then remove the paper and weights or rice and bake for a further 12–15 minutes or until the pastry is light golden. Set aside to cool.

Whisk together the eggs, milk, crème fraîche, dill and chia seeds and season with salt and pepper.

To assemble the quiche, line the pastry with the sliced potato, then cover with cabbage and scatter the flaked trout on top. Carefully pour in the egg mixture, lightly pressing down on the ingredients to let the liquid come to the top. Bake for 30–35 minutes or until golden brown and cooked through.

Serve hot or at room temperature, scattered with micro herbs, if using, and a green salad to the side.

STUFFED ROAST SNAPPER

You can make this dish using a whole red snapper but I find it easier to use
two large fillets; make sure to ask your fishmonger to pin-bone them for you.
The stuffing is simple, but works brilliantly due to the contrasting flavors
from the salty bacon and tangy capers.

olive or rice bran oil, for cooking
2 large shallots, finely chopped
2 cloves garlic, finely chopped
9 oz free-range bacon, fat and rind removed, diced
2 tablespoons capers, well rinsed
1 small bunch dill, finely chopped, plus extra sprigs to garnish
sea salt and freshly ground black pepper
2 large skinless snapper or halibut fillets (about 1 pound 9 ounces each),
 pin-boned
2 lemons, quartered

Serves 4–6

Preheat the oven to 425°F and line a baking sheet with parchment paper.

Heat 1 tablespoon oil in a skillet over medium heat, then add the shallot and
cook, stirring often, for 2–3 minutes. Add the garlic and cook, stirring, for
2 minutes, then add the bacon and cook for a further 2 minutes or until the
bacon is cooked. Set aside to cool, then pour into a bowl and stir in the capers,
dill, and salt and pepper to taste.

Season the underside of each fish fillet with salt. Place one fillet, salted-side
up, on the prepared sheet. Spoon the stuffing onto the fillet, patting it down
well, then top with the second fillet and secure well with butcher's twine.
Season well, arrange the lemon quarters around the fish and roast for
30–35 minutes or until the fish is just cooked through.

Serve immediately with the lemon quarters and dill sprigs alongside.

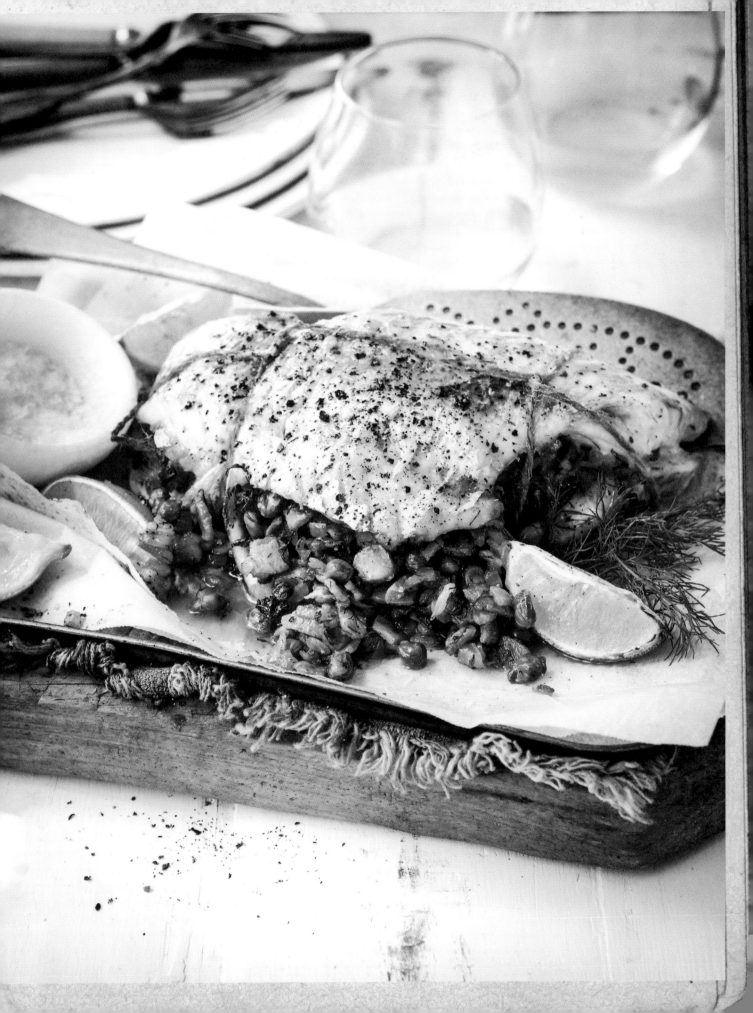

TRATTORIA PI

RISTORANTE

STARIA

GELATI ICE CREAM

VILLA
SAN
ONNINO

VIGNOLÀ
CAMPIGLIO
13
TAVERNELLE

ITALIA!

BOLOGNA
VENICE
CAPRI
Ravello
POSITANO

IL PODESTÀ
DELLA COMUNE DI MODENA

AVVISO.

E. F. MONTECUCCOLI.

TARDINI.

2561 2562 2563

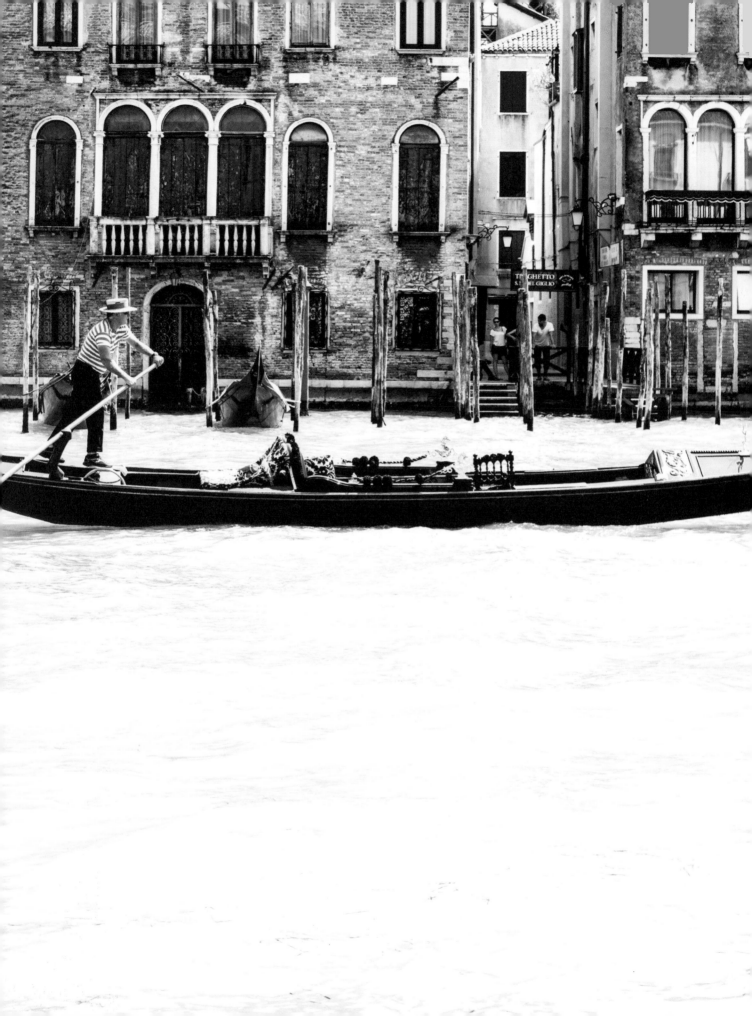

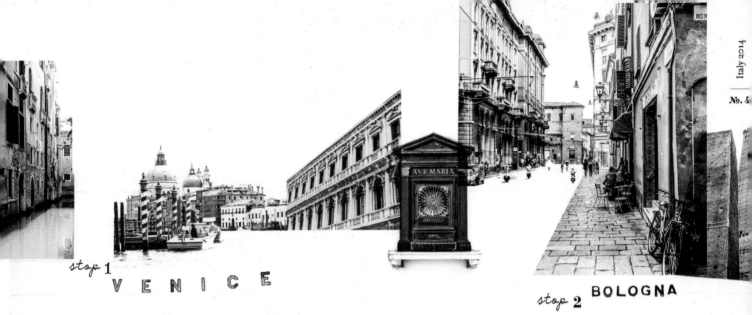

stop 1
V E N I C E

stop 2
BOLOGNA

In my mind, Italy is one of the most magical places on this planet. Despite the 24+ hour journey to get there from Sydney, it's a place I fall in love with more and more each time I visit. The people, the landscapes, the history, the medieval towns, the language – I am smitten by it all, but in particular, the food, as well-noted over the years on my blog.

Italian food is my favorite of all cuisines, and I love exploring all the regional cooking styles. Ergo, for my most recent vacation, rather than head back to my regular haunts of Siena and Tuscany, I decided to travel north to Venice and then onto Bologna to savor the culinary wonders this part of the country is famed for: parmesan cheese, cured meat, pork dishes and the most amazing balsamic vinegars I have ever tasted.

I started in Venice, a magical city I feel everyone should visit at least once in their lifetime. I'll never forget seeing the city for the first time on the super-fun water taxi ride from the airport, pinching myself that I was actually there – in Venice! – and marvelling at how utterly bizarre it is to see a city floating on the water. My parents used to have a painting of Venice hanging in our family home that I would gaze at for hours, and now, finally, I had made it here in the flesh!

Visiting Italy in July is always going to mean a lot – note, a LOT – of tourists, so admittedly Venice was jam-packed with people, but it was wonderful to see the men in their striped tops paddling gondolas down the canals, ferrying around tourists who were all manically snapping away at everything with their cameras. I chose to splurge a bit on this trip and booked one of the most beautiful hotels in this fairytale-like city: the famed Gritti Palace. It was divine and offered a romantic view of the Grand Canal and across the water to Santa Maria della Salute; enjoying dinner there by candlelight is a memory I will savor for many years to come.

Next stop: Bologna. What an incredible city, which sadly is often overlooked by visitors to Italy. I was a little underwhelmed initially, but when night fell, this university town came to life. I loved it! It's not half as touristy or expensive as Venice, and I got a very chilled and relaxed vibe from the town.

I decided to book myself on a food tour to get the best out of the city, the home of *ragu alla bolognese*. After the somewhat rude awakening of having to rise at 6 a.m. (on my vacation!), I was picked up at the hotel by a driver and joined seventeen others for an incredible day spent visiting a parmesan factory, prosciutto producer and, best of all as I adore the stuff, an authentic Modena-based family-run boutique balsamic vinegar business. This was the highlight of my trip and even inspired me to fork out a few hundred dollars for a 100-year-old bottle of balsamic, which I bring out for special dinner parties at home. I learnt how 99 per cent of most balsamic vinegars – even the ones you see in gourmet shops for over $100 per bottle – are not, in fact, 'proper' balsamic, as the real stuff must be bottled in the authentic Modena balsamic bottle, and must only contain 100 per cent pure grape must, without any additional ingredients.

The tour company was a hubby-and-wife set-up; the host, Alessandro, was crazy passionate, extremely knowledgeable and witty. He guided us expertly through a jam-packed, yet leisurely day – the highlight of which was a big group lunch where the food and wine flowed. Take it from me, a food tour is a must if you visit this area.

continued overleaf...

From there I headed south to check out Capri and the Amalfi Coast, a place I had long heard about but never seen. After the fastest, scariest train ride/ rocket journey in my life (no kidding, I think we hit 250 miles per hour at one point), I found myself in Naples in all its crazy glory. Sadly, however, it was just for a few hours (I will be back with my camera as the photo ops looked abundant), as then it was straight onto a ferry to Capri.

Oh. My. God. Did someone say nirvana? Capri is stunning. I felt like I was in a James Bond movie; it was so colorful and incredibly pretty. I took the cable car up the hill to Piazza Umberto, the little town square located in the historic center of Capri. Buzzing with people (all dressed in obligatory white) and the odd glamorous wedding, I was in awe of its beauty. I made my way up the narrow, winding white-walled streets, passing enormous Capri lemons tied in bunches outside shops, to find the hotel where I'd be staying for the next two nights; the uber-stylish Capri Tiberio Palace. It was very chic, and sparked my current obsession with hand-painted patterned tiles – they adorned the balcony of my room and I am now totally obsessed with them! A little further afield, I discovered the quieter and even more beautiful Anacapri, my favorite part of the island. It is a photographer's dream, with abundant bright pink and purple flowers cascading down chalky white walls.

Of all the amazing places I visited on this trip, the one that stood out over all the rest was Positano, the most picturesque village nestled in a bay south of Naples, where the buildings look as though they've been stacked higgledy-piggledy, one above the other, rising up the hillside. I met a Canadian woman there who said she's been back every year for the past twelve years, and I can understand why. As I sat on the ferry approaching Positano from Capri, I must have taken 1,985 photos as the boat pulled into the harbour. Never in my life have I seen such outstanding beauty. The various bright colors of the buildings crammed together climbing up the hill is utterly glorious.

Places I stayed and websites of interest:

thegrittipalace.com
italiandays.it
capritiberiopalace.it
palazzoravizza.it
sirenuse.it

LA
MELAGRANA

CERAMICHE S. RUBINO ANACAPRI

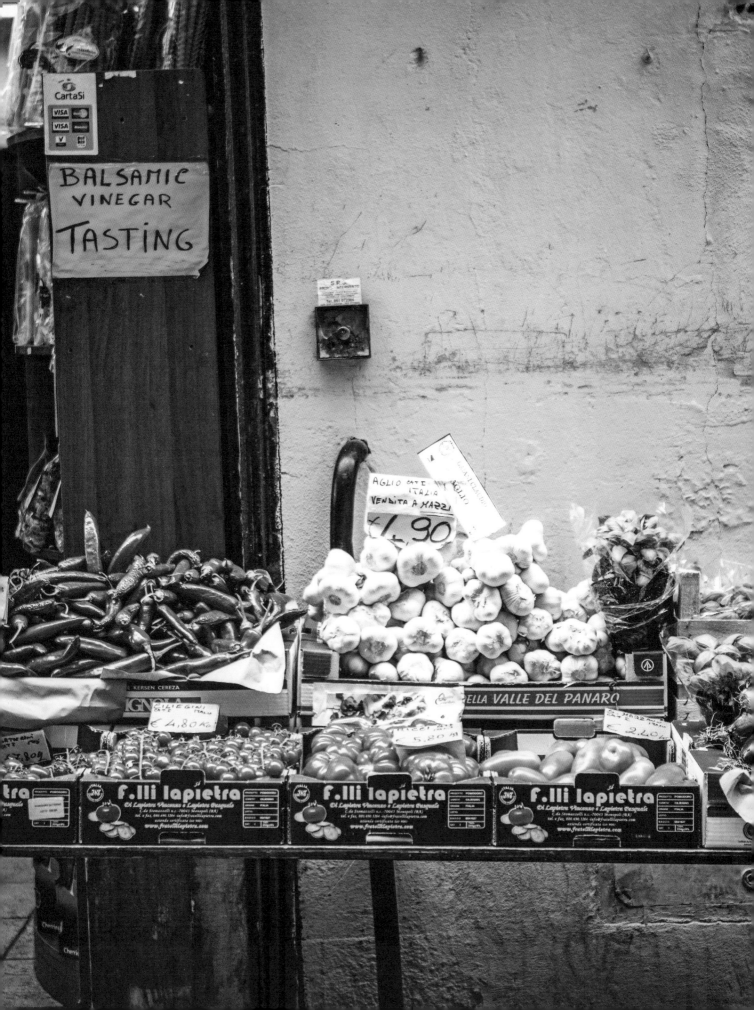

POSITANO

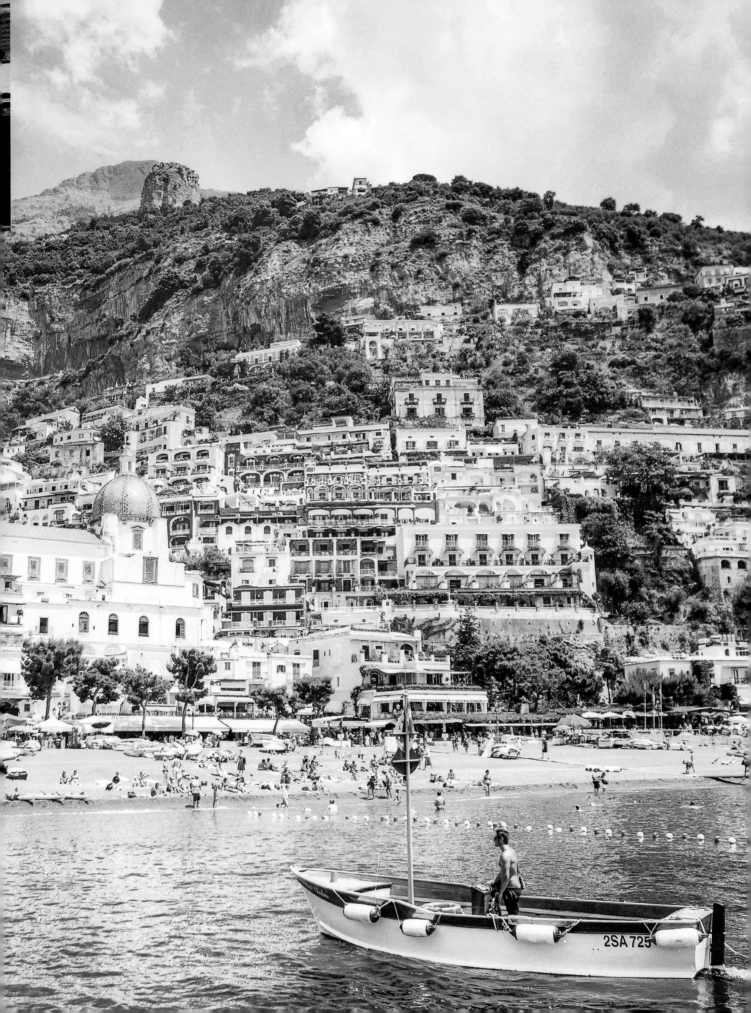

WET·GARLIC
£2.00/BUNCH
FROM OUR OWN MARKET GARDEN
SOURCED LOCALLY ORGANIC
BRITAIN
EUROPE daylesford

SPRING ONIONS
£2.00/BUNCH
FROM OUR OWN MARKET GARDEN
SOURCED LOCALLY ORGANIC
BRITAIN
EUROPE daylesford

www.daylesfordorganic.com

ye Valley
White

Valley
ite

Ye Valley
White
t English Asparagus
by the Chinn Family
art of the Wye Valley

MINI CUCUMBER
£2.99/KG
FROM OUR OWN MARKET GARDEN
SOURCED LOCALLY ORGANIC
BRITAIN
EUROPE daylesford

ASPARAGUS
£4.99/BUNCH
FROM OUR OWN MARKET GARDEN
SOURCED LOCALLY ORGANIC
BRITAIN

WHITE PURPLE
ASPARAGUS
£5.99 £6.99
FROM OUR OWN MARKET GARDEN ORGANIC
SOURCED LOCALLY daylesford

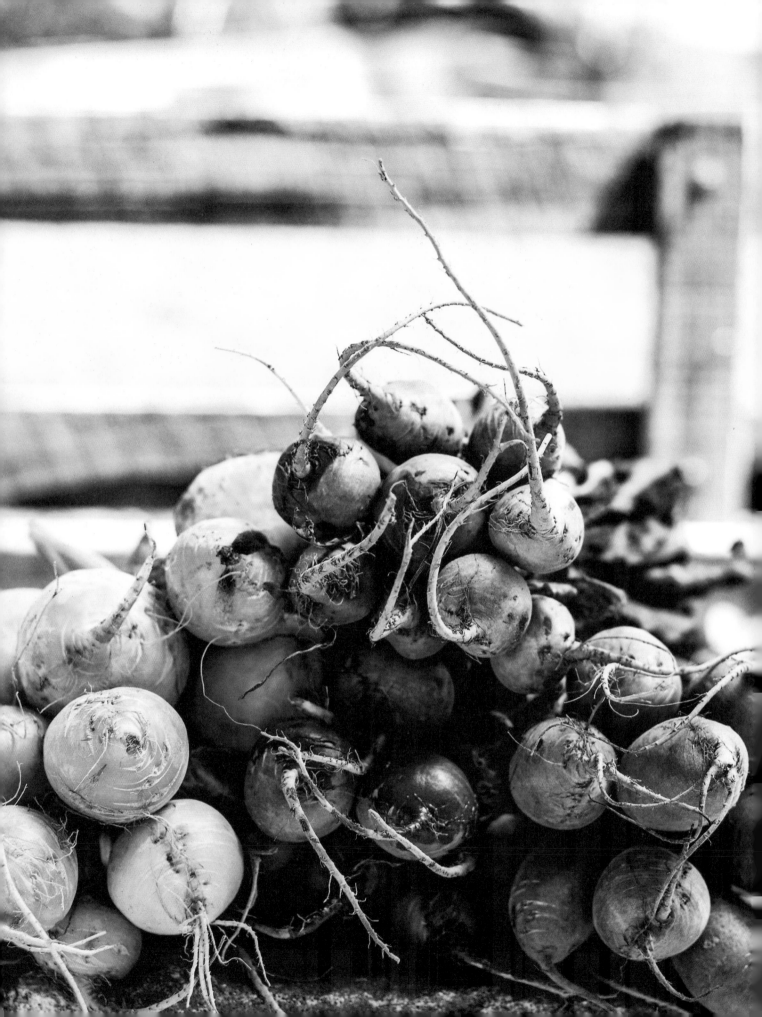

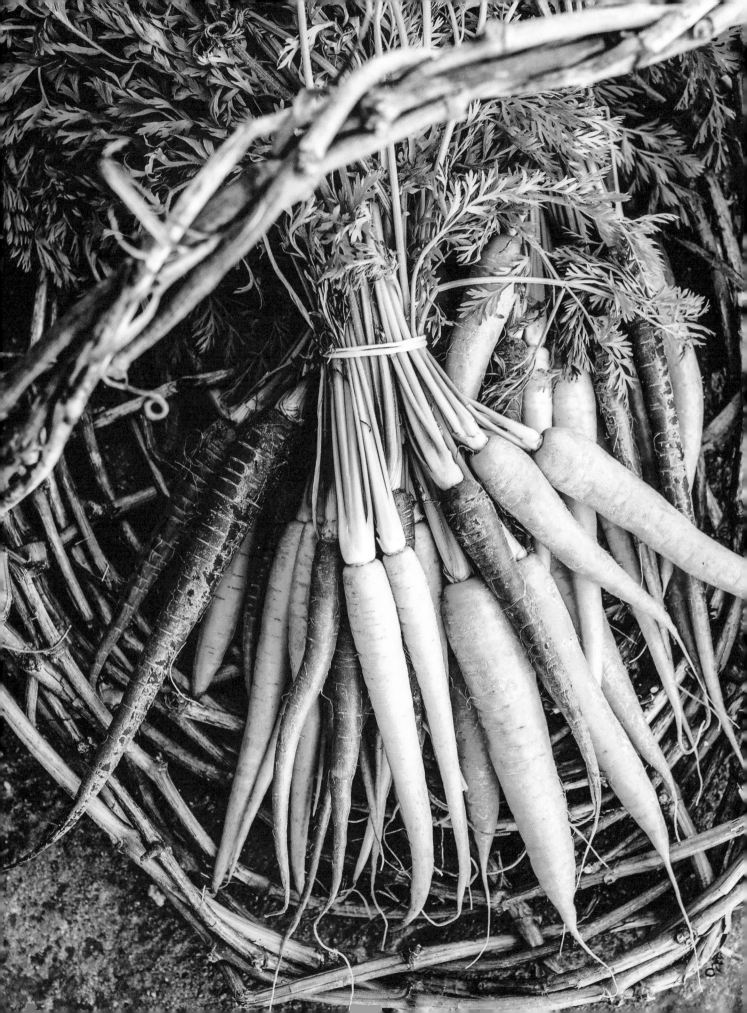

SPICED CAULIFLOWER CHEESE WITH CRUNCHY TOPPING

This makes a great weeknight vegetarian meal. Serve it with crusty bread, a green salad and a glass of gutsy red wine.

2 pounds 4 ounces cauliflower, broken into florets
1 teaspoon cumin seeds
1 teaspoon coriander seeds
4 teaspoons black sesame seeds
4 teaspoons white sesame seeds
2½ tablespoons chia seeds
sea salt and freshly ground black pepper
2½ tablespoons olive oil
2 cups coarse fresh bread crumbs, mixed with a little olive oil
1 handful very finely chopped flat-leaf parsley
⅔ cup shredded cheddar

CHEESE SAUCE
5 tablespoons unsalted butter
4 tablespoons all-purpose flour
29¾ fl oz milk
1½ cups shredded cheddar
sea salt and freshly ground white pepper

Serves 2 as a main, 6 as a side

Preheat the oven to 400°F.

Place the cauliflower in a large saucepan of water and bring to a boil over high heat. Reduce the heat to medium and simmer for 5–6 minutes or until a knife can just be inserted into the florets. Drain well and set aside to cool.

Place the cumin and coriander seeds in a small skillet over medium heat and fry for 1–2 minutes or until lightly toasted. Transfer to a mortar and grind to a fine powder with the pestle, then place in a medium-sized baking dish along with the sesame seeds and half the chia seeds. Season with salt and pepper, then add the olive oil and cauliflower and toss to coat.

For the cheese sauce, melt the butter in a large heavy-bottomed saucepan over medium–high heat. Add the flour and combine with a wooden spoon to form a thick paste. Reduce the heat to low–medium, then gradually add the milk, whisking well after each addition to incorporate and remove any lumps. Add the cheese and stir until melted and smooth, then season well and pour over the cauliflower in the baking dish.

Combine the bread crumbs, parsley, remaining chia seeds and 3 tablespoons of the cheese in a bowl, then scatter this mixture over the cauliflower. Top with the remaining cheese and season. Bake for 20–25 minutes or until the top is golden brown and crisp. Serve hot.

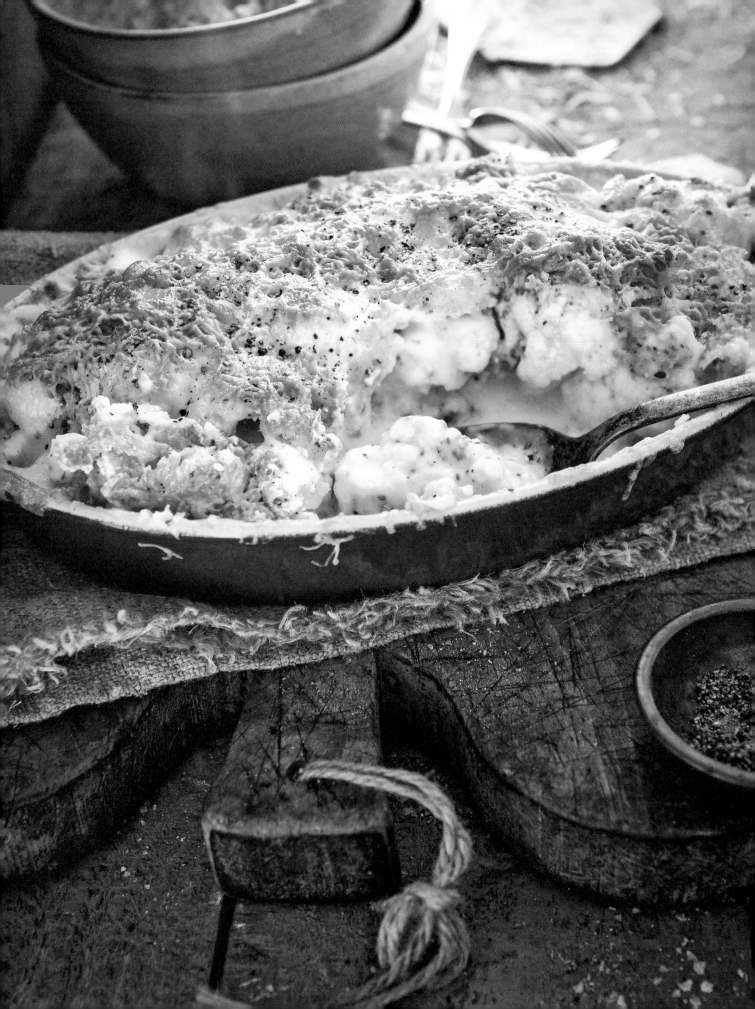

SMASHED POTATOES WITH ROSEMARY

These are easy to cook and always get eagerly gobbled up: I recommend making double the amount, as they disappear fast. They go really well with the lamb cutlets on page 106, along with, quite frankly, almost anything else.

3 pounds 5 ounces baby potatoes, scrubbed, larger ones cut in half crosswise
½ cup rice bran oil
4–5 sprigs rosemary, leaves stripped
sea salt and freshly ground black pepper

Serves 4 as a side

Preheat the oven to 425°F.

Place the potatoes in a large saucepan of salted boiling water and return to a boil. Reduce the heat to medium and simmer for 6–7 minutes or until the potatoes are just starting to soften but are still firm in the center.

Meanwhile, drizzle the oil into a large nonstick roasting pan and place in the oven for 5–6 minutes to heat up.

Drain the potatoes well, then carefully transfer them to the pan. Scatter over the rosemary and roast for 20 minutes.

Remove the pan from the oven and smash each potato firmly with the back of a spoon. Sprinkle over some sea salt, then return the pan to the oven for a further 25–30 minutes or until the potatoes are golden brown and super-crispy. Season with pepper and serve immediately.

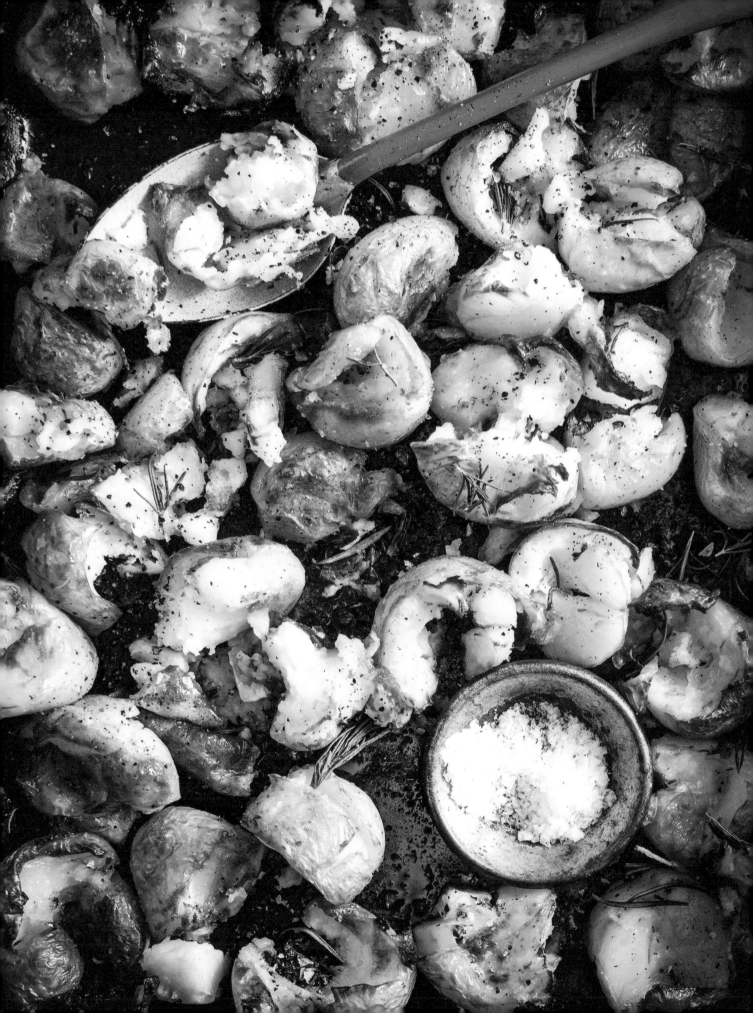

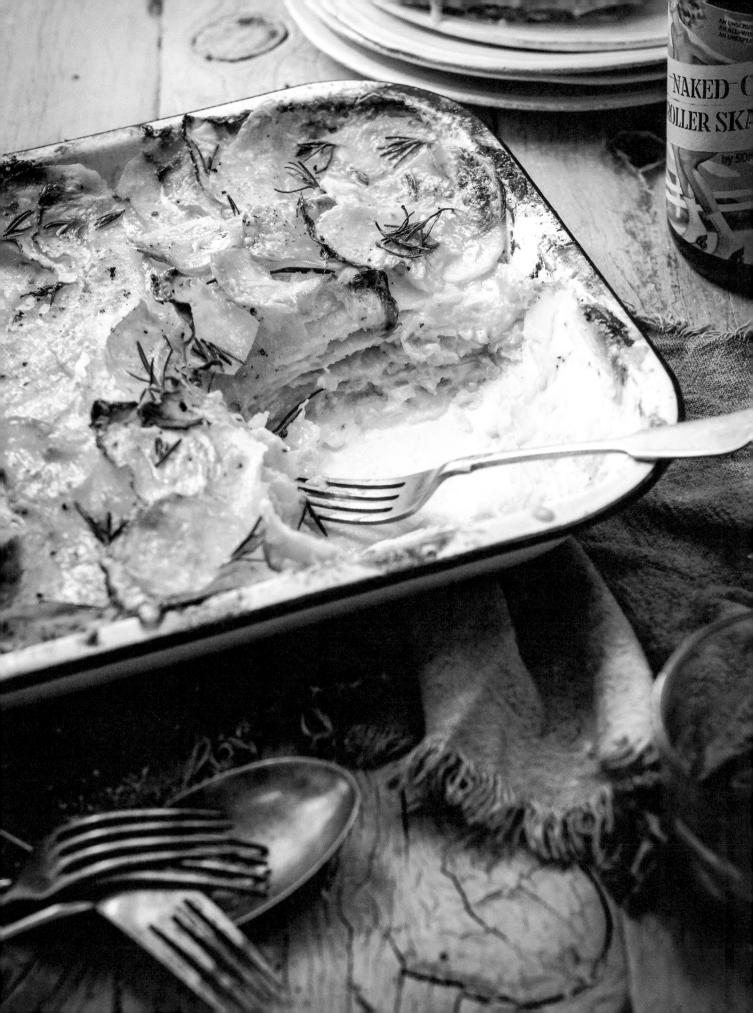

CELERIAC AND POTATO GRATIN

If you're looking for the best comfort food dish ever, then you've found it. Okay, this is not going to get you into those skinny jeans anytime soon, but it's out-of-this-world good. I make it all the time for cozy dinner parties, usually paired with roast lamb. I use a mandoline to cut the potato and celeriac into very fine slices.

21 fl oz heavy cream
1 heaped teaspoon hot English mustard
5 to 6 potatoes (about 2 pounds 4 ounces), very thinly sliced
1 pound 4 ounces celeriac, peeled and very thinly sliced
3 large cloves garlic, very thinly sliced
4 tablespoons butter
sea salt and freshly ground black pepper
5 small sprigs rosemary
1⅔ cups roughly shredded gruyere cheese, plus an extra handful to scatter

Serves 6 as a side

Preheat the oven to 400°F.

Whisk together the cream and mustard in a pitcher to combine.

Layer one-quarter of the sliced potato in a large roasting pan, slightly overlapping the slices. Repeat with one-quarter of the sliced celeriac, then dot with a few slices of garlic and one-quarter of the butter. Season with salt and pepper. Pour over one-quarter of the cream mixture, and scatter with the leaves from a sprig of rosemary and one-quarter of the shredded cheese. Repeat this process three more times.

Scatter the top with the extra shredded gruyere and remaining rosemary leaves and bake for 45–50 minutes or until the potato and celeriac are cooked through and the top is golden brown and bubbling.

ROAST VEGETABLES WITH GOAT'S CURD AND HAZELNUTS

A colorful, textural salad that is sure to impress. Use soft goat's cheese in place of goat's curd if you like.

1 bunch each baby purple and golden beets (approximately 6 beets per bunch),
 stalks trimmed leaving about ¾ in attached
olive or rice bran oil, for cooking
sea salt and freshly ground black pepper
1 bunch baby carrots, stalks trimmed leaving about ¾ in attached,
 scrubbed and halved lengthwise (keep smaller ones whole)
4 teaspoons dry white wine
2 teaspoons unsalted butter
2 sprigs thyme, leaves stripped, plus extra sprigs to garnish
1 cup hazelnuts
2 cups green beans, trimmed and cut lengthwise into thin slices
1 cup goat's curd, crumbled
4 teaspoons extra virgin olive oil
4 teaspoons balsamic vinegar

Serves 4 as a side

Preheat the oven to 425°F.

Scrub the beets clean, then pat dry with paper towel and place on a large sheet of foil. Drizzle with oil and sprinkle with a little salt. Wrap up the foil to cover the beets and roast on a baking sheet for 45 minutes or until tender when pierced with a small sharp knife (the cooking time will depend on the size and freshness of the beets; start checking them after about 25 minutes). Set aside to cool.

Meanwhile, lay a sheet of foil on a baking sheet and place the carrots on top. Drizzle with oil and add the white wine, butter and thyme leaves and season with salt and pepper. Cover with a second sheet of foil and pinch the edges to seal. Roast for 20–25 minutes or until tender, then set aside to cool.

Scatter the hazelnuts on a baking sheet and roast for 6–8 minutes or until golden brown. Wrap the hot nuts in a clean kitchen towel and rub to remove the skins. Leave to cool, then crush lightly using a mortar and pestle and set aside.

Cook the beans in a saucepan of boiling salted water for 1–2 minutes or until al dente, then drain and set aside.

Peel the skins from the beets, then halve and combine in a large serving dish with the carrots, beans and goat's curd. Scatter the hazelnuts and a few extra thyme sprigs on top.

Whisk together the oil and vinegar and drizzle over the salad, then season and serve.

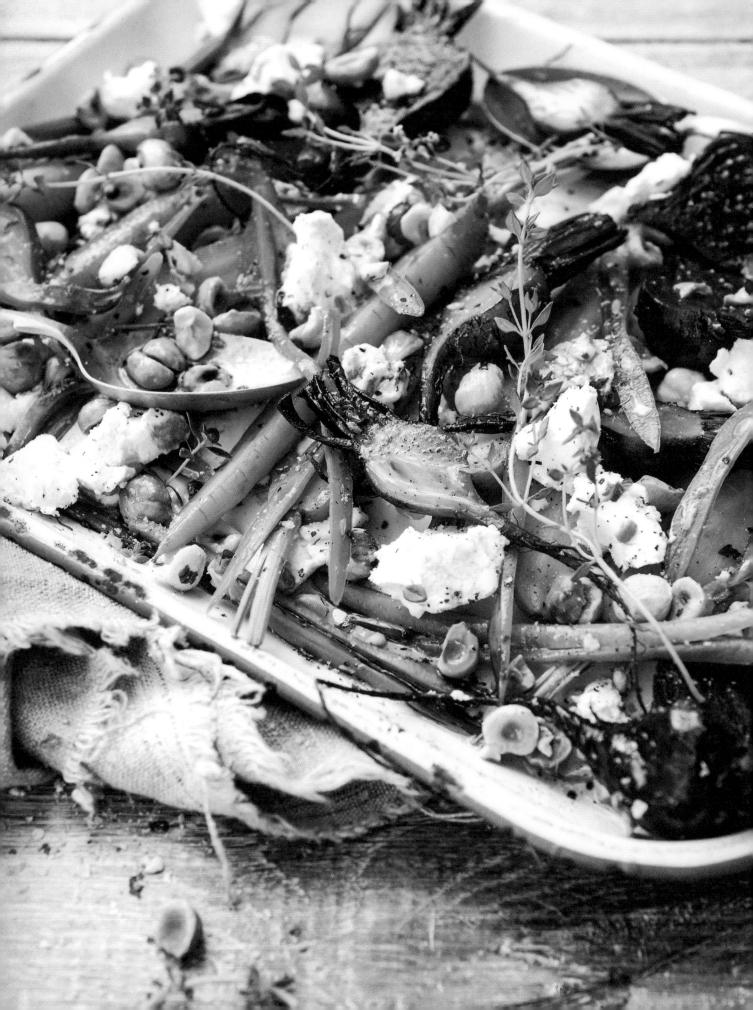

KATIE'S PARIS-STYLE MASH

I included a recipe for mash in my first book, but this is the one I make more regularly nowadays. You will need a potato ricer and a drum sieve to make the mash silky smooth, although a fine-mesh sieve will work, too. You want to be really sure there is no firmness in the middle of the potatoes when boiling them for mash. If they're not tender right the way through, you'll struggle to get a super-creamy, lump-free mash.

> 2 pounds 4 ounces large russet or Idaho potatoes, unpeeled
> 1 cup heavy cream
> 4 tablespoons milk
> 2 sticks unsalted butter, plus extra pat (optional) to serve
> sea salt and freshly ground white pepper

Serves 4–6 as a side

Place the potatoes in a large heavy-bottomed saucepan of salted water and bring to a boil. Reduce the heat to medium and simmer for 30–40 minutes or until a small, sharp knife can easily be inserted into the center.

Drain well, then leave to dry for 2 minutes before peeling (use a clean kitchen towel or rubber gloves to protect your hands). Return to the dry saucepan and place over low heat for 1–2 minutes, stirring occasionally, to remove any excess moisture.

Heat the cream and milk in a small heavy-bottomed saucepan over low heat until the mixture has warmed through – don't let it boil.

Using a potato masher, partially break up the potatoes. Push them through a potato ricer on the finest setting then, using the back of a spoon, push the mash through a drum sieve into a bowl. When the mash is smooth and completely lump-free, place it back in the pan over low heat, then add the warmed milk mixture and beat in lightly with a wooden spoon. Add the butter and beat lightly until melted and the mash is piping hot.

Season with salt and a good pinch of ground white pepper, then add an extra pat of butter, if using, and serve.

SWEET POTATO AND CAULIFLOWER CURRY

A fantastically warming and hearty vegetarian dish with a bit of kick.
Look for Malaysian curry powder at Asian food stores; it makes a world
of difference to the end result.

1 teaspoon fennel seeds
1 teaspoon coriander seeds
1 teaspoon cumin seeds
½ teaspoon ground turmeric
1 teaspoon Malaysian curry powder
sea salt and freshly ground black pepper
2½ tablespoons olive oil or rice bran oil
1 onion, finely chopped
4 large cloves garlic, finely chopped
1 long red chile, seeded and finely chopped
2½ tablespoons tomato paste
2 × 28 oz cans diced tomatoes
2 cups vegetable broth
1 pound 10 ounces sweet potato, peeled and cut into ¾ in cubes
½ head cauliflower, broken into florets
2 × 14 oz cans brown lentils, drained and rinsed
1 cup cashews, toasted and coarsely chopped
steamed brown rice, plain yogurt and cilantro, to serve

Serves 6

Place the fennel, coriander and cumin seeds in a nonstick skillet over medium
heat and cook, stirring, for 1–2 minutes or until fragrant. Transfer to
a mortar, then add the turmeric, curry powder and a large pinch of salt and
pepper and grind to a fine powder with the pestle.

Heat the oil in a large heavy-bottomed saucepan over medium heat. Add the onion
and a pinch of salt and cook, stirring often, for 3–4 minutes until softened. Add
the garlic and cook for 3 minutes, stirring frequently to avoid burning. Stir in the
ground spice mixture and chile and cook for 2–3 minutes, then stir in the tomato
paste, tomatoes and broth. Add the sweet potato and bring to a boil over high heat.
Reduce the heat to low, cover and simmer for 25–30 minutes or until the sweet
potato is just soft in the center when pierced with a small, sharp knife.

Add the cauliflower florets, stir and continue to cook for 8 minutes, then add the
lentils and cook just long enough to warm them through.

Season and serve piping hot with the cashews alongside, as well as steamed brown
rice, plain yogurt and cilantro.

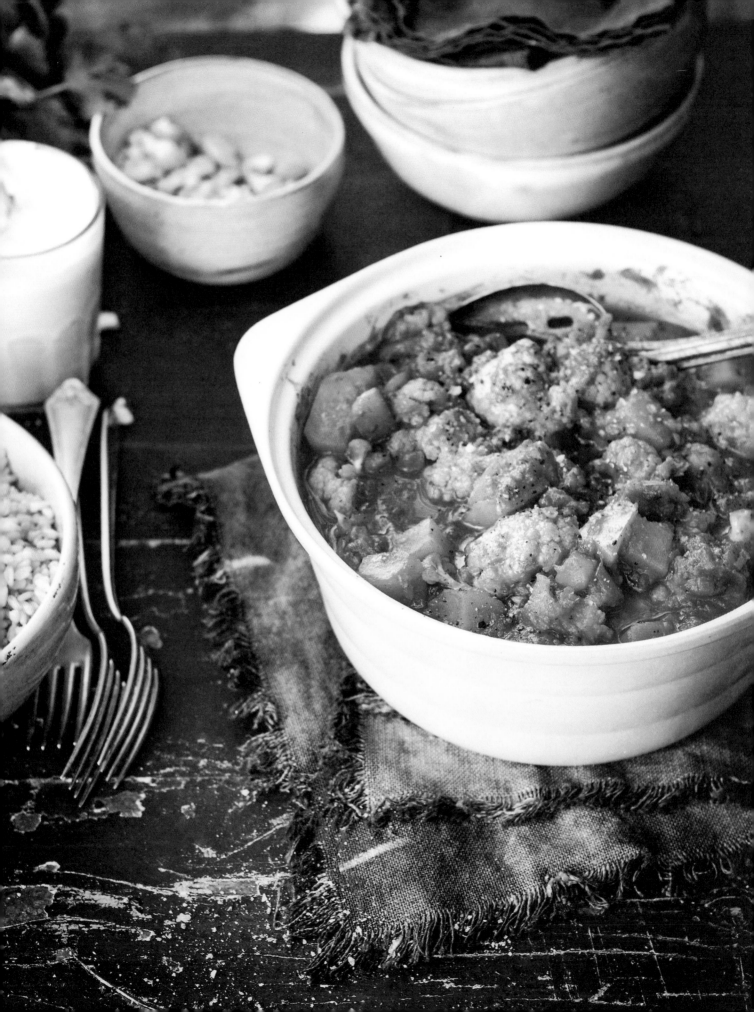

MUSHROOM, GOAT'S CHEESE AND PECAN RISOTTO

I love making risottos – they are superb for dinner parties, as you can par-cook
them, then finish off the cooking with the last few ladlefuls of hot broth just
before serving.

1 tablespoon unsalted butter
14 oz cremini mushrooms, quartered
1 handful thyme
½ cup pecans, halved lengthwise
5 cups vegetable broth
3 teaspoons olive oil
1 onion, finely chopped
3 cloves garlic, finely chopped
2 cups arborio rice
1 cup dry white wine
1¼ cups soft goat's cheese
1 cup finely shredded parmesan, plus extra to serve (optional)
juice of 1 small lemon
2 large handfuls arugula leaves, roughly chopped
sea salt and freshly ground black pepper
micro herbs (optional), to garnish

Serves 6–8

Melt the butter in a skillet over medium–high heat.
Add the mushrooms and fry for 2 minutes or until just
starting to brown, then add the thyme and cook for
a further 1–2 minutes, stirring often. Remove the skillet
from the heat and set aside.

Preheat the oven to 400°F and line a baking sheet with
parchment paper.

Scatter the pecans on the prepared sheet and roast for
6–7 minutes or until lightly browned, then remove
and set aside.

Pour the broth into a saucepan and bring to a simmer
over medium heat. Reduce the heat to low, then cover
and keep the broth warm until needed.

Meanwhile, heat the oil in a large heavy-bottomed
saucepan or flameproof casserole dish over medium
heat. Add the onion and cook, stirring often, for
4–5 minutes or until softened, then add the garlic and

cook, stirring often, for 3–4 minutes or until the garlic
is lightly golden.

Add the rice and stir to coat, then cook, stirring
constantly, for 1–2 minutes or until the rice is lightly
toasted. Add the wine and stir to deglaze the pan, then
simmer for 1 minute.

Reduce the heat to low–medium and add the hot broth,
a ladleful at a time, stirring after each addition until the
broth is almost completely absorbed before adding the
next. Continue until all the broth has been added and
the rice is al dente (it should take around 20 minutes),
stirring constantly and ensuring the rice does not dry
out (you can add hot water if you run out of broth).

Add the mushrooms, pecans, goat's cheese, parmesan,
lemon juice and arugula and stir to combine. Season
with salt and pepper, then serve scattered with extra
parmesan and micro herbs, if using.

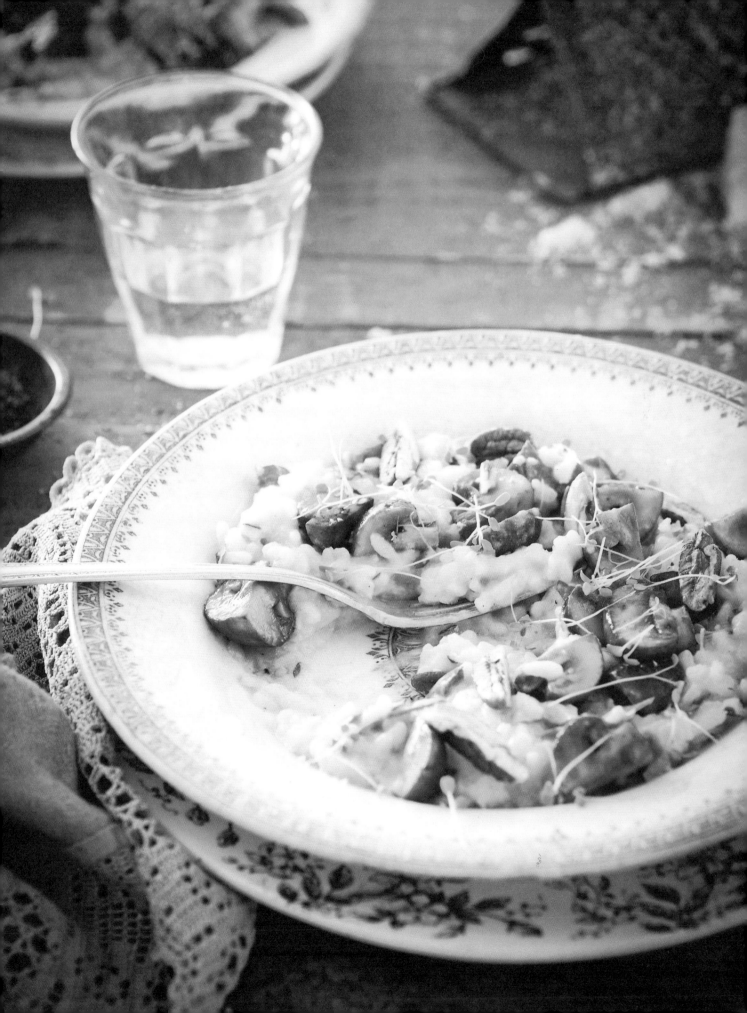

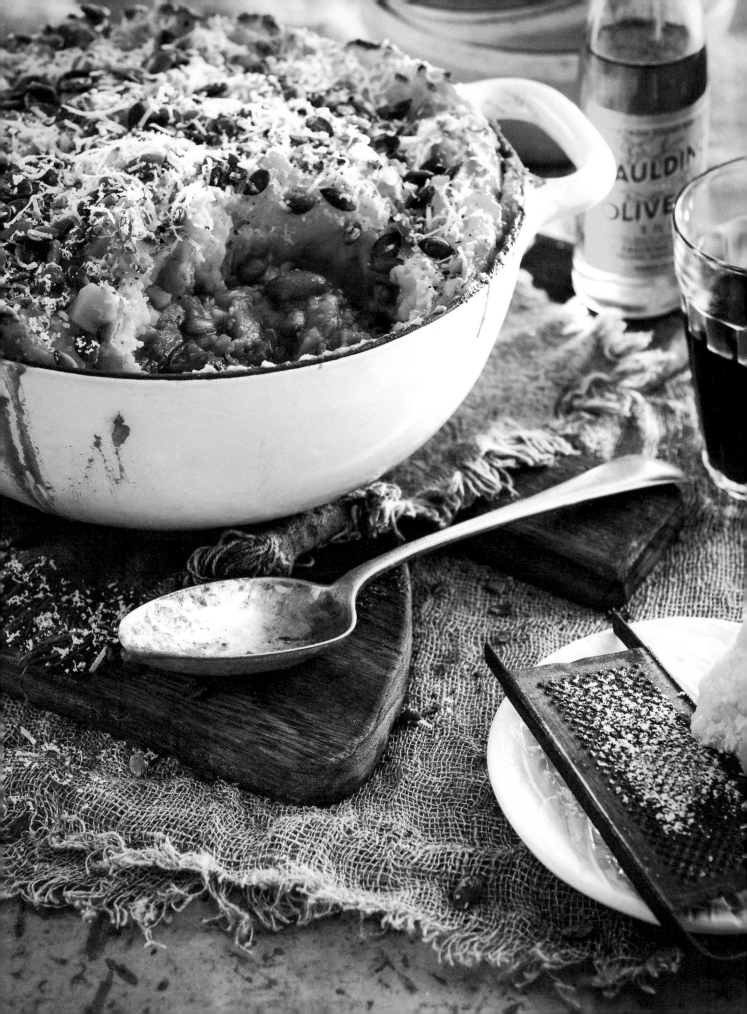

THREE-BEAN POTATO PIE

If you don't have a flameproof casserole dish you can make the filling for this pie
in a large heavy-bottomed saucepan, then transfer it to a lightly greased 10 cup
capacity roasting pan before baking.

1 tablespoon olive oil
1 onion, finely chopped
3 large cloves garlic, finely chopped
1 carrot, finely chopped
2 stalks celery, finely chopped
1 leek, white part only, trimmed, washed and thinly sliced
1 long red chile, seeded and finely diced
1 teaspoon smoked paprika
1 tablespoon tomato paste
4 tablespoons red wine
1 cup vegetable broth
1 handful each basil and oregano, torn
sea salt and freshly ground black pepper
1 pound 10 ounces sweet potato, peeled and cut into 1¼ in cubes
3 floury potatoes (about 1 pound 4 ounces), cut into 1¼ in cubes
2 tablespoons unsalted butter
4 tablespoons heavy cream
1 × 14 oz can adzuki beans, drained and rinsed
1 × 14 oz can cranberry beans, drained and rinsed
1 × 14 oz can kidney beans, drained and rinsed
4 cups baby spinach leaves
1 cup finely shredded parmesan, plus extra to serve
toasted pumpkin seeds, to serve

Serves 6

Heat the oil in a large flameproof casserole dish over medium heat. Add the onion and garlic and cook for 4–5 minutes, stirring often, or until softened. Add the carrot, celery, leek and chile and cook, stirring often, for 4–5 minutes or until the vegetables have softened. Stir in the paprika and tomato paste to coat, then add the red wine, broth and herbs, season to taste and cook over low–medium heat for 15–20 minutes or until the sauce has thickened slightly.

Preheat the oven to 400°F.

Meanwhile, place the sweet potato and potato in a large saucepan of salted water and bring to a boil. Reduce the heat to medium and simmer for 12–15 minutes or until

a small, sharp knife can easily be inserted into the center. Drain well, then return them to the pan and use a potato masher to mash. Add the butter and cream and stir to combine, then season to taste, cover and set aside.

Add the beans and baby spinach to the casserole and stir to combine well. Simmer for 2 minutes or until the spinach has just wilted and beans are warmed through, stirring regularly. Season to taste, then spoon the mash on top and fluff up with a fork. Scatter with the parmesan, transfer to the oven and bake for 20–25 minutes or until golden brown.

Serve piping hot with toasted pumpkin seeds and extra grated parmesan scattered over the top.

BABY EGGPLANT WITH HARISSA AND GARLIC

Super-easy, super-quick, super-tasty! These are little pops of flavor that make a fantastic side dish (especially with lamb), or nibbles for a dinner party.

1½ teaspoons harissa
2½ tablespoons olive oil
2 large cloves garlic, finely chopped
1 pound baby eggplants, cut into thick rounds
sea salt
1 small handful mint, finely chopped
freshly ground black pepper

Serves 4 as a side

Preheat the oven to 400°F and line a baking sheet with parchment paper.

Place the harissa, oil and garlic in a large shallow dish and combine. Add the eggplant and toss to coat well, then transfer to the prepared sheet.

Season well with salt and roast for 20–25 minutes or until tender. Scatter with chopped mint and season with pepper before serving.

MUSHROOM AND CARAMELIZED ONION QUESADILLAS

Quesadillas are brilliant for get-togethers. I often cook up a bunch of fillings and let people assemble their own before sticking the filled tortillas in the pan and warming them through.

3 tablespoons olive oil
2 onions, sliced
1 tablespoon dark brown sugar
⅓ cup balsamic vinegar
1 tablespoon unsalted butter
3 large cloves garlic, finely chopped
4 portobello or other large flat mushrooms, thinly sliced
3 sprigs thyme, leaves stripped
8 flour tortillas or wholegrain wraps
1⅔ cups shredded cheddar
1 handful baby arugula leaves, roughly chopped
sour cream and lemon wedges, to serve

Serves 4

Heat half the oil in a skillet over low heat. Add the onion and cook, stirring, for 10–12 minutes or until soft. Add the sugar and balsamic vinegar and cook, stirring, for 7 minutes or until the onion is caramelized and the liquid has reduced. Transfer the onion mixture to a bowl and wipe the skillet clean.

Heat the butter and remaining oil in the skillet over medium heat. Add the garlic, mushroom and thyme and cook, stirring often, for 3–4 minutes or until the mushroom is soft. Remove the pan from the heat and set aside.

Heat a grill pan or a large nonstick skillet over medium–high heat. Working one at a time, lightly toast the tortillas on one side for 1 minute, then set aside on a plate.

Place half the tortillas, toasted-side up, on a clean countertop. Divide the caramelized onion mixture, mushroom mixture, shredded cheese and arugula among the bases, then pop the remaining tortillas, toasted-side down, on top.

Return the skillet to medium–high heat. Add a quesadilla and cook for 1–2 minutes until toasted, then carefully flip with a spatula and cook for 1 minute. Transfer to a plate and keep warm while you repeat with the remaining quesadillas.

Cut into quarters and serve warm with sour cream and lemon wedges alongside.

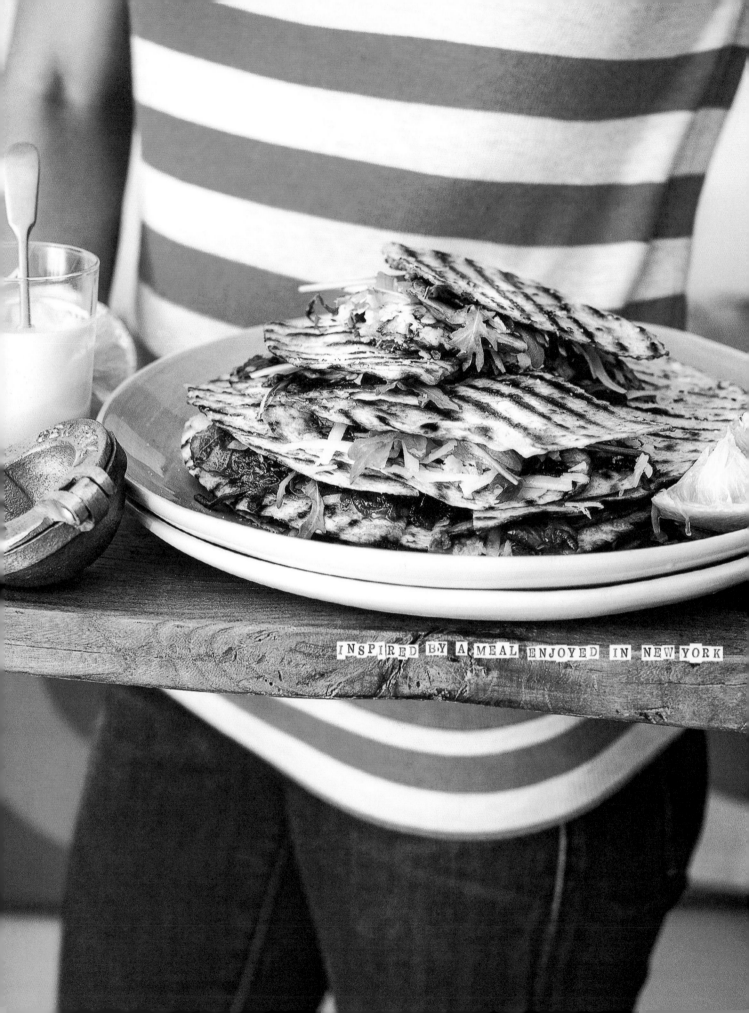

INSPIRED BY A MEAL ENJOYED IN NEW YORK

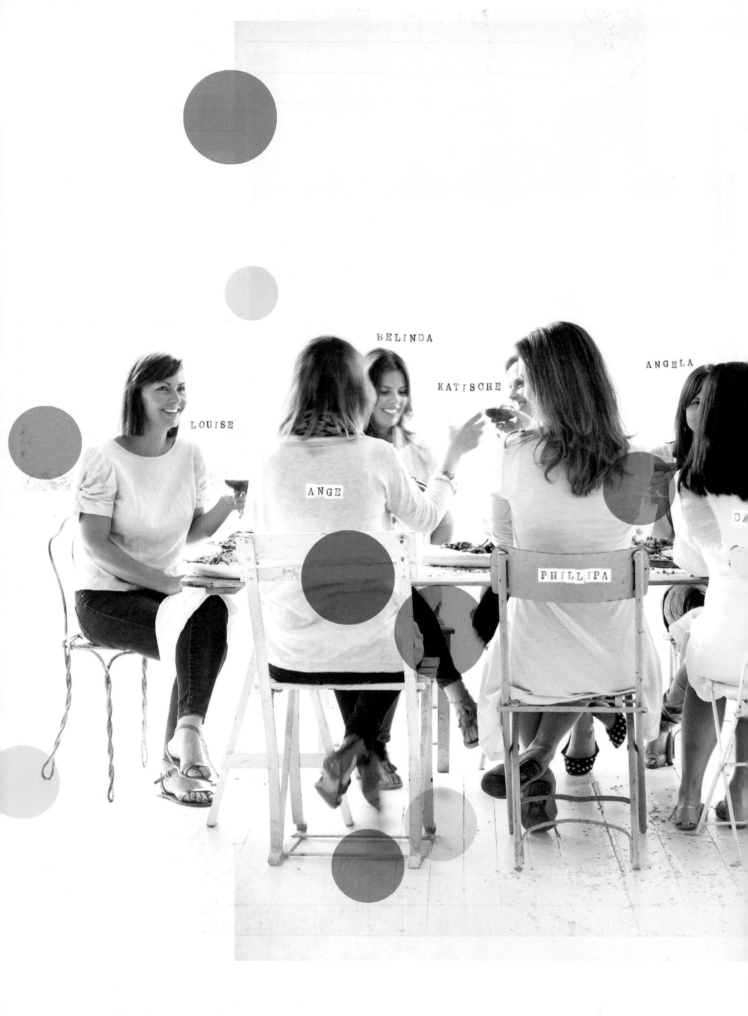

BELINDA

ANGELA

KATISCHE

LOUISE

ANGE

PHILLIPA

JESS

PETA

One of the most amazing things about running my blog
whatkatieate.com is all the incredible people I've met along the way.
I'm always intrigued to find out what sort of person follows
the blog and, in all honesty, I can say every single person I've met
has been a gem. In November 2012 I shot a story for Australia's
delicious. magazine of a lunch with a group of my blog readers. It
was one of my favorite shoots ever. When I decided to do a similar
shoot for this book, I put the call out for readers who might like
to participate. I was bowled over by the number of people who
responded and, whilst I would have adored to host a party for
forty-plus girls (!), logistically I had to keep it to a cozy nine.

Girls for lunch

The day went brilliantly. I arrived at the studio with my assistants
Lou and Madeleine to find nine of the most sociable, gorgeous
girls, totally chilled out, enthusiastically chatting with each other.
They were all so incredibly lovely and warm. It was amazing to see
how well they all got on – I think some lasting friendships were
made that day. I was particularly touched to see Katische again –
I had met her at a talk I gave at Christmas and she had flown in
from Perth just to be there, which was pretty special. I hope very
much I get to see all the girls again soon – but next time, I'll leave
the frantic cooking, styling and shooting out of it, and we'll all just
head to the pub for a drink.

Thank you again to Ange, Angela, Belinda, Dara, Jess, Katische,
Louise, Peta (and her hubby, who was an AMAZING washer-upper
and all-round super-help on the day) and Phillipa.

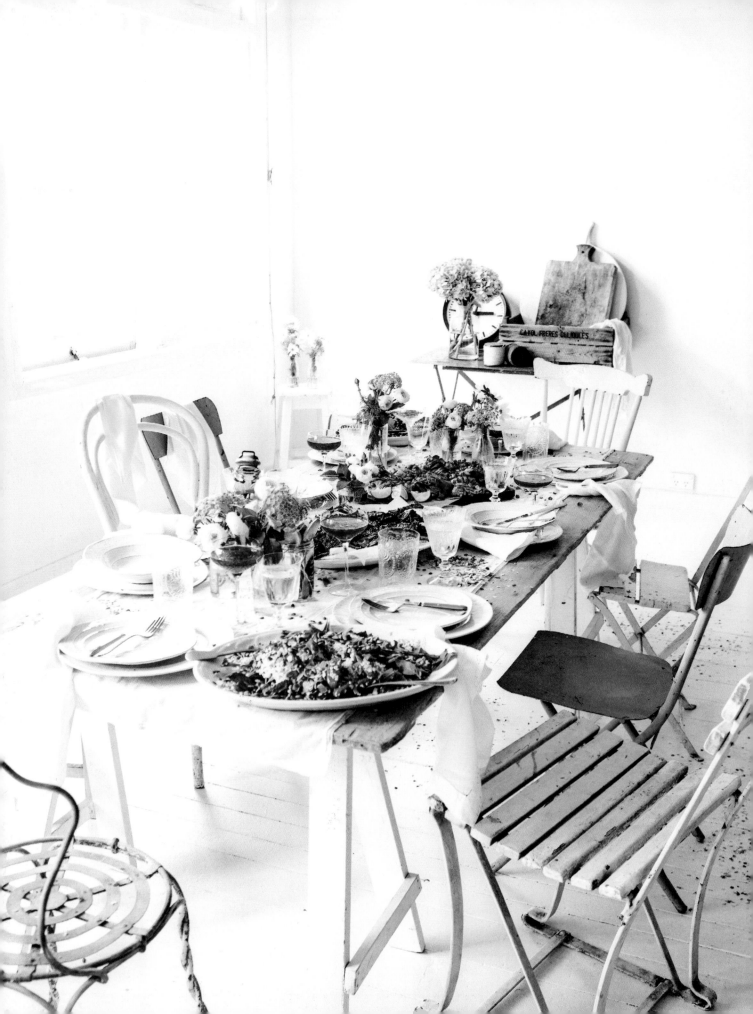

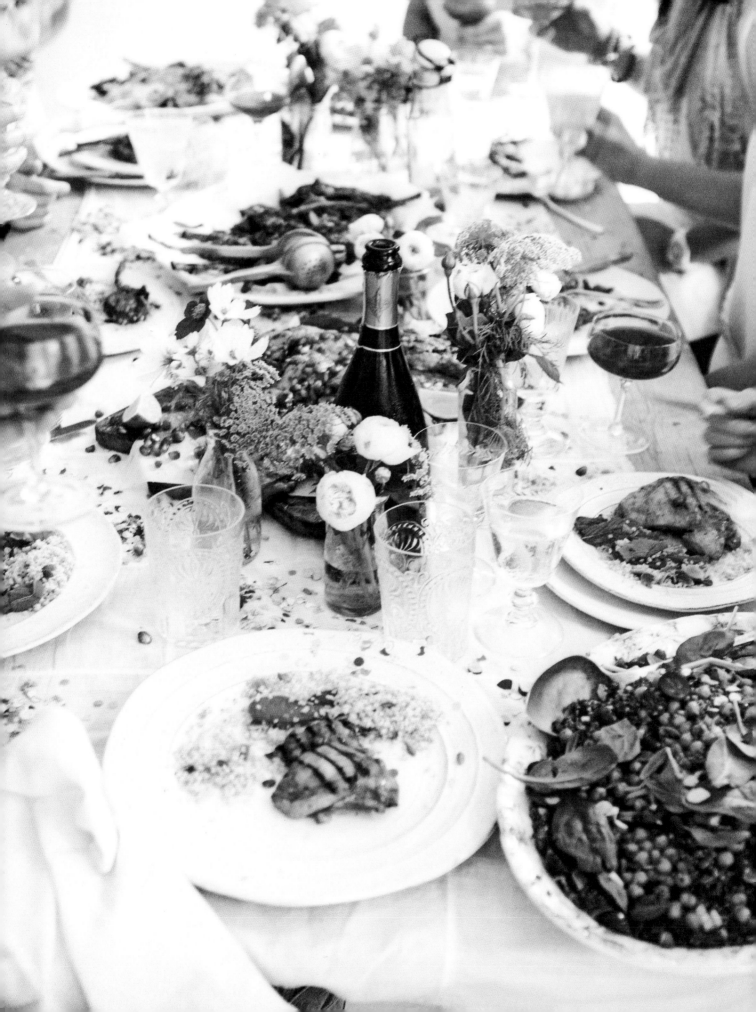

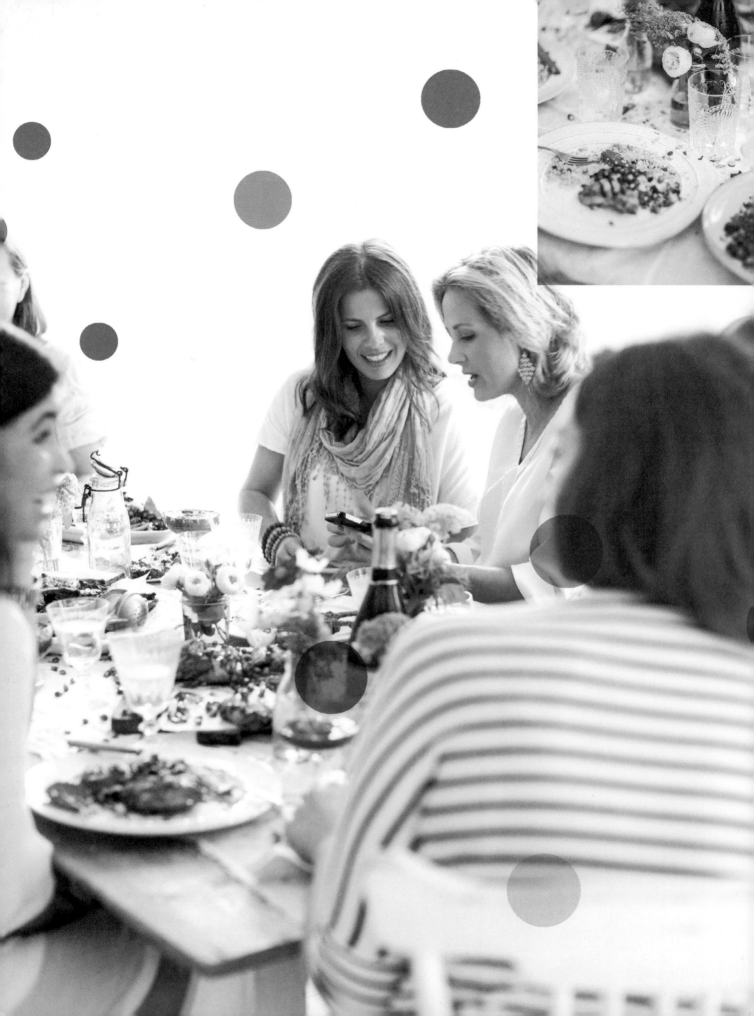

MENU

PIZZA,
PASTA
BREAD

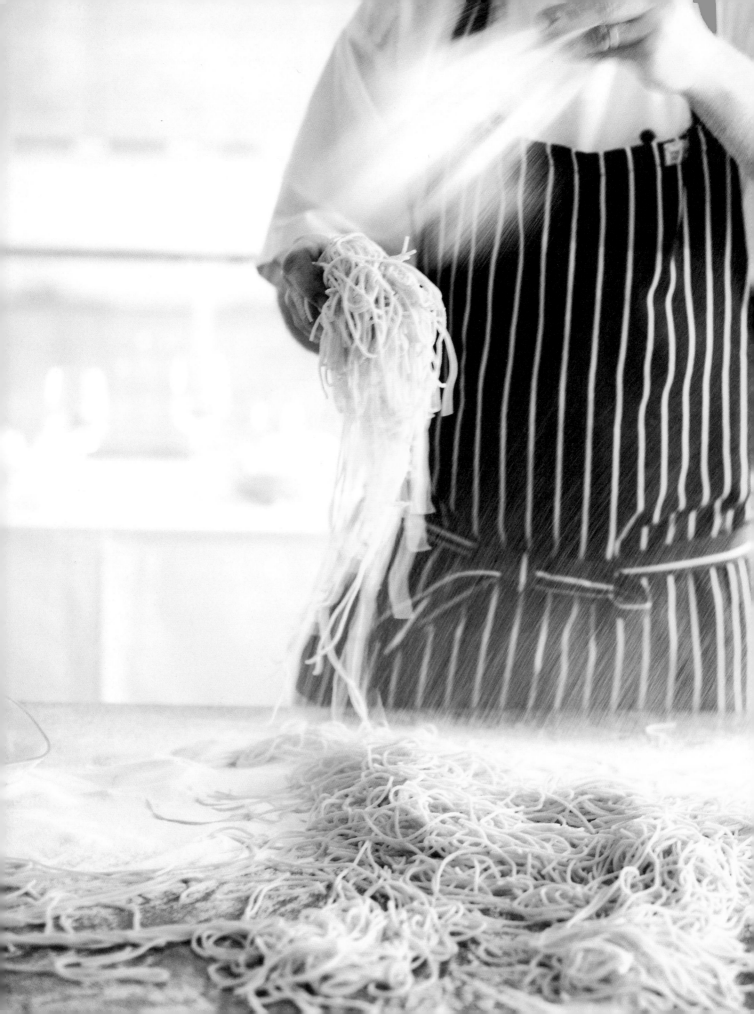

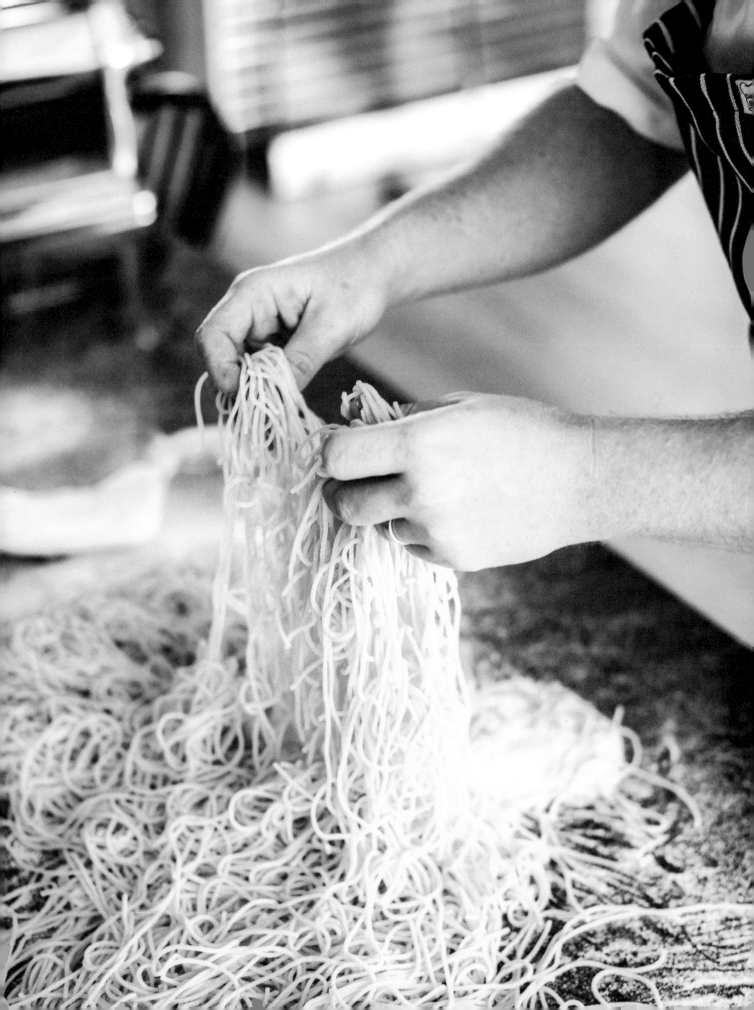

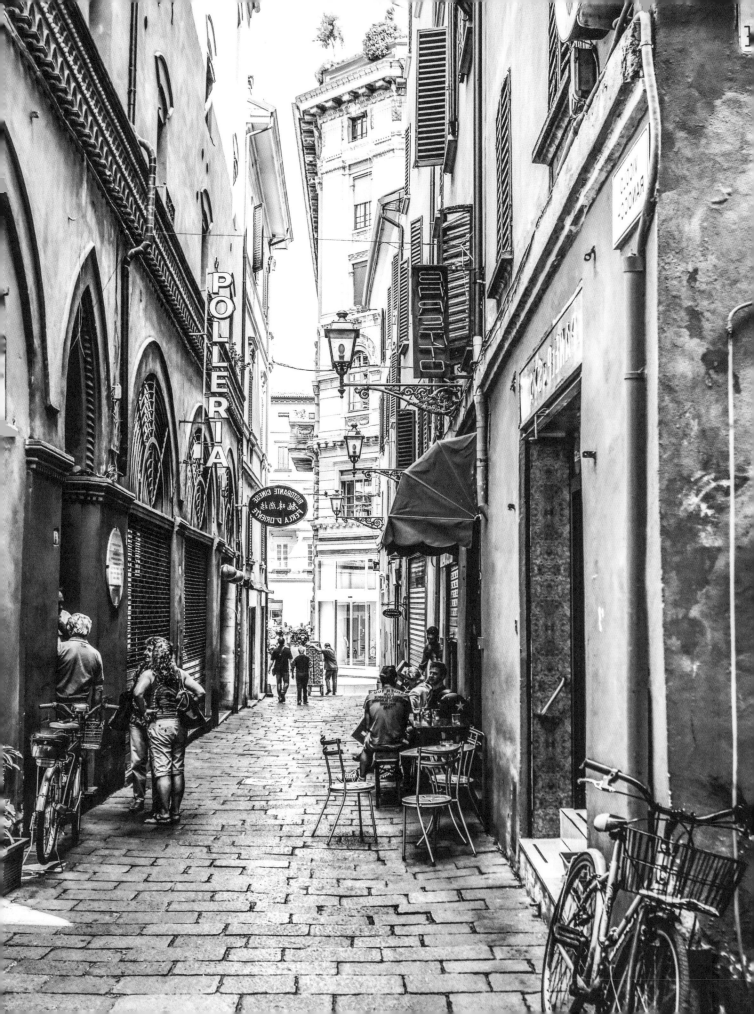

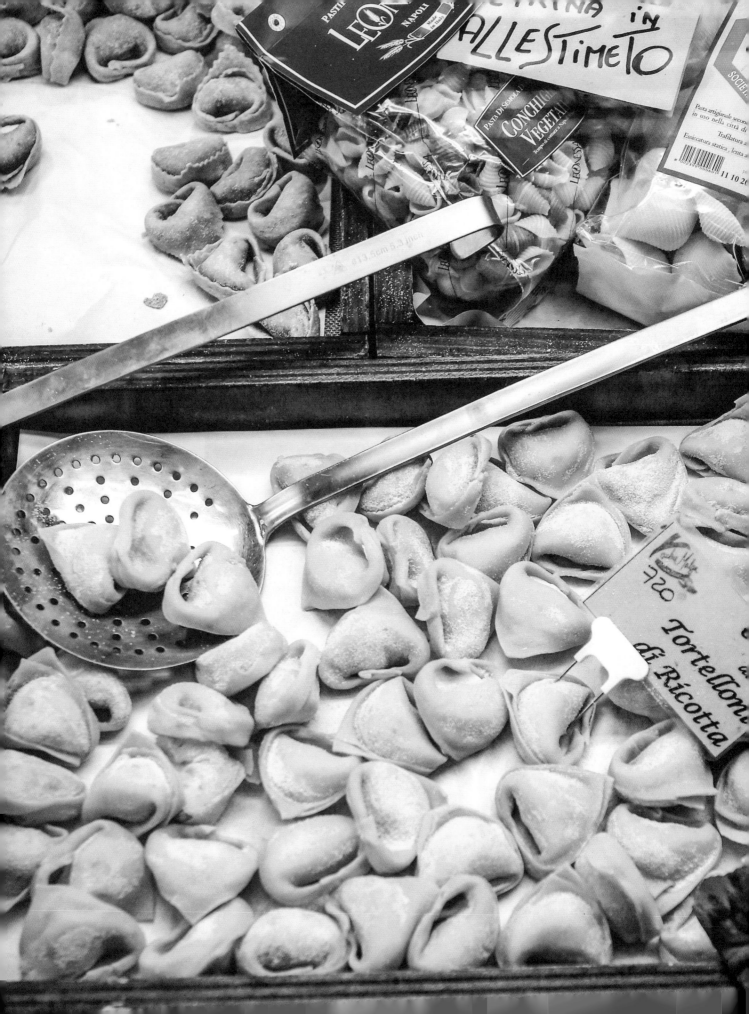

TOMATO, ZUCCHINI FLOWER AND SALAMI PIZZAS

A pretty, summery pizza bursting with fresh flavors. You can make the pizza dough in advance; wrapped tightly in plastic wrap it will keep for up to 2 days in the fridge or 1 month in the freezer.

№ 193

8 slices provolone cheese
20 thin slices spicy salami
10 baby zucchinis with flowers attached, zucchinis thinly sliced, flowers halved lengthwise and stamens removed
9 oz baby vine-ripened tomatoes
oregano, freshly ground black pepper and extra virgin olive oil, to serve

PIZZA DOUGH
2½ cups bread flour
fine salt
¾ teaspoon active dried yeast
2 tablespoons extra virgin olive oil

PIZZA SAUCE
olive oil, for cooking
1 small onion, finely chopped
3 cloves garlic, finely chopped
1 × 28 oz can diced tomatoes
1 cup tomato passata
pinch of crushed red pepper flakes
pinch of superfine sugar
10 large basil leaves, torn
sea salt and freshly ground black pepper

Makes 2 × 13 in pizzas (serves 4)

For the pizza dough, sift the flour into a large bowl. Make a well in the center and add a pinch of salt along with the yeast, oil and 7 fl oz lukewarm water. Whisk with a fork, gradually incorporating the flour from the sides. Using clean hands, bring the mixture together to form a dough, then transfer to a floured countertop. Knead the dough firmly for 5 minutes, really stretching it out as you go. (Alternatively, you can use a stand mixer fitted with a dough hook. Mix all the ingredients on medium speed until combined, then mix on low speed for 5 minutes.)

Place the dough in a bowl, cover with a damp kitchen towel and leave in a warm place to rise for 1 hour or until doubled in size.

Meanwhile, for the sauce, heat 1 tablespoon oil in a heavy-bottomed saucepan over low heat, then add the onion and garlic and cook, stirring often, for

3–4 minutes or until softened. Add the tomato, passata, pepper flakes, sugar and basil and simmer over low–medium heat, stirring often, for 15–18 minutes or until the sauce has thickened and reduced by about one-third. Season with salt and pepper and set aside.

Preheat the oven to 500°F.

Turn the dough out onto a floured countertop and cut in half. Place each piece on an oiled 13 in pizza tray and, using your hands, gently stretch the dough to fit the trays. Divide the pizza sauce between the bases and spread evenly. Top evenly with the cheese, salami, zucchini, zucchini flowers and tomatoes.

Bake for 12–15 minutes or until golden brown around the edges. Serve scattered with oregano, a good grinding of pepper and a drizzle of extra virgin olive oil.

KATIE'S HAWAIIAN PIZZAS

I love pizza. I could eat it every day, especially if it has a really good, thin, crispy base. But I have to say – and I'm going to admit this in print, ironically in a publication that I'm hoping millions of people will read – that my favorite pizza topping is ham and pineapple. At dinner with friends, I get teased mercilessly about it, so I'm taking a stand for all you H&P pizza lovers out there, and I've created a "fancy gourmet" version of this classic that we can all be proud of.

1 quantity Pizza Dough (see page 193)
9 oz buffalo mozzarella, sliced
8 thin slices prosciutto
olive oil, for drizzling
freshly ground black pepper

BARBECUE SAUCE
2½ tablespoons olive oil
1 small red onion, finely chopped
4 cloves garlic, finely chopped
1 tablespoon smoked paprika
4 teaspoons brown sugar
4 teaspoons Worcestershire sauce
2 cups tomato passata

PINEAPPLE SALSA
1 red onion, finely diced
3 cloves garlic, finely chopped
1 long green chile, seeded and finely diced
10½ oz drained canned pineapple slices, finely chopped
9 oz tomatoes, finely diced
finely grated zest of 1 lime
½ cup unsalted peanuts, finely chopped
1 small handful each cilantro and mint, finely chopped
sea salt and freshly ground black pepper

Makes 2 × 13 in pizzas (serves 4)

For the barbecue sauce, heat the oil in a large skillet over medium heat. Add the onion and garlic and cook, stirring, for 2–3 minutes or until softened. Stir in the paprika and sugar and cook for 1 minute. Add the Worcestershire sauce and passata and cook, stirring, for 10–12 minutes or until reduced by about one-third. Remove from the heat and set aside.

For the pineapple salsa, combine all the ingredients in a bowl. Transfer to a fine-mesh sieve over a bowl and set aside to allow any excess liquid to drain off. Discard the excess liquid.

Preheat the oven to 500°F.

Turn the dough out onto a floured countertop and cut in half. Place each piece on an oiled 13 in pizza tray and, using your hands, gently stretch the dough to fit the trays. Divide the barbecue sauce between the pizza bases and spread out evenly. Spoon one-third of the salsa onto each base, reserving the rest, then add the mozzarella and prosciutto and drizzle with oil.

Bake for 12–15 minutes or until golden brown around the edges. Serve with plenty of freshly ground black pepper and the remaining pineapple salsa dolloped on top, if you like.

GREEN PIZZAS WITH MUSHROOMS

This is one of my sneaky healthy recipes – the green sauce is full of kale and walnuts, and you could substitute cottage cheese for the goat's cheese if you like. You'll have some sauce left over, which is perfect tossed through freshly cooked pasta the next day. You can use ordinary kale leaves with the central stems removed if you can't get hold of baby kale.

1 quantity Pizza Dough (see page 193)
1¾ oz shiitake mushrooms, sliced
1¾ oz cremini mushrooms, sliced
¾ cup sliced soft goat's cheese
sea salt and freshly ground black pepper
2½ tablespoons extra virgin olive oil
toasted slivered almonds and baby kale leaves, to serve

GREEN SAUCE
1¾ oz arugula leaves
1¾ oz baby kale leaves
2½ oz broccoli florets
3 cloves garlic
½ cup almonds
1 handful basil
½ cup shredded parmesan
½ cup light olive oil
4 teaspoons lemon juice
sea salt and freshly ground black pepper

Makes 2 × 13 in pizzas (serves 4)

For the sauce, place all the ingredients in the bowl of a food processor and process until thick and combined.

Preheat the oven to 500°F.

Turn the dough out onto a floured countertop and cut in half. Place each piece on an oiled 13 in pizza tray and, using your hands, gently stretch the dough to fit the trays.

Spread about one-third of the sauce onto each pizza base (the remaining green sauce will keep in an airtight container in the fridge for 1 day). Divide the mushrooms and goat's cheese between the bases, season generously with salt and pepper and drizzle with oil.

Bake for 12–15 minutes or until golden brown around the edges. Serve topped with toasted slivered almonds and baby kale.

SPAGHETTI WITH BACON, CAPERS AND MINT

This simple, yet elegant pasta dish was inspired by my travels in Italy. It uses just a few ingredients and is equally good as a weeknight meal or piled onto a platter as part of a spread to feed a crowd.

4 teaspoons olive oil, plus extra for drizzling
1 onion, finely diced
7 oz free-range bacon, fat and rind removed, diced
2 cloves garlic, finely chopped
1 pound 2 ounces cherry tomatoes, halved, juice and seeds squeezed out
sea salt
$\frac{1}{3}$ cup capers, well rinsed
6 sprigs mint, leaves picked and torn
14 oz spaghetti
finely shredded parmesan, to serve

Serves 4

Heat the oil in a large nonstick skillet over medium heat and cook the onion, stirring often, for 3–4 minutes or until starting to soften. Add the bacon and cook, stirring often, for 4–5 minutes or until lightly browned. Add the garlic and cook, stirring, for 30 seconds.

Add the squeezed tomato halves and a good pinch of salt, then reduce the heat to low–medium and simmer for 5–6 minutes. Add the capers and mint, stir to combine and simmer for 1–2 minutes.

Meanwhile, cook the spaghetti according to the packet instructions. Drain, reserving some of the cooking water, then immediately add the spaghetti to the skillet and toss together with the other ingredients, adding a little of the cooking water to moisten. Serve hot with shredded parmesan.

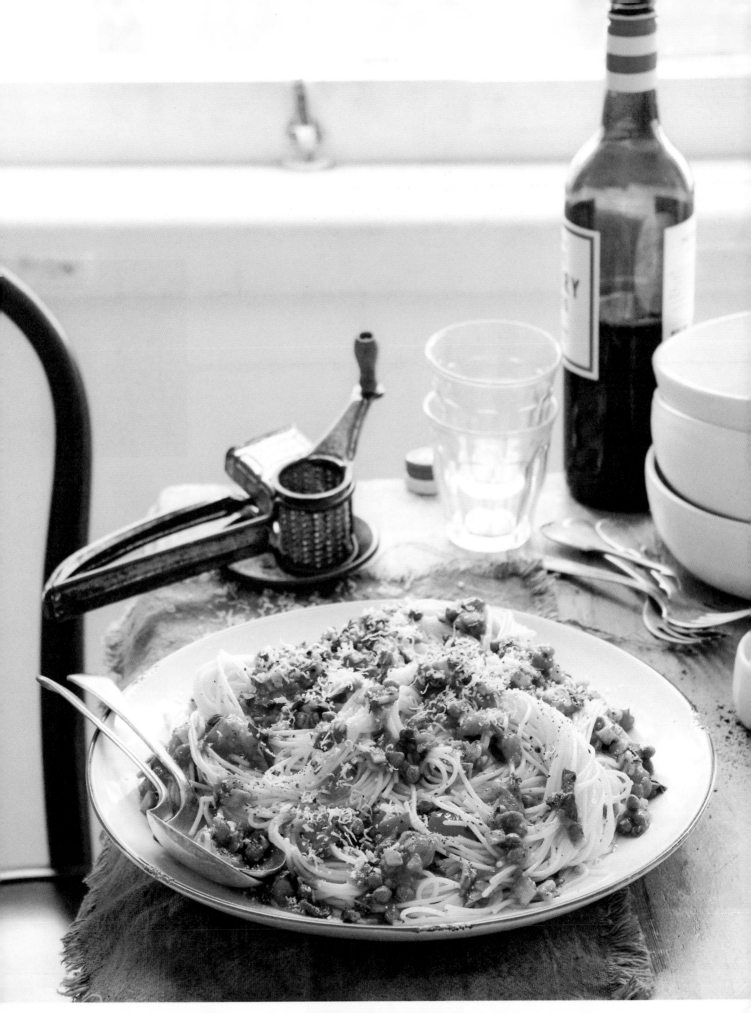

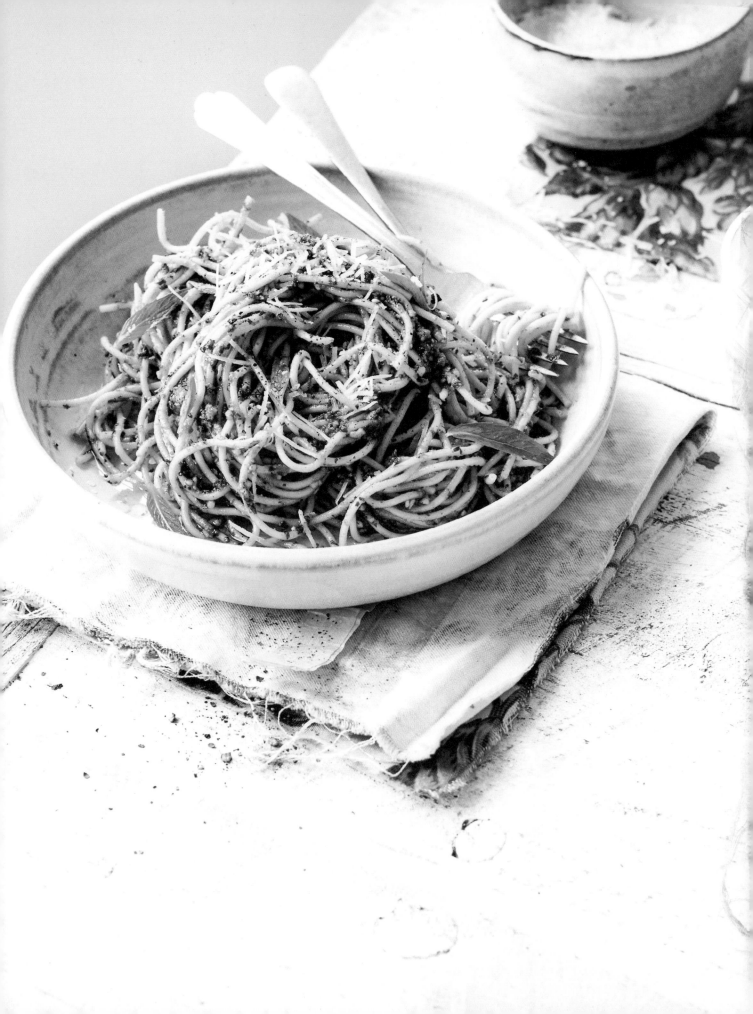

SPAGHETTI WITH ALMOND, MINT AND BASIL PESTO

This pesto is slightly sweeter than the traditional
version due to the inclusion of mint. Any leftover
pesto can be stored in an airtight container for up to
2 days in the fridge.

1 large bunch basil, leaves picked
1 bunch mint, leaves picked
2 cloves garlic, peeled
1 cup extra virgin olive oil, plus extra for drizzling
½ cup blanched almonds
1¼ cups finely shredded parmesan, plus extra
to serve
14 oz spaghetti

Serves 4

Place the basil and most of the mint in the bowl of
a food processor (set aside a few small mint leaves to
use as a garnish). Add the garlic, olive oil, almonds,
parmesan and 4 teaspoons water and whiz to
a smooth, thick paste.

Cook the spaghetti according to the packet
instructions, then drain, reserving some of the
cooking water, and transfer the spaghetti to
a large bowl.

Stir the pesto and a few tablespoons of the reserved
cooking water through the pasta to coat. Serve
immediately topped with extra parmesan, a drizzle
of olive oil and a few small mint leaves.

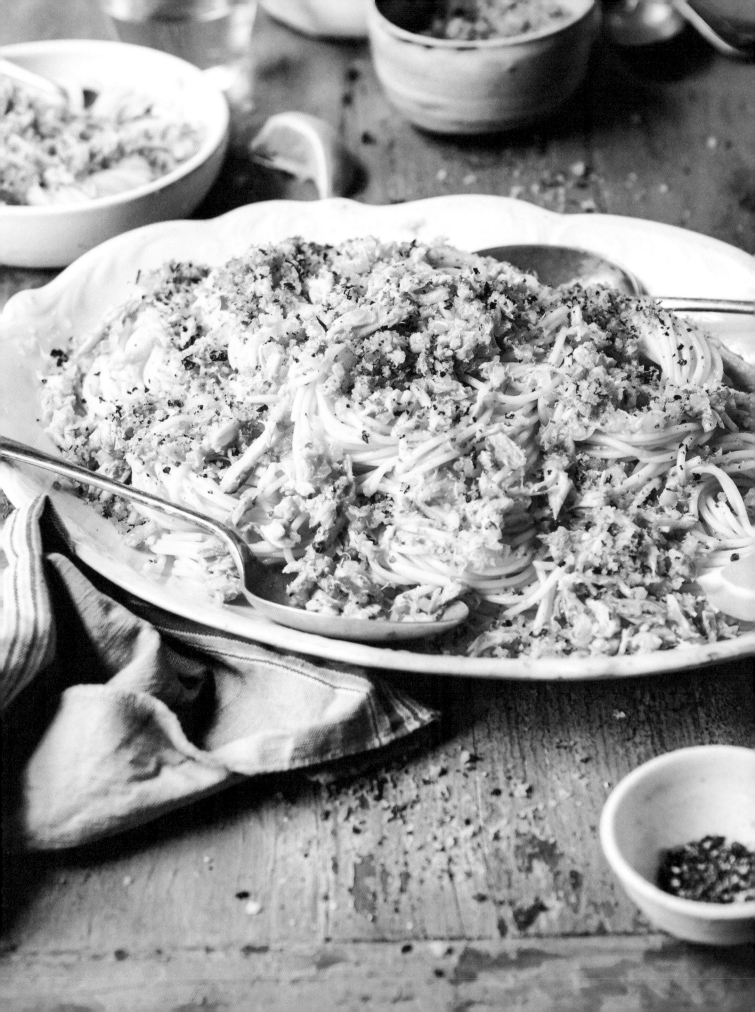

CRAB, LEMON AND CHILE SPAGHETTI

In Australia I buy fresh crab meat in 5 ounce packs; you could buy a whole crab and pick the meat yourself, but it will be pricier (and a lot messier!). This is a light, summery pasta dish for a weekend lunch. Serve with crusty bread and some chilled white wine.

⅔ cup olive oil
2 cups fresh bread crumbs
finely grated zest and juice of 1 lemon
sea salt and freshly ground black pepper
1 handful flat-leaf parsley, finely chopped
14 oz spaghetti
1 onion, finely chopped
3 cloves garlic, finely chopped
1 long red chile, seeded and finely chopped
15 oz cooked fresh crabmeat, drained and shredded if chunky
lemon wedges, to serve

Serves 4

Heat 4 tablespoons of the oil in a large skillet over medium heat. Add the bread crumbs, lemon zest and salt and pepper, then cook, stirring, for 6–8 minutes or until toasted and lightly golden. Transfer to a bowl to cool, then stir through the parsley and set aside.

Cook the spaghetti according to the packet instructions, then drain, reserving some of the cooking water.

Meanwhile, wipe the skillet clean, add 4 teaspoons of the oil and place over medium heat. Cook the onion and garlic, stirring, for 4–5 minutes or until softened. Add the chile and cook for 1 minute, then add the crabmeat and cook, stirring, for 1 minute or until warmed through.

Add the lemon juice and the remaining oil to the pan and stir to combine. Simmer over low heat, stirring occasionally, for 2 minutes to allow the flavors to infuse.

Add the hot drained pasta to the pan along with a few tablespoons of the cooking water to moisten. Toss together to combine well, then add half the bread crumb mixture and toss again to combine.

Transfer to a platter and scatter over the remaining bread crumb mixture. Serve immediately with lemon wedges to the side.

EGGPLANT AND MOZZARELLA LASAGNE

This is a perfect vegetarian main course. It takes about 1½ hours to salt and grill the eggplant, but you can do this the day before if you like. I use a 13 in × 8 in × 2½ in baking dish for this.

2 eggplants, sliced lengthwise into ¼ in thick slices
fine salt
2 tablespoons olive oil
1 onion, roughly chopped
4 cloves garlic, roughly chopped
1 long red chile, seeded and finely chopped
2 × 28 oz cans diced tomatoes
4 teaspoons tomato paste
1 cup good-quality red wine
4 teaspoons balsamic vinegar
4 teaspoons capers, well rinsed

1 bunch oregano, leaves stripped and roughly torn
pinch of superfine sugar
freshly ground black pepper
olive oil spray, for cooking
½ cup fresh white bread or sourdough
1¼ cups finely shredded parmesan
2 zucchinis, coarsely grated
3 tablespoons light sour cream
9 oz buffalo mozzarella, thinly sliced
3½ oz fresh pasta sheets, cut to size

Serves 6

Place the eggplant slices in a large colander and sprinkle with 2½ tablespoons salt. Toss to coat, then leave to stand for 1 hour.

Meanwhile, heat 4 teaspoons oil in a large heavy-based saucepan over medium heat. Add the onion and cook for 3–4 minutes until softened, then add the garlic and cook for 3 minutes, stirring often so the garlic doesn't burn. Add the chile and cook for 2 minutes, stirring often. Add the canned tomatoes, tomato puree, red wine, balsamic vinegar, capers, most of the oregano (saving a large handful for the crumb mixture) and the sugar and season with pepper. Stir to combine, then simmer over low heat for 45 minutes.

Thoroughly rinse the eggplant slices under cold running water, then lay them out on paper towel, patting with extra paper towel to dry thoroughly. Spray olive oil on one side of each slice, then place under the oven broiler, oil-side up, and broil for 3–4 minutes. Remove from the broiler, turn the slices over and spray with olive oil, then broil until golden brown. Drain on paper towel.

Preheat the oven to 400°F.

Whiz the bread in the bowl of a food processor to make coarse crumbs. Add the reserved oregano and whiz to combine, then add ½ cup of the parmesan and pulse to combine. Set aside.

Squeeze the excess water from the grated zucchini and pat dry with paper towel. Heat the remaining oil in a skillet over medium heat and add the zucchini, then cook for 3 minutes, stirring often. Reduce the heat to low, add the sour cream and cook, stirring, for 1–2 minutes.

To assemble, spoon half the tomato sauce into the base of a large rectangular roasting pan. Top with around half the eggplant slices, arranging them in a layer and slightly overlapping them. Add half the sliced mozzarella, half the remaining parmesan and then a layer of pasta sheets.

Add another layer of tomato sauce, eggplant, mozzarella, parmesan and pasta sheets, then top the pasta layer with the zucchini mixture, any remaining eggplant slices and the herbed bread crumbs.

Bake for 35–40 minutes or until golden brown and bubbling, then slice and serve.

SEEDED BAGELS WITH SMOKED SALMON

I always thought bagels would be difficult to make, but they are surprisingly easy. These are great for a cocktail party, or to serve as little hunger busters late at night after a few drinks. Fill them with anything you please: cured meats, pickles and mayo, or roast beef, watercress and horseradish sauce would be delicious, too.

No. 211

4 teaspoons olive oil or rice bran oil, plus extra for brushing
1 onion, finely chopped
2 large cloves garlic, finely chopped
4 teaspoons chia seeds
4 teaspoons white sesame seeds
4 teaspoons black sesame seeds
4 teaspoons poppy seeds
⅓ cup pine nuts
2 teaspoons active dried yeast
4 teaspoons superfine sugar
3 cups bread flour (at least 13% gluten), plus extra for dusting

1 teaspoon fine salt
5 tablespoons light agave nectar (see page 10)
9 oz light cream cheese
2½ tablespoons crème fraîche
4 teaspoons lemon juice
1 small handful dill, snipped
15½ oz smoked salmon slices
sea salt and freshly ground black pepper
lemon wedges, to serve

Makes 16

Heat the oil in a small skillet over medium heat, and cook the onion for 3 minutes or until just softened. Add the garlic and cook for 3 minutes, stirring often, until the onion is cooked through and translucent. Remove from the heat and leave to cool for 10 minutes.

Combine the seeds and pine nuts in a bowl and set aside.

Combine the yeast, sugar and 3½ fl oz warm water in a large bowl. Cover and leave to stand for 10–12 minutes until frothy. Stir in the flour, salt, cooled onion and garlic, half the seed mixture and 7 fl oz warm water. Mix everything together well with your hands and turn out onto a well-floured countertop.

Knead the dough for 10 minutes, stretching it out as you go, then shape into a ball. Place in a large bowl that has been greased with olive oil and cover with a damp kitchen towel. Set aside in a warm place for 1 hour or until doubled in size.

Preheat the oven to 375°F and line two baking sheets with parchment paper.

Half-fill a large saucepan with water and bring to a boil. Stir in the agave nectar.

Punch down the dough with your fist and turn out onto a floured countertop. Divide the dough into sixteen equal portions (each the size of a small egg) and form into balls. Slightly flatten each one, then use a ¾ in plain round cutter to cut a hole out of the centers. Swirl each bagel gently on your floured index finger until slightly stretched.

Working in batches of four at a time, place the bagels in the boiling water and cook for 1 minute, then flip with a slotted spoon and cook on the other side for 1 minute. Scoop out and leave to drain on paper towel.

Arrange the boiled bagels on the prepared sheets and evenly scatter the remaining seed mixture over the top. Bake for 30 minutes or until golden brown and glossy.

Meanwhile, whisk together the cream cheese, crème fraîche, lemon juice and dill in a bowl, cover with plastic wrap and refrigerate for 20 minutes.

Halve the bagels crosswise and smear the bases with the chilled cream-cheese mixture. Top with smoked salmon, season well and pop on the lids. Serve with lemon wedges.

CARAMELIZED ONION, FENNEL AND TOMATO FOCACCIA

This is a really flavorsome bread; give it a generous seasoning of sea salt before cooking to bring out the flavors. Serve it with a good-quality extra virgin olive oil to dip into.

2 teaspoons active dried yeast
2 pinches of superfine sugar
⅓ cup olive oil, plus extra for brushing
3 cups bread flour, plus extra for dusting
fine salt
4 red onions, thinly sliced
2 tablespoons light brown sugar
5 tablespoons balsamic vinegar
5 teaspoons fennel seeds
9 oz cherry tomatoes, halved
sea salt

Serves 8

Combine the yeast, sugar, 2½ tablespoons oil and 11 fl oz warm water in a bowl, then set aside in a warm place for 5 minutes or until frothy.

Sift the flour into a bowl and add 1 teaspoon salt. Make a well in the center, pour in the yeast mixture and stir to combine.

Turn out onto a lightly floured countertop and knead for 10 minutes or until smooth and elastic. Place in a large bowl that has been greased with a little olive oil and cover with a damp kitchen towel. Set aside in a warm place for 1 hour or until doubled in size.

Meanwhile, heat the remaining oil in a skillet over low–medium heat. Add the onion and cook, stirring, for 12–15 minutes or until soft. Add the brown sugar and vinegar and cook, stirring, for 7–10 minutes or until the onion has caramelized and the vinegar has been absorbed. Remove the skillet from the heat and set aside.

Punch down the dough with your fist. Turn out onto a lightly floured countertop and knead for 1–2 minutes.

Spread the dough out to form a rough rectangle, then cover the surface evenly with the onion mixture. Scatter the fennel seeds on top, reserving a few to scatter over later. Carefully fold the dough over on itself a few times until most of the onion mixture is incorporated into the dough (this bit can get a little sticky so ensure your countertop is well-floured).

Preheat the oven to 425°F and grease a baking sheet with olive oil.

Press the dough onto the prepared sheet, cover with a damp kitchen towel and set aside in a warm, draught-free place for 20 minutes or until doubled in size.

Use your finger to press dimples into the dough, then carefully press the tomato halves into the dimples. Brush well with oil and sprinkle over the remaining fennel seeds, then season with a few good pinches of sea salt.

Bake for 20–25 minutes or until golden and cooked through. Serve warm or at room temperature.

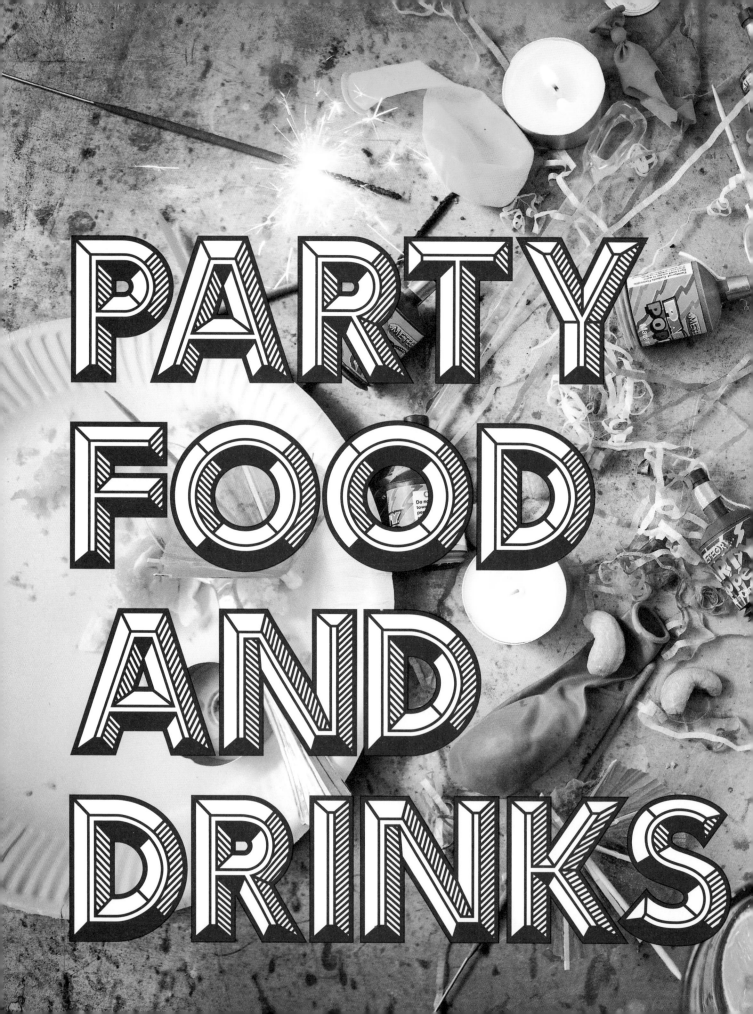

PARTY FOOD AND DRINKS

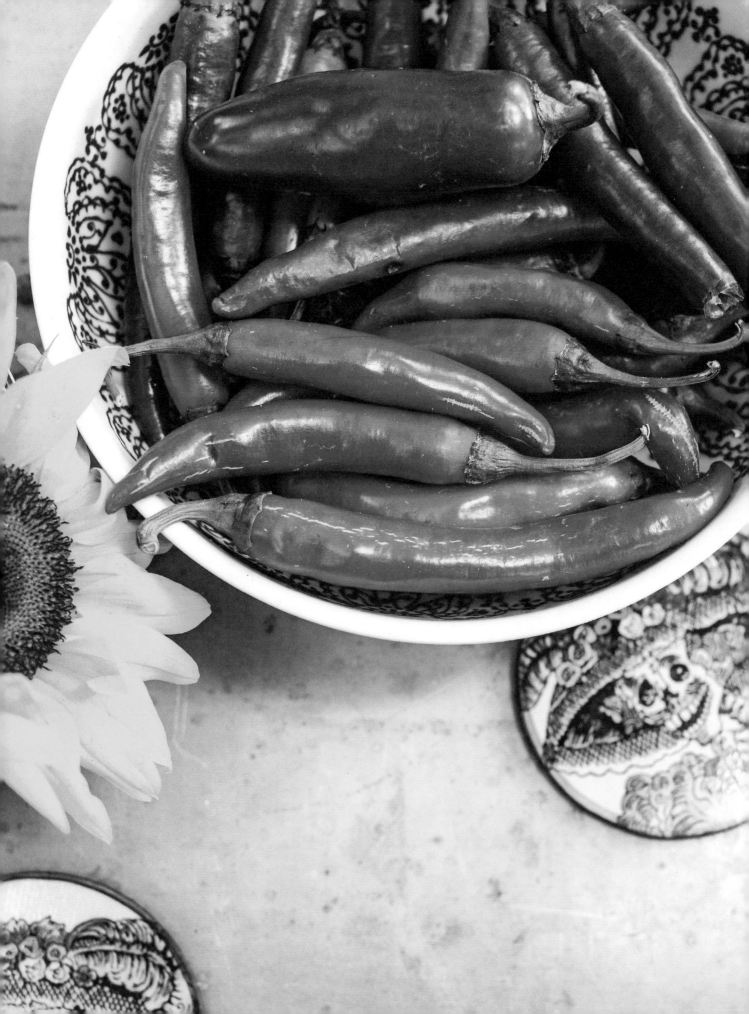

SPICED ALMONDS

My friend Michael Wohlstadt from Dairyman's Cottage in the
Barossa Valley (see pages 32–41) greets visitors to his guesthouse
with the most incredible tray of breakfast goodies, plus a
beautiful bottle of wine and these amazing spiced nuts. I gobbled
up so many of them during my stay there that I knew I had to
include this recipe in the book.

2 cups almonds
4 tablespoons olive oil
4 teaspoons sea salt
2½ tablespoons very finely chopped kaffir lime leaves
2 tablespoons dried garlic powder
1 tablespoon crushed red pepper flakes
1½ teaspoons sweet paprika
1 teaspoon chili powder

Serves 1–2

Preheat the oven to 475°F.

Place the almonds on a baking sheet, drizzle with oil and season
with salt. Spread the almonds out over the sheet, then roast for
10 minutes, tossing now and then, or until some of the nuts split.

Remove the sheet from the oven and sprinkle over the lime leaves
and spices while the almonds are hot. Toss to combine,
then leave to cool on the sheet.

Store in an airtight container for up to 1 week.

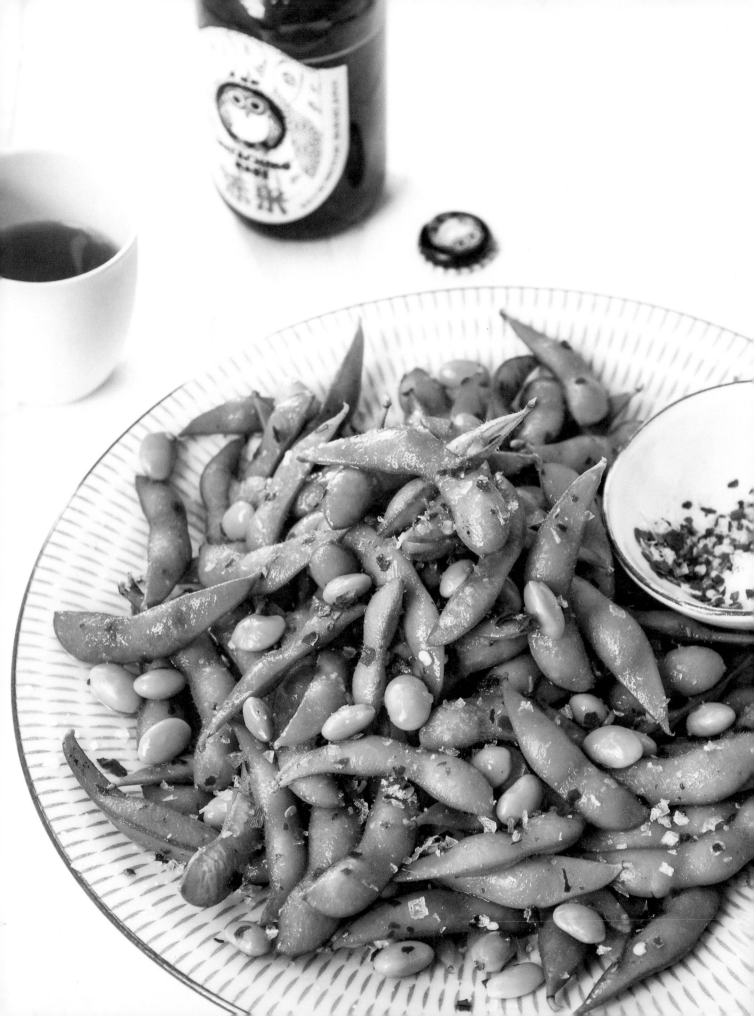

EDAMAME BEANS WITH MIRIN, SALT AND PEPPER FLAKES

These are really quick to prepare and incredibly tasty –
you'll be addicted in seconds. Brilliant for a cocktail party
or pre-dinner nibbles.

1 lb frozen edamame beans
4 teaspoons sesame oil
4 teaspoons mirin
4 teaspoons rice wine vinegar
2 teaspoons crushed red pepper flakes, plus
 extra to serve
sea salt

Serves 4–8

Place the edamame beans in a heatproof bowl, cover with
heatproof plastic wrap and microwave on high for 4 minutes.

Meanwhile, whisk together the sesame oil, mirin and rice
wine vinegar in a bowl.

Pour the dressing over the beans, then season with pepper
flakes and 2 teaspoons salt and mix to coat well.

Serve on a large plate, with extra salt and pepper flakes in
a small bowl to the side.

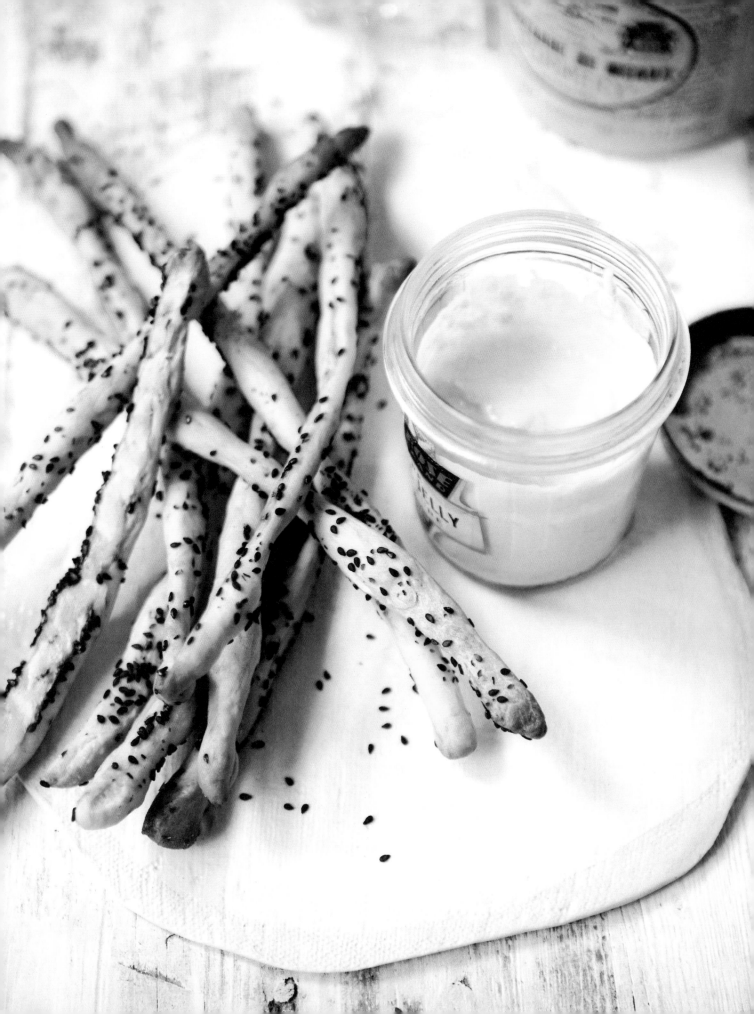

WASABI STRAWS WITH SALMON DIPPING SAUCE

Perfect for parties, these straws have a bit of a kick which is contrasted perfectly by the smooth and creamy dip. You can make the straws as long or short as you like.

1²/₃ cups all-purpose flour
1 teaspoon active dried yeast
2 teaspoons black sesame seeds, plus extra for baking
1 tablespoon wasabi paste
sea salt and freshly ground black pepper
olive oil, for brushing

SALMON DIPPING SAUCE
1 cup light sour cream
4 teaspoons tamari or soy sauce
juice of ½ lemon
9 oz smoked salmon, torn
sea salt and freshly ground black pepper

Makes about 40

Place the flour, yeast, sesame seeds, wasabi and ½ teaspoon salt in a stand mixer fitted with a dough hook. Add ²/₃ cup warm water and mix on low speed for 5 minutes or until smooth.

Turn out onto a lightly floured countertop and knead for a couple of minutes, then shape into a ball and place in a large bowl that has been greased with a little olive oil. Cover with a damp kitchen towel and leave to rest in a warm place for 1 hour or until the dough has doubled in size.

Preheat the oven to 375°F and line three baking sheets with parchment paper.

Pick off walnut-sized balls of dough and, on a clean countertop, roll them out to 8 in long sticks. Place on the baking sheets, brush with a little water and scatter over the extra sesame seeds. Bake for 15–20 minutes or until golden brown and crisp.

Meanwhile, for the dipping sauce, place all the ingredients in the bowl of a food processor and whiz until the smoked salmon is incorporated and the sauce is smooth. Season to taste with salt and pepper and set aside.

Serve the straws stacked on a platter with the dipping sauce alongside.

KATIE'S PÂTÉ WITH RHUBARB PASTE AND GLAZED PEARS

I'm a huge pâté fan and could eat it until it came out of my ears. For this one you'll probably need to order the duck livers in advance from your butcher. I use amontillado or oloroso sherry, but whatever sherry you can get your hands on will be fine.

1¼ sticks butter
3 shallots, thinly sliced
4 large cloves garlic, thinly sliced
9 oz free-range bacon, fat and rind removed, diced
4 tablespoons semi-sweet sherry
9 oz free-range chicken livers, trimmed
9 oz free-range duck livers, trimmed
2–3 sprigs thyme, leaves stripped
1¼ cups heavy cream
sea salt and freshly ground white pepper
sourdough bread, thinly sliced and toasted, to serve

RHUBARB PASTE

¾ bunch rhubarb, trimmed and cut into pieces (you'll need 9 oz trimmed rhubarb)
2½ tablespoons superfine sugar
½ cup blood orange juice or orange juice
2 teaspoons Grand Marnier
3 sheets gold-strength gelatin

GLAZED PEARS

4 pears, peeled, cored and cut into eight wedges
4 star anise
5 cardamom pods, bruised with the back of a knife
2½ tablespoons dark brown sugar

Serves 10–12

Melt half the butter in a skillet over medium heat. Add the shallot and garlic and cook, stirring, for 3–4 minutes or until softened. Add the bacon and cook, stirring often, for 6–8 minutes or until just golden brown. Add a tablespoon of the sherry and stir with a wooden spoon, scraping up any bits stuck to the bottom of the pan. Transfer the mixture to a blender.

In the same skillet, melt the remaining butter over medium heat, then add the chicken and duck livers and the thyme and cook for 3–4 minutes or until the livers are just cooked but still a little pink in the center. Add the cream and remaining sherry and stir to coat, then transfer to the blender. Blend all the ingredients until smooth. Season with salt and pepper and leave to cool for 15 minutes before transferring to sterilized jars. Set aside.

For the rhubarb paste, place the rhubarb, sugar, orange juice, Grand Marnier and 3½ fl oz water in a heavy-bottomed saucepan and bring to a boil. Reduce the heat to low–medium and simmer for 8–10 minutes, or until the rhubarb has collapsed and the sauce is thick. Strain through a fine-meshed sieve into a bowl and set aside to cool.

Place the gelatin sheets in a bowl and cover with cold water. Leave to stand for 5 minutes, then remove and squeeze out the excess water. Place them in a small heavy-bottomed saucepan with 2½ tablespoons of the strained rhubarb sauce and stir over medium heat until smooth. Transfer the gelatin mixture to the bowl with the remaining rhubarb sauce and combine well. Spoon evenly over the pâté in the jars, seal and refrigerate overnight.

For the glazed pears, place all the ingredients and 3 cups water in a heavy-bottomed saucepan over high heat. Bring to a boil, then reduce the heat to low and cook for 5–10 minutes, or until the pears are tender when pierced with a knife (the cooking time will depend on the ripeness of the pears). Remove the pears with a slotted spoon and set aside in a bowl, then simmer the poaching liquid over medium–high heat for 25–30 minutes or until reduced to a glaze. Return the pears to the sauce and simmer for 3–4 minutes, stirring gently, until the pears are glazed. Set aside to cool.

Serve the pâté with the glazed pears and plenty of toasted sourdough.

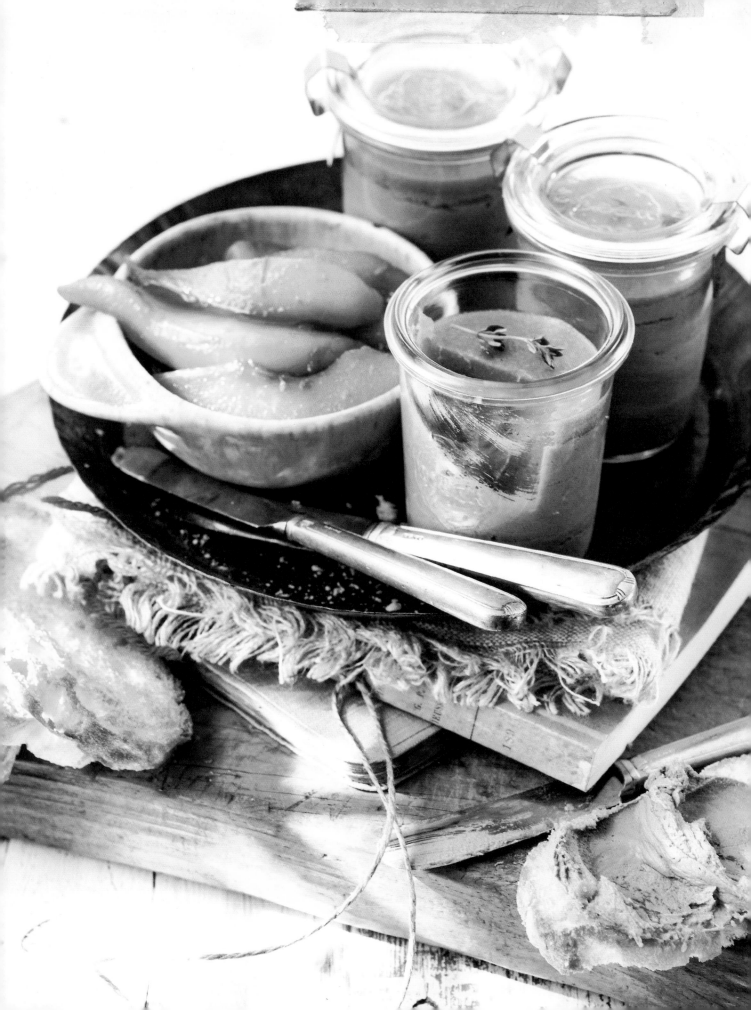

SHRIMP CROSTINI WITH TOMATO AND CHAMPAGNE SAUCE

If you really want to splurge, you can opt to use lobster tail meat in this dish instead of the shrimp. Try to get the best store-bought hollandaise sauce you can, as it makes all the difference.

12 toasted baguette slices and store-bought hollandaise sauce, to serve
1 pound 5 ounces cooked shrimp, peeled and deveined
dill sprigs and freshly ground black pepper, to garnish

TOMATO AND CHAMPAGNE SAUCE
3 large vine-ripened tomatoes
pinch of superfine sugar
3 tablespoons unsalted butter, plus extra for cooking
1 cup champagne or sparkling wine
Tabasco sauce, to taste
sea salt and freshly ground white pepper

Makes 12

For the sauce, cut the tomatoes in half and squeeze the seeds and juice into a small heavy-bottomed saucepan over low heat. Finely chop the flesh and add to the pan. Increase the heat to medium and cook for 2–3 minutes. Add the sugar and butter and cook until the butter has melted, then add the champagne or sparkling wine and simmer for 10 minutes or until the sauce has thickened and reduced slightly.

Transfer to a blender and whiz until smooth, then push through a fine-meshed sieve back into the pan. Place over low heat and simmer for 40–50 minutes, stirring occasionally, until thickened. Add an extra small pat of butter, a dash or two of Tabasco and season, then remove from the heat.

Spread each slice of toast with a teaspoon of hollandaise sauce and top with one or two shrimp. Drizzle with a teaspoon of the sauce and garnish with dill sprigs. Season with a little pepper and serve.

FETA CROSTINI WITH ZUCCHINI AND PROSCIUTTO

Use a baguette or other light bread for these — not a sourdough as it will be too heavy. I use a mandoline to thinly slice the zucchini; it's a great tool in the kitchen. Remember to cut the prosciutto into bite-sized pieces so the crostini are not too messy to eat.

1 large zucchini, very thinly sliced with a mandoline
finely grated zest and juice of 1 lemon, plus extra juice for cooking, and zest to serve
2½ tablespoons olive oil
sea salt and freshly ground black pepper
½ cup frozen baby peas
½ crusty baguette, cut into 12 × ⅝ in thick slices on the diagonal
1 clove garlic, halved
1¼ cups marinated feta, drained
1 handful mint, finely chopped, plus extra leaves to serve
6 thin slices prosciutto, cut into bite-sized pieces
extra virgin olive oil, for drizzling

Makes 12

Combine the zucchini, lemon juice and 4 teaspoons olive oil in a bowl. Season with salt and pepper and set aside for 15 minutes.

Meanwhile, blanch the peas in a saucepan of boiling water with a squeeze of lemon juice added for 30 seconds, then drain and set aside.

Heat a grill pan over medium–high heat. Brush the bread on both sides with the remaining oil, then grill for 1–2 minutes on each side until golden and charred. Rub the bread on one side with the cut-side of the garlic, then set aside.

Drain the zucchini, reserving the marinade, and place on the hot grill for 1 minute each side or until tender and lightly charred.

Add the feta, lemon zest and mint to the reserved marinade, season well and mash to a smooth paste. Spread the paste onto the bread slices, and top with prosciutto, zucchini and peas. Garnish with extra lemon zest and mint leaves, then drizzle with a little extra virgin olive oil, season and serve.

O'SHOCKO'S GUACO WITH CRISPY LIME TORTILLA CHIPS

My good friend Ian O'Shaughnessy makes the best-ever guacamole on the planet. Use just-ripe avocadoes and take care not to over-mash them, or the end result will look like baby food. *Arriba!*

finely grated zest of 2 limes, plus extra lime wedges, to serve
sea salt and freshly ground black pepper
8 soft corn or flour tortillas, each cut into eight wedges
2 cloves garlic, halved
light olive oil spray

O'SHOCKO'S GUACO
3 vine-ripened tomatoes
boiling water, for blanching
flesh of 3 avocadoes
finely grated zest of 1 lime
juice of 2 limes
½ small red onion, very finely chopped
3 cloves garlic, very finely chopped
1 small handful cilantro, very finely chopped
2 teaspoons chipotle sauce (see page 28) or a few dashes of Tabasco sauce
sea salt and freshly ground black pepper

Serves 6

For the guacamole, cut a small cross in the base of each tomato, then place them in a heatproof bowl and cover with boiling water. Leave for 30 seconds, then plunge the tomatoes into cold water to refresh before carefully peeling. Cut the peeled tomatoes in half, scoop out the seeds and discard, then finely chop the flesh.

Place the avocado flesh, lime zest and juice in a mixing bowl. Gently mash to a coarse texture using a fork. Add the tomato, onion, finely chopped garlic, cilantro and chipotle or Tabasco sauce. Gently fold together to combine, taking care not to break up the avocado too much, then season to taste. Cover with plastic wrap and place in the fridge to chill.

Preheat the oven to 400°F and line three large baking sheets with parchment paper.

Place the lime zest in a small jar with a lid, add a good pinch of salt and some pepper, then close the lid and shake to combine.

Arrange the tortilla wedges on the prepared sheets and rub the tops with the cut-side of the garlic. Spray with olive oil, then scatter over the spiced zest. Bake for 10–12 minutes or until golden brown and crisp, then leave to cool.

Serve the chips with the chilled guaco and extra lime wedges to the side.

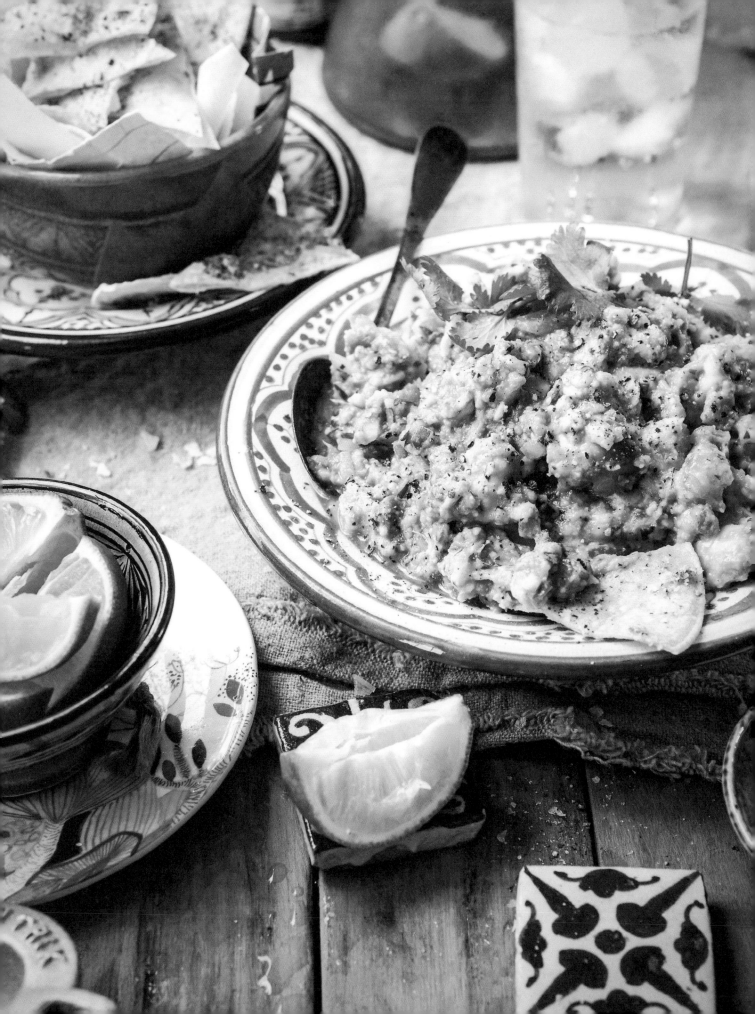

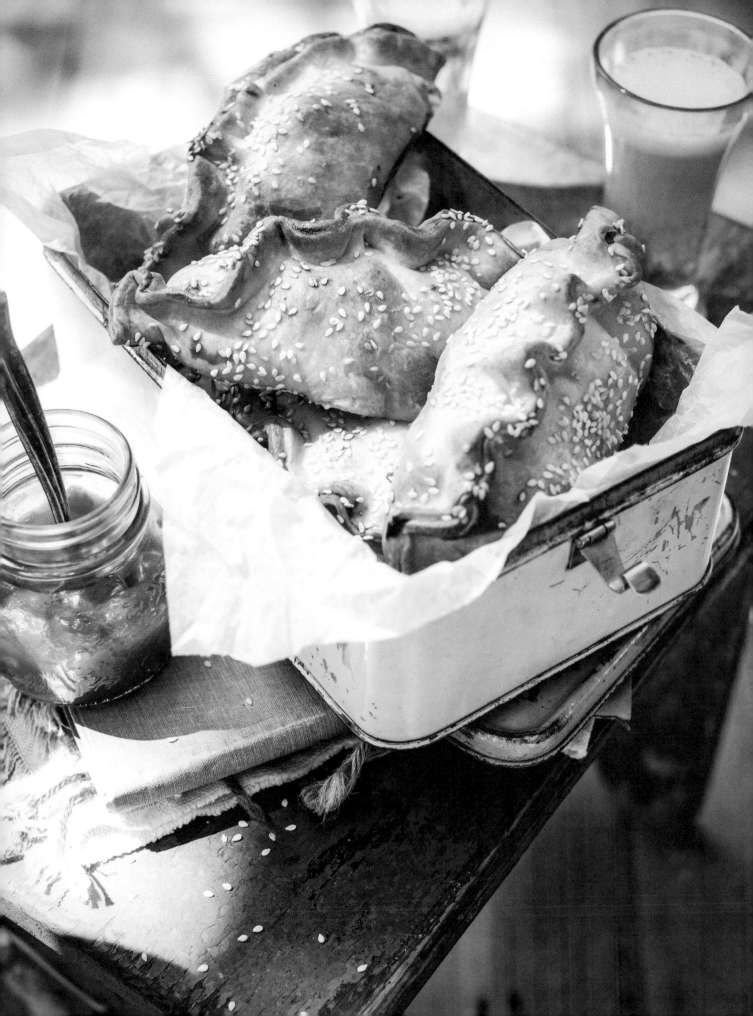

PORK AND PICKLED ONION PASTIES

These are perfect for a weekend picnic or to pack into school lunch boxes.
I use good old English-style brown pickled onions, an all-rounder potato like
Idaho, and a crumbly, sharp vintage cheddar for this recipe. You can use
store-bought shortcrust pastry, if you are short of time.

1 small potato (about 4½ oz), diced
4 teaspoons olive oil
½ small onion, finely chopped
2 cloves garlic, finely chopped
7 oz lean ground free-range pork
5 pickled onions, drained and chopped
2½ oz cheddar, diced
1 tablespoon finely chopped flat-leaf parsley
sea salt and freshly ground black pepper
1 free-range egg yolk, mixed with a little milk
4 teaspoons sesame seeds
good-quality tomato chutney, to serve

SOUR-CREAM PASTRY
1⅓ cups all-purpose flour, sifted
⅔ cup unsalted butter, chilled and cubed
4 tablespoons sour cream
freshly ground black pepper

Makes 8

For the pastry, place the flour and butter in the bowl of
a food processor and whiz until it resembles bread crumbs.
Add the sour cream and black pepper and whiz until the
dough just starts to come together; it should be soft and
a little sticky to the touch.

Turn the dough out onto a lightly floured countertop and
knead gently, shaping into a disc. Wrap in plastic wrap
and refrigerate for 30 minutes.

Meanwhile, cook the potato in a saucepan of simmering
water for 12–15 minutes or until almost cooked but still
a little firm, then drain and set aside to cool.

Heat the oil in a large heavy-bottomed saucepan over
medium heat. Add the onion and cook, stirring, for
3–4 minutes or until softened. Add the garlic and cook,
stirring, for 2–3 minutes. Transfer the mixture to a large
bowl and set aside to cool, then add the pork, pickled onion,
cheese and parsley to the bowl, season and mix together well.
Add the potato and carefully fold it through the mixture.

Preheat the oven to 400°F and line two baking sheets with
parchment paper.

On a floured countertop, divide the pastry into eight
equal portions and roll each portion out to a 5½ in round.
Divide the filling among the rounds, leaving a ⅝ in border.
Brush the edges with eggwash, then fold one side over the
other to enclose the filling and form a semi-circle. Pinch
the edges together to seal, then stand the pastie so the
join is at the top and gently push the filling down to form
a flat base.

Transfer the pasties to the prepared sheets, brush the
tops with eggwash and scatter with sesame seeds.
Bake for 30 minutes or until the pastry is golden brown
and the filling is cooked through.

Serve hot or lukewarm with tomato chutney.

MEATBALL SLIDERS WITH TOMATO CHILE SAUCE

Everyone loves sliders nowadays, and who can blame them? The following three recipes were inspired by a platter of sliders I've enjoyed on more than one occasion at a bar in the West Village in New York. If you can't get hold of fresh crabs for the crab sliders on page 239, use the tubs of fresh crab meat you can buy in some delis (just make sure you shred it well before use). I use a mandoline to finely shred the cabbage.

olive oil, for cooking
1 cup thinly sliced fontina cheese
1 large handful wild arugula leaves
20 seeded slider or baby brioche buns, halved crosswise

TOMATO CHILE SAUCE
4 teaspoons olive oil
1 onion, finely chopped
3 cloves garlic, finely chopped
1 × 28 oz can diced tomatoes
1 cup tomato passata
pinch of crushed red pepper flakes
pinch of superfine sugar
10 basil leaves, torn
sea salt and freshly ground black pepper

MEATBALLS
2 cups sourdough bread crumbs
2/3 cup milk
14 oz lean ground grass-fed beef
14 oz lean ground free-range pork
1/2 onion, finely chopped
4 cloves garlic, finely chopped
2 1/2 tablespoons flat-leaf parsley, finely chopped
1/2 cup finely shredded parmesan
pinch of grated nutmeg
4 teaspoons Worcestershire sauce
2 teaspoons wholegrain mustard
1 free-range egg
sea salt and freshly ground black pepper

Makes 20

For the sauce, heat the oil in a heavy-bottomed saucepan over medium–high heat, then add the onion and garlic and cook, stirring often, for 3–4 minutes. Add the canned tomatoes, passata, red pepper flakes, sugar and basil and simmer over low–medium heat, stirring often, for 15–18 minutes or until the sauce has reduced by about one-third. Season to taste with salt and pepper.

Meanwhile, for the meatballs, use clean hands to combine all the ingredients in a large bowl.

Divide the meatball mixture into twenty balls. Flatten them slightly and transfer to a paper-towel lined plate. Cover with plastic wrap and refrigerate for 20 minutes.

Preheat the oven to 400°F and line two baking sheets with parchment paper.

Heat 1 tablespoon oil in a large nonstick skillet over medium heat. Working in batches of five at a time, cook the meatballs for 2–3 minutes on each side or until golden brown, then transfer to the prepared sheets. When they are all browned, place the sheets in the oven and bake for 6–8 minutes. Remove and top each meatball with a slice of cheese, then return to the oven for 4–5 minutes or until the cheese has melted and the meatballs are cooked to your liking. Set aside to rest for 10 minutes.

To assemble, place the arugula leaves on the bun bases and top with a meatball. Add 4 teaspoons tomato chile sauce, then top with the bun lids and secure with a skewer.

MADE IN THE USA

L—R: MEATBALL SLIDERS WITH TOMATO CHILE SAUCE; LOBSTER SLIDERS WITH PEA MAYO; CRAB SLIDERS WITH CHIPOTLE MAYO SLAW

LOBSTER SLIDERS WITH PEA MAYO

(PICTURED PAGE 237)

16 thin slices round mild pancetta
1 bunch arugula or watercress, leaves picked
16 seeded slider or baby brioche buns, halved crosswise
8 baby vine-ripened tomatoes, sliced
10½ oz lobster meat, flaked into bite-sized pieces

PEA MAYO
pinch of superfine sugar
1 cup frozen peas
2 free-range egg yolks
4 teaspoons lemon juice
sea salt
4 tablespoons light olive oil
4 tablespoons canola oil
1 teaspoon Dijon mustard
2 teaspoons tarragon vinegar
freshly ground white pepper

Makes 16

Preheat the oven to 400°F and line a baking sheet with
parchment paper.

Spread the pancetta out on the prepared sheet and bake for
6–10 minutes or until crisp and browned, keeping an eye on
it as it cooks.

Meanwhile, for the pea mayo, half-fill a small saucepan with cold
water, add the sugar and bring to a boil. Add the peas and boil for
2 minutes, then drain and set aside to cool.

Place the egg yolks, lemon juice and a pinch of salt in the bowl of
a food processor. Process on high speed for 1 minute then, with
the motor running, add the oil in a thin, steady stream until the
mixture is thick and glossy. Add the cooled peas, mustard and
vinegar and season to taste with salt and pepper. Process again
for 1 minute until the peas are finely minced and the mayo is
a creamy pale-green color.

To assemble, place some arugula or watercress on the bun bases
and top with sliced tomato and pancetta. Add some lobster meat,
then drizzle with pea mayo. Top with the bun lids and secure with
a skewer.

CRAB SLIDERS WITH CHIPOTLE MAYO SLAW

(PICTURED PAGE 237)

5 tablespoons olive oil or rice bran oil
2 cups thinly sliced red cabbage
1 large green apple, halved, cored and cut into thin
 matchsticks, then covered in a squeeze of lemon juice
1¾ oz snowpeas, thinly sliced lengthwise
20 seeded slider or baby brioche buns,
 halved crosswise

CRAB CAKES

2 cups fresh white bread crumbs
1 lb 5 oz cooked fresh crab meat, drained and shredded
 if chunky
finely grated zest and juice of 1 lemon
2½ tablespoons salted capers, well rinsed
5 oz gherkins, drained well, very finely chopped
4 scallions, trimmed and thinly sliced
1 handful flat-leaf parsley, finely chopped
1 handful cilantro, finely chopped
2 large free-range eggs, lightly whisked
sea salt and freshly ground black pepper

CHIPOTLE MAYO

2 free-range egg yolks
4 teaspoons lemon juice
sea salt and freshly ground white pepper
½ cup light olive oil
1 teaspoon wholegrain mustard
4 teaspoons apple cider vinegar
½ teaspoon sweet paprika
4 teaspoons chipotle sauce (see page 28)

Makes 20

For the crab cakes, use clean hands to combine all the ingredients in a large bowl. Divide the mixture into twenty balls. Flatten them slightly and transfer to a paper-towel lined plate. Cover with plastic wrap and refrigerate for 20 minutes.

For the chipotle mayo, place the egg yolks, lemon juice and a pinch of salt in the bowl of a food processor. Process on high speed for 1 minute then, with the motor running, add the oil in a thin, steady stream until the mixture is thick and glossy. Add the mustard, vinegar, paprika and chipotle sauce and season to taste with pepper, then process for 20 seconds. Set aside.

Preheat the oven to 400°F and line two baking sheets with parchment paper.

Heat 1 tablespoon oil in a large nonstick skillet over medium heat. Working in batches of five at a time, cook the crab cakes for 1–2 minutes on each side until lightly golden brown (handle them carefully as they are quite delicate), then transfer to the prepared sheets. When the crab cakes are all browned, place the sheets in the oven and bake for 8–10 minutes or until golden brown and cooked through. Remove from the oven and keep warm.

Combine the cabbage, apple and snowpeas in a bowl, then add the chipotle mayo and toss to coat well.

To assemble, place the crab cakes on the bun bases, then top evenly with the slaw and the bun lids and secure with a skewer.

PRETZELS WITH CHOCOLATE AND SEA SALT

Yet another recipe inspired by a dinner in NYC, these are fab for parties:
the sea salt is a fantastic contrast to the bitter dark chocolate. Make them
as big or small as you like. Be sure to leave the pretzels in the boiling water
for only 30 seconds or they can become a little tough once baked. Serve
with small serviettes to avoid messy chocolate fingers.

1½ teaspoons light brown sugar
1½ teaspoons active dried yeast
2⅓ cups bread flour, plus extra for dusting
4 teaspoons Dutch-process cocoa powder
fine salt
olive oil, for brushing
⅓ cup baking soda
2¼ cups chopped good-quality dark chocolate
1½ teaspoons sea salt

Makes 30

Sift the sugar, yeast, flour and cocoa into a bowl with
a good pinch of salt, then add 7 fl oz warm water. Stir
to combine then, using clean hands, form into a dough.
Turn out onto a lightly floured countertop and knead
for 4–5 minutes until smooth and elastic.

Place the dough in a large bowl greased with a little olive
oil and cover with a damp kitchen towel. Set aside in
a warm place for 1–2 hours or until doubled in size.

Turn the dough out onto a lightly floured countertop
and shape into a log approximately 12 in long. Using
a sharp knife, cut into ½ in thick pieces, then roll out
each piece between your fingers to form a rope about
15 in long.

To form a pretzel shape, twist the ends of the rope loosely
together once or twice, leaving the ends apart. Take either
end of the rope and draw up and over, then press into the
center of the looped section. Moisten the join with a light
brush of water and press gently to seal. Place the pretzels
on lightly greased baking sheets (spacing them out well)
and set aside for 20 minutes to rise.

Meanwhile, preheat the oven to 350°F and line two or
three baking sheets with parchment paper.

Place 16 cups water in a large saucepan over medium–
high heat, add the baking soda and bring to a low boil.
Working one at a time, place each pretzel in the water
for 30 seconds, then remove with tongs and drain on
paper towel.

Arrange the pretzels on the prepared sheets and bake
for 35–40 minutes.

Melt the chocolate in a heatproof bowl that fits snugly
over a saucepan of simmering water, then set aside to
cool slightly.

Leave the pretzels to cool completely before dipping
them in the melted chocolate to coat. Sprinkle with
sea salt, then refrigerate until the chocolate sets.

ORANGE AND CORIANDER MARGARITAS

(PICTURED PAGE 244)

These are fantastically refreshing on a warm day. If blood oranges aren't in season, any fresh orange will be wonderful. I use fine French Celtic salt to rim the glasses, but you can use any type of fine salt.

½ teaspoon coriander seeds
juice of 4 limes
juice of 8 blood oranges
½ cup tequila
4 tablespoons Cointreau
2 teaspoons light agave nectar (see page 10)
crushed ice and bitters, to serve

Makes 4

Place the coriander seeds in a small skillet over low heat.
Cook for 30–40 seconds or until fragrant, then crush using
a mortar and pestle.

Place the lime and orange juices, tequila, Cointreau and agave nectar
in a blender and blitz for a few seconds to combine. Add the crushed
coriander, then transfer to the fridge to chill for 30 minutes.

Strain the cocktail mixture into a pitcher. Fill four glasses with crushed ice,
then pour over the cocktail and add a dash of bitters to each.

THE RED BARON

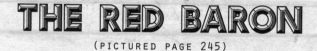

(PICTURED PAGE 245)

This recipe was given to me by my mate, Andy Lawrence.
We met through work – he's a digital operator and fantastic
photographer – and he's assisted me with some of the shots
for this book. He's a great guy to work with.

During a cocktail party at my place, Andy, who's worked in bars
in the past, came up with this cracker. It's a take on a Bloody Mary,
minus the vodka. Feel free to add tequila to the mix, too, if you like
something a little stronger.

fine salt
1 lime, quartered
ice cubes
¾ cup tomato juice
Worcestershire sauce
Tabasco sauce
sea salt and freshly ground black pepper
1 × 11.2 fl oz bottle Corona

Makes 1

Sprinkle some salt on a plate and spread out evenly. Rub a lime quarter around
the rim of a glass, then dip the rim into the salt.

Add 3–4 ice cubes to the glass and squeeze in the lime juice. Add the tomato
juice, a couple of dashes each of Worcestershire sauce and Tabasco and a little
salt and pepper and stir well.

Top the glass up with Corona, and continue to do so as you drink.

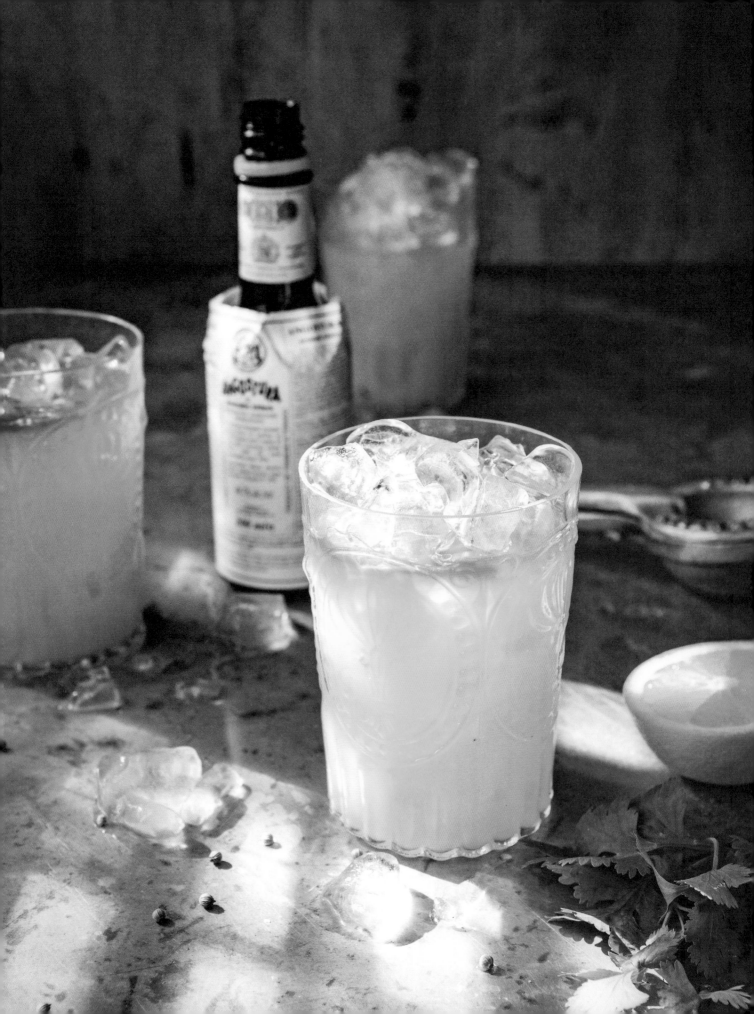

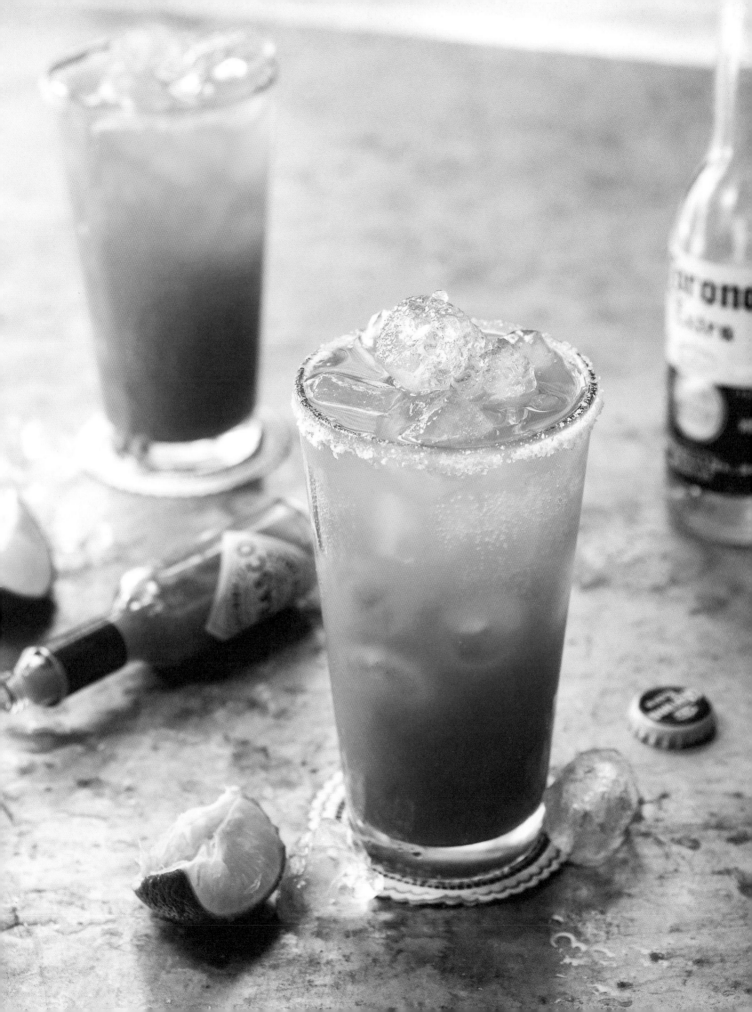

RASPBERRY AND POMEGRANATE 'MARTINIS'

(PICTURED PAGE 248)

These are great for a girly get-together; they look fab and super-pretty.
Use the best vodka you can get — I use an Aussie brand called 666;
the quality is fantastic and the bottle is rather cool, too.

$4\frac{1}{2}$ oz raspberries
4 tablespoons vodka
juice of 1 lime
1 tablespoon sugar syrup (see opposite)
$2\frac{1}{2}$ tablespoons pomegranate juice
1 handful crushed ice
pomegranate seeds and lemon or lime zest, to garnish

Makes 2

Set aside four or five raspberries for the garnish, then blend
the remainder to a smooth puree in a blender. Push through
a fine-meshed sieve into a bowl and discard the seeds.

Place the puree in a chilled cocktail shaker with the vodka,
lime juice, sugar syrup, pomegranate juice and crushed ice.
Close the shaker and mix well to combine.

To serve, strain the cocktail into a glass and garnish
with the reserved raspberries, pomegranate seeds
and lemon or lime zest.

BASIL JALAPEÑO MARGARITAS

(PICTURED PAGE 249)

The jalapeño-infused tequila and sugar syrup recipes here make enough for over thirty cocktails, so they're great for parties. You'll need to make the jalapeño-infused tequila two days ahead of time to allow the flavors to infuse. If you don't use it all, it will keep for up to three months in a sterilized jar, however, it does get stronger the longer the chiles are in the tequila, so it's best to remove and discard the chiles after a week or so unless you like rocket-fuel heat!

1 lime, quartered
7–8 large mint leaves, roughly torn
4–5 large basil leaves, roughly torn, plus extra to garnish
1 tablespoon white tequila
1 handful crushed ice
ice cubes, to serve

JALAPEÑO-INFUSED TEQUILA
2 cups white tequila
2–3 jalapeño chiles, seeded and halved lengthwise

SUGAR SYRUP
½ cup superfine sugar

Makes 2

For the jalapeño-infused tequila, place the white tequila and chiles in a jar with a screw-top lid. Seal tightly and set aside to infuse for 2 days before using.

For the sugar syrup, place the sugar and ½ cup water in a heavy-bottomed saucepan and bring to a boil, stirring so the sugar dissolves. Reduce the heat to medium and simmer, stirring constantly, for 2 minutes, then set aside to cool completely.

Squeeze the lime quarters into a chilled cocktail shaker, then toss the quarters in as well. Add the herbs and bash everything together with a cocktail muddler or the end of a rolling pin. Add the white tequila, 2 tablespoons of the jalapeño-infused tequila and 4 teaspoons of the sugar syrup, along with a good handful of crushed ice. Close the shaker and mix well to combine.

To serve, strain the cocktail into two glasses half-filled with ice cubes and garnish with extra basil leaves.

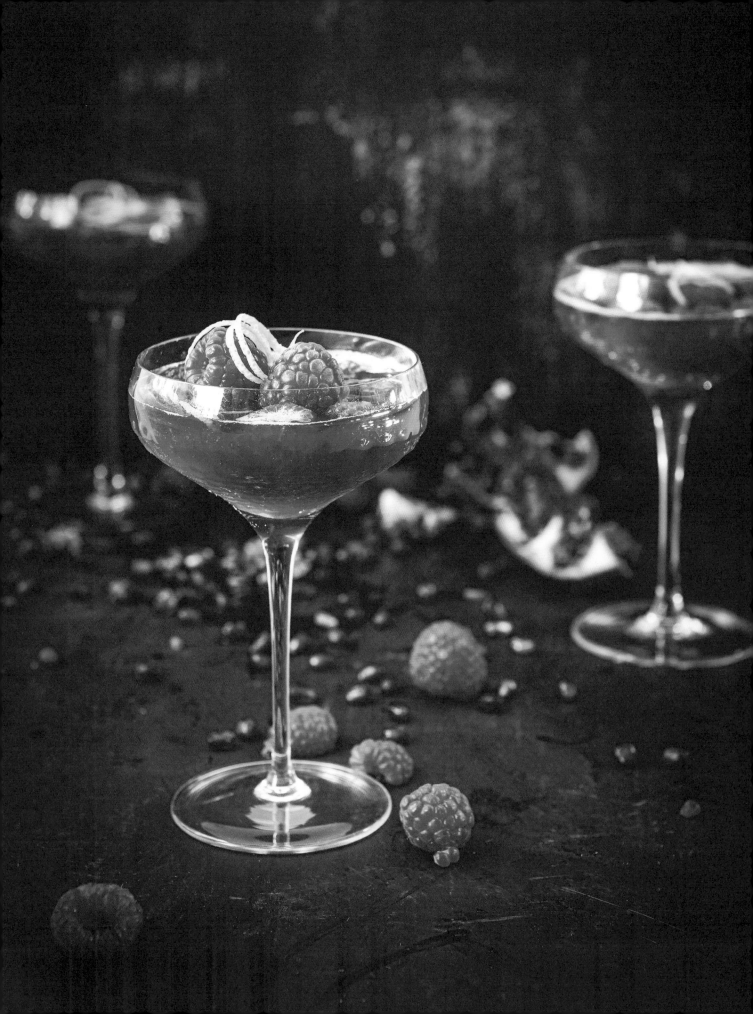

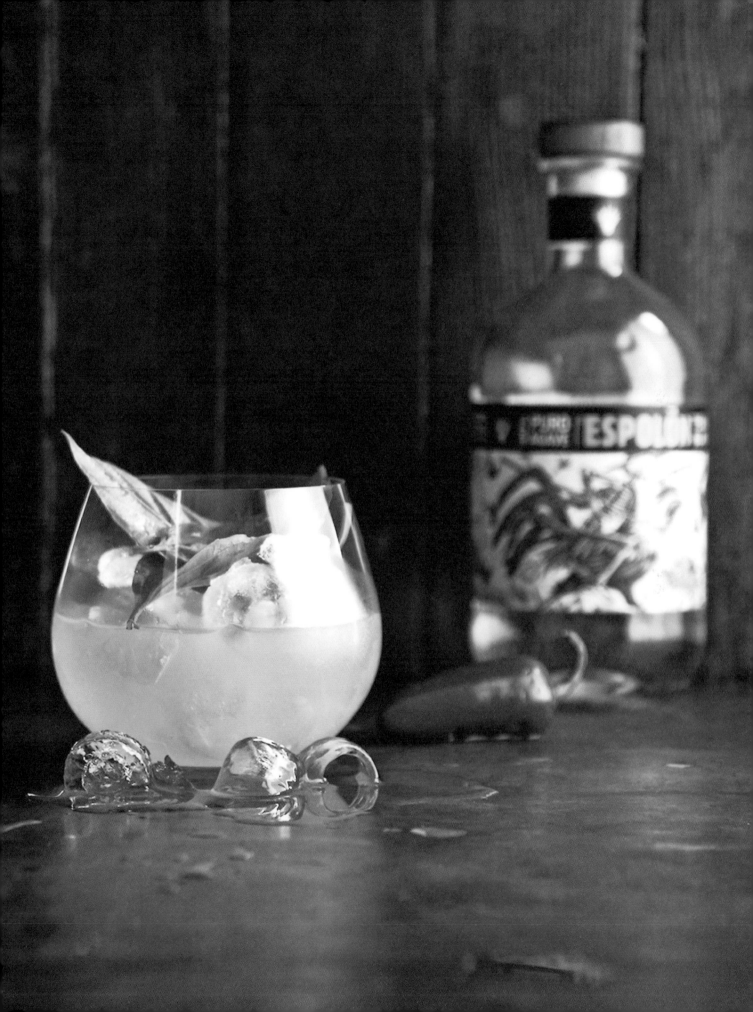

A MEXICAN WEEKEND AT MY PLACE

El malo

Blanco

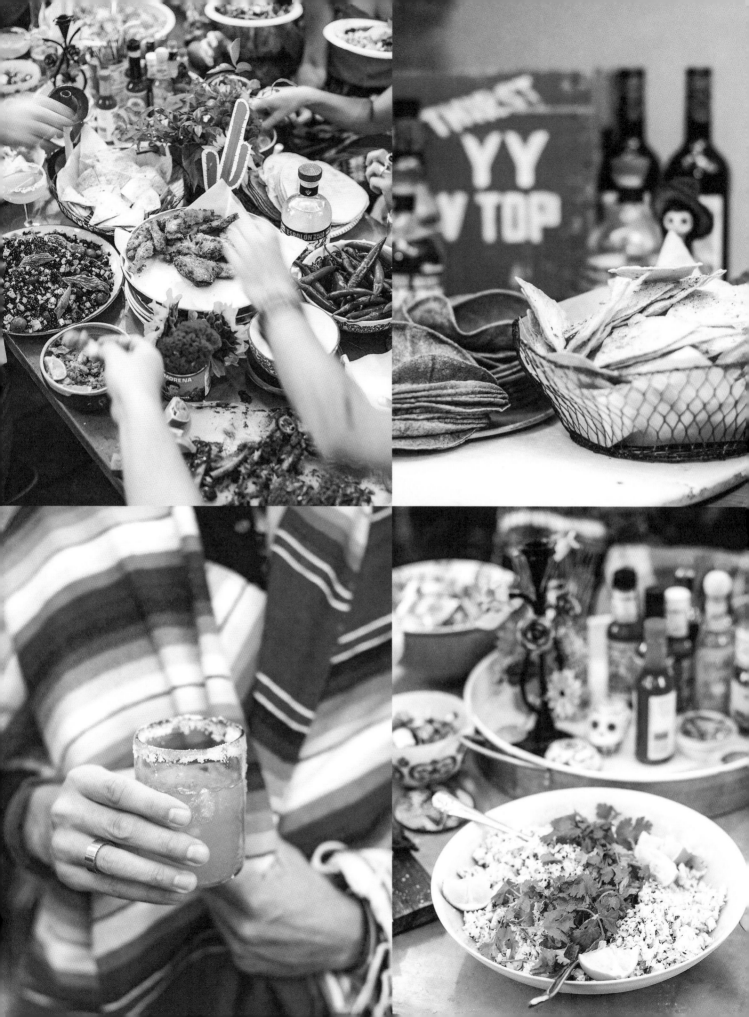

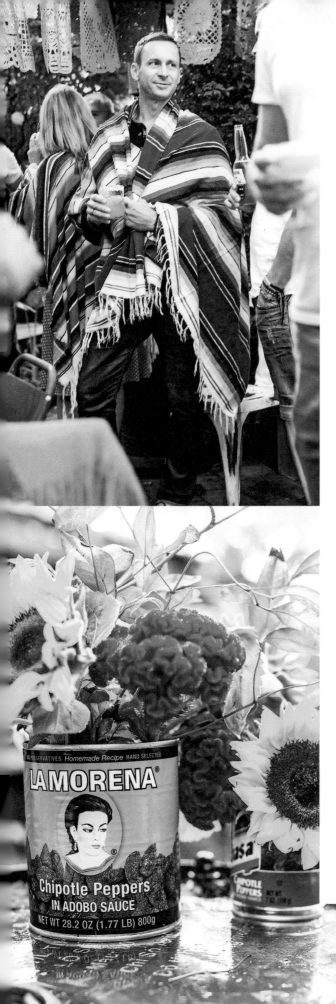

My photography producer Sophie Penhallow is a top girl. She's witty and fun and ridiculously wise beyond her years. Her advice (personal and professional) is always bang-on and she's been amazing to work with over the past three years that her agency, Network, has represented me. So, when I heard Sophie was turning thirty, I decided it was only fitting to throw her a bit of a celebratory birthday bash at my place. Seeing as she's crazy about Mexican food, and there are a few Mexican-inspired dishes in the book (as I've recently gone a bit nuts for all things to do with Mexican food myself), we all got together and had a bit of a fiesta – *arriba!*

With Sydney weather being a little unpredictable at times, especially in autumn, the overall feel of Mexico was somewhat lacking as it rained intermittently the whole day (sad/annoyed face!), but we didn't let that dampen our spirits and partied on from early afternoon until the wee hours.

No Mexican party is complete without a good old piñata-bashing session! Two of my younger blog followers were there, Georgia (fifteen) and Maddie (twelve). They are mad fans of my first book and I was thrilled to meet them. They were a delight to have around and bashed the piñata with incredible gusto – it was hilarious to watch.

Again, I couldn't have done all this without my assistant, Alice, and help with the styling from Lou Brassil, who sourced props for the day from a fantastic vintage furniture store in Sydney called Doug Up On Bourke. We also found loads of funky Mexican accessories at Holy Kitsch.

Websites of interest:

douguponbourke.com.au
holykitsch.com.au

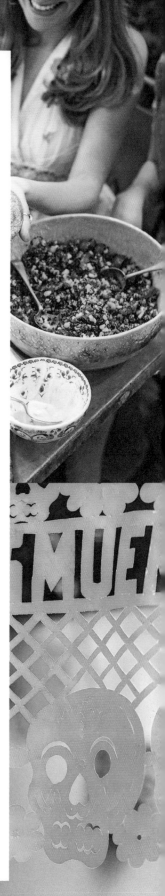

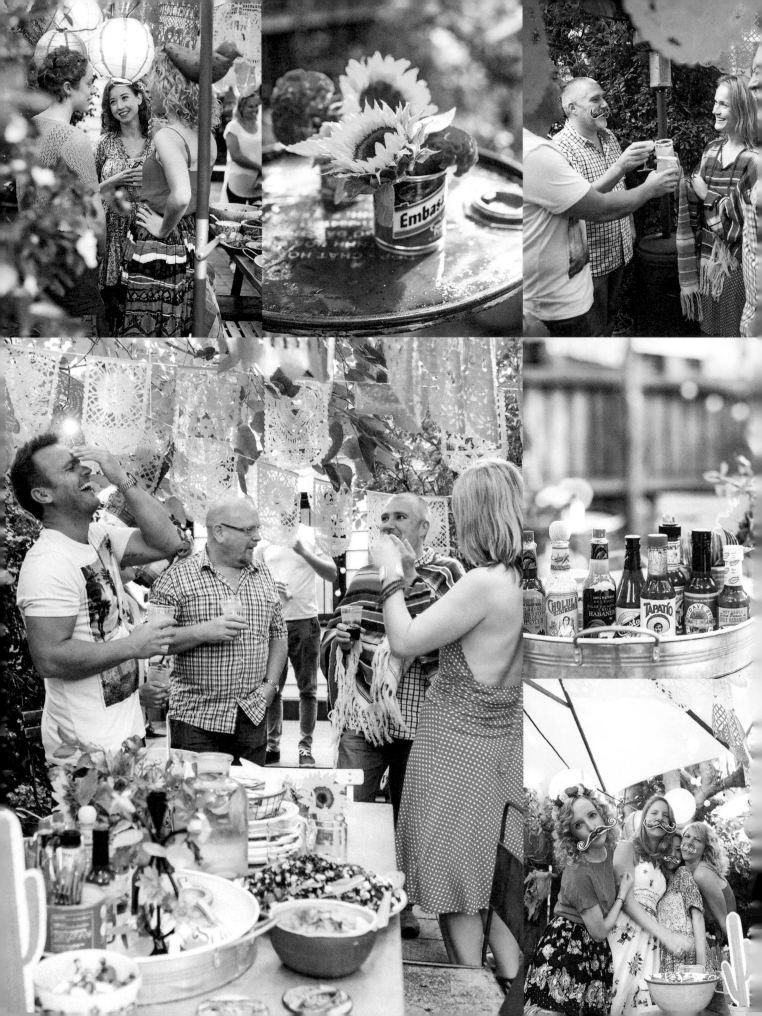

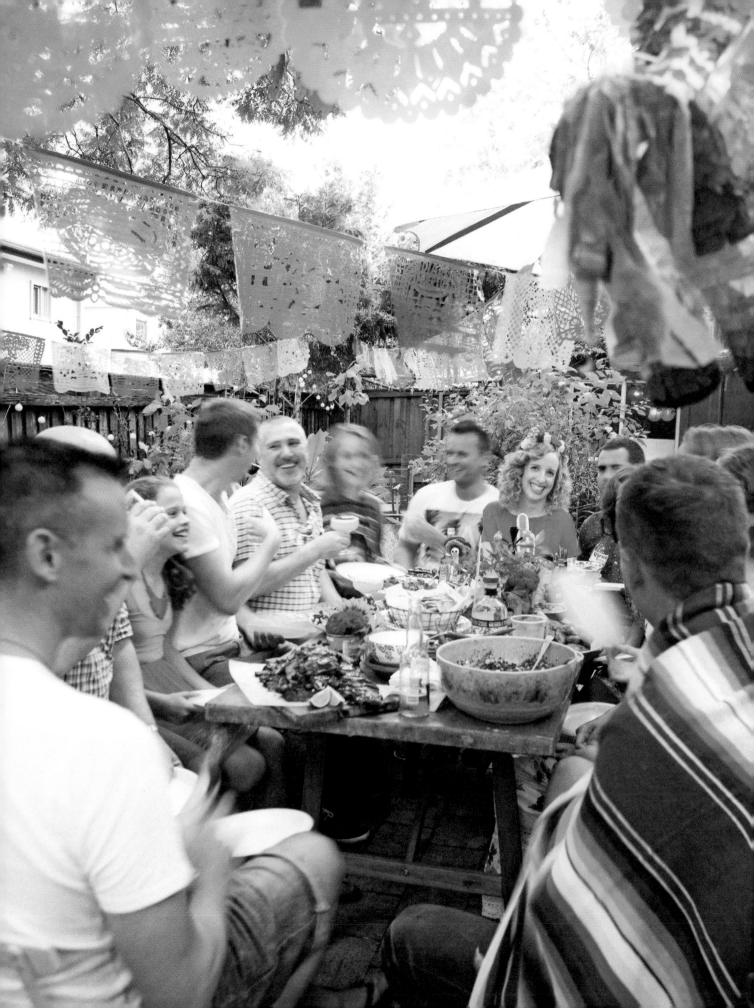

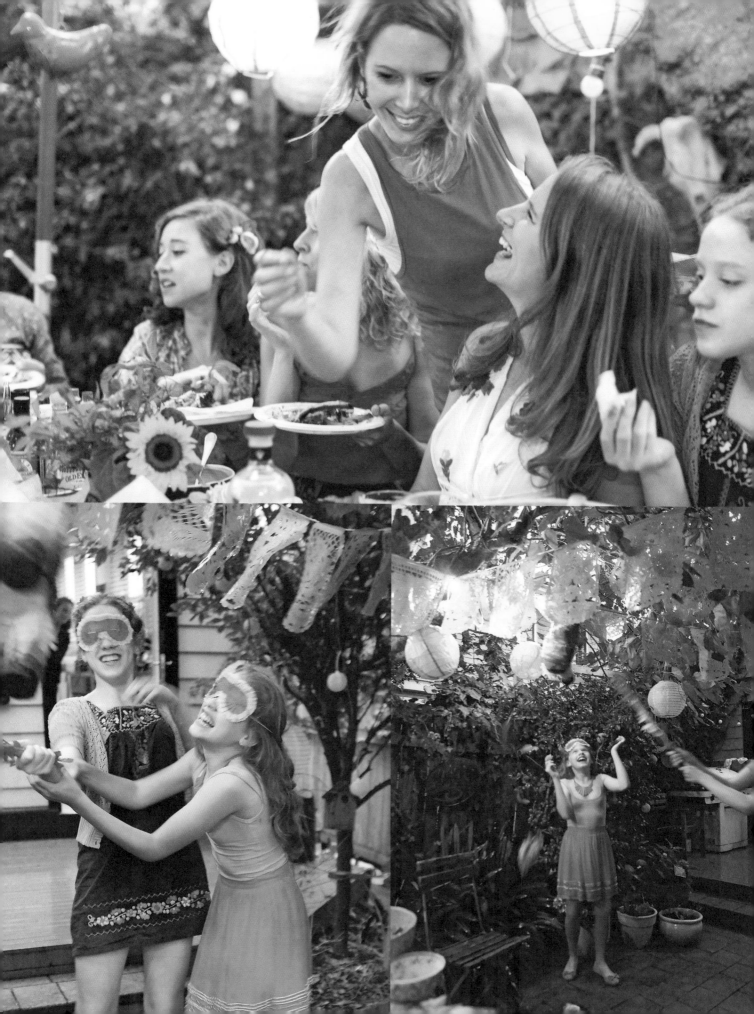

SWE

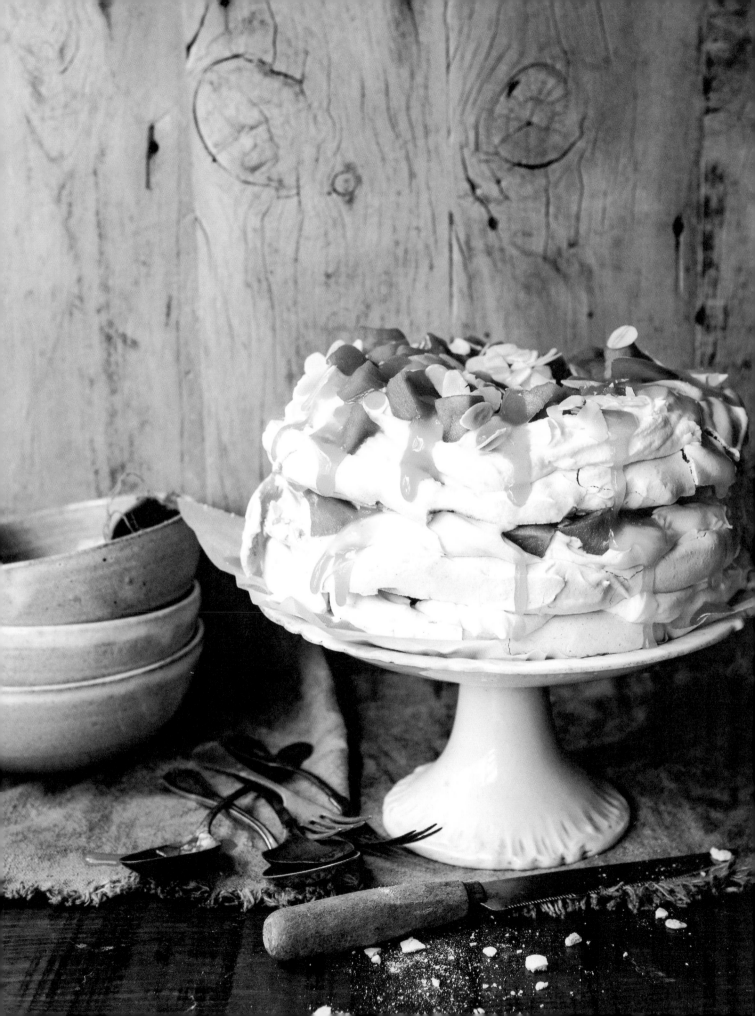

SPICED APPLE AND SALTED BUTTERSCOTCH PAVLOVA

This one's a bit of a show-stopper! Pavlovas are actually pretty easy to make once you get a bit of practice in. Use an appropriate-sized bowl as a template when drawing the rounds on the parchment paper.

confectioner's sugar, for dusting
½ lemon
6 free-range egg whites
10½ oz superfine sugar
fine salt
1 teaspoon white vinegar
1 teaspoon cornstarch
1 teaspoon cream of tartar
1 teaspoon ground cinnamon
1 cup mascarpone
1¼ cups heavy cream
1 quantity Salted Butterscotch (see page 283)
1 cup sliced blanched almonds, toasted

SPICED APPLE

5 large green apples, peeled and cored,
 cut into ¾ in cubes
1 cup prosecco or other sparkling
 white wine
⅓ cup firmly packed light brown sugar
1 star anise
1 teaspoon ground cinnamon
5 cloves
1 vanilla bean, split and seeds scraped

Serves 8

Preheat the oven to 325°F and line three baking sheets with parchment paper.

Draw an 8 in circle on each sheet of paper with a pencil and dust the inside of each circle with confectioner's sugar to stop the meringue from sticking.

Wipe the inside of the bowl of a stand mixer with the cut-side of the lemon to remove any traces of oil. Add the egg whites and whisk on medium speed for 2–3 minutes or until voluminous and frothy. Increase the speed to high and add the sugar, a tablespoon at a time, beating after each addition until the mixture is thick and glossy and holds firm peaks.

Add the salt, vinegar, cornstarch, cream of tartar and cinnamon and fold in gently to combine.

Dot a small amount of meringue mixture on the undersides of each corner of the parchment paper on the sheets to hold it in place. Divide the meringue mixture among the three trays, mounding it onto the paper within the circles. Flatten the tops and smooth the sides, then transfer to the oven. Immediately reduce the oven temperature to 275°F and bake for 1¼ hours.

Leave the meringues in the switched-off oven to cool completely with the door slightly ajar.

Meanwhile, for the spiced apple, place all the ingredients in a heavy-bottomed saucepan along with ½ cup water. Stir to combine, then bring to a boil over high heat. Reduce the heat to low–medium and simmer for 6–7 minutes or until the apple is starting to soften but is still holding its shape.

Remove the apple with a slotted spoon and set aside. Discard the star anise, cloves and vanilla bean, then simmer the remaining liquid over low–medium heat for about 15 minutes or until reduced to a syrupy glaze.

Stir the glaze through the reserved apple and set aside to cool completely.

Whip the mascarpone and cream together until thick and smooth.

To assemble, spread one-third of the cream mixture over the first meringue, top with one-third of the spiced apple, drizzle with one-third of the salted butterscotch and scatter with one-third of the almonds. Gently sandwich a second meringue on top and repeat the layering twice more. Serve immediately.

VANILLA PANNA COTTA WITH RHUBARB AND ROSE COMPOTE

A brilliant dinner-party dessert, this is incredibly easy to prepare and you can make it the night before so it's ready to whip out of the fridge after dinner. Feel free to top with other stewed fruits depending on what is in season.

3 sheets gold-strength gelatin
12 fl oz heavy cream
12 fl oz milk
⅓ cup superfine sugar
1 vanilla bean, split and seeds scraped

RHUBARB AND ROSE COMPOTE
1 pound 7 ounces rhubarb, trimmed and cut into 1½ in lengths
½ cup red wine
finely grated zest of 1 orange
2½ tablespoons honey
4 teaspoons rosewater
1 sheet gold-strength gelatin
1 teaspoon superfine sugar (optional)

Makes 4

Place the gelatin sheets in a bowl and cover with cold water. Leave to stand for 5 minutes to soften.

Meanwhile, combine the cream, milk, sugar and vanilla seeds in a heavy-bottomed saucepan. Bring to just below a simmer over low–medium heat, then cook for 5 minutes, stirring often and taking care not to let the mixture boil.

Squeeze out the excess water from the gelatin, then add to the pan and stir over low heat until dissolved. Remove from the heat and set aside to cool for 10 minutes, then pour into four serving glasses and refrigerate for 3–4 hours.

Meanwhile, for the compote, preheat the oven to 400°F.

Place the rhubarb in a roasting pan just large enough to hold it in a single layer. Add the red wine, orange zest, honey and rosewater and cover with foil. Pop into the oven and bake for 15–20 minutes or until the rhubarb is just tender but still holds its shape.

Drain the rhubarb through a sieve placed over a small saucepan to catch the cooking liquid. Set the rhubarb aside to cool completely.

Place the gelatin sheet in a bowl and cover with cold water. Leave to stand for 5 minutes to soften.

Place the saucepan containing the poaching liquid over medium–high heat and bring to a boil. Reduce the heat to medium and simmer for 1–2 minutes or until reduced to approximately ⅓ cup of liquid.

Squeeze out the excess water from the gelatin and add to the pan, then stir over low heat until dissolved. Taste the syrup; if it is very tart, stir in the sugar. Remove from the heat and set aside to cool for 15 minutes.

Spoon 4 teaspoons of the syrup over each of the set panna cottas, then divide the rhubarb among the glasses. Refrigerate for 1 hour or until the syrup has set, then serve.

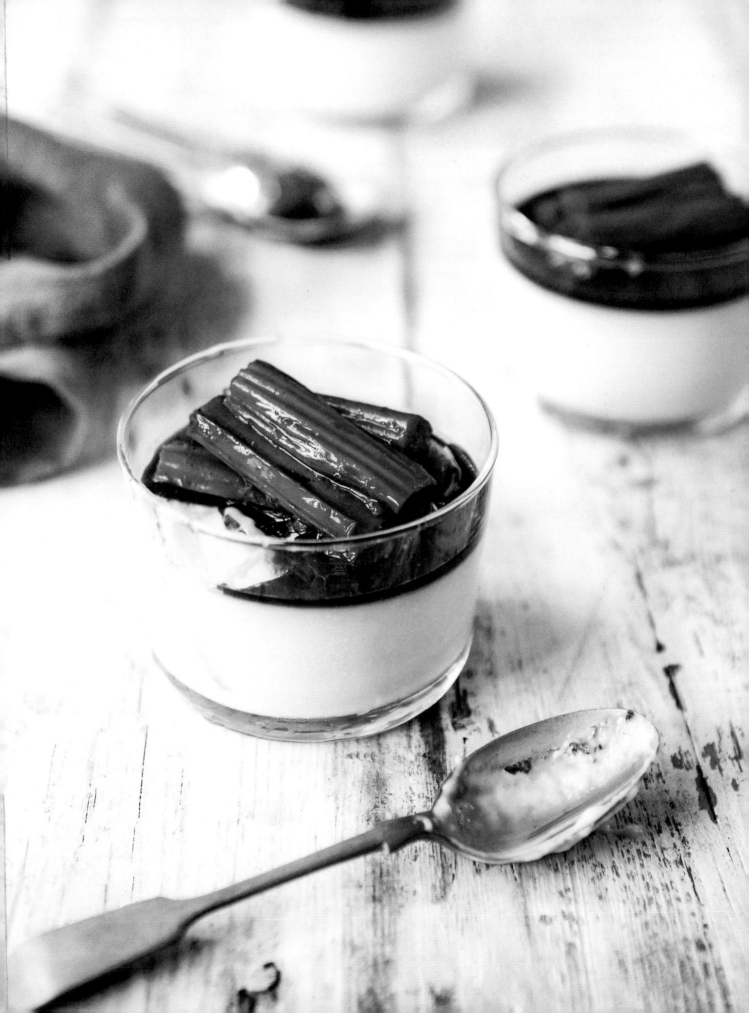

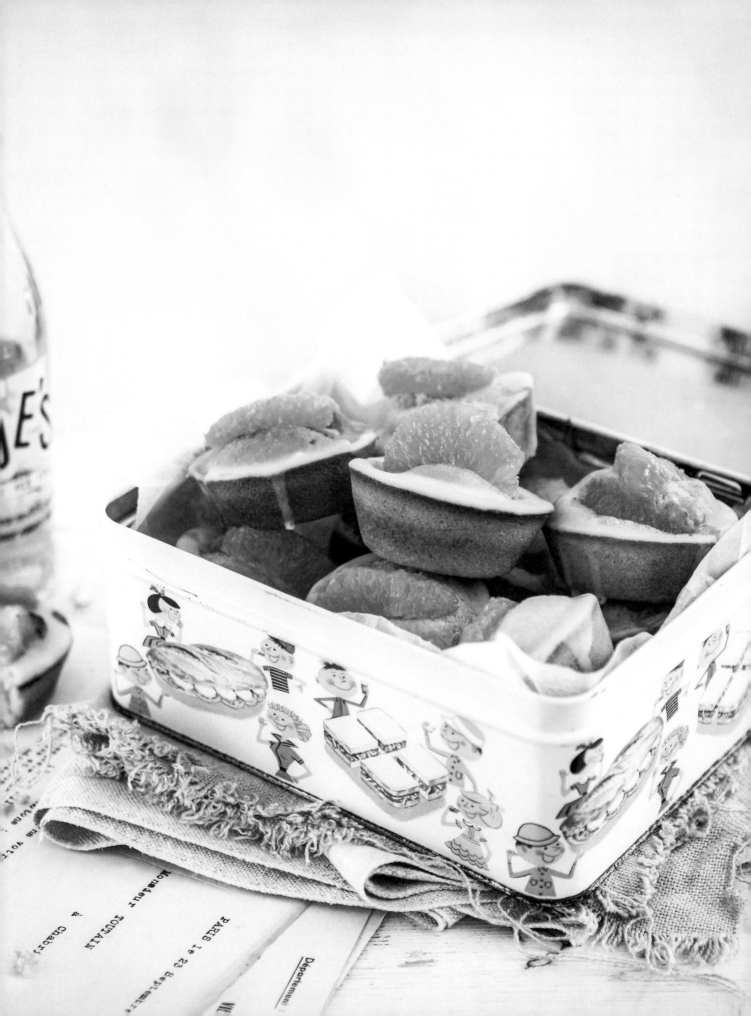

PINK GRAPEFRUIT, TARRAGON AND CINNAMON FRIANDS

I love making friands as they are so quick and easy, and great for morning tea. Tarragon works really well with grapefruit, and the latter adds a nice zing to these little almondy cakes. In Australia, these little almond cakes are known as friands. If you can, try to find a silicone financier pan to make this even easier, or use a regular muffin pan.

1½ sticks unsalted butter
3 pink or ruby-red grapefruit
⅔ cup all-purpose flour
1 cup almond meal
½ teaspoon ground cinnamon
2⅓ cups confectioner's sugar
6 free-range egg whites
5–6 tarragon leaves, very finely chopped

Makes 12

Preheat the oven to 400°F and grease twelve cups of a friand, financier or cupcake pan.

Melt the butter in a small saucepan, then set aside to cool.

Meanwhile, finely grate the zest from one grapefruit, then peel and segment this and one more grapefruit, and set the zest and segments aside. Juice the remaining grapefruit and set aside.

Sift the flour, almond meal, cinnamon and 2 cups, plus 2 tablespoons of the confectioner's sugar into a large bowl, and make a well in the center.

In another bowl, whisk the egg whites with a fork for 30 seconds or until frothy. Add to the dry ingredients, along with the cooled melted butter, and beat to combine thoroughly with a wooden spoon. Add the tarragon and reserved zest and combine, then transfer the batter to a pitcher.

Pour the batter into the prepared friand cups, filling each just over halfway. Bake for 20–25 minutes or until lightly browned. Remove from the oven and leave to cool in the pan for 10 minutes before turning out onto a cooling rack to cool completely. Spread out a sheet or two of foil under the rack to catch any icing that may drip down.

Sift the remaining confectioner's sugar into a bowl, add 3 tablespoons grapefruit juice and blend until smooth. Spoon the icing over the cooled friands and leave to set for 1–2 minutes before topping each one with a grapefruit segment.

CHOCOLATE AND HAZELNUT GELATO

(PICTURED PAGE 272)

The following two gelato recipes were given to me by my gorgeous assistant and all-round lifesaver, Alice. She has written a book or two on ice creams and gelatos, and these soft-serve style ones are particularly good. You'll need a candy thermometer and an ice-cream maker for both these recipes.

1 cup hazelnuts
½ cup heavy cream
2 cups milk
3 tablespoons Dutch-process cocoa powder, sifted
⅓ cup chopped good-quality milk chocolate
⅓ cup chopped good-quality dark chocolate
⅔ cup superfine sugar
1 free-range egg white
4 teaspoons Frangelico (optional)

Serves 4

Preheat the oven to 400°F.

Spread the hazelnuts evenly on a baking sheet and roast for 10 minutes or until golden and aromatic. Wrap the hot nuts in a clean kitchen towel and rub to remove the skins, then coarsely chop and place in a heavy-bottomed saucepan.

Add the cream and milk to the pan and place over low–medium heat, then bring to just below boiling point. Remove from the heat and add the cocoa and chopped chocolate, then whisk until the chocolate has melted and the mixture is smooth. Transfer to a heatproof bowl and set aside to cool, leaving the chopped hazelnuts in the mixture to steep.

Combine the sugar and 4 tablespoons water in a small, heavy-bottomed saucepan and bring to a boil, stirring regularly. Cook for 2–3 minutes or until the sugar has dissolved and the temperature registers 235°F on a candy thermometer.

Meanwhile, whisk the egg white in a stand mixer on high speed for 2 minutes. With the motor running, slowly pour in the hot sugar syrup; it will be voluminous and fluffy once incorporated. Continue whisking for 5–8 minutes or until the mixture is at room temperature.

Strain the hazelnut and chocolate mixture through a fine-meshed sieve into a bowl and discard the hazelnuts. Stir in the Frangelico, if using, and add to the egg white mixture. Whisk briefly until just incorporated. Transfer to a plastic container with a lid and refrigerate for 2–3 hours (or overnight) to chill completely.

Remove from the fridge and briefly whisk to combine in case the mixture has separated, then transfer to the bowl of an ice-cream maker and churn until frozen. Freeze for 1–2 hours before serving. It will keep in the freezer for 3–4 days.

BUTTERMILK GELATO

(PICTURED PAGE 273)

4 tablespoons heavy cream
1 cup milk
1 vanilla bean, split
¾ cup superfine sugar
1 free-range egg white
2 cups buttermilk

Serves 4–6

Place the cream, milk and vanilla bean in a small heavy-bottomed saucepan over low–medium heat and bring to just below boiling point. Remove from the heat and set aside to cool.

Combine the sugar and 4 tablespoons water in a small, heavy-bottomed saucepan and bring to a boil, stirring regularly. Cook for 2–3 minutes or until the sugar has dissolved and the temperature registers 235°F on a candy thermometer.

Meanwhile, whisk the egg white in a stand mixer on high speed for 2 minutes. With the motor running, slowly pour in the hot sugar syrup; it will be voluminous and fluffy once incorporated. Continue whisking for 5–8 minutes or until the mixture is at room temperature, then add the buttermilk and mix just until incorporated.

Discard the vanilla bean from the milk mixture and add to the egg-white mixture. Whisk for about 20 seconds or until combined.

Transfer to a plastic container with a lid and refrigerate for 2–3 hours (or overnight) to chill completely.

Remove from the fridge and briefly whisk to combine in case the mixture has separated, then transfer to the bowl of an ice-cream maker and churn until frozen.

This is best served immediately, although it will keep in the freezer for up to 4 days. It is delicious served with fresh berries or a fruit sorbet.

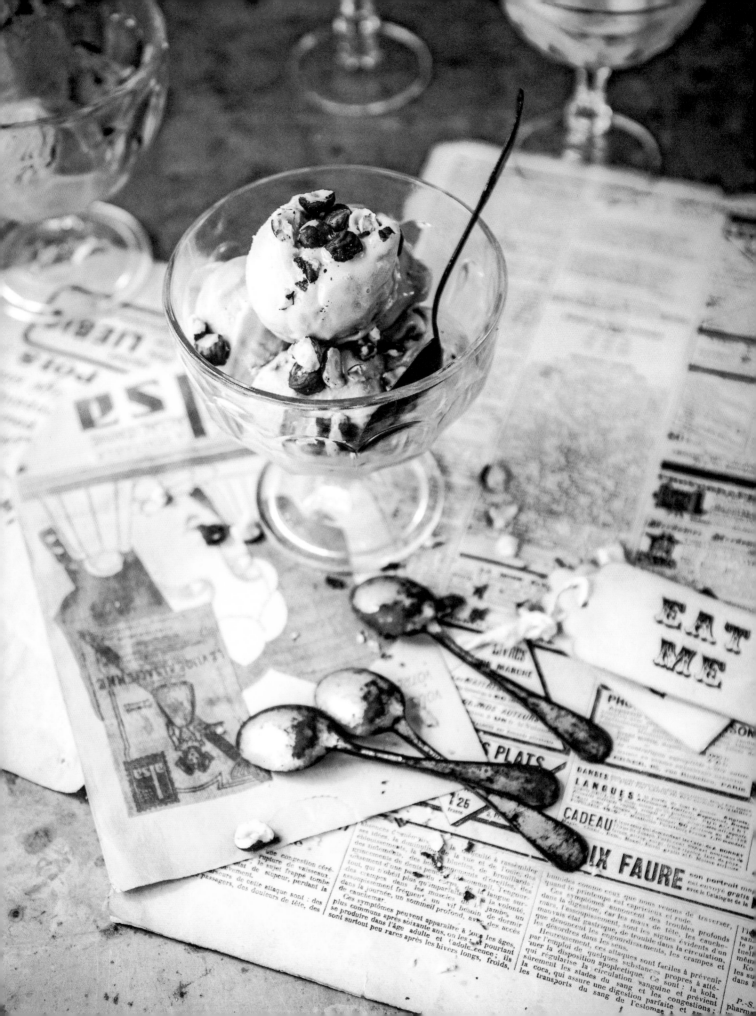

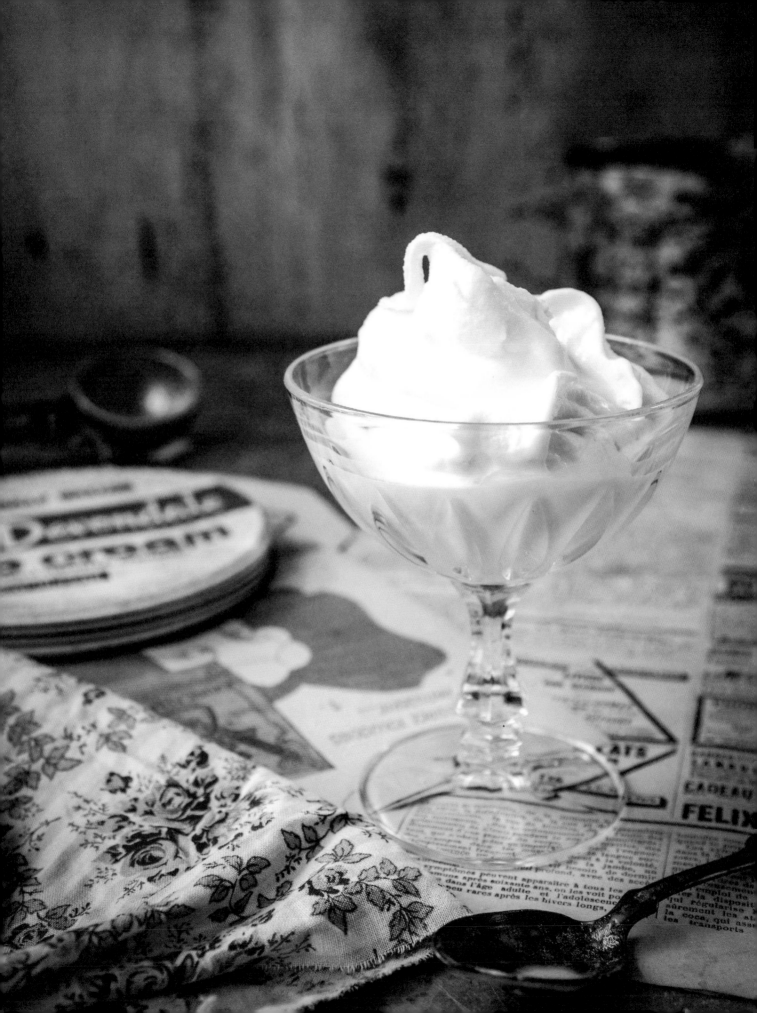

APPLE AND BLACKBERRY HAZELNUT CRUMBLE SQUARES

Another great picnic or school lunch box idea, these squares will keep in an airtight container in the fridge for up to 3 days.

⅔ cup chilled unsalted butter, chopped
2 cups all-purpose flour, sifted
¾ cup superfine sugar
1 free-range egg, lightly whisked
1 teaspoon natural vanilla extract
2 green apples, peeled, cored and chopped
9 oz fresh or frozen blackberries (thawed if frozen)
juice of 1 lime

HAZELNUT CRUMBLE
½ cup all-purpose flour
7 tablespons chilled unsalted butter, chopped
⅓ cup firmly packed light brown sugar, plus
 2½ tablespoons extra, for sprinkling
½ cup rolled oats
¾ cup toasted skinned hazelnuts (see page 164), chopped
½ teaspoon ground ginger

Serves 12

Whiz the butter, flour and ½ cup of the sugar in the bowl of a food processor until the mixture resembles fine bread crumbs. Add the egg and vanilla and whiz again to combine. Shape the dough into a ball, then wrap in plastic wrap and refrigerate for 20 minutes.

Meanwhile, place the apple, blackberries, lime juice, remaining sugar and ½ cup water in a large, heavy-bottomed saucepan. Bring to a boil, then reduce the heat to medium and simmer for 15–20 minutes or until the apple is soft and most of the liquid has evaporated. Remove from the heat and leave to cool, then puree with an immersion blender until smooth. Set aside.

Preheat the oven to 400°F and grease and line a 12 in × 9 in baking pan with parchment paper.

For the crumble, whiz the flour and butter in the bowl of a food processor until the mixture resembles coarse bread crumbs. Add the remaining ingredients and pulse to just combine, then set aside.

Remove the dough from the fridge, unwrap and flatten into a disc. Place between two pieces of parchment paper and roll out to a 12 in × 9 in rectangle, then use to line the pan.

Prick the base all over with a fork, then bake for 20 minutes or until it is starting to brown. Leave to cool for 5 minutes, then spread the pureed fruit mixture over the base. Scatter over the crumble, then sprinkle with the extra brown sugar. Bake for 25–30 minutes or until the crumble top is golden. Allow to cool in the pan for 30 minutes or until firm, then cut into squares and serve.

GLUTEN-FREE LEMON AND COCONUT CAKE

This cake was a massive hit on the blog when I featured it a while back, so I just had to include it, plus I adore the shot; it's one of my faves. If you like, you can cut the cake in half widthways and sandwich together using half the frosting, then top with the remaining frosting, or just frost the whole cake as I've done here. You can buy gluten-free flour and coconut flour from health food stores.

3 tablespoons, plus 1 teaspoon coconut flour
¾ cup gluten-free all-purpose flour
1 teaspoon baking powder
⅔ cup unsalted butter, softened
¾ cup superfine sugar
3 free-range eggs
4 teaspoons milk
4 tablespoons lemon juice
⅓ cup sour cream
2 cups shaved coconut flakes

LEMON CREAM-CHEESE FROSTING
1 cup cream cheese, softened
2 cups confectioner's sugar, sifted
finely grated zest of 1 lemon
1 tablespoon lemon juice

Serves 8

Preheat the oven to 350°F and grease and line a 7 in springform cake pan.

Sift the flours and baking powder into a bowl and set aside.

Cream the butter and sugar in a stand mixer for 8–10 minutes or until light and fluffy. Add the eggs, one at a time, beating after each addition. Add the milk, lemon juice, sour cream and sifted dry ingredients and beat on low–medium speed until smooth and combined.

Spoon into the prepared pan and smooth the top. Place on the center shelf of the oven and bake for 15 minutes, then increase the oven temperature to 400°F and bake for a further 30–35 minutes or until a skewer comes out clean when inserted in the center.

Remove from the oven and leave to cool in the pan for 15 minutes before turning out onto a cooling rack to cool completely.

For the frosting, beat the cream cheese in a stand mixer for 2–3 minutes. Add the confectioner's sugar, lemon zest and juice and beat for 5–6 minutes until light, thick and creamy. Transfer to a bowl, cover with plastic wrap and chill in the fridge for 1 hour to thicken.

Spread the frosting over the top and sides of the cooled cake, then cover with shaved coconut and serve immediately.

SELF-SAUCING MOCHA PUDDING

If you're a chocaholic who loves gooey, fudgy choctastic baked puddings, then this one's for you! Serve it warm with heavy cream or a good vanilla ice cream.

⅔ cup all-purpose plain flour
2 teaspoons baking powder
4 tablespoons Dutch-process cocoa
⅓ cup firmly packed light brown sugar
1½ tablespoons strong espresso coffee
7 tablespoons milk
1 free-range egg
3 tablespoons unsalted butter, melted
1½ tablespoons creme de cacao (optional)
heavy cream or vanilla ice cream, to serve

MOCHA SAUCE
⅓ cup firmly packed brown sugar
4 teaspoons Dutch-process cocoa powder, sifted
1 teaspoon espresso instant coffee powder
1 cup boiling water

Serves 4

Preheat the oven to 400°F and butter a 4 cup capacity souffle mold or deep baking dish.

Sift the flour, baking powder and cocoa into a large bowl, then add the sugar and stir to combine. Add the coffee, milk, egg, melted butter and creme de cacao, if using, and stir to combine thoroughly with a wooden spoon. Pour into the prepared mold and place on a baking sheet.

For the sauce, place the sugar, cocoa and coffee powder in a bowl and stir to combine. Scatter evenly over the batter, then pour the boiling water over the top.

Bake for 25–30 minutes or until the pudding has risen and the sauce bubbles up around the sides. Serve warm with cream or vanilla ice cream.

VICTORIA SPONGE CAKE WITH LIMONCELLO AND BALSAMIC STRAWBERRIES

This is my take on the classic English "4, 4, 4 and 2" Victoria sponge cake recipe that my mom used to make. Strawberries pair very well with lemon, and this recipe uses the Italian lemon liqueur, limoncello, which you'll find at Italian delis and selected liquor stores.

1½ sticks unsalted butter, softened
¾ cup superfine sugar
3 free-range eggs
1 teaspoon pure vanilla extract
1 cup, plus 2 tablespoons flour, sifted
4 teaspoons milk
4 teaspoons limoncello or 2 teaspoons lemon juice
8 oz mascarpone
7 tablespoons heavy cream
confectioner's sugar, for dusting

LIMONCELLO AND BALSAMIC STRAWBERRIES
14 oz strawberries, hulled and quartered
2½ tablespoons superfine sugar
2½ tablespoons limoncello or 4 teaspoons lemon juice
2 teaspoons balsamic vinegar
1 small handful mint, finely chopped

Serves 8

Preheat the oven to 400°F fan-forced and grease and line 2 × 8 in springform cake pans.

Cream the butter and sugar in a stand mixer for 5–6 minutes or until pale and creamy. Add the eggs, one at a time, beating after each addition.

Add the vanilla and half the flour and beat until incorporated. Add the milk and limoncello or lemon juice and beat to combine, then add the remaining flour and beat until combined.

Divide the batter between the prepared pans and smooth the tops, then gently tap the pan on the countertop to remove any air bubbles. Bake for 20–25 minutes or until the tops are golden brown and a skewer comes out clean when inserted into the center of each cake.

Remove from the oven and leave the cakes to cool in the pans for 5 minutes, before turning out onto cooling racks to cool completely.

Meanwhile, for the limoncello strawberries, place the strawberries, sugar, limoncello or lemon juice and balsamic vinegar in a small heavy-bottomed saucepan. Bring to a boil over high heat, then reduce the heat to low, add the mint and simmer for 2–3 minutes (the strawberries should be soft but still holding their shape).

Drain the strawberry mixture, reserving the syrup. Set the strawberries aside in a bowl. Return the syrup to the pan and place over medium heat. Simmer until reduced by half, then pour over the strawberries and leave to cool completely.

Whisk together the mascarpone and cream until smooth and thick enough to hold its shape. Spread the mascarpone cream over one sponge cake and place on a serving platter large enough to catch any juices from the filling. Top with the strawberry mixture, then sandwich the second sponge cake on top and dust liberally with confectioner's sugar.

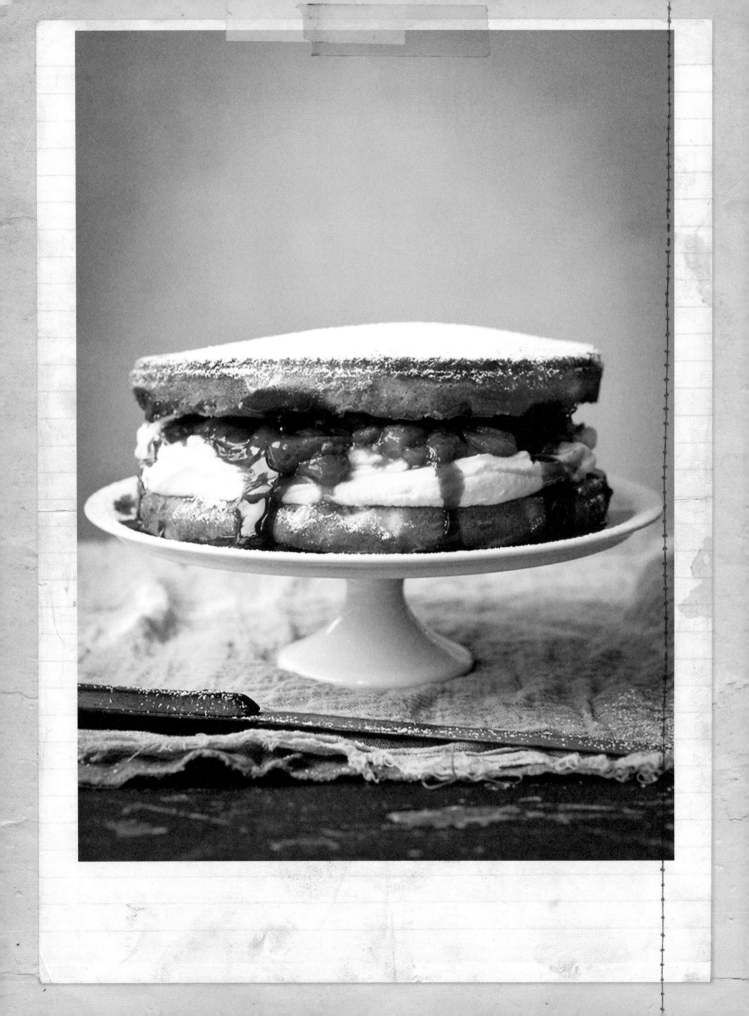

YOU´LL ENJOY
M. Polaner's

DOUBLE CHOC BROWNIES WITH SALTED BUTTERSCOTCH AND CHERRIES

These are incredibly naughty. You can cut them into squares, or into larger pieces and serve them warm for a dinner-party dessert with a good vanilla ice cream. When you are adding the butterscotch layer, don't worry if it blends into the batter a bit, just spread it out as best you can. The side bits are the best as the caramel goes all sticky and chewy!

1 stick unsalted butter, melted and cooled a little
4 teaspoons kirsch liqueur or 1 teaspoon pure vanilla extract
½ cup superfine sugar
3 free-range eggs
¾ cup all-purpose flour
½ teaspoon baking powder
½ cup Dutch-process cocoa powder, sifted
2½ tablespoons milk
½ cup finely chopped good-quality dark chocolate
9 oz sour or morello cherries from a jar, drained well
confectioner's sugar, for dusting

SALTED BUTTERSCOTCH
⅔ cup firmly packed light brown sugar
1 cup heavy cream
5 tablespoons unsalted butter, cubed
¼ teaspoon sea salt, crushed

Serves 12

Preheat the oven to 400°F baking pan and grease and line the base and sides of an 11¼ in × 7 in × 1¼ in baking pan.

For the salted butterscotch, place all the ingredients in a heavy-bottomed saucepan and bring to a boil, stirring often. Reduce the heat to low–medium and simmer for 15–20 minutes until thickened and smooth, then set aside to cool slightly.

Place the melted butter, kirsch or vanilla, sugar and eggs in a bowl and mix together. Sift in the flour, baking powder and cocoa powder and combine well with a wooden spoon. Mix in the milk, then fold in the chocolate and cherries.

Spoon half the batter into the prepared pan and smooth the top. Dollop with salted butterscotch, then top with the remaining batter. Bake for 35–40 minutes or until cooked through and the top is cracked a little.

Remove from the oven and leave to cool completely in the pan before cutting into squares. Dust with confectioner's sugar before serving.

PINE NUT, LEMON AND POPPY-SEED COOKIES

These lovely little buttery cookies are quick and easy to make. Sometimes I serve them without the filling; they're perfect with a cup of tea or to pair with a lemon mousse at a dinner party. The cookies themselves will keep for up to 7 days stored in an airtight container; sandwiched cookies will keep in an airtight container in the fridge for up to 4 days.

1½ cups self-rising flour
¼ teaspoon ground ginger
3 free-range egg whites
¾ cup superfine sugar
1 stick butter, melted and cooled
finely grated zest of ½ lemon
½ cup pine nuts, plus extra for scattering
4 teaspoons poppy seeds

LEMON AND CREAM-CHEESE FILLING
½ cup cream cheese, softened
5 tablespoons unsalted butter, softened
1 cup confectioner's sugar, sifted
finely grated zest of ½ lemon
2 teaspoons lemon juice

Makes 35

Preheat the oven to 350°F and line two large baking sheets with parchment paper.

Sift the flour and ground ginger into a bowl, stir to combine and set aside.

Beat the egg whites in a stand mixer on high speed until frothy. With the motor running, gradually add the sugar, about a tablespoon at a time, and whisk to firm peaks. Fold in the butter, lemon zest, pine nuts and poppy seeds with a large metal spoon. Gently fold in the flour mixture in two or three batches until incorporated.

Spoon the mixture into a large pastry bag fitted with a ⅝ in plain round nozzle. Pipe 1¼ in dots onto the prepared sheets at 2½ in intervals, then gently press the tops to smooth the surface. Scatter with the remaining pine nuts and poppy seeds, pressing them down slightly to help them stick.

Bake for 10–12 minutes or until golden brown around the edges, then remove and leave to cool slightly before transferring to cooling racks to cool completely.

Meanwhile, for the filling, beat the cream cheese and butter in a bowl until smooth, then add the confectioner's sugar, lemon zest and juice and combine until light and fluffy. Spoon into a pastry bag fitted with a ½ in round or star-shaped nozzle and chill in the fridge for 15 minutes.

To assemble, pipe some filling onto the flat side of half the cookies, then sandwich together with a second cookie, gently twisting the top one as you push down. Refrigerate for 1 hour before serving.

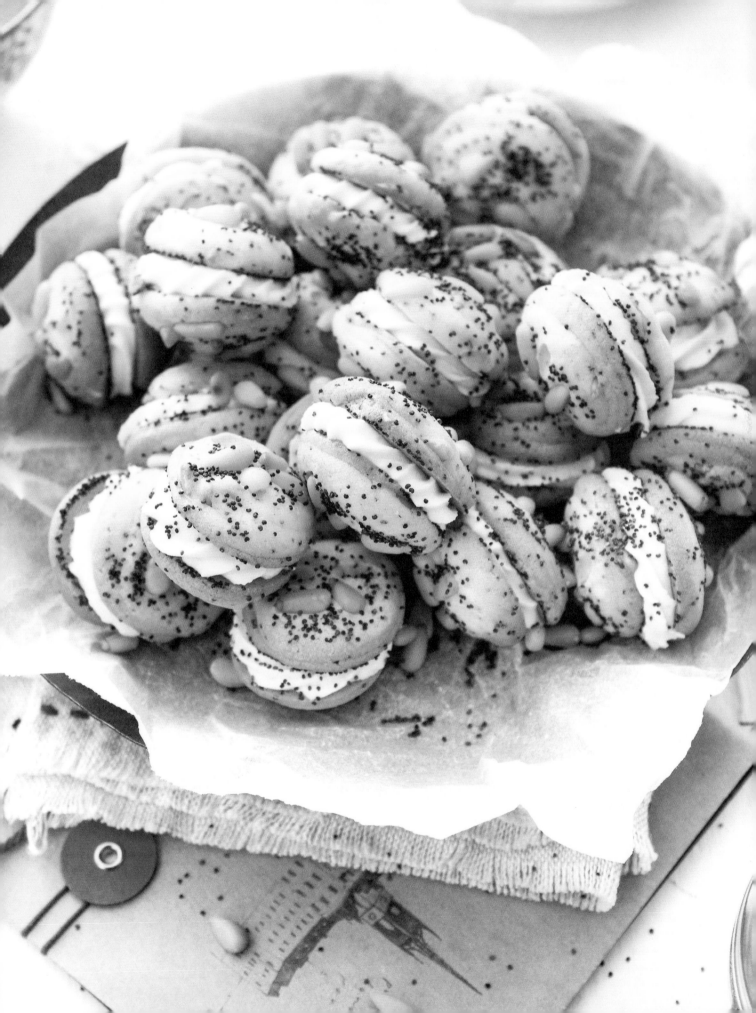

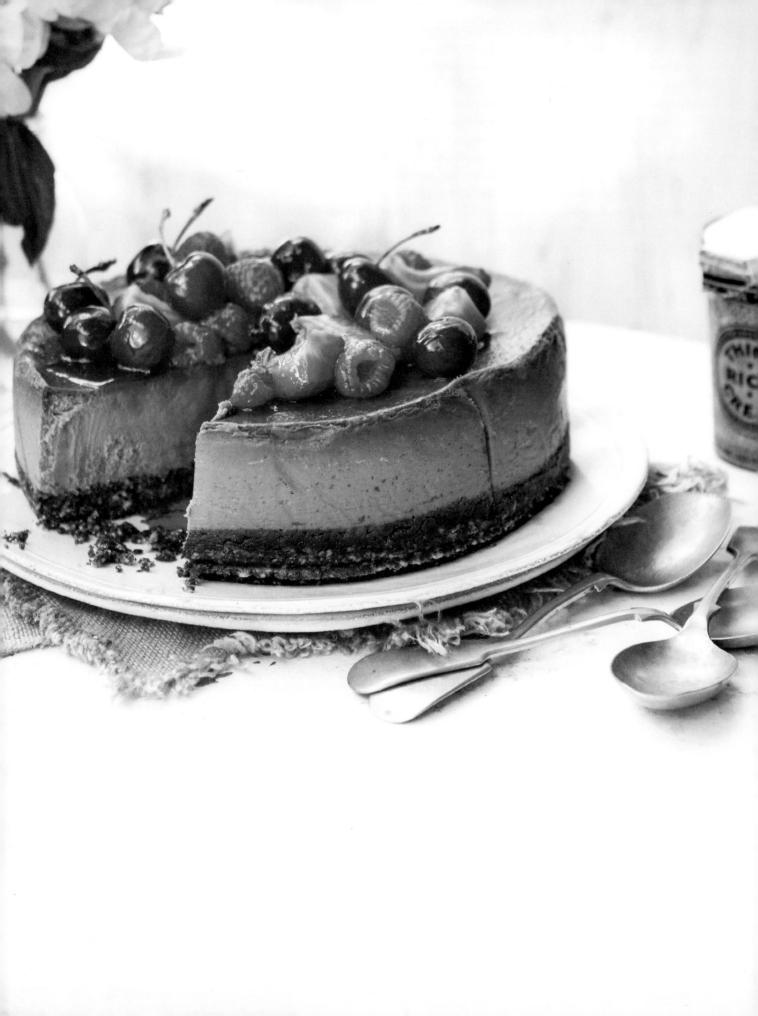

DOUBLE CHOC CHEESECAKE WITH BERRY SAUCE

№ 287

In Australia I use Arnott's Chocolate Ripple biscuits for the cookie base here, but you could use Oreo cookies; just bung them in whole, there's no need to scrape off the cream in the centers first. If you don't want to use amaretto, you can substitute with 1 teaspoon of pure vanilla extract. Leave some of the cherry stems attached for a nicer presentation, if you like.

9 oz plain (un-iced) chocolate cookies, such as Oreos
¾ cup blanched almonds
8 tablespoons unsalted butter, melted and cooled
½ cup good-quality dark chocolate
½ cup good-quality milk chocolate
2 cups, plus 1 tablespoon cream cheese, softened
1 cup light sour cream
4 free-range eggs
1 cup, plus 2 tablespoons firmly packed dark brown sugar
1¼ cups heavy cream, plus extra, whipped, to serve
4 teaspoons amaretto

BERRY SAUCE
9 oz fresh cherries (pitted, if you like) or sour cherries from a jar, drained well
9 oz strawberries, hulled and halved
5½ oz raspberries
4 teaspoons lime juice
3 tablespoons superfine sugar

Serves 8

Preheat the oven to 325°F and grease and line the base and sides of an 8½ in springform cake pan. Wrap the outside of the pan with foil, sealing it securely.

Whiz the biscuits and almonds in the bowl of a food processor to fine crumbs. Add the butter and pulse to combine. Press this mixture evenly into the base of the prepared pan and chill in the fridge for 30 minutes.

Melt the dark and milk chocolate in a heatproof bowl that fits snugly over a saucepan of gently simmering water, then set aside to cool slightly.

Beat the cream cheese and sour cream in a stand mixer on low–medium speed for 1–2 minutes until smooth and combined. Add the eggs, one at a time, beating after each addition until incorporated. Add the brown sugar, cream and amaretto and beat on low speed for 1 minute. Beat in the melted chocolate until combined.

Pour the batter onto the cookie base and tap the pan gently on a countertop to remove any bubbles. Place the cake pan in a large roasting pan and pour enough cold water into the roasting pan to come 1 in up the sides of the cake pan. Carefully transfer to the oven and bake for 1½ hours or until set at the edges with a slight wobble in the center. Leave in the switched-off oven to cool for 1 hour with the door slightly ajar, then remove and cool to room temperature, before chilling in the fridge for 1 hour.

Meanwhile, for the berry sauce, place all the ingredients in a heavy-bottomed saucepan, bring to a boil, then reduce the heat to low–medium and simmer for 3 minutes or until the fruit is soft but still holding its shape. Drain for 5 minutes over a bowl, reserving the syrup. Place the syrup in the pan and simmer over medium heat for 10 minutes or until thick and glossy, then gently fold into the fruit and set aside to cool completely.

Sit the cheesecake on a large plate and remove the pan, then top with berry sauce and serve with whipped cream.

BERRY ALMOND COBBLER

I used fresh fruit for this, but you can use frozen raspberries and blueberries if you wish; the result will be just as good. I've had this classic American dessert a few times on my travels in the U.S.; this is my own take on all the delicious cobblers I've enjoyed over the years.

1 pound 2 ounces strawberries, hulled, halved if large
13 oz blueberries
9 oz raspberries
4 tablespoons superfine sugar
1 teaspoon cornstarch
fine salt
finely grated zest and juice of 1 lime
2½ tablespoons light brown sugar
½ cup slivered almonds, toasted
heavy cream, to serve

COBBLER TOPPING
2 cups all-purpose flour
1 teaspoon baking powder
1 teaspoon cream of tartar
4 tablespoons light brown sugar
½ teaspoon ground cinnamon
pinch of fine salt
8 tablespoons unsalted butter, chilled and cubed
¾ cup buttermilk
4 teaspoons heavy cream
4 teaspoons amaretto (optional)

Serves 6

Preheat the oven to 400°F.

For the topping, whiz all the dry ingredients in the bowl of a food processor. Add the butter and pulse until the mixture resembles coarse bread crumbs.

Whisk together the buttermilk, cream and amaretto in a bowl, then add to the butter mixture and whiz until the mixture just comes together. Set aside.

Combine all the berries in a bowl and stir in the sugar, cornstarch, a pinch of salt, the lime zest and juice. Transfer to a baking dish (I use an 11¼ in round dish that is about 2½ in deep) and spread out evenly. Top with large clumps of the cobbler mixture (don't spread this out evenly; this is part of the charm). Sprinkle over the brown sugar and slivered almonds, then bake for 40–45 minutes or until the topping is golden brown.

Serve hot with heavy cream.

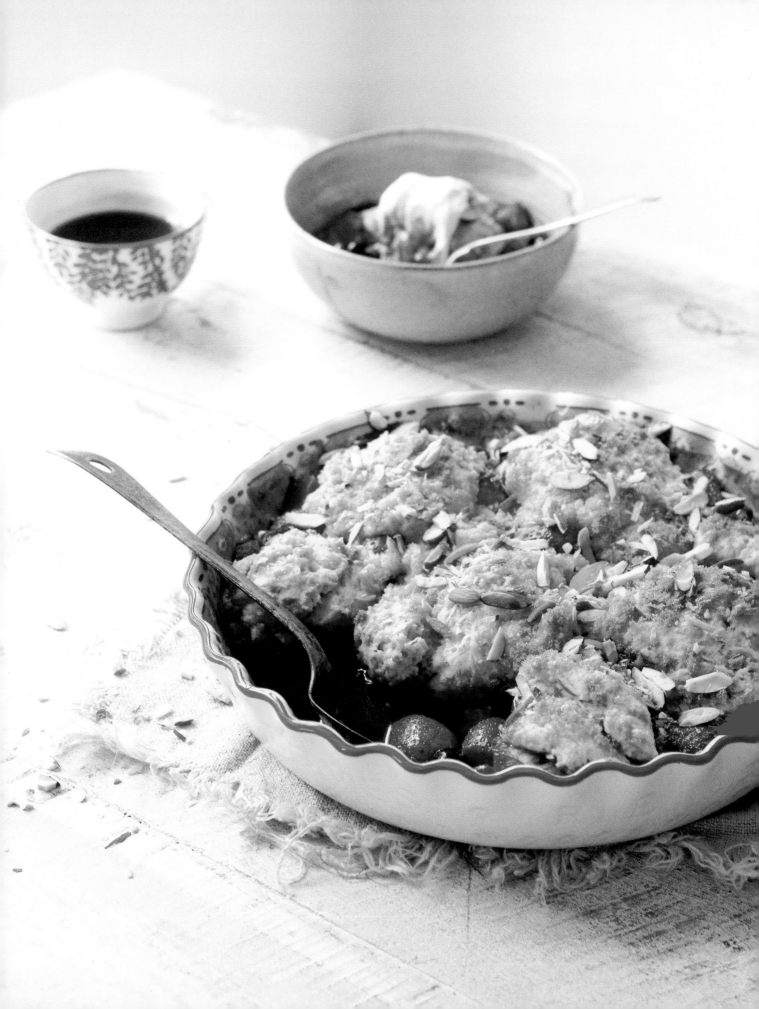

UPSIDE-DOWN PLUM CHIFFON CAKE

If plums aren't in season, you can use canned plums instead; just drain them well and pat them dry with paper towel. This cake may sink a little when you remove it from the oven but don't worry, you'll be flipping it over anyway.

8 plums, pitted, quartered lengthwise
1 stick cinnamon
1⅓ cups superfine sugar
4 free-range eggs, separated, plus 2 egg whites, extra
4 tablespoons olive oil
7 tablespoons milk
1 teaspoon pure vanilla extract
1 cup all-purpose flour
½ cup almond meal
1 teaspoon baking powder
pinch of cream of tartar
heavy cream, to serve

Preheat the oven to 350°F and grease and line the base and sides of an 8½ in springform cake pan. Place the pan on a foil-lined baking sheet.

Arrange the plum quarters, cut-side down, in an even layer over the base of the prepared pan.

Place the cinnamon stick, ⅔ cup of the sugar and 7¾ fl oz water in a heavy-bottomed saucepan and bring to a boil over high heat. Cook for 8–10 minutes (swirl the pan often but do not stir) until the caramel starts to turn golden brown, then carefully pour the hot caramel over the plums in the pan. Remove the cinnamon stick with tongs and discard.

Combine the egg yolks, oil, milk and vanilla in a large mixing bowl with a wooden spoon. Sift the flour, almond meal, baking powder and ⅓ cup of the sugar into a separate bowl and combine. Add this to the egg-yolk mixture and beat with a wooden spoon to form a thick batter.

Beat the six egg whites in a metal bowl with a hand-held electric mixer until thick and frothy. Add the remaining sugar in three or four batches, beating well after each addition. When the mixture is thick, frothy and voluminous, add the cream of tartar and fold in with a large metal spoon.

Spoon one-third of the egg-white mixture into the cake batter and fold in gently, then add the remaining egg-white mixture and fold in gently to combine.

Pour the batter over the plums, then transfer to the oven and bake for 50–60 minutes or until a skewer inserted in the center comes out clean.

Leave to cool in the pan for 15 minutes before slicing and serving warm with cream.

Serves 8–10

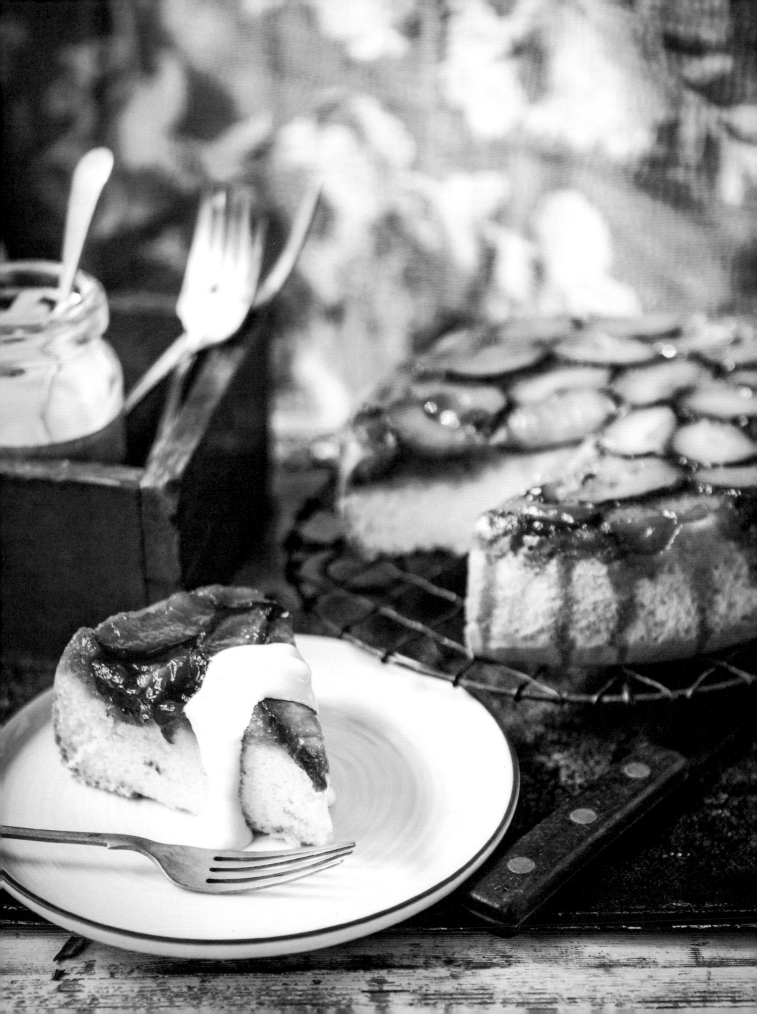

SHEEP'S MILK CHEESECAKE WITH MANGO AND PEANUT

Sheep's milk yogurt is available from gourmet delis and selected supermarkets, but you can use plain yogurt if you can't find it. Make sure you start this the day before you want to eat it, as the cheesecake needs to be refrigerated in the pan overnight so it is firm enough to slice.

¾ cup raw unsalted peanuts
9 oz graham crackers
7 tablespoons unsalted butter, melted and cooled
2 cups cream cheese, softened
4 free-range eggs
1 cup superfine sugar
1½ cups sheep's milk yogurt
½ cup heavy cream
4 teaspoons all-purpose flour
2 ripe mangoes, peeled, flesh cut away from the seed
4 teaspoons lime juice

Serves 8–10

Preheat the oven to 400°F and grease and line a 9½ in springform cake pan. Wrap the outside of the pan with foil, sealing it securely.

Scatter the peanuts on a baking sheet lined with parchment paper. Roast for 10–12 minutes or until golden brown, then remove and leave to cool for 5 minutes before transferring to the bowl of a food processor. Add the graham crackers and whiz together for 1–2 minutes or until broken down into fine crumbs. Add the melted butter and whiz again until well combined. Press this mixture evenly into the base of the prepared pan and chill in the fridge for 30 minutes.

Reduce the oven temperature to 325°F.

Beat the cream cheese in a stand mixer on high speed until smooth and creamy. Add the eggs, one at a time, beating after each addition until incorporated. Add the sugar, yogurt, cream and flour and beat on medium–high speed for 1–2 minutes to combine thoroughly.

Puree the mango flesh in a blender, then add the lime juice and stir to combine.

Pour the batter onto the cookie base and tap the pan gently on a countertop to remove any air bubbles. Pour the mango puree onto the filling in a spiral motion and, using a fork, gently swirl the puree into the filling. Place the cake pan in a large roasting pan and pour enough cold water into the roasting pan to come 1 in up the side of the cake pan.

Carefully transfer to the oven and bake for 1½ hours or until set at the edge with a slight wobble in the center. Leave in the switched-off oven to cool completely with the door slightly ajar.

Cover with plastic wrap and chill overnight before serving.

BELGIAN SHORTBREAD

I enjoyed this dessert at a Christmas dinner a few years ago,
and although I normally don't like dates, I loved them in this!
You get the crumbly pastry, sweet and sticky dates and crunchy
slivered almonds; I couldn't get enough of it . . .

8 tablespoons, plus 1 teaspoon unsalted butter, chilled

1/3 cup superfine sugar

1½ cups self-rising flour, plus extra for dusting

¼ teaspoon sea salt

1 free-range egg, separated

1–2 teaspoons milk (optional)

½ cup raspberry or plum jam

2/3 cup plump moist dates, seeded and chopped

3 tablespoons slivered almonds

Serves 8

Preheat the oven to 325°F and grease and line a 10 in round tart pan
with a removable base.

Place the butter, sugar, flour and salt in the bowl of a food processor
and whizz until the mixture resembles fine bread crumbs. Add the
egg yolk and pulse until the mixture just comes together (add a little
milk if the mixture is too dry). Turn out onto a floured countertop and
knead into a ball. Wrap in plastic wrap and chill in the fridge
for 30 minutes.

Divide the chilled dough in half. Roll out one portion between two
sheets of parchment paper into a 10 in round; don't worry if it's not
a perfect circle, as it will all come together as it bakes. Gently drape the
pastry over the rolling pin and transfer to the pan, pressing it down.

Place the jam in a bowl and press down with the back of a spoon until
smooth and softened.

Spread the jam evenly over the pastry in the pan and cover with the
chopped dates. Roll out the second portion of dough in the same way
as the first and lay on top of the dates. Beat the egg white and brush
over the pastry, then sprinkle with the slivered almonds, pushing
them down slightly.

Bake for 40–45 minutes, then cool completely in the pan or on a
cooling rack before cutting into wedges to serve.

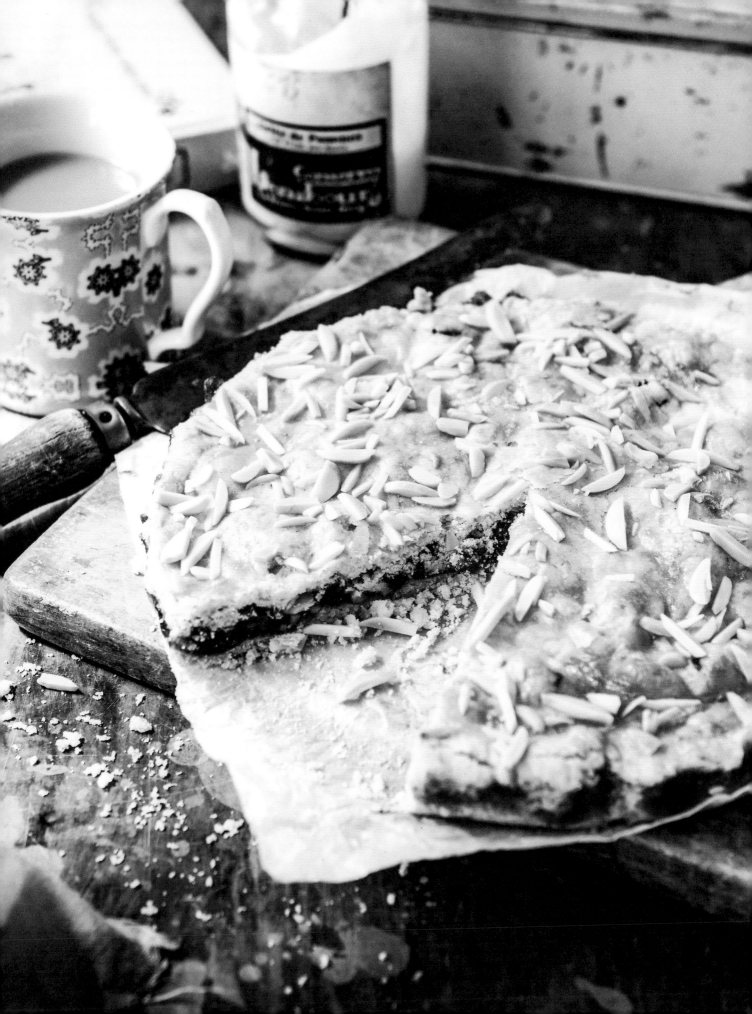

BEHIND THE SCENES

Alice

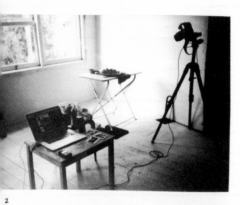

2

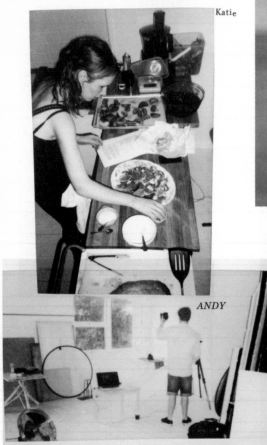
Katie

ANDY

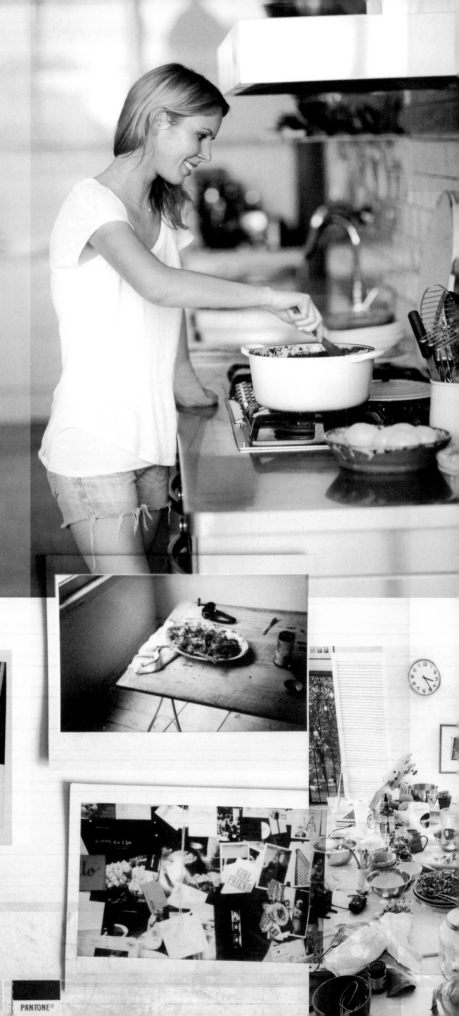

You will need ...

1 kg uncooked prawns, peeled an[...]
tails intact
Juice of 2 limes
Sea salt and freshly ground black pepper
2 limes, halved
Extra lime quarters and crusty bread, to serve

For the Thai dipping sauce ...

2 cloves garlic, crushed
2 tablespoons fish sauce
3 tablespoons lime juice
2 tablespoons brown sugar
½ small red onion, finely diced
1 long red chilli, finely chopped
1 long green chilli, finely choppe[d]
1 tablespoon chopped coriander
1 tablespoon chopped mint
1 x 1 cm piece ginger, finely grated
Pinch sea salt and freshly ground black pepper

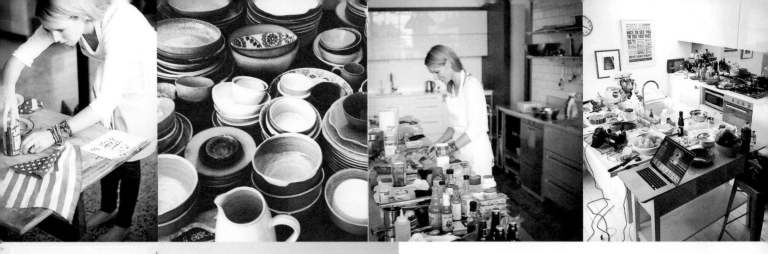

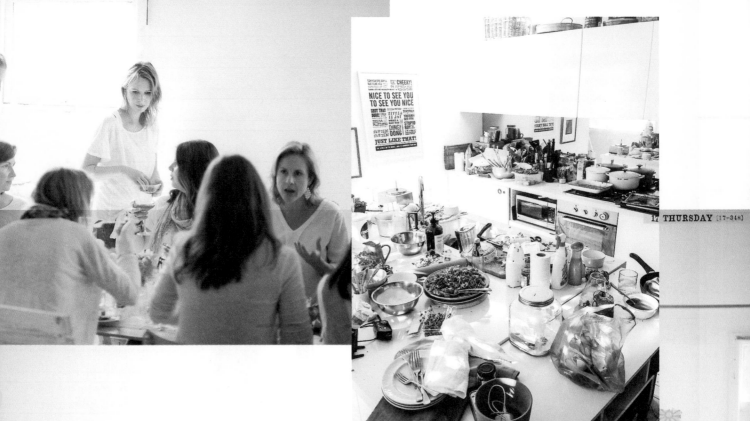

17 THURSDAY [17-348]

18 FRIDAY [18-347]

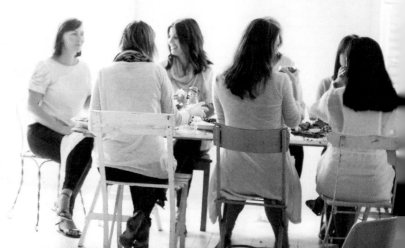

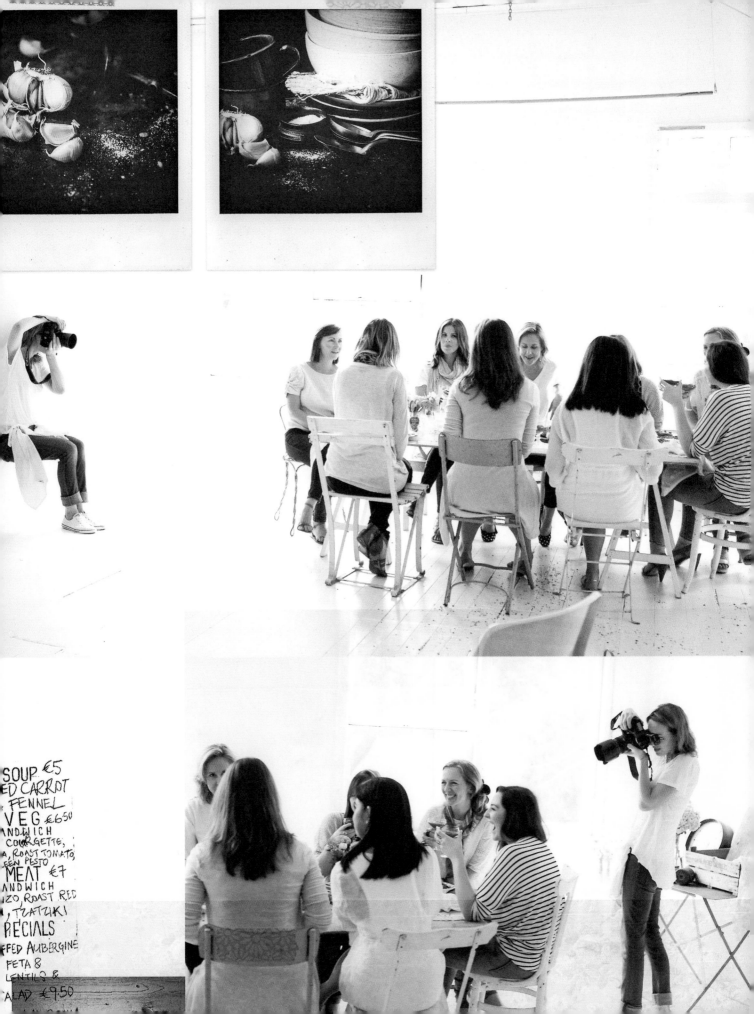

SOUP €5
ED CARROT
FENNEL
VEG €6.50
NDWICH
COURGETTE,
, ROAST TOMATO,
EEN PESTO
MEAT €7
ANDWICH
IZO, ROAST RED
, TZATZIKI
PECIALS
FFED AUBERGINE
FETA 8
LENTILS &
ALAD €9.50

I want to say an enormous thankyou to all the people who have helped me complete this book over the past year.

Most importantly, to my amazing assistant, Alice Cannan. If it wasn't for you, I don't think there would even be a second book! You are an incredible assistant and friend. Thankyou for all those trips to the supermarket, all the washing up, chopping veg, cooking, handing me things on set before I even knew I needed them, and for helping to make what is often an immensely stressful situation a much calmer one.

To everyone at Penguin Australia — Julie, Virginia, Katrina, Evi O, Daniel and Elena — again, without your input, we may not be reading these pages.

To Nick Banbury, quite possibly THE world's best recipe tester! Nick, thankyou for your diligence and perfectionism: I have accumulated a wealth of knowledge from you. I am chuffed to have been paired with someone who possesses such an amazing knowledge of all things food.

To all my friends back home in Ireland, in NYC, elsewhere around the globe and here in Australia, you know who you are — you've been so supportive throughout the book process and, most importantly, through a very tough time personally in early 2014.

To my 'Rozelle gang': Michelle, Andy and Colin — your unending friendship and support means the world to me. I would be lost without you three.

To all my incredible friends in the Barossa: Jan and John Angas; Michael Wohlstadt; Caroline and Donna; David and Jennifer; Fiona and Mel — thankyou for all your help, support and hospitality. I look forward to the next glass/bottle of red at Hutton Vale!

To Madeleine Mouton: thanks again, M, for being there just when I needed you. To Lou Brassil for your amazing styling help. To all the super 'Weekend Girls' Lunch' blog readers — your enthusiasm and great spirit on the day was invaluable and I so enjoyed meeting you all.

To Sophie, my photo producer, for being a great friend, a good laugh and juggling jobs for me with the busy book schedule.

To Georgie and all the girls at Major & Tom: once again, Georgie, your support and friendship is greatly cherished.

To Vlad, the coolest courier in Sydney. Prop collection and return would have been hellish without your chilled-out, "nothing is ever a problem" nature.

To Chris the butcher at Darling Street Meats: thanks for supplying the best meat in town and for prepping it all so perfectly for me.

To everyone mentioned above, this book is totally dedicated to you all.

To my sister Julie, Claudio, Erika, Colm, Leonie and Tim — I love you all endlessly.

Thankyou from the bottom of my heart. xx

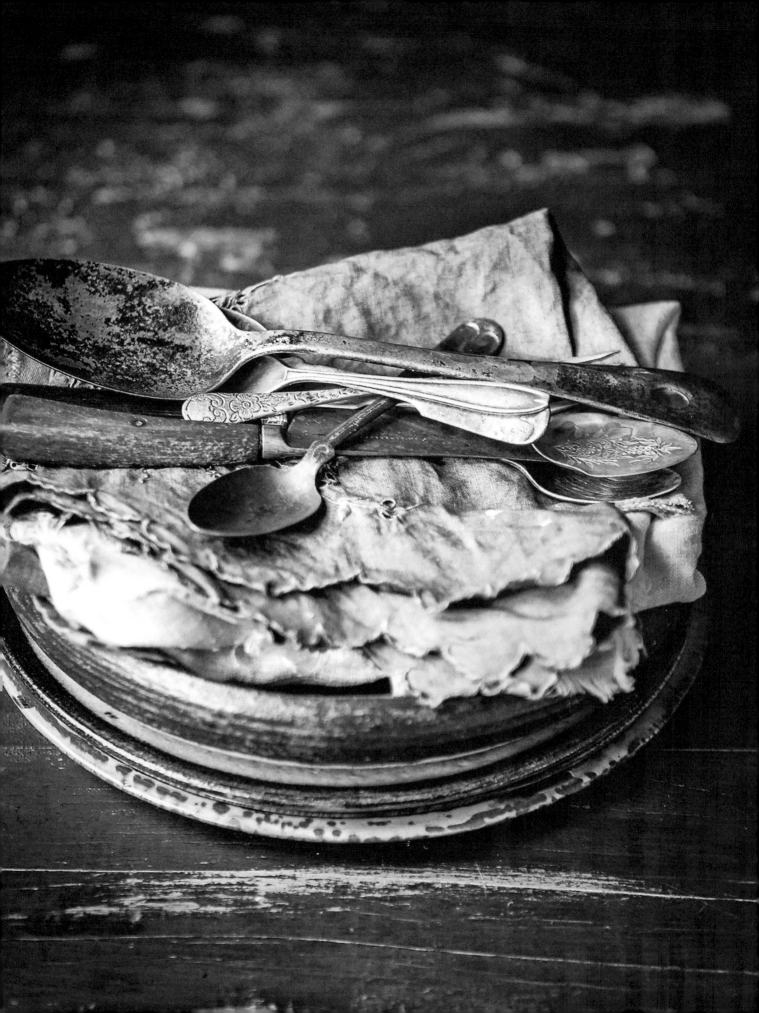

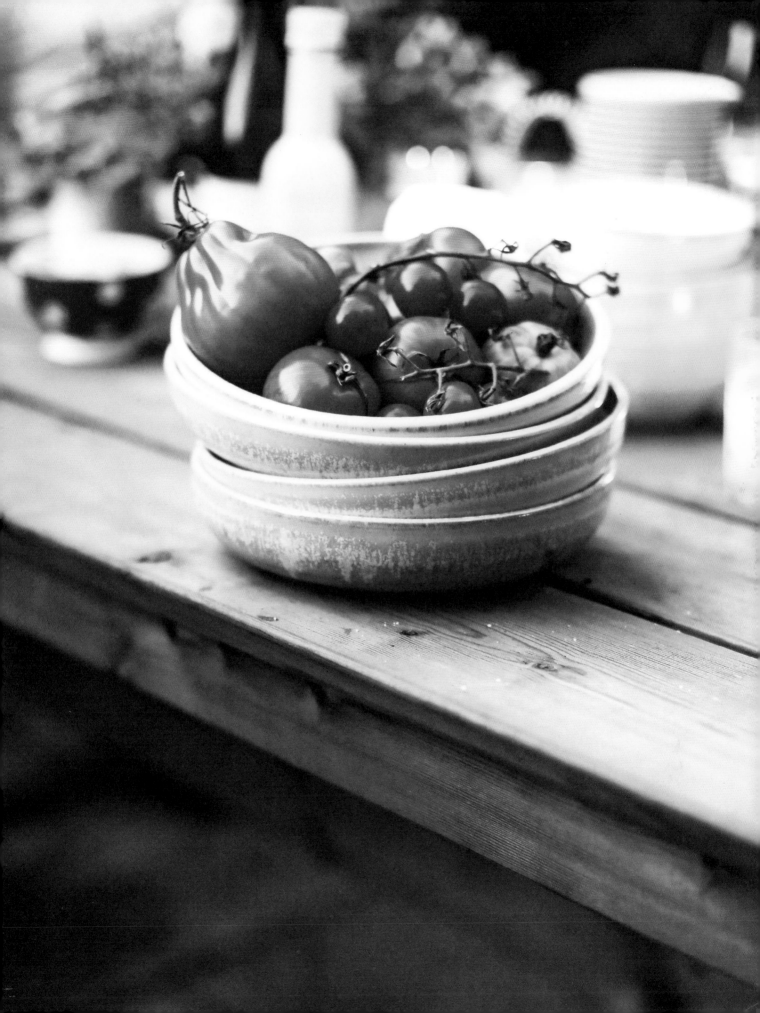

VIKING STUDIO

Published by the Penguin Group
Penguin Group (USA) LLC
375 Hudson Street
New York, New York 10014

(Penguin logo)

USA | Canada | UK | Ireland | Australia | New Zealand | India | South Africa | China
penguin.com
A Penguin Random House Company
Published by Viking Studio, a member of Penguin Group (USA) LLC, 2015

First published in Australia by Penguin Group (Australia)

Photograph on page 89 by Valery Rizzo. All other photographs by Katie Quinn Davies.

ISBN 978-0-525-42895-4

Printed and bound in China by 1010 Printing International Ltd

10 9 8 7 6 5 4 3 2 1

Set in Filosofia

Designed by Katie Quinn Davies

Chairs and props for A Weekend Girls' Lunch kindly supplied by Ici et La (*icietla.com.au*).